A Perfectly Ordinary Paradise:

an intimate view of life on Brawley Creek

~ John Hess ~

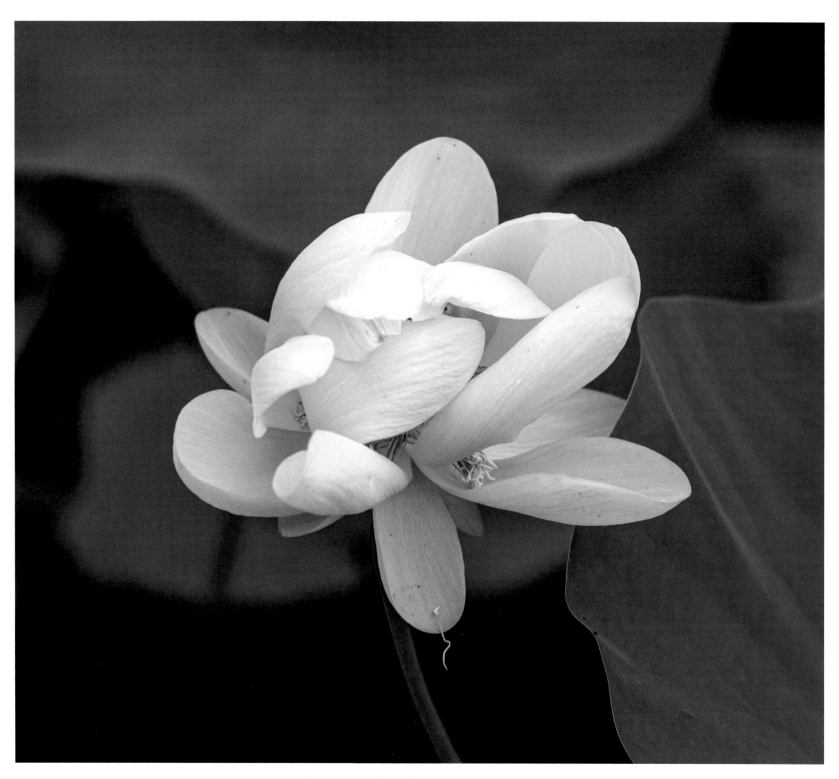

As this book goes to press, an American Lotus (Nelumbo lutea) opens it first flower here at Brawley Creek. Their flowers produce sizable seeds, and we've no idea how it made its way here, but their large elevated flowers and enormous dark green leaves make a striking combination.

For Gina ~ elated by discovery and in awe of the beauty and the tranquility she encounters here, she too enjoys the affectionate familiarity with, and deep respect for, the other lives in this little community that has become sacred to us.

Published by Brawley Creek Photography
www.brawleycreek.com

A Perfectly Ordinary Paradise: an intimate view of life on Brawley Creek
John Hess

ISBN 978-0-578-95127-0

First Edition October 2021
Printed in the U.S.A. by Edition One

(Front cover) A Hover fly takes pollen from the stigma of Chicory.
(Back cover) Clockwise: Red-winged Blackbird, Poison Ivy foliage, White-tailed Deer fawn, Red Raspberry Slime, Hedge branch cross-section, Monkey Flower, Cardinal wing-feathers, milkweed seed dispersal, Great Blue Lobelia flower bud.

Cover Design by John and Regina Hess

Contents

To be anywhere
you have to speed down
and walk slowly
to know intimately
just your small plot
of earth
that was given to you
by luck and
divine Chance.

From: *Afloat* by Jonathan Greene,
Broadstone Books 2018, used by permission.

About the Photographs

All the images in this book, excepting the aerial photographs and one other, were taken here at this Place—on the Brawley Creek property or within a stones throw. That's an important point because the reader needs to know that all of these events happened here. And they happen every season of every year, although we don't always see them. They also happen in every other Place that allows life to develop with minimal disturbance for a few years.

All the photographs are manipulated. That is necessary to pass off two-dimensional clusters of silver, or two-dimensional spatters of ink as images that fool us into pretending that they have three dimensions. That deception is inherent in paintings and in photography, and it always has been. The term "Photoshopped" is often used to imply that the images aren't trustworthy, but in this book, it means that I have adjusted the raw photographs to make them clearer and sharper, and to present accurately the colors as I experienced them when I took the pictures. There is a lot of technology between releasing the shutter and the image that appears at the end of a very long process that ends in that image, rendered in ink, on these pages. There is no replacement for seeing the real thing, but this is about as close as you can come in a book.

In a few places I've made more invasive adjustments, merging two or more images into a single frame. I've done that with the Red Fox (below) for aesthetic effect, and in a few other photographs to make meaningful comparisons between events from different times. All such adjustments are noted in the captions.

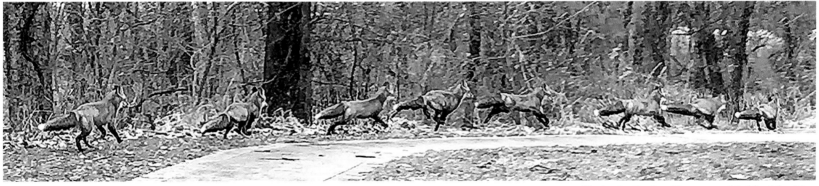

A Red Fox runs down the front walk.

Photos by Regina Hess, assembled by John Hess

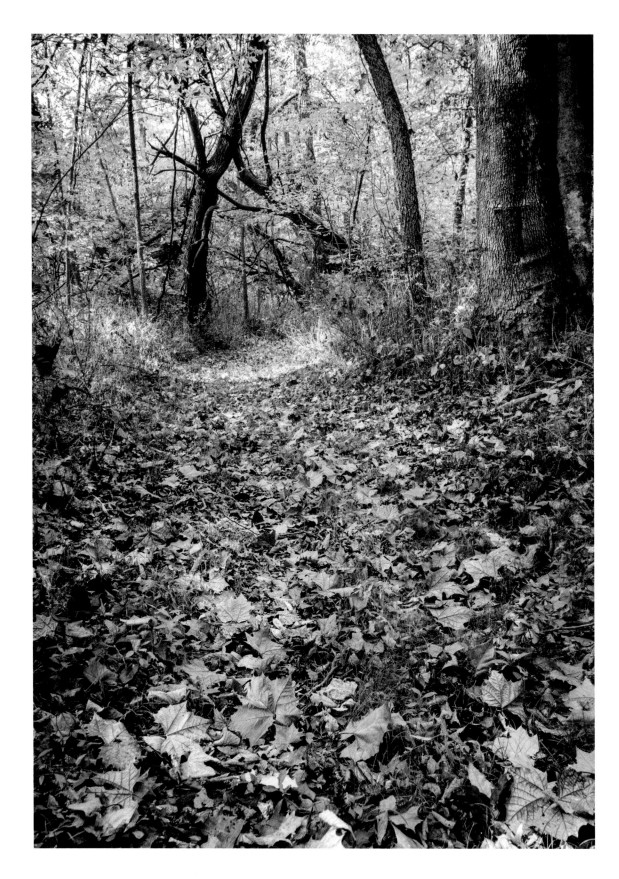

Preface: Most parks have trails like this; any small woodlot could. It's a generic trail, nice—even inviting—but to Gina and me, this trail is a treasure because we know it intimately. We know something of its history and of the lives of these trees. There is a big difference between a generic trail and a treasured place, and the gap between them points to the difference between place as a location, and Place as a consolidation of every aspect of that location; history, ecology, and culture.

Preface

"I find it suits me to be rooted here, in one landscape, for long enough to know not just the sights but the names of the stars that go over at night and the weeds and spiders and the family history of the ruined houses in the woods and the rocks in the road cuts. One life is hardly enough."

~ Douglas Harper

We've discovered a 30-acre patch of paradise tucked away in rural Missouri and we are privileged to be its custodians. Anyone driving by would see 30 acres of ordinary; with gates of tubular steel—a little rusted—definitely not pearly. But then this is an earthly paradise. Gina and I have lived here for nearly four decades; we've both grown to love it and it suits us to be rooted here. We know it as Brawley Creek. The years Gina and I have spent here have been powerful for us, and we see ourselves as members of a biological community that is rich and complex beyond imagination.

Brawley Creek is unarguably ordinary: unexceptional, commonplace, unremarkable, even humdrum. Places just like it are found everywhere in our ecological zone—every unimproved floodplain, ridge, and roadside ditch. One might wonder what there is to write about, but this ordinary place is sprinkled with jewels such that every outdoor experience is like a vast Easter egg hunt. That is what turns this place into a paradise. The point of this book is to help you find those treasures where you are. Yes, there are ticks and mosquitoes, but they are important components with roles to play. Understanding why this must be

so becomes apparent as we develop a balanced perspective of the world and of our place in it.

This book is about Place. It is a nebulous term that has grown to encompass everything about a location. The photograph on the first page is there to help distinguish the narrow view of place—this spot as identified by its GPS coordinates, and the more inclusive view of Place that embraces every aspect of that location. The nature of this Place is revealed in dribs and drabs throughout this book. The trail in the figure follows a shallow depression that at one time carried the water of Brawley Creek. The large, gray Sycamore trunks on the right bank of that abandoned creek bed are resident beings we know as "the twins"—genetically identical, having sprouted from the body of a dying parent, and both well over 100 years old today. We know about the parent only because the twins wrapped their bases around their mother like clinging children. The parent is entirely gone, but she left the imprint of her body on the kids. Knowing their story turns them from generic Sycamores into The Twins, and they give us a glimpse into the past that reaches back at least two centuries.

Every observation tells us about the lives of the residents. The arch over the trail, about 30 feet past the twins is formed by two Osage Orange trees—commonly called Hedge, the colloquial name I will use. Hedge trees were repatriated early in the 19th century from further south where they had been driven by the advancing glaciers. All across the Midwest, they were planted in hedge rows to contain livestock. Their branches spread widely and form dense tangles armed with lots of short, stiff thorns—a kind of bio-barbed wire that was eventually replaced by steel.

By now Hedge trees have made themselves at home and they are common invaders of unused fields that, like ours, become woodlands if not maintained. They are well suited to open habitats because their branches spread widely to capture sunlight, but they are poorly suited for the woodlands that inevitably grow up around them. Eventually the weight of those branches spreads too wide, their fused, multiple trunks split, and their heavy branches catch in the trees around them. That failure is the backstory of the arch that comes to our attention only because I cut a trail under it. These observations tie together the elements of a community and begin to build a sense of Place. We find all of it fascinating.

When I first went birding, my interest was only in the birds. I was pleased just to see a few birds that were familiar and for which I now had names: I began to notice details of plumage and behavior. The experience was pleasurable, and I soon found myself painlessly absorbing information within a community of naturalists, knowledgeable and supportive people who shared what they knew and their excitement in it. I began to see the importance of knowing about migration times. On occasion I saw beauty that was far beyond anything on a printed page, but birds are only a part of the complex, interdependent web that surrounds us—inevitably the whole community is drawn into the picture. The experience has been fascinating; deeply rewarding. That entanglement is profound because each experience eventually leads to the study of life itself—as distinct from the study of living things.

As a biology professor, I was privileged to teach these things as a way to share my fascination while making a living. Biology coupled with photography makes a powerful combination and as far back as graduate school I began to study photography as a tool that allowed me to probe the lives and physical structures of other life forms and to share the details that I find so fascinating. Becoming immersed in this world as both biologist and photographer, merged the pleasurable experiences of science and aesthetics, and it provided access to the emotional part of our brains in the ways demonstrated by Ansel Adams, Eliot Porter, and other masters who showed me the power of imagery to create awe, nurture joy, and motivate.

My interests have broadened, and I've had many years to study and consolidate information about how ecosystems work, and I'd like to share that as well. Taken in combination as I've done here, enables a broader perspective of the world while holding on to intimate details of the individuals that populate the community. It is a level of understanding that carries responsibilities, and this work is a part of my effort to spread that joy and to make clear that it is available to everyone everywhere.

Most of us live in the midst of a network of perfectly ordinary paradises, if we knew how to recognize them, but that requires an investment—the entry fee may seem steep, but the payments are tiny, and each is accompanied by a little burst of pleasure so that it is more like paying for a donut than sending off a mortgage payment.

My trajectory took me beyond the instant response to beauty with a different kind of pleasure where intellectual involvement enriches our experiences—learning the architecture of community members, and the way resources flow so as to bind the community together, are intangibles that dictate how it works. A few natural laws control the movement of energy and matter, and shape everything—the behaviors of species, their mating rituals, and the details of family life. We are all familiar with the plot lines of those stories; they are much older than humanity because they are driven by fundamental forces that shape us all. Sex is everywhere. There are plants that seduce their insect pollinators with scents that promise food or sex, but those promises are only click-bait. Cuckoldry and bondage, are commonplace, embryos are left on doorsteps, and there are furious battles in defense of territory. There are powerful predators and their prey—both of whom must be clever and agile if they are to appear in the next episode. Among life forms more distant from us, there are exploding fruits, and fruits that beg to be eaten. There are parasitic wasps that consume their host from the inside and then burst out, leaving a terminally wounded walking shell devoted to assisting the parasite—about as close to a zombie as one might imagine. All of this happens in seasonal cycles—residents come and go, permanent residents enter dormancy and reemerge. Migrants arrive and depart on tight schedules, and reproductive periods begin and end, scattered across the seasons in ways that maximize the number of offspring, and match their capabilities to the changing seasons. Watching this unfold underscores the unity as well as the divisions of our world.

In the opening pages of Will and Ariel Durant's short book, The Lessons of History, the authors list the many facets of their chosen subject—politics, philosophy, technology, religion, and more. They recognize that their work is "…a precarious enterprise, and [that] only a fool would try to compress a hundred centuries into a hundred pages of hazardous conclusions. We proceed."

I know the feeling. This book too, has been reduced to the barest essentials. I've discarded one fascinating thing after another, in order to squeeze what I can between these two covers, addressing the most fundamental mega-processes while retaining the intimacy promised in the title. I've chosen to consider life processes broadly and objectively even when they run counter to our cultural narratives—I'm offering you the red pill.† Even so, I've chosen not to address the future, where the sixth extinction—the elephant in the room—already looms large. It is a very big elephant that casts a long, dark shadow, but that isn't what this book is about. Rather, I've chosen to celebrate the beauty and complexity of the present as illuminated by echoes of the past, and to dwell on achieving an awareness that can enrich life as it is right now. This inclusive perspective will touch on our place in the world and push us to recognize that there is in fact just one community, of which we are a small part. My hope for the readers who take this journey with me is that you will see more carefully, enjoy more fully, and think more broadly as you experience the rich pleasures that surround us, and that you will experience the pleasure that comes when we see ourselves as a part of this grand enterprise.

† The reference is to The Matrix—in which Neo is offered the choice of a red pill that will allow him to see reality, or a blue pill that will allow him to continue living unaware.

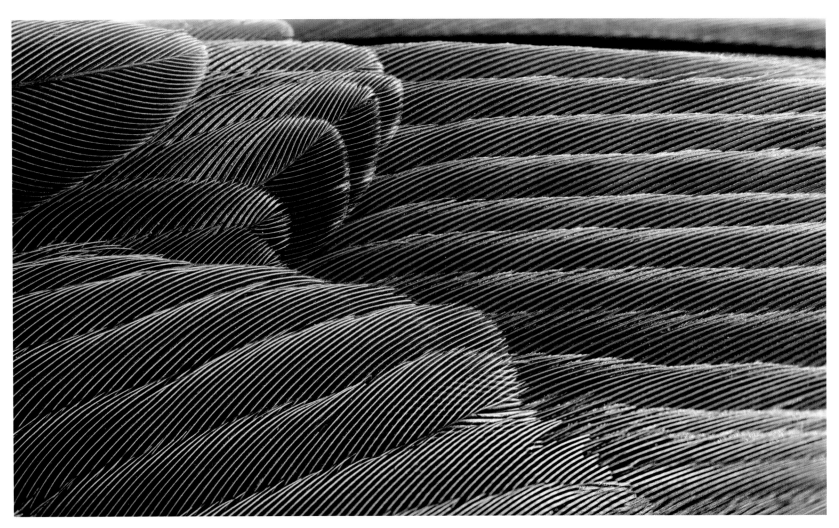

Introduction 1. Architectural detail in the wing of a female Cardinal is a source of awe in the "little infinity." The aesthetic dimension is available to all, but photography allows us to share an image that borders on hyper-reality. Accumulating the technical knowledge to understand the excellence of a bird's wing and the feathers that make it work requires something more; and there is always more to learn.

Adjusting Perspective: an Introduction

"In indigenous ways of knowing...we know [things] not only with our...intellect, but also when we engage our intuitive ways of knowing, of emotional knowledge and spiritual knowledge."

~ Robin Wall Kimmerer

"There is a beauty in discovery. There is mathematics in music, a kinship of science and poetry in the description of nature, and exquisite form in a molecule. Attempts to place different disciplines in different camps are revealed as artificial in the face of the unity of knowledge."

~ Glenn T. Seaborg, Nobel laureate

Part of being human is a craving to experience awe, and we seek it out. We find awe in places that are outside of our normal lives—often well beyond the scale in which we live our lives. I think of that realm as the Grand Infinity. We search for it by putting ourselves in places where we sense overpowering forces. So, we stand beneath the soaring arches of a gothic cathedral immersed in silence; it is a powerful experience, with both architectural and spiritual components, and it makes us feel small. We explore the infinity of the night sky to come face to face with incomprehensible distances and forces, and we shrink to almost nothing.

People say that the experience of awe centers them and brings a deep calm. It seems likely that natural selection has favored awe as a source of pleasure. Psychologists have shown that experiences like these increase our sense of well-being and our expression of generosity and altruism, making us feel more connected to people and closer to

them in a way that benefits social groups. The selective advantage of those sensations for social species like ourselves is obvious, and sharing them together, in groups, would serve to promote social cohesion.

The best place to begin is by recognizing that we have a craving for awe which we often find in things that are beyond our experience. I envision a Little Infinity as distinct from the Grand Infinity. They occupy the ends of a long spectrum. The little infinity is incomprehensibly small but equal to the grand infinity in that both lie beyond our ability to experience them directly. But the little infinity is something with which we interact intimately—viruses certainly have more immediate impact on us than supernovas. We exist in only a tiny sliver of this infinite spectrum, at the interface between two infinities. For the most part, we'll explore that sliver of scale in which our senses function— where living things produce vibrations at speeds that our ears can hear, where a sliver of the vast electromagnetic spectrum is visible as color, and body sizes are of dimensions that we can resolve with the naked eye. Occasionally we'll take a field trip into the infinities.

This subdivision is highly anthropocentric, but then we are humans, and we are trying to understand those parts of the nonhuman world we can experience directly, and understand from the limited perspective of an intensely social species with unique powers of reason. That is still more than enough for several lifetimes.

The sliver we inhabit holds items worthy of awe, but after our initial discoveries in childhood we relegate them to the status of "ordinary"— the way things are—and we dismiss them. To find the awe, we need only take the time to let the power of their structure speak to us, but we are busy and reluctant to do it. Georgia O'Keeffe created large, sensuous paintings of flowers to demand the attention of people. "When you take a flower in your hand and really look at it, it's your world for the moment…. Most people in the city rush around so, they have no time to look at a flower. I want them to see it whether they want to or not." To experience much at all, we need to set aside a few moments and attend to it.

Awe comes to us primarily through our receptors of sight and sound. They are our windows on the world that allow us to gather information over great distances. And then we think—using those sensors (and others) as feelers that inform our responses. This is congruent with the way our brain works. I respond to the image of the Cardinal's feathers as a mix of colors and shapes that are provocative for reasons that are partly innate and partly cultural.

Anybody with an interest in how things work will be struck by the details visible in this modest enlargement. Awe comes from the intricacy of the structure, and perhaps how hard it would be to create such perfection. It elegantly satisfies the needs of the bird—a nearly weightless construction that serves as both wing and propeller, the precise but flexible distribution of feathers that must slide over one another with very little friction, not only so that they move easily, but also so they don't destroy the tiny and necessarily flimsy parts. And how can such a complicated device be grown at the bottom of a tube (feather follicle) and then extruded to unfurl and harden. Seeing the mind-boggling complexity that combines both structure and function is worthy of awe, but it is different from the first quick response and comes from a separate source. Having access to both magnifies the experience of awe.

I see this response as the organization of our brain, playing out in a way that was initially popularized as right brain and left brain. The current model has replaced two sides with two systems, but the functions of those systems correspond roughly with the right brain/left brain formulation.† Daniel Kahaneman calls them System One, which is very fast, and System Two, which is slower. It may be inelegant, but it is what our ancestors bequeathed us, and the different speeds greatly affect the way we respond to events. Imagine a tortoise and hare paired in a three-legged race. For lack of better terms, I'll refer to these two systems by their functional abilities as the Emotional Brain and the Rational Brain. Learning to use both parts is like becoming bilingual as an adult. People who have integrated their responses to both systems and are fluent in both seem to me like wise people. We are not quite the autonomous, rational beings that the philosophers of the Enlightenment envisioned.

The emotional brain houses the amygdala, located near the center of the brain where rage, fear, sexual arousal, and pleasure are initiated. Its response is almost instantaneous—we fly into a rage and have fits of jealousy. And when we do, our rational brain is left in the dust. The

† Jonathan Haidt's "The Righteous Mind" (2012) and Daniel Kahaneman's, "Thinking Fast and Slow" (2011) are good sources for this point of view.

mechanism is innate and very old, older than the early reptiles. It manipulates us by triggering the release of hormones that control our physiological and psychological state, preparing our bodies for situations that we anticipate; adrenaline, cortisol, oxytocin, serotonin, and dopamine drive emotions that shape our behavior. Rage and fear are extreme responses; anxiety and minor irritations produce lesser responses. A student loudly clipping fingernails during a lecture—my lecture—is a case in point. The irritation arrives instantaneously, while the rational brain is trying to determine a proper response. These chemical triggers have been around for a very long time, and they are identical or very similar in most vertebrates. One is entitled to suppose, as a default position, that the nature of emotions experienced by other warm-blooded vertebrates—using virtually the same chemistry that we do—are similar to our own.

The rational brain is housed in the cortex where it organizes, reasons, and plans. Often, it has to restrain the emotional brain and I hope it yielded a productive response to the fingernail-clipping student, but I don't remember that part. Think of the rational brain as a gangly, indecisive supervisor of our behavior, compared to the polished, instantaneous, time-tested powers of the emotional brain—the rational brain having had only a few millions of years of experience in trying to control emotional responses, as opposed to the hundreds of millions of years when the emotional brain dictated our actions with little interference. When aggressive words turn to violence, we are inclined to see that as a failure of our rational brains to control our emotional brains—we didn't get ahold of ourselves. Maybe this balance is a product of selection, finding in favor of powerful emotions because they provide a gateway to dominance that leads to higher reproductive success; easily seen in social species like ourselves.

We are inclined toward binary thinking, reducing a spectrum of complex ideas into two camps as we did with "us" and "them," right/left, fast/slow, nature/nurture, body/soul, conservative/liberal. Science and Art. In the humanities, departments of art and of music offer courses in art and music appreciation. You might expect a course in life appreciation in departments of biology, but the sciences focus heavily on anatomy and mechanisms and that is a plateful all by itself. The well-rounded person is expected to pick up life skills as fragments, and those are taught in other departments: aesthetics in departments of music, art, and literature, philosophy, history, and communication skills in others. But the unembarrassed search for aesthetics in biology has fallen through the cracks. As a biology teacher I sympathize, but given today's explosion of information, we can master only narrow specialties. We can't go back to the Renaissance Period when a person of da Vinci's caliber could excel in so many areas of learning.

Science is about cause and effect, the reasoned explanations of things, and it is supposed to provide objective answers. This emphasis has been enshrined in an effort to keep emotional attachments from distorting our observations, and scientists are taught to maintain an emotional distance. Aldo Leopold in "A Sand County Almanac" (1949) addresses the unintended consequences of this balancing act with wry finesse.

"There are men charged with the duty of examining the construction of the plants, animals, and soils which are the instruments of the great orchestra. These men are called professors. Each selects one instrument and spends his life taking it apart and describing its strings and sounding boards. This process of dismemberment is called research. The place for dismemberment is called a university.

A professor may pluck the strings of his own instrument, but never that of another, and if he listens for music, he must never admit it to his fellows or his students. For all are restrained by an ironbound taboo which decrees that the construction of instruments is the domain of science while the detection of harmony is the domain of poets."

Emotional responses contribute to creativity and the sciences could benefit by carefully embracing them. Achieving a well-balanced view of the world requires the active engagement of both parts.

Regardless of where you find yourself along the spectrum of the arts and sciences, how much you know about life outside of the cocoons in which we live, or how busy you are, it is important to the sense of well-being of all of us, to take some time to experience the pleasure that comes from awe, and the joy that comes from discovery. It takes only a minute of attention to be struck with awe at the intricate struc-

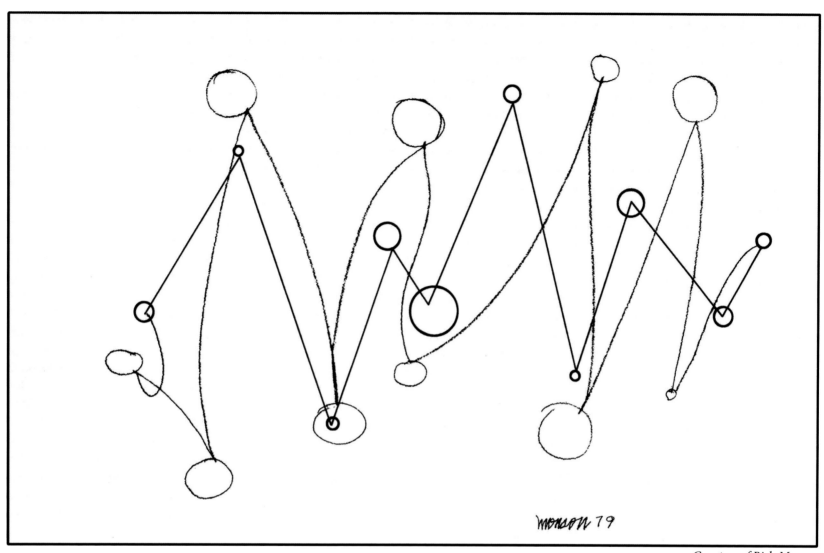

Introduction 2. Rich Monson's whimsical drawing is titled "Arts & Sciences," and it is rich in meaning for such an elemental work—perhaps because it is so elemental. It speaks to the differences between science and the arts. It recognizes that art goes to places that science cannot, depicts the comparative inflexibility of science, while both advance—out of parallel—in looking to understand the world.

ture of a seed pod or the Cardinal's wing, and each experience builds relationships with things outside of ourselves that make life richer. The more you learn, the more satisfying this relationship becomes, but it can be enjoyed at every level of expertise—from simply taking pleasure in the beauty of a wildflower to exploring the chemical attractants that flowers release to market themselves to pollinators.

All of this must be seen in the context of the Sixth Extinction—the very big the elephant in the room. It behooves us to spend some time outside of the anxiety that comes from it and this book can serve that end as that missing course in life appreciation.

It is worth paying attention to ancient wisdom. From the 6th century B.C.E., Lao Tzu claims that, "If you are depressed you are living in the past. If you are anxious you are living in the future. If you are at peace, you are living in the present." From the mid-20th century C.E., Georgia O'Keeffe urges us to make a flower our "world for the moment." That sentiment has been reduced to, "Smell the roses" and at the

moment, it lives on mostly as a smiley emoticon. But they all say the same thing, and consistent advice vetted for over 26 centuries and by countless cultures should carry some weight. The present is where we actually do things. It is where we experience joy and awe, neither of which have much of a shelf life. All the more reason to treasure what we now have around us and the things that it can teach us. These things engender awe; with awe capturing out attention, understanding and respect follow. Together, they create a sense of well-being that always seems in short supply. And for Gina and me, it engenders reverence. The pages that follow can serve as a primer for this journey; if you are already a traveler, you will enjoy your experiences even more. But regardless of your starting point, I'll enjoy your company.

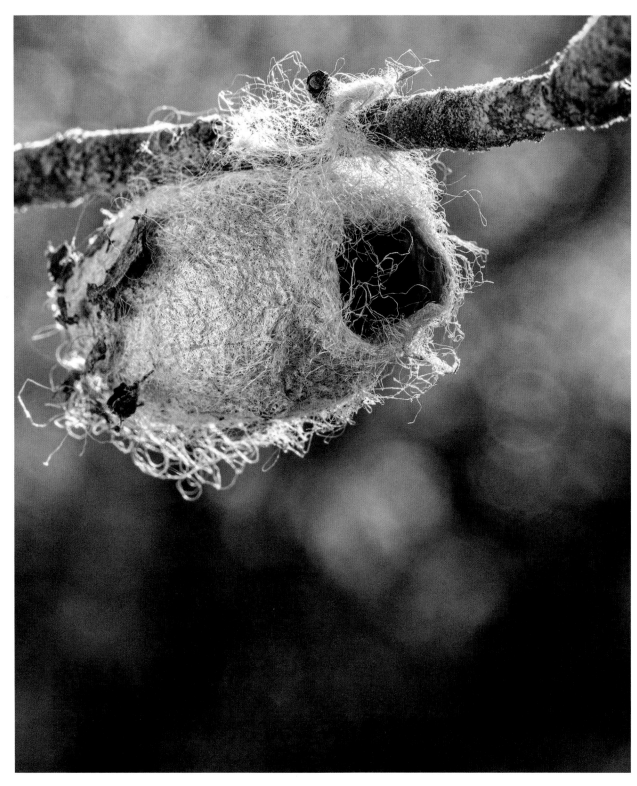

1.1 This empty cocoon is the work of Polyphemus (*Antheraea polyphemus*), one of the giant silk moths, who left her cocoon to see the word with new eyes (literally).

1

Engaging the World Outside our Cocoons

"When one tugs at a single thing in nature he finds it attached to the rest of the world."

~ John Muir

The empty, weathered cocoon on the facing page looks like a shanty in silk, but it is a marvel even though it is not so plush as our own cocoons. But then it was extruded by the caterpillar that lived in this extraordinary refuge, as she totally reconfigured her body while experiencing a period of complete helplessness. The cocoon is of indeterminate age—it has weathered at least four seasons, maybe more, and still the silk strands remain tough and flexible. It appears haphazard, but like much of the world around us, it is highly ordered; the caterpillar's DNA holding the algorithms that direct its construction. Gina found it on the twig of a young Elm tree that Polyphemus caterpillars find to their taste; a few leaf fragments remain attached. Less apparent, the silk itself is made from repurposed elm leaves.

The occupant was a Polyphemus Moth, a local relative of Silk Moths in the Orient that have been studied so extensively that we know a lot about their cocoons. The details that follow apply to that species, but we can expect the Polyphemus cocoon to be similar if a little smaller. Silk moths spin their cocoons of a single, continuous strand of silk about a half-mile long. Viscous silk is secreted near the mouth, extruded as a thread that quickly hardens on contact with air. The caterpillar builds the outside framing with a thick strand and subsequently covers the inside with finer silk coated with an adhesive so that the finished interior is as smooth as, well, silk. Sealed against the outside environment, this cocoon provides a favorable home for the vulnerable caterpillar as she

pupates prior to her debut as an adult. When that time arrives, the moth secretes an enzyme that dissolves the adhesive, leaving a tangle of separated silk strands to be negotiated as she emerges into the outside world completely transformed. Silk is expensive and the cocoon is a large outlay of resources for a caterpillar who has already eaten for the last time. The mission of her old body was to eat; the mission of her new body is to disperse and reproduce; the latter her reason for being. The new mission requires a new body. She needs wings and reproductive organs but no gastrointestinal tract as her mouth parts are only vestigial. Those have been deemed non-essential, excess weight. From the time she begins spinning her cocoon she is coasting on the energy from her days of eating. Her trajectory is that of a ballistic missile that amasses kinetic energy from the time of its launch and then coasts until its arc is complete. That is true whether her mission is accomplished or not. Polyphemus is an extraordinary species in some ways, but then every species is extraordinary in some ways. All of us surviving species can trace our lineage through billions of years without a broken link; a truth that, given a little thought, is self-evident.

We humans are also an extraordinary species; in some ways. Our social complexity is probably beyond that of every other vertebrate life form, and we are justifiably proud of our strengths, but probably we are not as special as we think. We are philosophically provincial in a way that has earned its own name: anthropocentric. We are proud of our strengths the way that Cawker City, Kansas is proud to claim the world's largest ball of twine, and that Brandon, Iowa boasts the largest frying pan in their state—a pan that can fry 528 eggs at a time. We humans are proud of the groups with which we identify, and enthusiastic about the prowess of the home team, community, tribe, nation. It is a defining characteristic, and it is an ingredient in our extraordinary and very successful social structure.

Like the Polyphemus Moth, we are driven to make our surroundings comfortable and functional. We have succeeded beyond the imagination of ancestors only a few generations back. We have built formidable barriers against raw environmental conditions, and all of us like the comfort and convenience that our cocoons provide us. Like the modest silk and adhesive construction on the opening page, they protect us from the elements and decrease our vulnerability to animals on the outside that would appropriate our food stores. Those are, after

all, the primary functions of a cocoon.

We've been so successful that the extent of our physical discomfort from environmental conditions has all but vanished. Our cocoons have swelled from cabins to mansions, and we don't like to leave them. And we've shaped the rest of our world accordingly—contoured to our pleasures. For travel we've built mobile cocoons—made of steel, powered and upholstered with fossil fuels—that shelter in a special bay within the home cocoon. We drive them to work-cocoons, and afterward to different sorts of cocoons to do our hunting and gathering, where we can get milk without the inconvenience of a cow.

Looking at how we live our lives from an outside perspective is eye-opening. Nearly everything with which we surround ourselves is an extension of our mind—conceived and built by us. Inside, we walk on carpets of nylon or polypropylene. The wood in our homes is increasingly virtual wood; an image of wood grain printed on a veneer that overlies particle board held together with phenol-formaldehyde resins. The animals we encounter are pets that we've molded to appeal to us in body and behavior. Even the fruits and vegetables we eat have been shaped to our tastes and so thoroughly altered that their ancestors are barely recognizable.

Outside, the landscape most of us experience is predominantly urban or suburban and we rarely come into contact with actual dirt. Instead, we walk on asphalt (driveways, parking lots), or concrete (roads, sidewalks, floors). Our green spaces are either private lawns or urban parks that are, in essence, public lawns that are also monocultures of European grasses. Even the Kentucky Bluegrass in our lawns is Eurasian.

The countryside that we are inclined to view as "out in nature" has also been reconfigured into vast expanses of row crops. The grasslands are primarily

 pastures, populated with cattle, sheep, goats, and horses; the lot of them having come to us through Europe. The whole mix is as thoroughly European as the first pilgrim to set foot on Plymouth Rock. We can still encounter approximately natural communities in woodlots and parks although they are greatly altered, but the native communities of prairie and swale remain only as tiny, protected fragments.

Structurally, our metaphorical cocoons are nothing like real ones, but they do sequester us. We enjoy a level of comfort that was unthink-

able in times past, even for emperors. It's an opulent existence and we live lives of extraordinary privilege. It has become the norm, and it is probably fair to say that we are rarely grateful for it. But we like all of it—a lot. All of us.

We like it so much that we spend as much time as we can inside, where the bugs are less diverse and less interesting, but the temperature and humidity are controlled. More specifically, we'd rather not "get our hands dirty" and the technology that makes possible our cocoons allows us to option out of those chores. Few of us would rather chop and split firewood, as our ancestors did, than turn on the heat pump. But spending that time in contact with the wood and splitting lengths to reveal the beautiful grain structures is akin to opening an oyster and finding a pearl. It is interacting with the world. That is the trade-off of failing to maintain contact with the world outside of the cocoons. We don't need to cut firewood to be comfortable, and we have lost any sense of what we've given up. If you are not into chainsaws and splitting wood, you can still walk through a stand of Milkweed and absorb the rich, heavy scent, noticing the brightly colored insects that live there and interact with them, absorb their beauty, and wonder how they do the things they do. There is nothing like it, and no replacement for it.

Recognizing our privilege is hard because we are swimming in it. Our best chance to grasp life outside is to explore it as a timid guest, watching and disturbing as little as possible to learn about life in a foreign community and to see how it functions as individuals interact. If we approach the world in this way, we can experience its beauty and grace while we learn about it. We can find an endless source of awe in the little infinity to which we have access, and in so doing we can enjoy the deep pleasure of feeling at home in a biological community in which our ancestors came of age.

Nature-deficit disorder is not a bona fide psychological condition (yet), but it is real with well-established physical and psychological costs that are a consequence of our alienation. We are physically com-

† I dislike using the word "nature" this way, but I've not found a better way to communicate that part of our world as our culture sees it. It implies that "the Natural World" is external to us rather than the place where we live—that it exists some place other than where we live. I register my objection with scare quotes, as I did here, and I use the term sparingly and under protest.

fortable, and entertained by a broad range of televised events, including virtual experiences in "nature."† They are highlights, edited for appeal, and distorted so they fit into our cocoons. There is no substitute for getting to know our cohabitants as individuals rather than caricatures. This book is yet another synthetic experience and it won't remedy the situation, but it provides a guide to seeing the outside world in greater depth. The world we explored as children is still there but rarely interpreted with the knowledge base of an adult. The rest of this chapter brings adult knowledge to bear on the world we all saw as children, along with appreciation of its complexity. Here at Brawley Creek, our everyday world is very much like everybody else's except that we look at it. All of it is commonplace and all of it is extraordinary.

And what is more commonplace than a Dandelion? When we first discovered one as a child, we studied it by pulling it apart. We found that the stem is hollow and holds a bitter, white fluid, but probably we didn't recognize any other notable structures in the debris, though I remember that if you crushed the flower on someone's arm it left a yellow stain. As adults, we have things to do, and we can't stop to make every dandelion "our world for the moment." We've learned the life skill of scanning, identifying, and dismissing peripheral things, but have lost (or perhaps never learned) the skill of attending to them and extracting pleasure from them like a hummingbird takes nectar. We've been dismissing such things since adolescence, but if we revisit that flower as adults we can see it again for the first time. Sort of. And we can try to understand the meaning of that little machine and see how it works.

Dandelions flower extravagantly in the spring, a welcome burst of color after a winter of weary pastels, although not everyone is pleased. They are a European invasive that thrives on the high nitrogen fertilizers commonly applied to lawns—they are resilient, incredibly successful immigrants, and no less beautiful for being frowned upon.

A single composite inflorescence like this one is made up of individual, tiny florets. The details of their flame-like florets usually go unnoticed because they are small and complicated. Each floret is a single reproductive unit, so you can think of the flower as a reproductive colony rather than as a single structure. The outer florets mature first, and those dark, withered curly-cues on the left in Figure 1.2, are shriveled pollen receptors (stigmas), now out of service, while the ovaries of

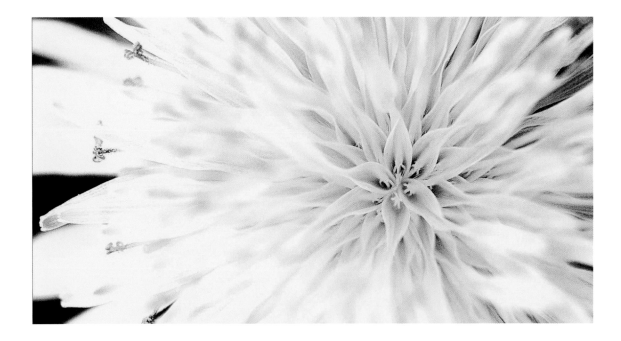

1.2 The Common Dandelion (*Taraxacum* sp.) is surprisingly beautiful but often dismissed as a "weed" because it is such a standout in lawns. Seeing the beauty in a Dandelion requires only that we look at it and use our emotional parts. Understanding the remarkable way that it works, requires our rational parts.

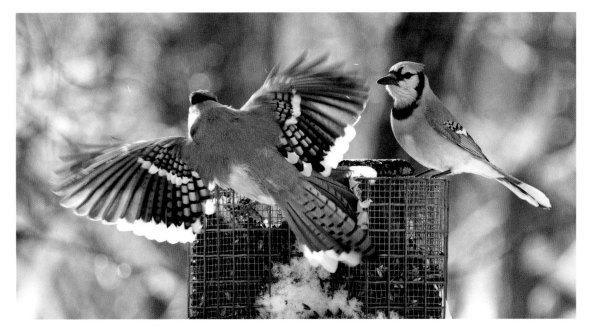

1.3 The ubiquitous Blue Jay is a scrappy resident with a fondness for harassing owls, dominating feeding stations while gulping whole seeds, one after another, and generally disturbing the peace. But they aren't eating those seeds, they're storing them in a gular pouch—like the gular pouch of pelicans only size appropriate. The small swelling, detectable on the throat on the standing bird, is evidence that his gular pouch is not empty.

those florets are maturing seeds. Meanwhile, the wave of younger, sexually active florets has advanced all the way to the center where the last few florets are still accepting pollen.

The colors of plants and animals are particularly interesting to me and I learned early on about structural colors. Dandelions are yellow from within. Their cells carry pigments that can be transferred by crushing the flower as noted. Blue Jays on the other hand, aren't really blue—an assertion that could be the opening round in a long and pointless argument about what is necessary to be blue. Bluebirds, Indigo Buntings, and Blue Grosbeaks are not blue either—none of them carry blue pigment, nor do any other terrestrial vertebrates. Crushed blue feathers will appear dark-gray because the only pigment they

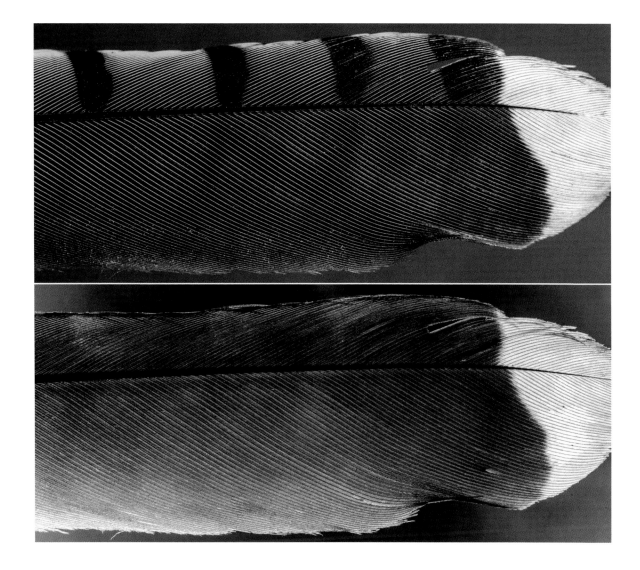

1.4 A molted flight feather from a Blue Jay. The two images are identical except that in the top frame the light came from above the feather; for the bottom frame the light came below.

carry—like crows and most sparrows—is melanin. But for their structural colors, we would see Jays as dingy, gray-brown birds.

Concentrations of melanin, as seen on the Blue Jay's necklace, absorb all visible wavelengths. Their blue feathers would be dark also, except that the blue parts have a screen of "blue-producing" cells on the upper surface of the black-brown feather. Those cells scatter the shorter wavelengths (blues)—some of which bounce back to the observer. We see them as blue because they carry particles of a size that scatter blue wavelengths but that don't affect red and yellow wavelengths that pass through them and plunge into the melanin where they are absorbed.

Figure 1.4 illustrates this effect. It shows the same feather twice.

The black and blue bars that appear on the leading vane of the feather differ only because the black parts have no blue-producing cells. These two frames differ only in the direction of the lighting. The blue one is lighted from above, the brown one from below. It works this way: light coming from below strikes the melanin layer first, where all wavelengths are absorbed equally. The light that eventually penetrates through to the viewer has been stripped of all wavelengths equally, so the feather passes a neutral color. The feathers of Cardinals are red because they carry red pigment. They appear red regardless of the placement of the light source.

This mechanism, or a similar one, is responsible for most blue color in vertebrates. There are other ways of producing pure and in-

tense colors, like the brilliant red gorget of male hummingbirds that is solid black when it is not reflecting brilliant red wavelengths in our direction. So that's why Blue Jays appear blue. Why being blue should be advantageous for them is a deeper question that doesn't have a simple answer, but we know the power of brilliant colors. Male hummingbirds dazzle us, but more to the point they dazzle the females, while at the same time threatening other males.

Skinks use their dazzling blue tail to deflect attention—magicians call it misdirection. We fall for it reliably as do others who want to catch them and that explains why juvenile Skinks carry an eye-catching blue tail (Figure 1.5). It seems like a really bad strategy, but it persists in several species of Skinks and they seem to be doing well. Their blue color is produced by a mechanism similar to that of Jays. The torso and head hold all of the vital organs, and that makes the tail expendable. The brilliant blue tail is to misdirect predators with color vision, suggesting that birds are important predators of young Skinks.

This arrangement works two ways. Plan A: a bird, maybe a Blue Jay, spies the tail and begins his attack. If the Skink detects the attack, he can escape quickly into the brush or under a rock. The Jay, whose atten-

tion is focused on the brilliant tail, is more apt to miss as the Skink lunges forward than if he had targeted the head or torso. If the Skink is unaware of the attack until he feels the beak close on his tail, he still has a good chance of escape. That's Plan B.

Unlike many lizards, the tails of Skinks break off easily, and when they do, the free tails wriggle wildly, thrashing about and demanding the attention of the predator. While the Blue Jay is trying to subdue the tail, the essential, striped part of the Skink's body can escape. It is like a mugging where the mugger takes only a wallet. It is not exactly win-win, but the predator gets a nutritious snack, and the Skink gets away with his vital parts, still alive and able to grow a new tail. The new one won't be blue, so each Skink is born with just one get-out-of-jail-free card. It's a nifty trick all by itself, but there is more to it. Generally speaking, body parts don't just break off. A Skink's tail snaps off, but it is not like snapping green beans; it's more like the beans snap themselves.

Skinks are evolved to amputate their own tails by muscular action alone. Each of the tail vertebrae is constructed with a cartilaginous layer in the middle, a weak plane that breaks easily to allow a clean sep-

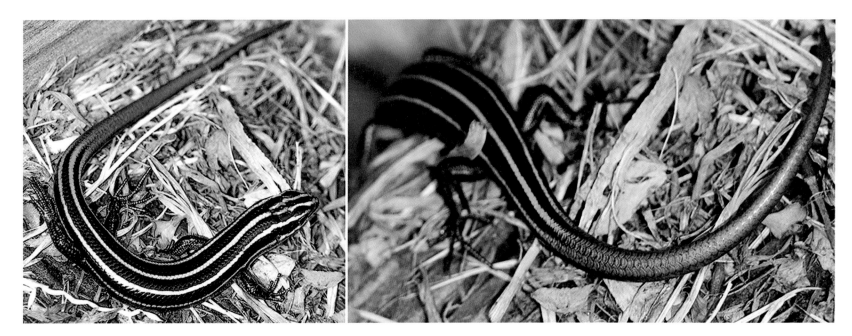

1.5 The body of young Five-lined Skinks (Plestiodon fasciatus) is more than half tail and it is this electric blue. This Skink, exploring some spilled mulch on a stair tread, disappears from view by crawling over the lip. The tail remains exposed, but it can disappear in a flash of blue.

aration. It functions like the perforations along the bottom of my electric bill; the two parts remain firmly attached until stress is applied in the right way. One of those ways is provided by the Skink himself. Skinks have muscles that perform the task and at the same time constrict the severed blood vessels minimizing blood loss. The tail does not simply break off—it is jettisoned, an action triggered perhaps by a surge of adrenaline, and assisted by the Blue Jay acting as midwife, but it does not simply break off.

The orchestrated self-amputation of a Skink may seem exotic, but separating parts is accommodated widely in less spectacular ways. Our teeth are deciduous; we shed our milk teeth to replace them with permanent teeth. That is a kind of self-amputation, less elegant than the loss of a Skink's tail if my memory serves me. Programmed separations happen in diverse ways, each suited to the life form.

Birds molt (replace their feathers) each year, discarding worn and increasingly inefficient plumage and replacing old feathers with new. Males that produce brilliant breeding plumage often undergo a second, partial molt that amounts to changing into less conspicuous work clothes. It is a sophisticated process; the flight feathers of the wings and tail are molted with precision and in a predetermined sequence that may take a month or so. Birds molt in late summer, providing fresh flight surfaces that are especially important for birds that migrate, and new insulation that is critical for birds that will overwinter.

Feathers are dead by the time they become functional, their connection with bodily fluids severed. For their entire working life, the friction between the quill and the wall of the feather follicle holds them in place. Smooth muscles in the follicle wall grip the quill, the strength of that grip regulated by a chain of events. The timing is influenced by changing day length and registered by the pineal gland, triggering the endocrine system to release hormones that will relax the smooth muscles holding the feather in place. The growing replacement feather pushes the old one out of the follicle.

The lack of a solid connection between feather and follicle makes sense of a childhood memory. My grandmother, before plucking a recently killed chicken, always thrust the body into a bucket of hot water. The bucket served as a little post-mortem hot tub that relaxed the muscles and so released their grip on the quills. Plucking was a lot easier after that soak.

The most abundant self-amputators are trees with deciduous leaves. The process is slower and less dramatic, but the fundamentals are the same. As the time for the leaf drop approaches, the plant builds an abscission layer between leaf and twig. It produces a clean break after the most valuable resources are withdrawn from the leaves (Figure 1.6). Of course they don't just fall off. Like the Skink's tail, they are released after another well-orchestrated preparation that closes off the vessels connecting them. By the time the leaves drop, the closure is already complete.

These few examples expose the complexity of events that we often think of as simple. In each a singular discovery; a molted feather lying on the ground, a flash of brilliant blue as a little Skink slips between the boards of a deck, a leaf snapping off of a twig with just a touch or a light breeze, is a part of a story. Knowing these details about how our neighbors negotiate the challenges of their lives allows us to feel at home. It's like watching a neighbor drive off and knowing that he is going to his Thursday night poker game, or that couple across the street is just back from a rehearsal of the community chorus.

These elaborate structures and processes function so perfectly because they have been tweaked and polished for many millions of years, creating life forms that approach perfection in their environments. Every part of every species is so integrated within itself and within its community that we can make the default assumption that they are near optimum in every important respect;† from their lung capacity (if they have lungs), to their response to day-length, and to the entire structure of a digestive tract evolved to efficiently process the foods they now require. There are exceptions, of course, but as long as a species maintains a healthy population, we can assume that its members have been constantly updating themselves and perfecting their fit as the environment changes this way and that. Those changes are always occurring and they are as unpredictable as the stock market.

The world is full of questions that each of us learned to dismiss long ago, by taking refuge in the eventual response a toddler's parent, who

† Some parts serve no apparent function. They are the irrelevant side effects of a helpful mutation, or they are evolutionary baggage, which was not purged by negative selection pressures. Stephen J. Gould likened them to spandrels—architectural details with no structural function.

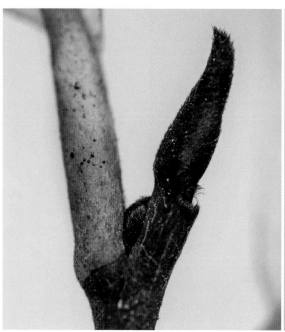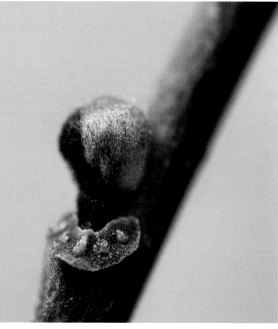

1.6 Left: The stem of a Pawpaw leaf (*Asimina triloba*) is seen at its attachment to a twig from which it is about to be released. The boundary between stem and twig—the abscission layer—is visible just below the small, dark lateral bud, sheltered between the stem and twig. Right: An equivalent image, after the leaf has dropped, exposes that abscission layer below a now-swollen lateral bud. The vessels that served the leaf before it became a liability, are visible as light-colored stubs that project from the leaf scar.

has been asked one too many questions: "because" or "that's just the way it is." But there is an ultimate answer. Blue Jays are blue—everything is the way it is—because historically, birds that were bluer produced more young over their lifespan than those who were less blue. It is entirely unsatisfying, but it has the benefit of being both accurate and true. Natural selection is the most powerful and intuitive of the evolutionary forces, easily seen in predator/prey interactions, but selection is much more sophisticated than that. Its scope is statistical and populational, and that makes it harder to grasp because those are abstract entities, and less engaging because they don't reach our emotional brain.

I don't know the value to a Blue Jay of being blue, but I know something about the shapes of their parts that have aerodynamic function. Their tails are about five inches long. No doubt, natural selection could have pushed it one way or the other as it did in the Blue Jay's relatives—nine inches in Magpies, three inches in Pinyon Jays—but it didn't. These three species are all corvids—the family of Crows and Jays—and so they emerged from a common gene pool and diverged. The Blue Jay's environment, acting through natural selection, established that five inches was optimum for Blue Jays, and it did so by minimizing the reproductive success of Jays whose tails were determined by selection to be too long or too short.

Here's a thought experiment. A six-inch tail would make Jays slightly more maneuverable and permit more effective pursuit, but Blue Jays don't hunt by pursuit and a longer tail produces more aerodynamic drag and makes it more expensive (in terms of calories) to fly anywhere—calories that could be better spent making more yolk for her eggs, or simply keeping warm. Besides, a six-inch tail feather costs more to make than a five-inch feather and there are 12 tail feathers, replaced annually. All are tiny costs, but the net effect, taking into account the challenges faced by Jays and summed over many birds and many years, is that selection has favored a tail that is shorter than six inches. As a consequence, Jays with too-long tails would have operated at a lower efficiency overall and maintained a lower caloric reservoir. That hurts them in many ways, the most visible being egg production because it is easy to count eggs. Blue Jays average five eggs per nest. In my scenario, some Jays with the longer tail might be able to produce only four eggs sometimes. Over time, the genes that favor longer tail feathers will decrease without requiring a predator. It is subtle. Nobody is caught and killed, but the average tail will become shorter. Similar forces will act on Jays with a too-short tail as well as those with wings that are too pointed, and every other bit of anatomy and physiology

will be continuously refined.

Back in the real world, tail length is the tiniest bit of the whole machine, but all of the parts need to work in concert. Looking at just the components that permit flight, we can assume that the length, breadth, and shape of the wings have been sculpted to be aerodynamically optimum for the kind of flight required of Blue Jays; including for example, rounded wings that increase aerodynamic drag but improve maneuverability. But the wings are only a part of the flight mechanism. In order for them to work at highest efficiency, the size and shape of the antagonistic muscle pairs that power the wings must be matched to these demands. And the distribution of the blood supply that fuels these muscles must provide enough sustenance but not too much. And the lungs must work with an efficiency that provides the needed oxygen. All of these and many more details must be fully compatible—all of them under constant selective pressure, honed continuously to sharpen the integration and effectiveness of the whole package. Every part of every species, every enzyme function, is integrated and polished in this way. It's complicated. And that's just Blue Jays.

At higher levels of organization, we find the same processes at work. Blue Jays are just one of the thousands of component parts of this ecological community—all of which must interact, and all of them are a never-ending work in progress, all of them modifying their bodies and behaviors to fit a changing environment. Each species needs to mesh effectively with the rest of the community in the same way that the parts of an individual need to mesh with each other. Whatever their role, each species must fit into a community in the same way that the component parts of flight mesh with each other to make a functioning whole.

Species fit into a community like pieces of a jigsaw puzzle. Wood Pewees choose deep forests, Towhees choose brushy edges, and Meadowlarks choose tall grass prairie. Oops. Prairies are nearly all gone, so now the Meadowlark gene pool has been forced into harvested grain fields and hayfields, both populated by European grasses; they also occupy the broad medians and verges of our interstate system, where their gene pool is surely being reshaped to optimize for that change. The new habitats may produce fewer Meadowlarks per acre than the prairie did, or not, but Meadowlarks will eventually make the best of this new habitat. Until it is no longer available to them.

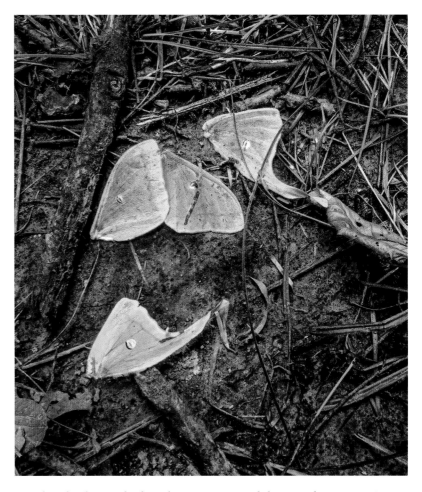

1.7 There has been a death in the community and these are the remains. A Luna Moth (*Actias luna*) carries its calories in its body, so predators strip off the wings to get them out of the way. The closeness of the four wings suggest that the dismemberment took place on the ground, so likely the predator was a mammal—maybe a shrew.

We quickly come to terms with the fact that we can't know everything, so we turn to myth to fill the gap and to please children and adults alike. There is no denying the fact that we love stories, especially if they resolve difficult questions, and a fanciful, entertaining story is better than none at all. Rudyard Kipling stepped into the breach with his, "Just So Stories for Little Children." North American children have been similarly entertained by Thornton W. Burgess, the author of a flock of Mother West Wind "How" and "Why" stories that tell us how the crow lost his beautiful voice and why the bear lost his long tail. Among biologists, Kipling's title has become a pejorative applied

to an assertion with inadequate data, because (unlike Kipling and Burgess) biologists are limited to natural explanations, so idle speculation as to why a Cardinal has a crest is a derided as a "Just So Story."

Figure 1.7 shows the remains of a Luna Moth, encountered along the trail. The moth was taken by a predator who stripped the wings from the body like we might peel a banana, to expose the plump nutritious center. I've been puzzled by the tails on the Luna's hind wings that always seem to be twisted. Besides messing with the symmetry and offending my aesthetic sense, it seems aerodynamically questionable. But if the wing-tails on all Luna Moths are twisted, it's not a flaw—it's a feature. And a feature calls for a reason.

I could write a Just So story of "How the Luna Moth got His Twisted Tail" and call it a hypothesis. I could claim that the tails on Luna Moth wings make them stealthy—the twists distorting the echoes from the ultrasonic chirps of bats, misdirecting the bat to a point behind the abdomen, in much the way a Skink's tail misdirects a Jay. It is consistent with known science. It's creative and quirky, it seems possible, and it satisfies because it is something rather than nothing. But without the research to back it up, it is another "Just So story." But Lee and Moss (2016) did the research and validated the hypothesis—a new twist on an old tail.

<p style="text-align:center">***</p>

Watching wild things interact, I wonder what they feel. They are machines certainly, but then so are we. Not long ago it was fashionable to emphasize the behaviors of animals as a series of events, a choreographed routine, in which a stimulus cued the performance—emotions not required. Sometimes animals can be pushed to behave in ways that seem scripted, performing stereotypical behaviors that appear irrational. This is especially true of birds whose actions suggest such triggered responses. Konrad Lorenz's hydraulic model of behavior describes actions that, like a toilet flush, require a delay before the trigger works again. Human sexual response is another obvious example. I was taught that the gap between the stereotypical behavior of bird behaviors and our own, lay in our conviction that our behavior is reasoned, but recent work by scientists like Jonathan Haidt (2012) suggests that this is an illusion. We get hungry and start looking for food. Here's how that works for us. When our blood glucose drops to about

85mg/dL our internal chemistry motivates us to eat by creating the sensation we recognize as hunger. We start looking for a snack—Robins begin foraging for worms.

Eating triggers the synthesis of serotonin and a variety of other endorphins—very old neurotransmitters that we share with other beings as evolutionarily distant as fish. They create a feeling of well-being, a sensation that we recognize as satiety. Cortisol, another very old neurotransmitter produces anxiety. The strong similarities between our anatomical and physiological functioning and those of related life forms makes it difficult to hold onto the conviction that our systems operate differently. In particular, it's hard to hold onto the conviction that other species—whose bodies generate the same chemicals that fulfill the same functions and elicit the same behaviors—do not experience the same emotional responses. Our responses are controlled by our internal chemistry. It seems improbable that other species, using the same chemistry, lack similar emotional responses. If that is so, then hunger, or the experience of anxiety triggered by increased levels of cortisol, likely feels similar in both humans and dogs. These same kinds of chemicals generate empathy in some animals and they make us sensitive to particular stimuli. We can see the results clearly in ourselves, driving our actions in powerful, predictable, and sometimes irrational ways—behaviors so predictable that they seem scripted.

Humans are world class empathizers, so our hearts break for a baby bird caught by a cat who, true to her nature, is playing catch and release with him. When the bird is exhausted, the cat may bring it home for the kittens to practice their capture and kill techniques. Cats have no visible empathy—no detectable concern for the pain they are inflicting. We wish that they didn't behave that way because we can't bear to see animals suffer.

The experience of empathy is one of the differences between us and, say, cats who are more typical mammals—this is a place where our natures collide. Arguing for the cat, this insensitivity enhances their hunting skills. It is as much a part of the success of cats as their claws and long canine teeth. Cats are a solitary species, and it is hard to imagine an empathetic cat; possibly because such a creature would be extinct. But we are social animals and that demands different sensitivities. Empathy is essential to our well-being and quite probably to our existence. We evolved from social primates as tightly-knit social

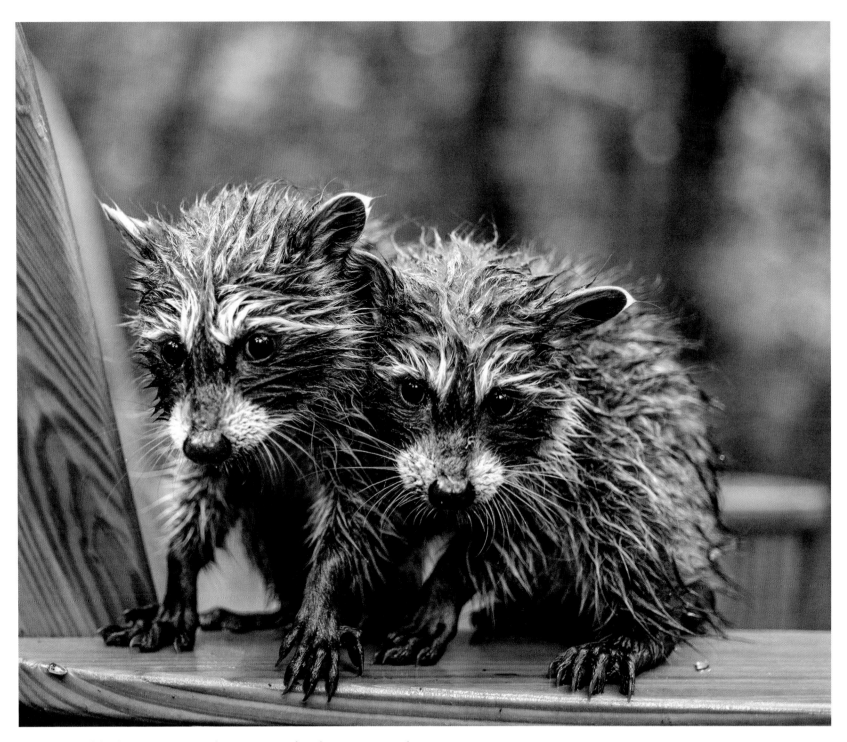

1.8 What a pitiful sight. Our response to the image comes from how we interpret their proportions and their postures. We see cold, wet, frightened, submissive, and abandoned toddlers. You could caption this, "Mom's going to kill us when we get home."

groups—tribes. Our survival is tied to cooperation among individuals, and our empathetic abilities are innate and an essential part of being human.

We see the world through human eyes of course, and we apply our expectations to a world in which empathy is nearly nonexistent. If we could discuss the issue with a spider, or a fox, or a hawk, they likely could not fathom such behavior outside of one's own family—particularly the spider. That is not to say that the actions of these solitary species are mechanical and devoid of passion. For the combatants—a pair of Robins fighting furiously over territory, or bull Elk engaging in real combat, they may well feel much like we would if we were the participants. They are, after all, responding to the same chemicals, acting in similar organ systems, in vertebrate bodies. Of course, we can't know what they are feeling, only what we are feeling and that those feelings are mixed.

We think of ourselves as rational beings, but we should recognize that our emotions strongly influence and sometimes dominate our activities. They are puppeteer to our puppet. We move as our strings are pulled or as our buttons are pushed, two idioms that suggest that we are automatons more than free-will, independent beings. It is not particularly flattering, but it seems to be the case anyhow.

We take shapes and sounds that we receive—templates really—and respond to them as surely as Pavlov's dogs. They trigger emotions so reliably that, as a group, those stimuli are called "releasers." Our innate responses to a variety of releasers leaves us open to manipulation, even while being fully aware of the mechanism. Those impulses are hard to resist—maybe impossible. This has not escaped the notice of the advertising and entertainment industries who use these templates to shape opinions, tilting us to favor one kind of dishwashing liquid over another and to feel empathy for cartoon characters.

The Raccoon kits in Figure 1.8 are there to pull those strings. They are about six weeks old, and they made their way onto our deck chair after a thunderstorm one day in June. They project helplessness and abandonment, even though they may well have simply wandered off on an excellent adventure while their mother was foraging.

We instantly recognize these Raccoon kits as young by their short muzzles, abruptly rising foreheads, their seemingly large eyes enhanced by black patches (eye-shadow?) and other more subtle clues

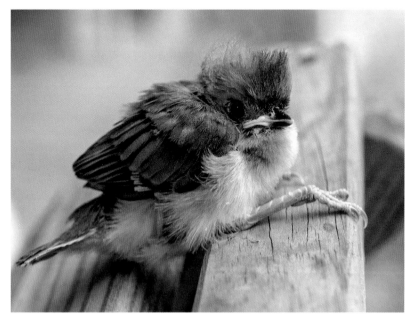

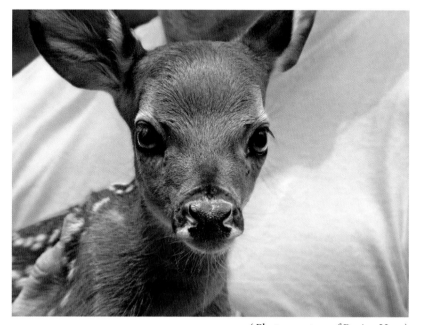

(Photo courtesy of Regina Hess)

1.9 Two packages of releasers are personified in the Tufted Titmouse chick and White-tailed Deer fawn. The gangly legs and stubby tail of the Titmouse enhance the appeal as do the large vulnerable-looking eyes of the fawn.

that produce empathetic responses. Through their posture, we imagine that these kits are experiencing fear and anxiety. Probably they are, but then we don't really know. We respond to the signals, and as seemingly abandoned babies, we find them even more pitiable. We derive all of this from their proportions and posture. Few of us would not admit to an urge to care for them. Such is the power of releasers as they play out in humans. The illustrations of what are now Disney characters—Bambi, Simba, and a broad array of princesses—have oversized eyes that encourage us to feel protective toward them.

There are releasers of many kinds seen in the accompanying figures. Combining more in a single individual increases our urge to protect. Stubby noses and high foreheads are particularly strong releasers, and they create the same response in us if they are anywhere close. The Tufted Titmouse chick in Figure 1.9 doesn't have a high forehead, but he simulates one with feathers, but the White-tailed Deer fawn has the whole package. Figure 1.10 adds a Chickadee that is so little, the jaunty beret that includes his eye make of him a tiny bandit, and yes, they are cute too. The two-day-old Cardinal chicks in the adjacent panel also present powerful releasers that the parents find irresistible. They don't

have the power of cute, but they are helpless and that affects humans. The nearly white perimeter of the gape outlines the target that nestlings present to their parents. That visual, accompanied by a compelling vocal display, costly for such tiny birds, is an absolutely essential expenditure. That gape is a powerful releaser by itself, especially when accompanied by the screeching sounds that come out of it. They are really annoying (to us) and if I were a bird, I'd stuff a worm in it, too.

These releasers serve all of us well, human and non-human alike, by tugging at the strings that direct us to care for our offspring. In tribal societies, the benefit of a broad sensitivity to releasers tends to bring any children of the tribe under its umbrella of care. One would expect other species to experience those peripheral effects too. Cardinals illustrate an equivalent behavioral quirk that accompanies their empty nest syndrome. Before the chicks leave, the location of the nest is, well, of cardinal importance. It is the place to which the parents carry food. Once at the nest, parents target the gapes of the nestlings as seen in Figure 1.10. The outer rim of the gape is prominent and surrounds a pink/red/orange bullseye that fades to dark at the center.

When the kids leave home and the chicks have scattered into the

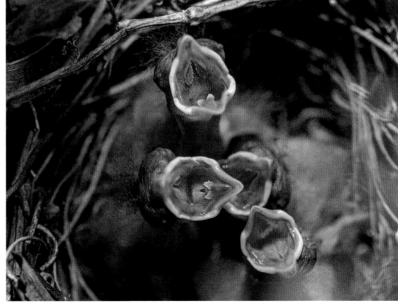

1.10 This Black-Capped Chickadee carries the same pattern—high forehead and short "snout" to which we respond. The two-day-old Cardinal chicks also carry powerful releasers, though they are not particularly compelling to human sensitivities.

brush, the nest location is no longer important, and the parents modify their feeding ritual. There are predators about, and the chicks must be less vocal because they are defenseless. The parents keep track of several locations, go to those spots and search for that potent visual releaser. What could go wrong? Not very much really, unless there is a backyard pond with low oxygen concentration, and with Goldfish. Then, Goldfish rise to the surface and gape. Goldfish have the right stuff too, or at least the essential stuff and on such rare occasions, Cardinals feed the Goldfish. Imagine the surprise of the Goldfish who is suddenly fed from an alien world. They quickly learn to move toward the edge of the pond and beg.

Our response is also to broad shapes and not very focused. It is not rational in the sense that it doesn't materially benefit us. We respond to the template presented in the form of puppies, kittens, and the preceding figures, in proportion to how well they fit the template. We invariably describe them as "cute." Clearly such releasers are not very precise, and so our response to such diverse images can be seen as peripheral effects—as side effects of a necessary medication. Those mechanisms were in place long before there were humans.

Witnessing different species interact, it is nearly impossible to form no opinion, and that influences how we act toward them. We project our values—the values of a social species—onto them and take them to task for violating those values. It's uncomfortably close to the Cardinal and the goldfish. It is the flip side of fawning over young mammals, and it would be of little consequence but for our outsized impact on diversity.

Benjamin Franklin famously opposed the choice of the Bald Eagle as our national bird on moral grounds:

"He is a Bird of bad moral Character, …He does not get his Living honestly. You may have seen him perched on some dead Tree near the River, where, too lazy to fish for himself, he watches the Labour of the Fishing Hawk; and when that diligent Bird has at length taken a Fish, and is bearing it to his Nest for the Support of his Mate and young Ones, the Bald Eagle pursues him and takes it from him."

Franklin argued instead for the Wild Turkey—a strutting, belli-

cose, ladies' man, flagrantly polygamous—in which the relationship with his females ends with his dismount, after which he cares only for himself. Whatever you think of that, it has been a very successful strategy in turkeys. The choice of a bird to symbolically embody the newly minted United States of America is loaded with assumptions linked to the bird's likeness. Otherwise, it might as well have been a chickadee or a mayfly.

Justifying either on moral grounds is a challenge, but we chose the Bald Eagle. I would guess the turning point was its war-like visage, the result of bony projections over the eyes that protect those critical organs. They function like safety goggles but in our anthropocentric world, we see that as stern and threatening. In the era of "Don't Tread On Me," that was important. Had Franklin won, maybe today the Great Seal of the United States would feature a turkey holding a shield to his breast while clutching arrows in his right foot and an olive branch in his left.

None of us would say out loud today what Franklin did, but we quietly lean in that direction. Finding that Bald Eagles mate for life somehow burnishes their luster, and we are only moderately judgmental of libertine turkeys; maybe because they are so delicious.

A century later, in 1888, at the height of Rousseauian romanticism, Samuel Lockwood, Ph.D., published, Animal Memoirs in which he writes of a snowbird (a Junco,) "What a gracious bird! I dare say, a Christian bird; for is he not obeying the injunction of the Apostle,— 'Be kindly affectioned one to another, with brotherly love!'" Really over the top for a Ph.D. and it shows little progress a full century after Franklin. Today, two-and-a-half centuries after Franklin, we still allow our sense of fair play to influence us, and that suggests that those values are deeper than culture. They are values characteristic of social species—chimpanzees, elephants, dolphins, and wolves for example, animals who have evolved interpersonal behaviors similar to our own, because they have proven adaptive.

In The Selfish Gene, Richard Dawkins, made a strong case for the selective value of genes that promote selfish behavior. More recently E.O. Wilson argued that selfish actions, suitable or even essential for solitary species, are unsuitable for social species. Living in groups as we do, selfish actions, those that favor the individual over the group, are destructive to cohesion. Among them we find sloth, theft, gluttony,

jealousy, adultery, and murder, which we recognize as sins. Actions that promote tribal cohesion and lubricate social interactions—loyalty, faithfulness, courage, honesty, and generosity among them—we see as virtues. These virtues make social coherence possible and they work very well in small tribes, less so in mega-cities. In a solitary species, The Virtues would make no sense at all, and in any imaginable configuration, one would expect them to lead to extinction.

Our moral posture as humans is both innate and strongly reinforced by culture. Like empathy in reverse, we respond negatively to infractions of the code, as surely as we do to physical releasers, even when other species violate our codes. And we are judgmental of animals who do cruel or unfair things as though we expect them to behave according to the rules that benefit social species. Like humans.

The bird in Figure 1.11 is a Brown-headed Cowbird. Conservative columnist James Kirkpatrick, a devoted birder, once compared them to street gangs, "black-jacketed, brown-hooded, objects of fear and loathing." He said eloquently what most of us are inclined to feel, even understanding something of animal behavior. They live in an amoral

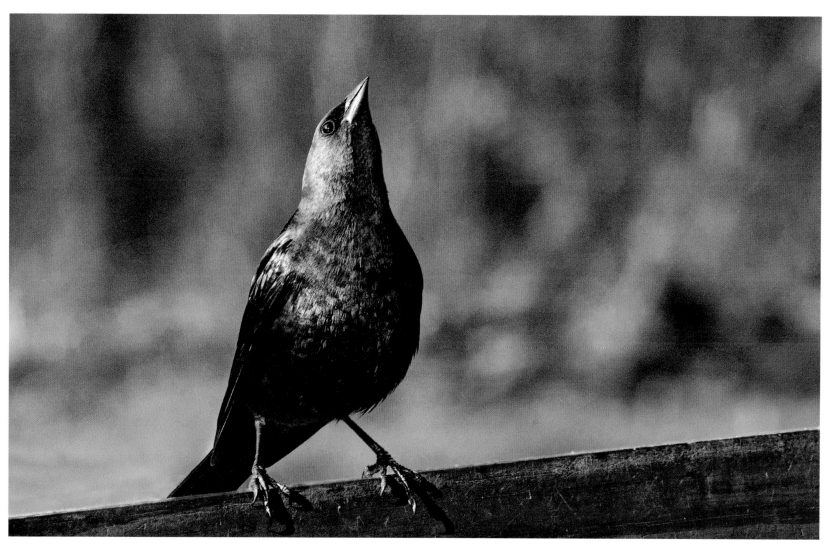

1.11 A male Brown-headed Cowbird—that "object of fear and loathing"—makes an aggressive display to his image reflected in a window, through which this photograph was taken. This posture, "bill-up" or "bill tilting," is an aggressive display among blackbirds. Similar displays can be seen at human gatherings (nose in the air) where it has a similar, but probably more nuanced, meaning.

world, but still we thrust our values onto them, and they fall short. Their lives are well worth examining for that reason alone.

Cowbirds are recognized as brood parasites, so the females don't make nests. They drop their eggs, one at a time, in the nests of other species—into foster care. This way, they can produce up to 36 eggs per year, making their reproductive potential about three times that of a Robin with three consecutive nests in one season. Their parenting style runs counter to our own sense of decency and in describing them we often expose our opinion through our use of charged words or phrases. To illustrate the point, I'll describe the situation using charged words, strike-through them, and follow with more neutral words placed in brackets.

The female Cowbird's ~~assault~~ [approach] is sophisticated. She must select an appropriate host species. There are obvious poor choices—Killdeer, who expect hatchlings to feed themselves, won't do, and House Finches are very nearly vegan, so Cowbird hatchlings would starve. Cowbird females display remarkable stealth, selecting nests with an incomplete clutch so that their own egg hatches at about the same time as the host's, often slightly earlier. The Cowbird hatchling grows quickly, and with a head start he takes advantage of [out-competes] his nest mates and ~~takes more than his share~~ [garners a larger fraction] of the food, growing bigger and stronger ~~at the expense of~~ [than] their pseudo-siblings. The rule book of bird parenting doesn't include a section on Cowbirds and the host parents seem oblivious to the ~~saboteur~~ [different chick] among them. Commonly, half of the host's hatchlings die, sometimes all of them. Occasionally, the host recognizes the odd egg, and ejects it, or abandons the nest and starts over, but most don't see through the deception, and once hatched they care for ~~Rosemary's Baby~~ [the nestling].

Initially, we tend to find the lifestyle of Cowbirds repugnant. Seeing it happen and knowing that the parent has likely suffered the loss of half of its brood, the injustice of it piques our empathy, offends our sense of fairness. This kind of writing is common editorial practice and usually it expresses the perspective of the author, and we all absorb it. Here are some baby pictures of a melded family in a Cardinal nest.

It sounds like an easy life, but Matt McKimLouder, whose research is deep into how this thing works writes, "If it were easy to be a parasite, everyone would do it." Cowbirds often return to a nest they've para-

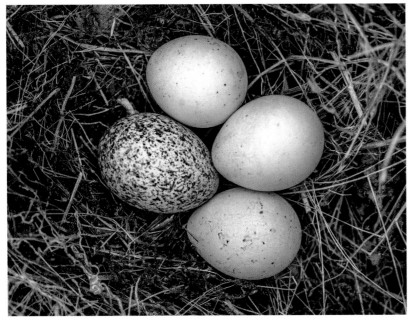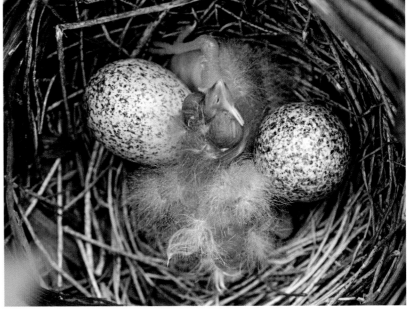

1.12 Left: A Cowbird egg stands out amid the eggs of a Phoebe. The difference between them is obvious (to us) but the parents don't seem to notice. Right: Two infertile eggs in a Cardinal's nest, and two hatchlings: a robust Cowbird and a less-developed Cardinal barely visible beneath his nest-mate. By chance or design, the Cowbird is positioned to get the first bit of food brought to the nest.

sitized, and if the Cowbird egg has been ejected, they destroy the nest, forcing the parents to build new ones and lay a new clutch of eggs, repeating the stage at which they can be victimized again. We might think of the species as a sort of Cowbird mafia—"Nice nest you got here… be a shame if anything happened to it." Cowbird females keep track of their successes too, remembering which foster parents worked for them last time and returning to them next year in the way that Blue Jays remember all those places they've hidden acorns. So, Cowbirds must build a library of nest locations for weeks and retain those memories for at least a year, an incredible achievement that we are disinclined to acknowledge.

Our response to eagles, turkeys, and now Cowbirds, is the tip of a very large iceberg that shapes the way we relate to many species. To see them with our biases in place is human, to see them in neutral terms, divine—or at least difficult. But if we can set aside the quirks of a social species—our quirks—then we can see that they are an evolutionary tour-de-force, orchestrating an elegant and effective capture of resources. No moral codes have been violated, because of course there are none, except within social species. According to the Rules of the Game that we will lay out in the next chapter, all of this is fair play—admirable—a stunning play by an opposing team. Huzzah! But setting aside such deep responses is difficult, something like trying to hold a beach ball underwater. It could hardly be otherwise because of who we are.

So we'll peek out of our cocoons and embrace the various elements that shape the way life functions here at Brawley Creek. But first, we'll take a look at the foundation of it all—the forces that underlie everything and so write the Rules of the Game. Those rules regulate all interactions among the participants and create the paradise outside of our cocoons.

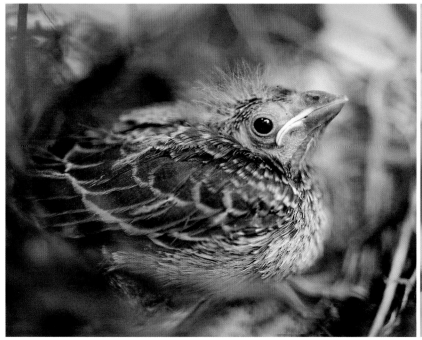 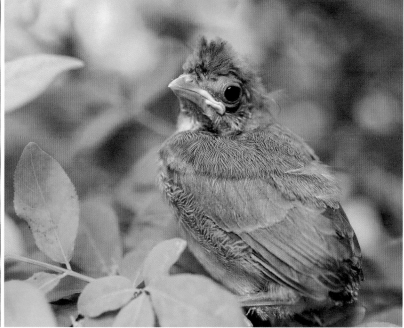

1.13 The Cardinal nest seen in Figure 1.12 produced these two fledglings. Left: Cowbird. Right: Cardinal. Both are homely by our standards, but I suspect that if the Cowbird had the benefit of a crest—a false high forehead like the Cardinal—he would be "cuter."

2.1 The nominal subject is the butterfly, an Eastern Tailed Blue (*Cupido comyntas*). But this image is foundational, because of the intense green: the color of chlorophyll, the producer of wealth, and the cornerstone of every economy. This little butterfly is supported by the grass in more ways than one.

2

Natural Economics: The Rules of the Game

"Follow the money."

~ Deep Throat

The photograph on the facing page was carefully chosen. It has a certain aesthetic appeal accentuated by the frailty of a tiny butterfly; his mass is so nearly nothing that it has no apparent effect on the horizontal blade of grass that supports his weight. The overwhelming sea of green emphasizes his Lilliputian size and that makes everything about him seem even smaller: the fringed wings with impossibly tiny tails on the hind-wings, the spindly legs that seem incapable of holding up even such a tiny mass, and the barely visible, banded antennae. And I suppose those large, black, featureless eyes—the sort attributed to aliens by Earthling illustrators—assist in making the creature more mysterious. That is my rational assessment of the aesthetic component. It's not enough to warrant a place here at the beginning of a chapter on the Rules. It's here nevertheless because the butterfly, supported by the greenery is a consequence of the Rules of the Game. In my view, enjoying the aesthetics without understanding the Rules is like watching a game of chess without any notion of the invisible parts—the names of the pieces, the kinds of moves they can make, and their relative powers.

Learning those Rules takes some effort. Many of us are content to experience the world predominantly through its colors, its sounds, scents, and textures, and that is worthwhile and a source of great pleasure for many. But there is a deeper pleasure, one that strengthens our sense of belonging, and it can't be extracted solely from the aesthetic response. For that, we need to know the Rules of the Game and recognize that all of us—us living things—are playing by the same rules. That is oddly empowering, per-

haps because in understanding those Rules we recognize a real world that exists beyond our senses. Building on that foundation, we can address the questions that don't come from aesthetics; the most obvious being why that butterfly has chosen such an exposed position, making himself vulnerable to visual predators. And why it is important, even essential, for him to do that.

This is a male, and he is exposed because he needs a post from which to watch the nearby legumes—particularly the clovers. His species feeds and pupates on legumes. That means that females will spring from legumes as surely as legume flowers. And when those females are looking for places to lay their eggs and for a male to fertilize them, they will gather near those same legumes. Males can recognize females of interest because their abdomens are swollen with eggs, females for whom it is worth taking the risk. His future—or rather the future of his genes—depends on his taking this risk and getting away with it. All of this may seem like common sense, but if it is, it's because we have absorbed the most obvious parts of The Rules as common knowledge, and we've shaped our lives and our expectations in accord with them. Knowing the Rules resolves questions about how living things function, in concert and in opposition, how they shape their behaviors, and how ecosystems must be structured. Naturally those are the ecosystems upon which we depend too.

In spite of the unimaginable complexity of these systems, knowing that they operate according to such strict Rules means that they can be understood. In her book Unsheltered (2018), Barbara Kingsolver points to a monumental shift in paradigm ushered in by Charles Darwin. She phrased it this way, "Nature [isn't] just a cabinet of curiosities any more. It [is] a machine . . .". That powerful idea stimulated the Victorian imagination and provoked an uproar that has yet to subside. Victorian gentleman-scientists were fanatic collectors of those curiosities: beetles pinned and identified, bird skins carefully arranged in trays, and plants from all over the world pressed, stacked, and labeled—all of them curiosities in cabinets, broken machines that don't do things anymore.

Doing things, having a purpose, is inherent in the concept of machines, including biological machines. They have a mandate—a prime directive—and it is unambiguous: reproduce, on penalty of extinction. The lives we see around us are the elite. All living species are the survivors, while the vast majority of species spawned by our ancestors have failed. We survive by successfully competing for resources. We—all of us—face challenges from others of our kind and competing species, from predators and parasites. Overarching all of these struggles, life forms must also adjust to the constantly changing physical and chemical environments. All of us have learned to use our bodies efficiently in the ways that our place in the ecosystem demands. That leads to simplicity of structure, and that leads to elegantly constructed bodies and carefully sculpted behaviors. The Rules of the Game are the foundation upon which all of it rests.

The Laws of Thermodynamics were formulated in the domain of physics; chemical interactions must conform to the laws of physics, and biological machines must abide—absolutely—to the foundational laws of both disciplines. There is no way to scam the system, there are no loopholes, and the Rules cannot be bent. Inconvenient Truths are true regardless of how we feel about them.

These two laws may seem peripheral, but they shape the complex chemical reactions that amount to life, and in that way, they have directed the evolution of life forms, how ecosystems are structured, and how life forms are permitted to interact.

The 1st Law of Thermodynamics requires that:

Energy is neither created nor destroyed.

Paraphrased, "you can't get something from nothing," its most powerful ecological application lies in one of its corollaries, "energy must come from somewhere and it must go somewhere." In a biological context, the most profound application of this law occurs in the capture of energy and its confinement in the chemical bonds of sugar. That is the essence of photosynthesis. Energy and matter, so wed, remain locked together until those chemical bonds are broken. The 1st Law is the physics behind, "follow the money," a powerful mantra for people tracing the flow of resources—economists and ecologists, as well as investigative journalists. It illuminates relationships, clarifies motives, and predicts actions. We encounter it constantly, hidden in expressions like, "Is it worth it?", "Why should I?", and "What's in it for me?"

The 2nd Law of Thermodynamics requires that:

Every energy transfer is inefficient†.

The 2nd Law can be paraphrased, "you can't catch a break." The 2nd Law applies to all chemical transactions—to life itself—and establishes that, while energy is neither created nor destroyed, it can and does convert into forms that are not useful, eventually into heat that simply dissipates, appearing to disappear. Think of the 2nd Law as a sales tax. A very large sales tax paid on every transaction. Mostly we see a tax that has been paid as gone, but like heat energy, it is still somewhere, even though it has no value to you because you can't access it.

These Rules are at the core of both ecology and economics, which focus on the movement of materials and energy through systems. The two disciplines are so strikingly similar that we can think of them as twins; ecologists track these movements as they pertain to living systems; economists track them as they pertain to human activity. It is precisely because humans necessarily abide by the same Rules as the rest of the community that ecology can teach us so much about ourselves.

Clearly, there must be broad overlap between ecology and economics, and just as clearly the practitioners see the world from different perspectives. Isolation between disciplines is nothing new—the gap between biologists and chemists used to be absolute. Biologists pinned insects and chemists mixed elixirs. Biologists still pin insects and chemists still mix elixirs, but the two disciplines have become seamless, connected through biochemistry. Ecology and economics are just beginning to merge. The Journal of Ecological Economics was first published only 30 years ago, and we can hope the two disciplines soon become as seamless as biology and chemistry—although economic decisions are riddled with values and quickly become highly political.

† The phrase "every energy transfer is inefficient," properly should read that, "with every energy transfer, entropy increases." But entropy is a difficult and counterintuitive concept. We can avoid confusion and still capture its essence by substituting "inefficient transfers" as equivalent to "useful energy is lost" or "entropy increases." This level of precision will be adequate for this discussion.

All of us are familiar with the language of business even though we may not be fluent. We have an intuitive understanding of income, profit and loss, and taxes. We have a reasonable understanding of supply and demand, wholesale, retail, monopoly, and the effects of flooding the market. We understand the mortgaging of assets, fee-for-service, and bankruptcy. Recognizing the profound similarities between ecology and economics opens a library of familiar events that will serve as metaphors in understanding energy flow in the ecological realm.

In order to measure the movement of materials and energy, we need agreed-upon units. Economists measure gain or loss in dollars, ecologists measure them in calories, which measure energy directly and will serve as a universal currency.

Leaving grand theory for a moment, we'll examine the books of a biological machine, starting with an audit of a bird's energy budget. The bird in question is the European Garden Warbler (family Sylviidae). We don't have them at Brawley Creek, but we do have the Louisiana Waterthrush, an American warbler (family Parulidae). The two warblers are practically doppelgängers in spite of their geographic and evolutionary distance. Both are similarly proportioned, weighing 20 grams with roughly similar plumage and equivalent migratory behaviors. Garden Warblers summer in Europe and migrate across the Mediterranean Sea. Our Waterthrush summers here and migrates across the Gulf of Mexico in the fall. They are a good match, and the Waterthrush (Figure 2.2) will serve to put a face on these events.

Garden Warblers begin stockpiling fat in late summer to fuel their risky migration from Sicily to Tripoli. To have a good chance of arriving at their destination, they must save up enough calories to pay for the flight. Having enough calories at their disposal is critical because bird machines run on fat as surely as a small aircraft runs on gasoline. If the warblers run out of fat in transit, they will be out of fuel and will drop into the sea like Icarus. Research suggests that they experience a 10% a mortality rate.

Flying uses antagonistic muscles that can be equated with the pistons in an internal combustion engine. Both demand energy for the power stroke and the flight muscles burn through their fat supply as the bird flies. The Garden Warbler has an efficiency of 51 mpg in still air. This kind of mpg is 51 miles per gram of fat. A gram of fat holds

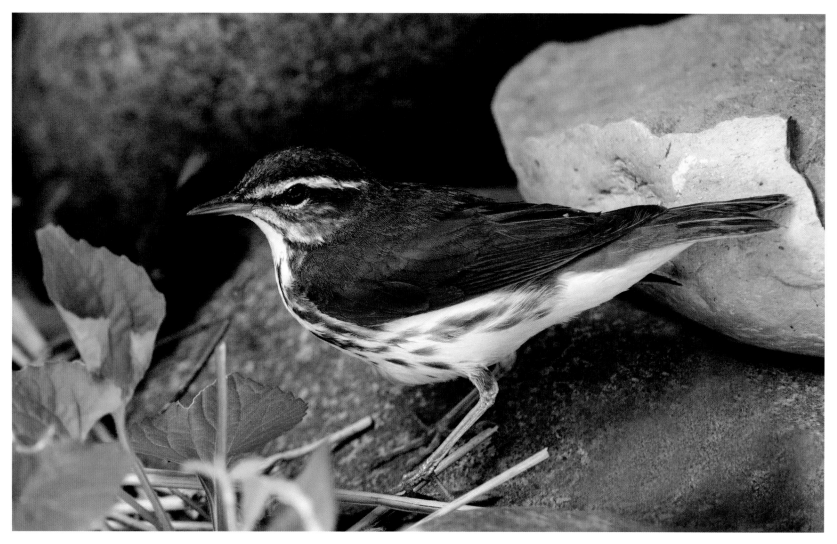

2.2 A Louisiana Waterthrush, is a local, but he could pass for a Garden Warbler in size, body shape, and coloration. He will provide an image to keep in mind as we consider the Garden Warbler of Europe, discussed in the text.

9,000 cal (9 Cal)† so we know the flight to Tripoli will cost him six grams. They can't understand that, but they don't need to. They act on signals from their bodies that tell them when they are ready to leave. Even immature birds, who can't possibly know where they are going, achieve a high level of success, so they usually make good decisions. The stakes are high and there is strong selective pressure for having made a good decision.

Their success hinges in part on their weather forecasting abilities because, if they run into a headwind of only 11 mph, their efficiency

† A calorie (cal) is the amount of energy required to raise the temperature of 1 gram of water by 1°C. It is easily confused with a Calorie (capital "Cal") that we use to measure the energy content of foods on a scale fitting for us.

1 Calorie is equal to 1,000 calories.

It is worth pausing to appreciate that we consume on a very different scale from the animals in this book, such that a glass of whole milk carries enough calories to fly a Garden Warbler from Sicily to Tripoli and back.

drops to 23 mpg and they'll not make it even half way. Maybe they sense the barometric change of an approaching front, or they draw information from some other source, but at some point, they must make a go/no-go decision. It must be like flying standby. If they wait for an 11-mph tail wind, they can fly for a third less. Those are identical to the calories we require to drive our muscles, of course. Our sources of calories are different—we eat different kinds of meat, we grow hair instead of feathers, we make clothing, and we build cocoons rather than nests, but we capture those same calories and spend them according to those same laws.

As a social species, we organized ourselves into tribes and eventually into very large groups where we have found it useful to create currencies as a stand-in for calories—a process that has led to the dollar economy of today. Calories and dollars are both measures of value in the way that miles and kilometers are measures of distance. The value of calories, however, is fixed and cannot be inflated or deflated, while currencies fluctuate. Still, an equivalency can be entertained because both measure the value of energy invested in some thing. Until 1971 the U.S. operated under the "gold standard" where the value of a dollar was equated to a fixed quantity of gold. Skipping back a couple of millennia, the currency of the day was the denarius; one denarius was equivalent in value to 10 asses. Another jump lands us in ancient Egypt where purchases were made by barter; usually quantities of grain or oil. Each jump brings us closer to the original currency—both oil and grain have caloric value that can be measured, while their equivalent value in currency fluctuates wildly over time. All currencies are vastly more convenient than calories as a way to represent and transfer units of energy from one person to another—much more convenient than a tub of olive oil or half an ass.

It is helpful to think of energy as the currency in two worlds, the ecosphere, where calories are the currency, and the econosphere, with its dollars. All of us live in both worlds. A farmer in the ecosphere harvests calories for himself and his family. But to become part of the econosphere he must create a surplus far beyond his biological needs. He has to produce large excesses of corn calories that he and his family cannot eat, in order to convert them into dollars, with which he can buy gallons of diesel fuel and tons of machinery. While it is not often recognized, the economy rides on the ecology like a rodeo cowboy bursting from the chute on a two-thousand-pound bull with a mind of its own.

The movement of calories through the economy is not confined to food. There are lots of calories in wood, as we shall see later. I've sketched a bare bones transit of a product through our dollar economy to shed some light on the relationship between ecosphere and econosphere. An item of ecological value, say an oak tree, enters the econosphere when it can reasonably be assigned a dollar value—usually when it is harvested. Timber becomes lumber and some proportion of it becomes a table that lives its economic life in somebody's home. It picks up dings, scratches, and burns; it gets old and creaky, and eventually it dies economically—it is bankrupt—its value becomes negative because the owner must pay for its burial in a landfill. That accomplished, the wood in the table has left the econosphere. It still has ecological value—caloric value—because those calories, held in the chemical structure of the wood, feeds decomposers equipped to harvest it, even as it rests deep in a landfill.

Clearly, the way energy moves through these systems is central to their operation and it is not surprising that ecosystems are built around it. Naturally, economies must be too. While this book is about the sliver of the little infinity that we experience directly—what we think of as our environment—we have to dip our toes into the infinities on either side of us. The energy that runs the entire enterprise comes with the fusion of hydrogen into helium. On arrival here, sunlight "excites" electrons—turning that radiant energy into chemical form. That is the essence of photosynthesis. Mixing carbon dioxide and water in the presence of sunlight to make sugar is among the most consequential of all reactions. It takes place outside our preferred size range, but as the foundation of energy flow it can scarcely be ignored. There is the chemical process itself to consider, the elaborate, if tiny, facility in which it happens, including the necessary physical machinery to accomplish the process, the movement of raw materials and product within the facility, and the warehousing of that product.

The energy products are now in chemical form in a size range that we can comfortably think of as our ecological community—those masses of energy that we are familiar with as trees, birds, and butterflies. Every part of it is edible by some living thing that together serve as the conduits through which energy moves as it flows through the

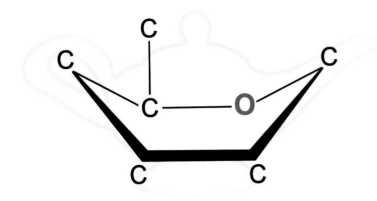

2.3 A molecule of glucose is diagrammed here in its "boat" configuration. It's a small molecule with just six carbon atoms configured in a ring and held in this shape by a breakable oxygen bridge. The outline is to call to your attention a coincidental similarity to Aladdin's lamp. The 6th carbon protrudes from the ring like the mast of a sailboat.

ecosystem. The rest of the chapter—the rest of the book actually—will amount to a study of selected conduits, how they relate to each other, and how they move energy/mass through them while making a profit.

The enterprise is organized so that the numbers of distributors, consumers, and recyclers are appropriate for the work that needs to be done—it self-regulates the labor force. Finally, we'll look at the molding of the individual species, as seen through the lives of the workers in the natural economy, each shaped for their jobs so that all serve the system.

As sunlight is converted into chemical energy, an energy tax is paid as demanded by the 2nd Law; and it is exorbitant. Photosynthesis captures only 3 to 4% of incoming light—a surprisingly poor showing, given that it is the energy supply for the entire biosphere, but then it is what we have evolved to live on. Photosynthesis is the all-important process that turns transient sunlight into excited electrons and stores their "excitement" in chemical form—the sugar glucose. It's a complicated series of reactions but the recipe is simple: mix equal parts of carbon dioxide and water in a leaf and bake in sunlight at normal temperatures. Oxygen will be driven off and a molecule of glucose is the edible product. It is as close to magic as we are likely to get, but it is good science. The 1st Law is satisfied because the sun has lost energy and

now, we are holding some of it.

The chemical structure shown in Figure 2.3 provides a useful icon that gives shape to a nebulous idea. Such things are not part of our daily experience, so I'll draw on metaphor. It is both fortuitous and ironic that the boat form approximates the shape of oil lamps rumored to confine genies. It is fortuitous because we can now think of photosynthesis as the process of building the lamp that holds the power of the genie captive within its bonds. From sugar molecules and a few necessary elements, we can build anything structural from oaks to elephants, and sugar itself is the ultimate fuel that, stored as fat, powers the wings of warblers.

The most common element of life (beyond those in glucose) is nitrogen, which makes proteins possible. Adding phosphorus to the mix, permits DNA. A pinch of sulfur, iodine, copper, and a few others, expand the functions that biomolecules can serve. Magnesium is another. It is the active element in chlorophyll, and it functions like iron does in hemoglobin. Eventually, this unlikely mix of chemicals can be assembled into a living, growing being, that can reproduce after its own kind. Even more amazing, it can become self-aware as an adaptation for coping with the demands of life.

The interactions of molecules take place near the far end of the little infinity on a scale that the human mind is ill-equipped to fathom. But we'll take a shot at it. A teaspoon of sugar carries 16,000 calories†, but the transactions among cells operate on a vastly smaller scale. A leaf needs to build a quintillion (10^{18}) molecules of glucose to make just one of the 16,000 calories in that teaspoon. The work required to produce a ten-pound bag of sugar, is beyond our capacity to imagine. Trying to accommodate so many orders of magnitude in the little infinity is an echo of the grandeur we experience through the night sky of the grand infinity. It generates a sense of awe and refreshes our humility, but both pass quickly. The transience of that feeling is one reason for bothering with these details. If we can understand these complicated mechanisms through our rational brain, we can rekindle those sensations with a little reflection.

The manufacture of glucose is done in a facility of microscopic pro-

† You may be familiar with 16,000 calories as the 16 Calories in a teaspoon of table sugar.

2.4 Left: A very young Persimmon leaf (*Diospyros virginiana*) provides an overview of the glucose production facility as it grows to achieve production; its newly synthesized chlorophyll tight against the veins. Right. ~ 15X. The mature leaf of a Redbud (*Cercis canadensis*) shows well over 100 work spaces where the cells house and tend the chloroplasts that actually make glucose. The supply pathways for the distribution of raw materials and the export of product are prominent.

portions, but being a manufacturing facility, it has much in common with large industrial plants we use to build product compatible with our dimensions. So, we'll wander about inside a leaf as if it were the size of our enormous facilities. Figure 2.4 shows the facility as if seen from a satellite. Large distribution channels can be seen but the site where the magic takes place—where gold is spun into straw—escapes us.

Manufacturing facilities require the input of raw materials, their distribution, the collection of the product, and its export. Those requirements account for those great bundles of tubes—the vessels of supply that serve the processing cubicles, air exchangers, and eventually the export of product. The work stations are housed in chloroplasts. All of this machinery was built from glucose as the primary raw material and now it is being used to make more of it.

One last point. Neither green plants, nor electric generating facilities, produce energy. That is forbidden by the 1st Law. We describe them as producers, or as power plants, because that is the most immediate source of the power we use, but in fact, both of them are energy converters—sunlight into sugar, fossil fuels into electricity. That brings the 2nd law into play, and it exacts the energy tax, typically 90% or more. The magnitude of that tax is important to keep in mind because both the calorie economy and the dollar economy run on after-tax energy, and because the dollar economy rides on the calorie economy, the loss is magnified. Contemporary photosynthesis is inadequate to fuel our dollar economy at the level we want; that is entirely predictable because no one has yet found that we have all that we can use. We have no upper bound, so we've turned to the vast supply of fossilized photosynthesis—coal, oil, and gas—that represents the pooled output of millions of years of photosynthesis. Our use of that fuel typically requires at least two costly transitions; we turn coal into heat, then convert the heat to electricity. Those conversions are inefficient as required by the 2nd Law, but we need it to run the machines of our techno-sphere and those conversions are the lifeblood of our dollar economy. We have vast reserves of fossil fuels that we've used to alter our climate—a situation that provides an opportunity to mix metaphors. In burning those fossil fuels, their genies still intact, we not only release the genies from the lamps—we open Pandora's box.

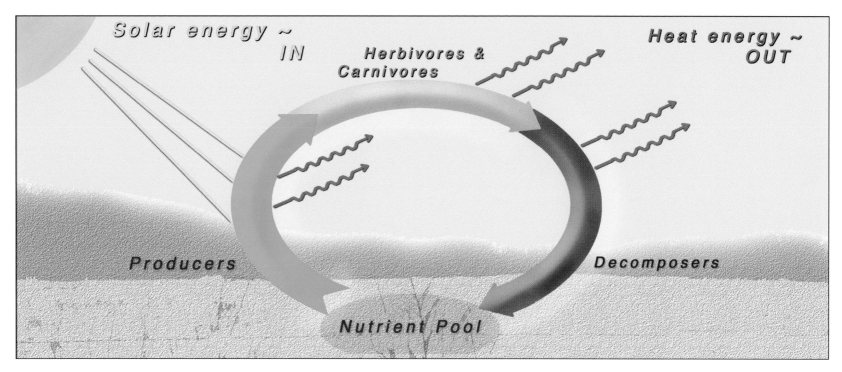

2.5 The relationship of energy and matter in an ecosystem, illustrated. The premier event of the ecosystem is the binding together of energy and mass, made possible only through photosynthesis within the chloroplasts.

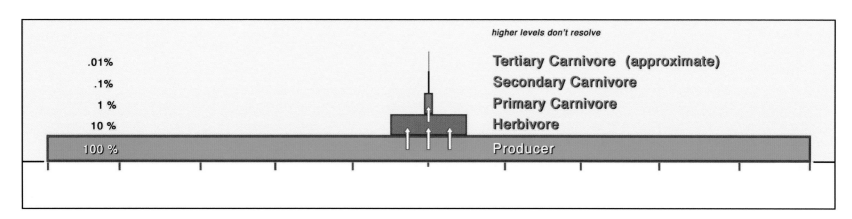

2.6 This pyramid is proportioned to illustrate the impact of the 10% rule on population structure within ecosystems. The entire edifice rests on the producer tier which supports all higher levels. Each tier represents the approximate number (or mass) of consumers that can be sustained. Each tier is only 10% of the one that supports it and upon which it rests. The percentages stacked on the left side report the relative energy content in each tier, as predicted by the 10% Rule.

The Rules, along with an overview of photosynthesis, are the foundation of energy flow in ecosystems. There are two organizational details of this foundation that deserve particular attention because they are intangible.

The first part, addressed in Figure 2.5, is a nod to the 1st Law and it lays out where energy comes from, and where it goes, including a fling with matter that is resident on the planet. That fling constitutes life. Matter is tangible of course, and it cycles endlessly, confined to the earth by gravity, it goes round and round like the blades of a windmill. Energy (entering as sunlight) is intangible and has no detectable gravitational constraints. It drives this cycle like wind drives a windmill. As energy, it will dissipate (2nd Law) and eventually leave the planet as heat. Such a simple idea, but where it goes from the time it becomes entangled with living things, quickly becomes complicated and profound.

Driven by that energy, producers are empowered to draw both water and nutrients from the nutrient pool, concentrated in the earth by gravity; and they draw carbon dioxide from the air. The energy in sunlight binds them together in an energy/mass complex—glucose. The non-green parts of the cycle—herbivores, carnivores, and decomposers in that sequence—represent the passage of this complex, a sort of energy/mass bolus through the ecosystem like a rat through a snake. All living things eventually fall to decomposers, even the decomposers themselves, and they ultimately release their last bit of energy as heat, as they replenish the nutrient pool. Ecologists generally restrict the term consumer to animals that eat their prey as we do, reserving the decomposer name for fungi and bacteria, who digest their prey at a molecular level, but except for the producers, all of us can only consume. The track of that energy is conventionally recognized as a food chain.

The second organizational detail is addressed in Figure 2.6. It is a different view of the same process but focused instead on the movement of energy/mass through the ecosystem. And naturally it reflects the impact of the 2nd Law, the one that pertains to energy dissipation. Producers are the sole source of energy that feeds life, and that makes them the most significant part of this pyramid. They make wealth. All the rest of us, one way or another, are consumers. It is our ecological role. We've evolved to fit into it and the ecosystem has flourished with this structure.

Like the previous illustration, Figure 2.6 has the subtlety of a stick figure, but it focuses on a truth that is entirely inconvenient. Using a pyramid with tiers rather than links of a food chain, this figure shows us in ball park figures, how much energy is lost due to the inefficient transfer of energy demanded by the 2nd Law. That transfer is only 10% efficient, so that 90% of the energy escapes from the ecosystem (dissipates as heat) when food is taken from each tier and moved to the next higher level. There is variation of course, but that rate of loss is consistent enough to warrant a name—the 10% Rule. These percentages explain why each tier is so much smaller (90%) than the one below it. Their sizes are limited by the magnitude of that unavoidable energy tax.

This figure is drawn to scale in an attempt to highlight the severity of the energy losses. The first order of consumers—Herbivores—populate the second tier and in due time will pass their flesh to one of the carnivores in the third tier, and subsequently taken by successive predators until it reaches the ultimate consumers, like grizzly bears, wolves, and humans. All will die eventually of course, and the energy/matter in their bodies will fuel the decomposers, not represented in this pyramid model. Seen in this way, a placid, grazing cow (herbivore) is transferring energy/matter from the grass (producer) to the cow who will now hold it. For a while.

The producers are the foundation and the starting point. However much energy those producers hold in their flesh at any given moment, they represent 100% of the energy available to that ecosystem. In spite of the minimalist nature of this figure, this pyramid models an impenetrable thicket of conduits that feed energy by one path or another from the bottom to the top.

We use metaphors to minimize the complexity of real events, and the familiar idea of a food chain is one of them. This model assumes that we can identify the path of energy through a series of consumers among this tangle of possibilities (e.g., grass > mouse > snake > hawk). Despite its failings, the food chain successfully presents the core idea. Its weakness lies in representing the flow of energy as a single chain, while in reality, those channels form a maze through which energy flows like a braided river with multiple, diverging and intersecting channels.

Forcing real life to represent such simple models reveals their flaws. As omnivores, we humans operate on several levels at once. With a steak and potato meal, we vacillate between bites from second to third tier consumers, while a spouse, sitting across from us with a salmon dinner will consume at perhaps the fifth or sixth tier—aquatic food chains tend to be long. The pyramid, drawn to scale, suggests the enormous number of producers required to support that salmon. Usually, textbook illustrations of this pyramid are not to scale because the highest tiers fail to register, as they do in Figure 2.6.

A little reflection will make it more concrete. Suppose that an owl requires a mouse every day to sustain himself. There must be 365 mice in the second tier to feed him for a year—plus a buffer, if the system is going to be sustainable. If one acre can support 365 mice, it will support just one owl, two acres are required for a pair of owls; more acreage is required to raise a family. It is a lot of mice for a few owls in this crude approximation, but the proportions present one of those permeating patterns that are invisible to us as we walk the trails, seeing neither mice nor owls.

<center>***</center>

Decomposers are the third part of the cycle in Figure 2.5. Like us, they are dependent on plants for their energy no matter how convoluted the route by which it reaches them. Decomposers operate at the cellular/molecular level, where they dismantle dead material of every kind—like a search and rescue crew poking through the rubble of a collapsed infrastructure intent on liberating the last trapped genie.

What's in it for them? We find well-dead bodies repulsive, but then that's just us and our evolved sensibilities—a three-day-old carcass is an appealing find for a vulture. But every carcass—producer, consumer, or decomposer—is a pocket of energy and they still hold a lot of energy, enough to pay for their disposal. Fly larvae (maggots) are small and a dead mouse is large in proportion and it carries large quantities of protein and fat. To a maggot, the mouse must seem like a beached whale.

Decomposers break big molecules into smaller ones and the released energy nourishes them. Those smaller units still hold energy, and they are now suitable for smaller decomposers who attack different bonds. Cracking those bonds to release their energy is like cracking a pecan to extract the meat. The breaking of specific bonds is repeated at ever smaller scales, and proceeds until the energy-bearing molecules have reached their lowest energy level. The carbon is now returned to its original state as carbon dioxide, those nutrients returned to the nutrient pool, and once again available to producers. It is a grand story—you can't make this stuff up.

The decomposition crew consists primarily of bacteria, molds, and other fungi, living in the soil; that is primarily where the job is, among decaying root systems, rotting tree trunks, and the like. We can't see the decomposers at work along our trails—they range in size from tiny to microscopic and their work is surreptitious, deliberate, and silent. But it is visible to us in rotting wood and properly prepared compost. They are essential to the ecosystem because they close the circle. In so doing, they make valuable resources of the dead of all sorts, and their toxins, not to mention all of the fecal material released by all the animals.

We'll confine our attention largely to producers and consumers large enough to be encountered on a walk, because the decomposers are too small, except for a few of the largest constructions that rise above ground, creating the flower-like shapes we recognize as mushrooms. They are the work of otherwise microscopic creatures that climb above ground, building those towers as a means of reaching into the wind to disperse their spores. That process can be likened to roots sending up a tree rather than the more familiar perspective evidenced by our notion of "putting down roots." Those towering structures are so large that they reach up into our slice of the little infinity, which they would see (if they could see) as a land of giants, not far removed from the story of Jack and the Beanstalk. They comprise a substantial but amorphous population called a mycelium, made of cell-sized strands (hyphae) that live underfoot. Most of their constructions are transient, some "live" for less than a day, but they expose their spores into the wind like a wind sock on a pole, for their dispersal. They are as essential to the survival of their species as flowers are to plants, and they are every bit as complex and elegant as flowers. Several kinds of dispersal towers are seen in Figures 2.7 - 2.12.

The Inky Cap Mushroom in Figures 2.8 & 2.9 are growing on a straw bale that will be home to a crop of our Sweet Potatoes. As the straw rots, the mycelium sends up this fragile mushroom—a typical fruiting body—for dispersal of the spores. The mass of the fungus lies

2.7 One of the Gilled mushrooms, likely the Oyster Mushroom (*Pleurotus ostreatus*). Its natural color runs from off white to tan but it is shown here in monochrome sepia, to favor its contours. Its role is to decompose wood. This mushroom is one of those towering dispersal phases built to specifications dictated by the mycelium that fuels the enterprise, and using energy from the decomposing log to provides the energy to fuel it.

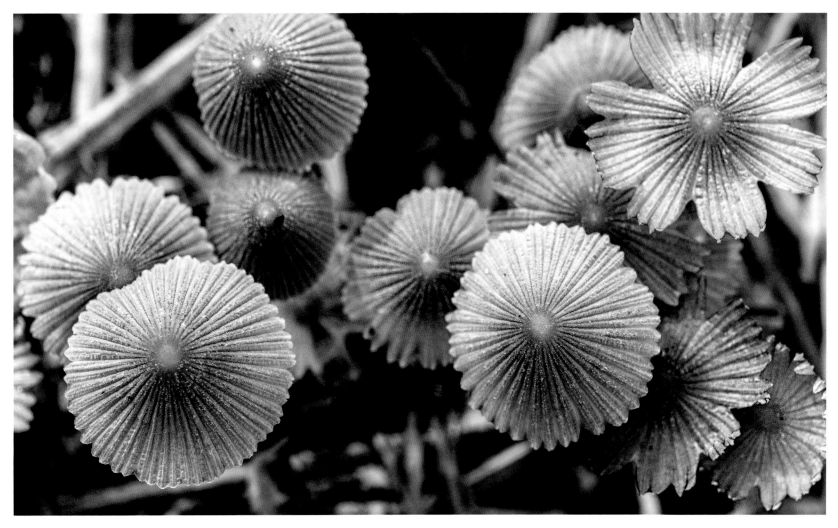

2.8 Seen from above, the cluster of Pleated Inky Cap Mushrooms (*Parasola plicatilis*) reveal several stages of aging that follow one another quickly, from just-opening caps, to fully opened caps with tattered fringes. The tearing and upward curling at the edge of the cap is not simple wear, that fringe allows the spores better access to the wind and likely increases the turbulence.

underground but, when triggered, it sends up this fruiting body. Slender and frail the stalks are still strong enough to raise and deploy the cap so that its spores can be released into the wind; anything more robust would be a waste of energy. It disintegrates within 24 hours, mission accomplished, shriveling into an inky puddle like the Wicked Witch of the West.

In understanding the profound significance of the flow of energy in any working system, we've touched details that can now be ushered from abstract theory to real experiences here on Brawley Creek. We've compared calorie and dollar economies to show the commonalities among living things and the limitations we all experience, discussed The Rules that limit energy use, identified its origin and its destinations, recognized its conversion to chemical form, outlined the general shape of its movements in broad strokes, and noted the channels in which it flows: producer, consumer, and decomposer. Now it's time to ground that theory in flesh and blood, and in nectar and sap. The first step is to identify a few specific jobs that need to be done and the workers employed to do them.

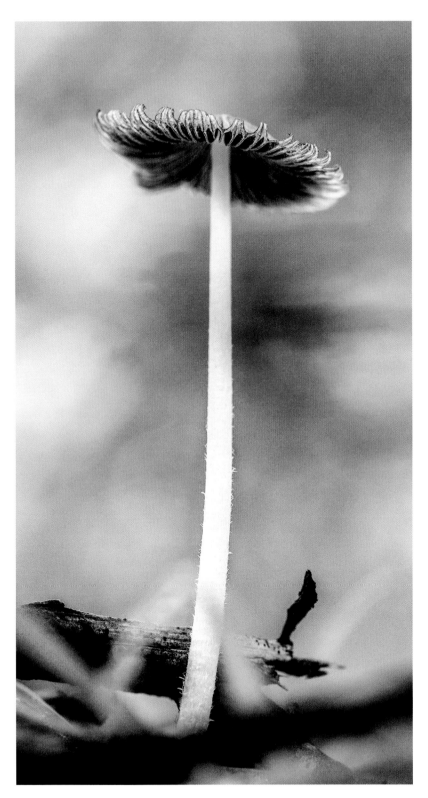

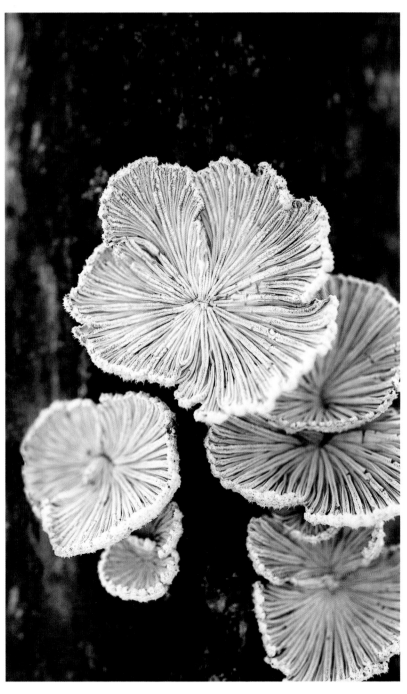

2.10 Split Gill Mushroom (*Schizophyllum commune*). Decomposing twigs that are long dead but slow to fall from the canopy are the typical environment for this fungus. As the twigs rot, they weaken, eventually falling to earth where we can find them. The reproductive life of this mushroom must be extremely complicated as researchers have reported over 28,000 distinct sexes.

2.9 The transient fruiting body of the Inky Cap is flower-like but asexual, dispersing spores rather than seeds.

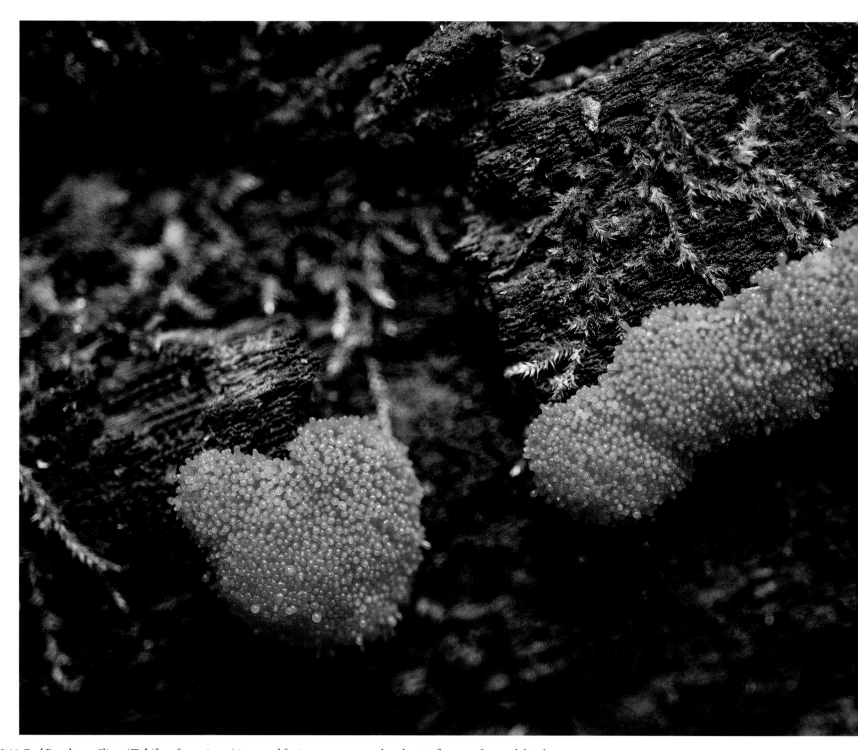

2.11 Red Raspberry Slime (*Tubifera ferruginosa*) is named for its appearance rather than its flavor—often such bright colors tell us not to taste. Left: These clusters are decomposing a Honey Locust log that fell during a storm in 1993. Right: This single cluster of sporangia is growing on an Elm log. Soon all will dry and shrivel, releasing their spores.

2.12 ~ 7X. One of the globular springtails is harvesting spores as he walks the ridges of mushroom gills. The spores are abundant, and the springtail can be imagined as a gardener, walking a row of produce, and deciding which to take. Springtails are one of a large array of fungivores—slugs, box turtles, fly larvae, chipmunks, and humans among them.

Ecologists envision the calorie economy as a plethora of opportunities to earn a living. Every habitat is an economic unit that requires a variety of workers with different skill sets that can live their lives under the dominion of ecologically dominant forms—grasses in prairies, trees in forests. Each habitat is host to a work force of consumers that fit into it like a correctly placed piece in a jigsaw puzzle. Meadowlarks function well in prairies and woodpeckers in forests. Each job in the work force has a job description—"must be able to extract grubs from dead wood and create shelter in same." That description would eliminate all but a few woodpeckers from a pool of applicants. By being much more specific—which kinds of grubs and whether the dead wood remains standing or has fallen—will eventually pare down the applicants to a single species—one species that will fit into that niche more effectively than any other. That specificity is a powerful concept, and it rounds out the idea of the biosphere as a vast job market where each job requires a very specific array of specialists that very few different plants or animals can satisfy. Across the landscape then, there exists a broad array of occupations—niches—and they provide a living for every species of a habitat.

In this world, the plants are "haves" by virtue of their monopoly on energy—the rest of us are "have-nots." Producers, with all their economic might, live in a tough neighborhood and they have few options. They have no choice but to lay out their leaves, exposing those vulnerable solar collectors to the sunlight and in so doing, open themselves to attack by a vast array of life forms specialized to eat them. At this level, the activity is less like a job market and more like an attack by the hordes of Genghis Khan. Leaves are eaten by hundreds of species of caterpillars with their tiny chewing parts, by browsing deer, and by cattle or bison whose large, grinding maws take in grass by the mouthful. The producer's respond by growing enough leaves to feed the masses and still prosper, much like the produce department of grocery stores that plan for losses due to spoilage.

Producers are not helpless, they have chemical and physical defenses, but every defense they invent, generates a counter defense among the herbivores, leading to the tremendous array of specialists that have come into being by their endless probing for weak spots. This probing and innovation takes place in every level of consumption within the pyramid. Two forms of physical defense that target particu-

2.13 Thorns on the stems of the Bristly Greenbriar (*Smilax hispida*) are exposed to view in winter. The impaled leaf squares with my personal experience with those thorns. A caterpillar would be unable to move from one widely spaced leaf to another, nor would a deer find it suitable for browsing. Mice would be unlikely to scamper up this stem to take berries, effectively saving them for birds who will provide a wider distribution of their seeds.

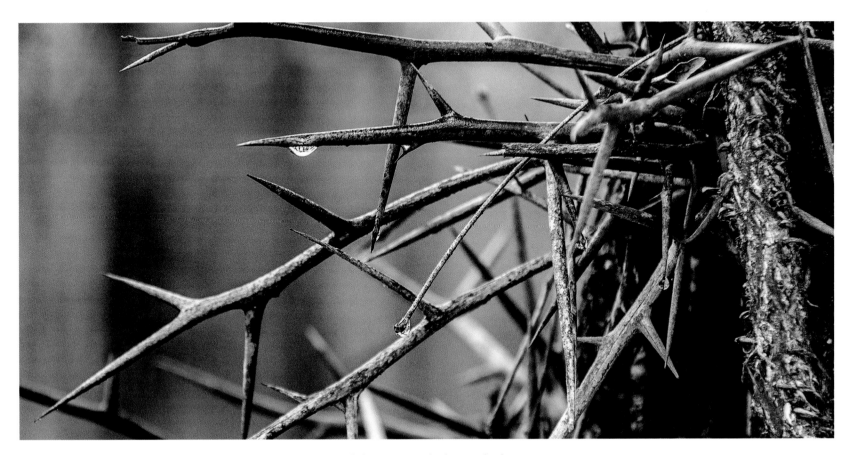

2.14 One might wonder what the trunk thorns of a Honey Locust (*Gleditsia triacanthos*) are evolved to repel, certainly not humans, who were not yet about when the thorns evolved.

lar kinds of consumers are seen in Figures 2.13 and 2.14.

Eons of defense piled upon counter-defense have created a veritable soap opera of intrigue where the bottom line is that things of value are often taken without compensation—an event that humans are inclined to see as vices. That appropriation is in violation of social codes peculiar to social species. We humans see in these interactions every kind of vice with a creativity that reaches far beyond most of the Commandments. There is deceptive advertising, misdirection, manipulation through promised or implied sexual access, third-party interference, identity borrowing, and outright theft in an infinite number of complicated ways, from pick-pocketing through parasitism, to predation. The ways in which the actors parry and thrust are fascinating. Some relationships are collegial, the rest adversarial. Here is a sampling.

Collegial relationships are most obvious between flowers and their pollinators. These are fee-for-service transactions. In our dollar economy, you mow my lawn and I pay you twenty bucks. If I don't offer enough, you won't provide the service. Ecological workers are paid in calories—a system of barter. In the calorie economy a bee is "hired" to transfer pollen from a flower's anthers to their stigmas, as the Bumble

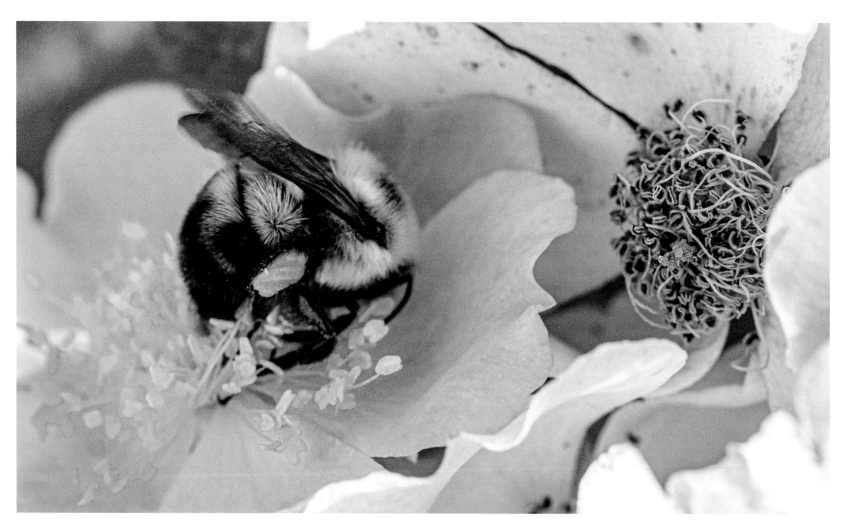

2.15 A classic fee-for-service relationship shows a Bumble Bee (*Bombus* sp.) deep in the tangle of pollen-bearing anthers at the center of a Prairie Rose (*Rosa setigera*). She has already collected a mass of pollen, carried in compacted form in the pollen baskets on her last pair of legs. The pollen is part of her payment for pollinating the rose, the rest is paid with nectar.

Bee is doing in Figure 2.15. The bee is paid in nectar and/or pollen, micrograms of the plant's own flesh, and the flower achieves fertilization. The nectar fuels the work and the pollen will nourish larvae in the hive.

I don't want to pay any more than I have to for a service and neither do flowers for the same reasons. I need to pay enough to compete in the labor market or the workers will find other "employers." Seen from the perspective of the foraging bee, she must be paid enough to cover the costs of travel, with enough left over after paying the exorbitant energy tax, to invest in and maintain the hive; and of course to make more bees. Natural selection arbitrates any disputes. Figure 2.15 shows one of the commonest transfers of energy from producer to herbivore—from one tier to the next.

Using bees and flowers as examples is perhaps trite. Here is a less known pairing that exposes the baroque, specialized relationships among strange bedfellows. These bedfellows are Spring Beauties—a small but abundant spring wildflower—and ants. Spring Beauties pay ants to plant their seeds. They pay them in calories of course, but they don't have to feed them pollen or nectar, as is sometimes the case. They make an "ant baby food" entirely for the purpose of paying the ants.

2.16 ~ 40X. One-twelfth the size of an M&M, these Spring Beauty seeds (*Claytonia virginica*) are fresh from the seed pods and they are exquisitely sculpted.

The flower produces tiny seeds not much over 1 mm in diameter (Figure 2.16), but the seeds come with an elaiosome, the lighter colored material that fills the notch in each seed like icing spread sparingly on a cupcake. Elaiosomes have no apparent function except to pay ants who carry the seeds underground. Imagine clipping a dollar bill to the outside of a package to pay for its delivery.

The elaiosomes are baby food made for the ant's larvae who will eat those parts without damaging the seeds—something like sucking the chocolate off of peanuts. In a novel twist, the seeds, now useless from the ant's point of view, are carried off to a waste chamber where they are discarded along with excrement, and other organic waste, like throwing melon rinds onto the compost pile. That is to say, those seeds are now planted and fertilized, safe from seed eaters and remarkably well positioned to germinate when spring arrives. Next year, the ants who planted the crop will benefit further by the superior germination of the Spring Beauty's seeds they have tended.

Lacking a collegial relationship, producer and consumer often become adversarial—the participants play offense and defense, with the producers taking charge of their own defenses. The most obvious of them is the erection of fortifications such that their conflict looks more like a castle under siege and less like a quiet game of chess. Arbitration is not likely to resolve the different agendas of plants and hordes of caterpillars eating their leaves, any more than one might hope to bring a fox and mouse to an agreement. They are irreconcilable antagonists, and the plants build fortifications that range from the thorns and spines seen earlier (Figures 2.13 & 14) to bristles and microscopic hairs of a size, shape, and distribution that targets their most likely antagonists. The defenses they deploy tell us something about the threat that they were evolved to repel.

Most plants make themselves toxic or at least unpalatable. Pines make resins, oaks make tannins, and many other species—most famously the milkweeds—make themselves toxic with cardiac glycosides; but every defense can be countered, and the arms race is endless. The actions and reactions drive innovation to extraordinary heights, and the strategic interplay has produced the fascinating resilience and beauty that we can enjoy from our privileged position as observers.

2.17 ~ 5X. Brushing a fingertip lightly across the surface of a Hedge tree's flower—a Hedge apple in the making—breaks off a few wiry pollen receptors and triggers a discharge of latex that discourages most insect activity.

Latex sap is a common defense. It often carries toxins, but it is lethal in other ways that are less obvious to us because of the scale at which they work. We find latex on our fingers sticky and of no real consequence, but a small insect will find it deadly. Latex seems to be under pressure, such that a minimal break in the surface releases a burst of viscous latex, a tsunami of toxic goo, as seen in Figure 2.17. But beyond the toxicity, small insects find that it sticks to their tiny and complex mouth parts, effectively and permanently gumming up the works.

Many producers benefit from predators that police the foliage—warblers, nuthatches, and woodpeckers—and wasps that attack caterpillars. The birds flit about, picking off caterpillars and other invertebrates as food. Just how they proceed is less known, but one of the ways is to specialize. A particular wasp searches for a specific species of caterpillar. Warblers function as employees whose work-station/feeding-zones are focused in self defined zones—the tips of the branches high in the canopy, or those near the trunk, or within the sub-story—each has a particular zone where they are the most effective foragers.

They don't fix the problem for the producers, of course, but their work helps minimize the damage, helping to keep those producers vigorous and productive in the solar energy business.

While the marauding herbivores are an offensive force, they must play serious defense while they are busy marauding. They must take steps to minimize their losses to predators. Caterpillars of many moths and butterflies become more exposed as they eat, but cryptic coloration and a few behavioral tricks make them inconspicuous to the scanning searches of hunters. Here are a few examples.

The Tobacco Hornworm (Figure 2.18 - left panel) is eating the leaves of a Moonflower. He is about 4 inches long and rich in fat as he nears the time for pupation. That makes him a prime target. He has learned to eat surreptitiously. First, he is not just green, he is an excellent match of the particular green of the host plant. Second, clinging to the midrib or stem, he begins eating at the tip of the leaf, bending it back so that as he chews, he remains hidden by the leaf like an accomplished fan dancer. Furthermore, he eats on both sides of the midrib so

2.18 Left: a caterpillar of the Sphinx Moth (*Manduca sexta*), is recognized in its larval stage as a Tobacco Hornworm, but he likes tomatoes, which are related, as well. He demonstrates eating-while-hiding under a leaf, not showing so much as his mandibles. Right: a Unicorn Caterpillar Moth (*Schizura unicornis*) takes a different approach. He eats in plain sight, using his unlikely shape and coloration to deflect interest—I first thought he was a dead and curled fragment of the dogwood leaf.

that the exposed surface of the leaf remains nearly symmetrical, and the damaged leaf doesn't draw the eye because what is missing is not obvious—he doesn't create asymmetric leaves, or leaves with holes. Finally, he finishes the whole leaf, stem and all, leaving little evidence that a leaf is missing. If disturbed, he falls to the ground.

The Unicorn Caterpillar Moth in Figure 2.18 (right panel) has a different strategy—hiding in plain sight. The caterpillar is fully exposed while feeding, but with his mixed colors and odd shape, he doesn't look much like a caterpillar. He resembles a leaf with brown, curled edges, as I first thought until I took a closer look. He is suggesting that there was a caterpillar here but now he is gone. And look at the damage he did!

Sometimes consumers work entirely out of sight. Even then they

2.19 Looking like a petroglyph, the deep scars incised in the wood beneath American Elm bark, are galleries of the European Elm Bark Beetle (*Scolytus multistriatus*), that carries spores of the Dutch Elm Disease fungus (*Ophiostoma ulmi*). The small trails radiating from the galleries mark the feeding tracks of the grubs. These galleries run parallel to the grain, distinct from those of our native Elm Bark Beetle (*Hylurgopinus rufipes*) whose galleries run across the grain.

are subject to probing woodpeckers. The deep lines scored into the wood of a dead elm branch (Figure 2.19) are galleries created by European Elm Bark beetles, well known because they carry the fungus that causes Dutch Elm Disease. Female beetles are only a millimeter wide, but they can chew through the bark and excavate a long gallery in the sapwood. They lay eggs along the length of it like a school bus dropping off kids. As they proceed with their work, they sometimes inoculate the tree with fungal spores like a bee spreading pollen. When the eggs hatch, the grubs begin eating their way through the thin layer of sapwood. They move perpendicular to the gallery and so avoid their siblings, dispersing in diverging lines like so many arboreal moles. The tunnel width maps the growth of the grubs. Short tunnels mark deaths. Their environment is perfect; moist, dark, sheltered, and filled with pulverized phloem and larval manure, that it is eventually invaded by decomposers of all sorts so that when the tree dies, it has already been infiltrated by decomposers. Those tunnels don't become visible to us until the tree dies and the bark sloughs off. Apparently, the grubs chew loudly enough that woodpeckers can hear; woodpeckers are equipped and motivated to excavate them, but the fungus remains and will eventually kill the Elm.

If we are to understand life and revel in it, we must consider death. The living systems that we hope to understand, and embrace, experience life and death in equal proportions. In a world ruled by thermodynamic laws, death is yet another inconvenient truth. It is not only unavoidable, it is absolutely essential. But that doesn't make it ho-hum. In a room with many metaphorical elephants, this is the biggest of them—bigger even that the climate elephant. Given its size, we will benefit from acknowledging its place in the grand scheme of things, even an appreciation of the central role of death. Death is the other half of life—we don't need to like it, but it is a part of the package. The logic is straight forward. Parts of a machine—bio-machine or techno-machine—wear out; its a facet of the 2nd Law. In a sustainable system, broken parts must be replaced with new parts built from the rubble of broken parts. It is the very essence of Producer, Consumer, Decomposer. It is at the core of the system.

Looking on death dispassionately is not easy. We push it to the back of our minds, but all of us live under the cloud of our own death—we are probably the only species so "gifted" as to be aware of our own impending deaths. Because we empathize so powerfully, seeing dead animals in our approximate size range provokes a potent response. We are very selective in our responses though, and the dead fly on the window sill doesn't move us.

Our view of life is influenced by our expectations, and our expectations are carefully tended and, well, provincial. We have expectations for our senior years—a period of retirement in which we can invest in ourselves, maybe write a book, and as we become elderly and perhaps infirm, someone will care for us. That is community. We should be aware that the social structure that enables these expectations, are unique to our species.

Outside of our cocoons, individuals rarely grow old. Free-living animals have a life span about half that of captives who are provided adequate food, medical care, and who are free of parasites and safe from predators. That says something profound about the challenges they face on the outside—challenges that will eventually bring them to their predators who become the beneficiaries of their estate, such as it is.

The calorie economy has no retirement and there are no golden years. A clean road kill, as disturbing as that is to us empaths, is perhaps the quickest and least painful end for which many might wish. Lacking that quick end, death comes gradually through the rigors of life, parasites, or starvation, most likely all of the above, finally ended by a predator. That is the natural course of life for other species.

Watching a Luna Moth approach her programmed death, one wonders what she feels. Does it hurt? The adult segment of their lives is ephemeral and eventually, even though unable to fly, their legs still work, and they creep along the ground fluttering weakly. Perhaps they will drift off painlessly as if going to sleep, but eventually a flycatcher or a shrew or some other vertebrate will find her and the energy remaining in her body—her estate—rises to the next tier, less 90% of its value. The Rules of the Game dictate the details of this wonderful and horrible system.

Charles Darwin said it admirably: "There is grandeur in this view of life…whilst this planet has gone cycling on according to the fixed

laws of gravity, from so simple a beginning, endless forms most beautiful and most wonderful have been, and are being, evolved."

Those endless forms are the beauty we treasure. We seek it out, the splendid architectures of their bodies, the resonance of their choruses, and the brilliant colors of their sexual displays. They are part of this system; they live alongside us and they bring us joy. All of that aesthetic power is a part of our community here at Brawley Creek, along with the quirks and idiosyncrasies of our local ecosystem that are intimately tied to the history of this place and so fixed in time.

The forces we have been exploring—the Rules of the Game, the strategies and interactions of competitors, and their distillation into niches—all are universal and timeless. But when we begin looking at historical events and seasonal changes, we enter a more bounded world where time is of the essence. We experience time in two ways at once—either linear or circular, depending on the subject of our interest, and that is a distinction worth noting.

3.1 A branch of White Oak has been cut and polished to present the intersection of length and width, the boundary between longitudinal growth and concentric growth. Wood records the events of its lifetime, presenting them from two points of view.

3

It's About Time

"…If you forget mortality…you could really believe that time is circular, and not linear and progressive as our culture is bent on proving … Everything returns upon itself, repeats and renews itself, and the present can hardly be told from the past."

Wallace Stegner, "Crossing to Safety"

Watching events unfold here at Brawley Creek, I've come to see that time exists as three facets of awareness, and I'm not referring to past, present, and future as Dickens would have it, although we most often parse time that way. An online dictionary describes time as an, "indefinite and continuous duration…in which events succeed one another." Another reads, "the indefinite continued progress of existence and events." We can agree that it is indefinite and sequential. We use different parts of it for whatever purpose we have in mind. Of course, time is just time and everybody has an acquaintance with it. So I see the field as clear for me to offer a view of time that served as the organizing framework of this book. We exist at the interface of three facets of time that I've decided to recognize as: Timeless, Linear Time, and Circular Time. The photograph on the facing page is a metaphor for all three.

Timeless: A number of facets of our existence just are. They are founded in Physics and Chemistry, and they include phenomena like gravitational attraction, the positive charge of protons, and thermonuclear reactions—The Rules of the Game are among them. Timeless and universal, they are independent of

time. They just are. Everything we will be seeing in these pages rests on these Rules, which are broadly accepted by skeptical scientists as the closest we can come to Truth. The pyramidal structure of ecosystems, and the cycling of matter are all accomplished in obedience to The Rules and their corollaries. The broad categories of producer, consumer, and decomposer evolved according to them. Even the pollination of flowers by bees is directed by the realities of economics that originate in The Rules. We access this facet only through our rational facilities.

Circular Time: The orbiting of our tilted planet is the source of Circular Time. It is subordinate to the timeless forces, but it creates a periodicity that has powerfully shaped the activities of living things. Circadian rhythms, lunar cycles, and in temperate zones, powerful seasonal changes that are surely circular as they unfold. It is a strong force in life forms, but also impacts geological features with its cyclic glaciations, and its annual freeze-thaw actions. I've devoted a sizable proportion of this book to the activities at Brawley Creek that take place in Circular Time. We feel its impact through an awareness that is non-rational—that is to say, through our emotional selves. Life forms without a rational capacity respond to its signals by altering their behavior according to their kind. Birds begin to sing as day length increases, and plants begin to flower; decreasing day length triggers the southward migration of birds like the Garden Warbler and the stockpiling of fat in Groundhogs. We look at the Weather forecasts, but we also feel the tug of seasonal changes internally.

Linear Time: Only humans live in Linear time. It is a creation of our minds that was made possible by the idea of an afterlife which allowed the idea that there was more to life than the endless cycling of seasons ending in death. We began counting seasonal cycles and marking them on the imaginary Arrow of Time as we became knowledgeable about the past—about the history of everything. Linear Time allows us to speak of conditions centuries into the future, by projecting the Arrow into it. All such projections are fabricated based on conclusions we've drawn from the history of the earth and the living things on it. All of

this is an exercise of the rational brain, but it clearly impacts our emotional selves. Lao Tzu suggested that the past is a source of depression, and that anxiety comes from worrying about the future. Those emotions are part of the downside of living too much in Linear Time where the past and future dominate our thoughts.

The Present: I've excluded this important, even critical, unit of time from consideration because it is unique—different in the way that the familiar three dimensions (length, width, depth) are distinct from the fourth dimension—duration. Being in the Present, is like being one of a foursome who, on counting up who is present, comes up with only three—failing to count himself. The Present is critical because it is what we experience directly, and it is the platform from which we draw conclusions about the other three, but it is no more tangible than sentience.

The idea of linear and circular time, which I acknowledge is pretty far removed from common discourse, is not original. Wallace Stegner draws on the idea as noted in the introductory quotation of this chapter, and a statement often credited to Mark Twain, makes use of both perspectives in a way that is congruent. "History doesn't repeat itself, but it rhymes." History is linear and the rhyming is circular—seasonal.

One of the reasons that parsing time is so difficult is that we live in all three facets at once. All of us living things are exactly equal in our relationship with the timeless forces. I know what it feels like to fall out of a tree, and so does the squirrel who recently fell out of a tree onto our deck, riding a stub of rotted branch all the way. He got up and ran away. That was not my experience, but we both understand gravity in that way.

All of us live in circular time, too, but unlike the rest, we humans see the world in linear time as well, and increasingly so. We see it as a species where it shapes the views that empower Western culture, and we see it individually as it measures out our lives. Being aware of our own mortality means that we experience the ticking of a clock that we don't really notice until we reach our twenties, but that gets progressively louder as we age.

It is unique to humans and powerful.

When we try to understand the life forms around us and their behaviors, there are several barriers besides that clock; there is the distance that stems from our cocooned lives; there is our recognition of living in a world that we regard as reason-based, while we are relatively unaware of our emotional responses; and there is the constant anticipating that we do—usually with some level of anxiety—about what is going to happen to us. It's probably safe to say that none of those ideas enter the mind of an owl with a full belly, sitting in a tree.

So if we hope to get inside their minds of the creatures that we encounter daily (or under their bark), and connect with them from the most open-minded stance we can manage, it will help if we can recognize the gulf that separates us. When Georgia O'keefe advised us to take a flower in our hands and really look at it—to make it our world for the moment, she was encouraging us to take a break from linear time and luxuriate in natural time. For many it is like a meditation, and for us it is like a salve on tired muscles.

Recognizing these profound differences allows us some insight into the sensations and motivations of creatures without rational capabilities. We can try to subtract out the rational component of our knowledge, like you would subtract the weight of a container when weighing flour for a recipe. We can't really do that, but it is well worth the effort.

Trying to absorb that world as if we are not who we are is daunting. That world is complex beyond imagining. There are many cycles with different periods that overlap—cycles with vastly different frequencies, from circadian rhythms that regulate our sleep periods, to lunar cycles that have such diverse effects as influencing menses and forcing tidal movements. And the seemingly endless parade of these short-term cycles is subsumed by century-long dry periods, like the "great drought" in North America, implicated in the collapse of both Puebloan and Mound-building civilizations nearly a millennium ago, and which may be on the threshold of return in the southwestern United States. These blocks of time are dwarfed by looping glacial advances and retreats, driven by cycles with frequencies that span millions of years. All of those cycles are superimposed on everything, creating rhythms within rhythms—making things rhyme.

Here at Brawley Creek, we experience a place with its inhabitants. We live in linear time of course, but I suspect that we live circular time more than most people, as we respond to the world outside of our cocoon. Walking the creek bed, we can hold in our hands the remains of a fossilized fern that lived in circular time 300 million years of linear time earlier. We marvel at its detail and its antiquity while we attempt to bridge the years in our minds—connecting that fossil to its descendants, living at our feet and still living in circular time.

We'll begin our exploration of Brawley Creek in linear time, three hundred million years back. It seems like a good place to join this work in progress. Naturally, The Rules, being timeless, are always in effect.

4.1 ~ 2.4X. The brachiopods, found in this three-inch sliver of limestone from Brawley Creek, were part of a thriving, saltwater community on the sea floor south of the equator. Now, 300 million years later, 3,000 miles to the north, and about 1,000 feet higher, their remains have flaked off the parent rock. Released to the elements, the last record of their existence will finally be dispersed.

4

The Backstory

"Human history is a brief spot in space, and its first lesson is modesty."

~ Will and Ariel Durant, "The Lessons of History" (1968)

The land that now hosts our home on Brawley Creek—that part of the North American tectonic plate upon which we live—first emerged from the ocean for a geological instant about 300 million years ago, subtle as an alligator surfacing to see the above world before subsiding in his own good time. But that didn't happen here. "Here" is about 38° into the northern hemisphere, and the emergence in question took place below the equator, about the latitude of Peru. Most of the North American continental plate, on which we are currently adrift, was tropical and much of it below the equator. We've been drifting ever since; "we" being the continental plate and all of its passengers. As I write, we have passed 38°North—traveling 3,000 miles of latitude during that time. It's been a colorful past, with dinosaurs, fluctuating sea levels, mass extinctions, glaciations, and more. This area—Brawley Creek—hosted shallow marine life for extended periods of time, then freshwater swamps—tropical of course—and then estuary, those fluctuations were driven by crustal uplift and subsidence, the expansion and withdrawal of great sheets of ice reaching far out from the South Pole. Finally, we've been uplifted enough that our land supports terrestrials.

The North American plate is our vehicle, and it is still moving, so slowly that calling the movement glacial is hyperbole. The passengers on the vehicle are oblivious—we go to sleep in one place, and by morning we'll be 10 billionths of a mile from where we went to sleep. It's not much, only about one-third the length of a sperm's tail, so it takes awhile to get anywhere. Still, it isn't exactly nothing, and it explains in one stroke why

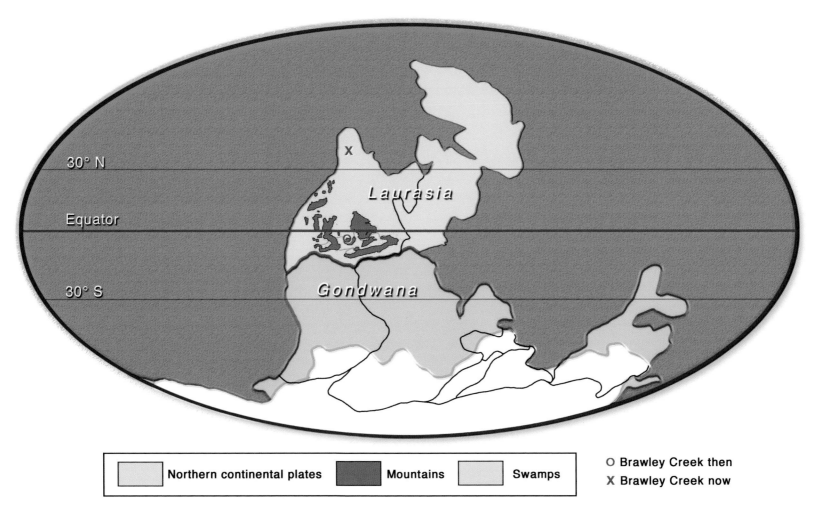

4.2 The collision of Laurasia and Gondwana briefly formed the supercontinent Pangaea, 300 million years ago during the Pennsylvanian Period. That collision raised mountain ranges, the Appalachians among them, near the line of contact (dark green). As if in recoil, the North American Plate began moving north and rotating counterclockwise, carrying us in a long arc to our present location.

the fossils in our sedimentary rocks were of tropical forms while we are living well into the temperate zone.

There was but one continent then, seen in Figure 4.2, and appropriately called Pangaea. It formed by the collision of Gondwana to the south, and Laurasia in the north, the line of contact marked by the dark green line between them, seen in Figures 4.2 and 4.3. It was a titanic fender-bender, driven by unimaginable forces that are moving us still. The damage to our vehicle was substantial, a crumpled eastern seaboard with appropriately-sized folds running in an arc to the west.

Those folds were thrust to altitudes of 14,000 feet, equivalent to the height of the Rocky Mountains today, and they ranged as far west as the Marathon mountains of southwestern Texas. Today what remains of those mountain ranges are their eroded stumps, and it's hard to see them as they once were, jagged, snow-capped peaks. A similar event just 50 million years ago formed the Himalayas when an independent subcontinent that we now recognize as India, moving north, collided with Asia, creating a similar fender bender that thrust that range to its current height, which is still rising as the Indian plate continues to push.

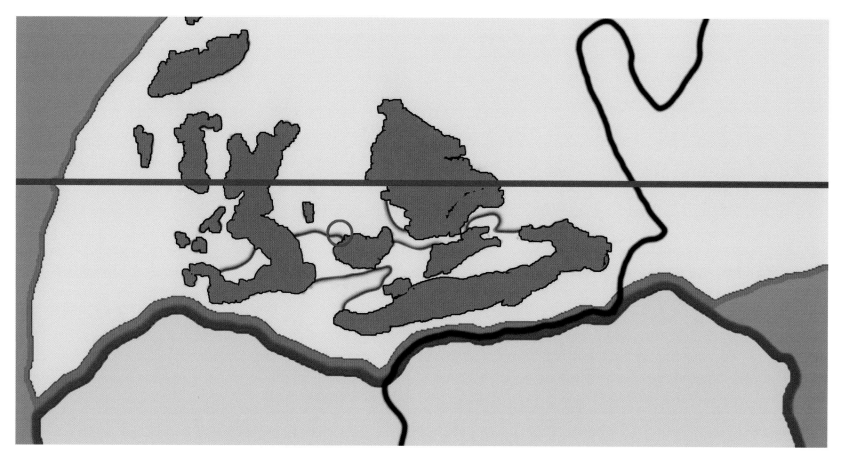

4.3 An enlarged part of Figure 4.2 makes clear that much of the North American plate was underwater. The mountain ranges along our east coast and points west, forced precipitation that facilitated the great tropical swamps, the remnants of which exist today as coal beds. The red circle on the west edge of the Ozark Plateau, marks our home and that of the tropical brachiopods seen in Figure 4.1. Their interment took place then, long before there was a creek to exhume them.

The enormous ice cap that covered the South Pole and nearby land masses advanced and retreated over many millions of years like the glaciers of our recent Ice Age. Sea level rose and fell by hundreds of feet as that icecap expanded and contracted, and those fluctuations were part of the unsettled and colorful past of western Missouri. Runoff from rain forests on the flanks of those spectacular mountain ranges to the south and east brought layers of sediment that, interacting with the fluctuating sea levels, produced mixtures of limestone (shallow saltwater), sandstone (fresh water), and shales and mudstones (estuaries) that formed as the seas rose and fell. The communities that thrived in that tropical sea created communities that have left our sedimentary rocks rich in fossils from that time.

Today, as the creek cuts into those layers, the fossils are released to be tumbled and crumbled by the current that pushes them across the gravel bottom. Their fragments can be found in large numbers along our gravel bars, and they tell us what lived here back when we were tropical. That was the Age of Amphibians and the freshwater swamp communities supported ferocious, heavy-bodied carnivores weighing hundreds of pounds at the tops of their pyramids that dominated the vast, tropical swamps like the crocodiles of today. By now, however, the Ozark chain has been worn to nubbins and the surviving amphibians, the tiny frogs and frail salamanders, are shadows of their giant ancestors.

The exuberance of that pivotal period coincided with a spike in at-

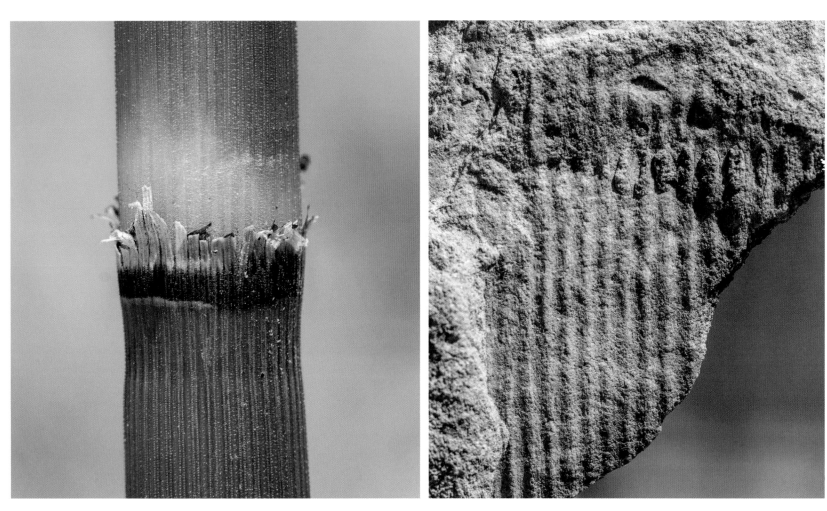

4.4 Left: ~ 2X. Spore-producing Horsetails (*Equisetum hyemale*) now grow in the shade of our seed-producing canopy. They retain the structural elements of the ancients but grow only to heights of three or four feet. Right: ~ 1.6X. A fossil in sandstone is all that remains of an ancient Horsetail (*Calamites* sp.) that flourished here 300 million years ago when we were tropical.

mospheric oxygen that reached 35%, well beyond today's 21%, and not surprisingly, there were consequences. New possibilities were open, especially among insects. Dragonflies (*Meganeura*) with wingspans of 26 inches were possible and they make our dragonflies with their 4-inch wing spans seem like toy models of those Pennsylvanian species. We find fragments of fossils from that community, mostly plants, as one would expect because of the pyramidal structure in force in every time. That forest consisted of vascular plants as tall as our oaks and hickories, but they were distinct from ours in that they reproduced by spores rather than seeds—flowers not yet having been invented. As new life forms evolved, their predecessors became extinct but sometimes, as with the amphibians and dragonflies, their body plans remain, in reduced scale. Horsetails (Figure 4.4) and ferns (Figure 4.5) are spore producers that remain with us, paired with their ancient forbearers.

Following the Pennsylvanian period and midway through the Permian ~280 million years ago, this part of Missouri gained elevation and the seas withdrew for the last time, leaving us with something like 280 million years of blank pages—pages without great beds of sediment to tell us of time here. We have no record of two major extinction

4.5 Ferns are long past their time of dominance too, but they remain diverse and ecologically active on the forest floor. Left: ~ 7X. The leaflets are from Ostrich Fern (*Matteuccia struthiopteris)* that grows here. Right: ~ 4X. A leaflet of a Pennsylvanian fern (*Pecopteris* sp.) probably a tree-fern, also in sandstone.

events, we missed the Age of Reptiles entirely, the rise of mammals, the origin of birds and of flowering plants, and the evolution of grasses. Those ages are known from strata in other places, but our record here resumes with the Pleistocene glaciations that began three million years ago as massive glaciers advanced and retreated as glaciers do, and in so doing they began to write on the pages of linear time. Water, withdrawn from the oceans, accumulated on the continents as mountains of ice, reaching altitudes of 10,000 feet, and dropping sea level 200 feet below its present level. The vast Laurentide Ice Sheet covered large parts of North America and Europe and glacial fronts advanced and retreated, marking a succession of ice ages separated by interglacials. The continents were arranged nearly as they are now, and at the moment, we enjoy an Eden-like interglacial that we think of as normal and take for granted. We imagine that it is our birthright.

The community of life here was vastly different. All of those geolog-

ical upheavals and their ecological consequences left us with life forms barely recognizable as the descendants of the survivors of those epic events. As we approach the present, we stand at the threshold of events that will span shorter lengths of linear time, in nearby locations. We can build a more nuanced picture of the world if we associate that timing with other pivotal events. For instance, a little over three million years ago, the African climate was entangled with the European part of the Laurentide Ice Sheet when "Lucy," a young Australopithecine woman, was living in the savannas of northern Africa. Knowledge of her existence is one of those pivotal events that help us build context, dovetailing other notable historical events with what is happening here, and helping us find our place in the broad sweep of human history.

Glaciers are known for crushing and grinding everything under them and moving the parts ahead of them to form moraines. Just

150,000 years ago, the Illinoian glacier advanced to within 25 miles of us—not quite a kiss, but ecologically bracing and titillating because they are powerful climate-altering entities. We were not crushed by all of that ice, but the severe climate so close to the glacial face left an imprint that we can recognize because it split a few species. Glaciers push things ahead of themselves, not only glacial debris, but all of the ecological zones with which we are familiar today: tundra, boreal forest, mixed forest, and temperate deciduous forest. All of those zones were pushed south, often well in advance of the glacial face, each filled with populations of interacting species, communities that moved with them.

At present, the gulf coast sits at a latitude of 30°N. As ecological zones were pushed south, the citizens of those communities were split, the eastern communities retreating, deep into Florida, the western ones into Mexico. There, living in different climates and separated for tens of thousands of years, some species differentiated into eastern and western variants. When the glaciers finally receded, the ecosystems trailed behind the white, glacial wall as it moved north again, like the very long train of a Royal bride, and the ecological zones that had been compressed, expanded like an accordion.

As the residents of those eastern and western refuges moved north, they encountered each other in the vicinity of the Mississippi River. During their isolation, eastern and western populations evolved independently and along different lines. On their reunion, some resolved the genetic differences they had accumulated, mated successfully, and merged, but others found the differences irreconcilable and split, remaining distinct, and leaving an imprint that can be seen today, most commonly noticed in birds. Eastern Meadowlarks, Eastern Bluebirds, and Eastern Kingbirds came from the Floridian peninsula. Western Meadowlarks, Western Kingbirds, and Western Bluebirds came out of Mexico; other species followed suit.

Climate is a product of temperature and precipitation, which are thoroughly entangled. Cold air can't hold as much water as warm air, so in spite of all that ice on the tundra, the precipitation amounts are typical of desert. Tundra gets about eight inches of precipitation per year—about the same as Phoenix, Arizona. That is important to us here, because the Brawley Creek watershed spent a lot of time as tundra, and the ecosystems that returned to us from the south require more precipitation. Higher temperatures are coupled with higher levels of precipitation that result in more productivity. They capture more energy, and they are richer and more diverse.

Today, deciduous trees dominate. Dry winds come to us out of the rain shadow of the Rockies. Grasslands that lie to our west dominate under dry conditions but as one moves east the grasses grow taller as low-pressure systems draw moisture from the Gulf of Mexico. The air masses mix and somewhere along the gradient, the increased precipitation allows the temperate deciduous forest to dominate. We live in that zone of transition.

We can track ecological changes over the last 50,000 years because a chain of springs along the Pomme de Terre River just 40 miles to our south has been excavated. In the bottoms of those springs, layers of pollen from wind fertilizing forms tell us of the plant communities, and the bones of animals who died at the springs are layered with them as though pressed between the pages of a book. The oldest levels date to 49,000 YBP†, and taken as a whole, they paint a remarkable picture of life here not so long ago. The dates identified in the following paragraphs hint at the ecosystem that could support those kinds of plants and animals at that time.

40,000 YBP: Had we had been living here then, Brawley Creek would have threaded through a deciduous forest much like today's but there were alligators of the same species (*Alligator mississippiensis*) that ranges into northern Arkansas today. They will no doubt expand their range to the north as the climate warms. We'd have hosted a woodland species of Mastodon (*Mammut americanum*) who stood nine feet at the shoulder and weighed five tons, and we would have seen the Great Bison (*Bison latifrons*), eight feet at the shoulder and over two tons, their horns spread as wide as those of a Texas longhorn and only slightly curved.

30,000 YBP: The glacier was advancing, and it became cooler and dryer, something like having western Minnesota come to visit, bringing its pine woodlands mixed with oak. As the glacier advanced fur-

† YBP is an acronym for "Years Before the Present." It is useful for large units of time, but we'll shift to the more precise Gregorian calendar when we encounter human activity. Then we will identify time as either C.E. (Current Era) or B.C.E. (Before Current Era)

ther, it became dryer still and grasslands expanded to the east. The new kids on the block included the huge Columbian Mammoth (*Mammuthus columbi*) with its great, curved tusks, taller and considerably heavier than the African Elephant of today. Mammoths were grazers of grasses and sedges, and their presence is consistent with advancing grasslands. There were Ground Sloths (*Glossotherium harlani*) weighing over a ton, and even a Woodland Musk Ox (*Symbos cavifrons*). The Great Bison was replaced by a smaller species (*Bison antiquus*), much more like our modern bison but still 25% larger. There were camels (*Camelops* sp.) and horses (*Equus* sp.), both of which originated in the Americas before migrating to Asia and Africa, where they became successful as their parent species became extinct.

20,000 YBP: The tongue of the most recent glacial advance pushed to the Des Moines River and it became still colder here. The springs show no activity, but with the passage of a few more thousand years, the face of the glacier was in retreat and the springs began to talk to us again. Spruce forest moved in, along with willows and cottonwood, suggesting the transition from tundra to boreal forest. The mastodons and ground sloths who had been pushed out by the cold, returned, and a Tapir (*Tapirus veroensis*) joined the fauna. The Giant Beaver (*Castoroides ohioensis*) lived here then; though at 250 pounds, he was closer to the size of Black Bear. Maybe he made a home on Brawley Creek. Camels and horses returned too, and there were llamas (*Lama* sp.)

We think of prairie with its Bison and Pronghorns, as the most widespread ecosystem here, but that grassland was very different. Much like the African veldt of today, it held a surprising collection of those ecological equivalents. The megafauna consisted of elephants—mammoths, mastodons, and others. North American horses filled the role of Zebras on the veldt. There was an American Cheetah, and an array of what I'd call super-predators in keeping with super-sized prey: an American Lion half-again the size of today's African Lion, Saber-toothed Cats weighing 600 pounds, and there were predators we are familiar with but scaled for the times: Dire Wolves were 25% larger than today's Gray Wolves, and a Short-faced Bear three times the size of our Grizzly. One would have wished for something more than a spear before stepping off the porch to walk the trails.

This was the ecosystem spread like a banquet before the Clovis people who arrived 13,300 YBP (also recorded as 11,300 B.C.E.), turning the Pleistocene into the Holocene. Most of the megafauna were lost in the extinctions that followed, prey species disappearing first, followed quickly by the predators dependent on them. Their smaller equivalents remain; Bison and Elk weathered that extinction event, along with Gray Wolves, Grizzly Bears, and Mountain Lions, only to be pushed out as Missouri was settled, and the maximum supportable size dropped again to the level of White-tailed Deer, Coyotes, and Bobcats. This is consistent with the pyramidal structure of populations dictated by The Rules.

The Clovis people were not the first humans in the Americas, but their presence coincides with the beginning of the megafaunal collapse when the face of the retreating glacier was only 500 miles from Brawley Creek. The landscape here, at that time, was "mixed grassland-pine-spruce," much like western Minnesota's grasslands in its northwestern quadrant. There is little doubt that the Clovis people spread quickly across North America at the beginning of the Holocene. Eighty percent of today's Native Americans are direct descendants of the Clovis People.

They were hunters of mammoths and mastodons but there were many other animals that we now consider large, that must have been easier prey: horses, camels, and llamas were widespread in the Americas at that time, and dart points from a Clovis tool cache uncovered in Colorado, carried traces of both horse and camel protein. The extinction of the vast and diverse megafauna, those herds of large, meaty, and naive animals, has long been attributed to the Clovis people whose power is thought to rest on mastery of the technology of the day. The now famous Clovis point, a knapped spear point invariably described as beautiful and elegant, was paired with an atlatl, a notched shaft of wood that functionally extended the length of the throwing arm. The combination allowed heavier projectiles to be thrown at higher speeds. They penetrated deeper into thick flesh and could be thrown from safer distances. Together, they permitted new hunting methods that coincided with the Pleistocene extinctions in the Americas. Some argue that climate change was the principal cause of this extinction event, but there is a pattern: the disappearance of large birds and mammals, took place in Australia (50,000 B.C.E.), in Madagascar (350 B.C.E.), and in New Zealand (1,300 C.E.). Those events all coincided

with the arrival of humans.

By 8,000 B.C.E., the face of the retreating glacier still covered Lake Superior, so while it was warming here in Missouri, it was still much colder than it is now. In North America, this time is recognized as the Archaic Period (8,000 - 1,000 B.C.E.) The Clovis culture had spread across the continent from west to east—an ironic and prescient expression of Manifest Destiny in reverse. They split into regional groups and like the species pushed into refugia by advancing glaciers, they adapted independently to those new environments, establishing customs and technologies suited to the ecosystems in which they lived. Hunter-gatherers tinkered with agriculture and became more sedentary, at least seasonally. Wild rice became a staple for natives of the upper Great Lakes region as they acquired harvesting and processing skills and built them into their culture. Inland groups favored corn, squash, and beans while the coastal cultures learned fishing and shelling appropriate to the ecology of estuaries. As the Clovis culture was expanding in the Americas, sheep were being domesticated in the Middle East, and Jericho was converting from a favored camping area into a settlement.

Brawley Creek holds artifacts of this great expansion. Many "arrowheads" have been taken from the creek by neighbors and friends and there seems no end to the supply. Our home is only three miles from the headwaters of Brawley Creek so there must have been favorable camp locations upstream—perhaps summering sites near those springs, which served people for many thousands of years.

The two "arrowheads" shown in Figure 4.6, were found during an hour or two of walking the gravel bars in the creek bed. Dr. Jeff Yelton, Professor of Anthropology, UCM enlightened me on just what we'd found. First, they are not arrowheads, they are dart points; darts that could be thrown with an atlatl. Bow and arrow technology didn't arrive in the New World until the seventh century C.E.

I can imagine a hunter discovering a core of weapons-grade chert in the Mississippian strata about 25 miles to our east. He hammered off a few flakes, evaluated them and began knapping the point in Figure 4.6 (right). Eventually it was brought to Brawley Creek where it was lost or discarded near the headwaters and buried for thousands of years. Brawley Creek, now cutting sharply into its banks, released the dart point into the creek to begin a short period of tumbling, wearing

of edges, and reburying. But on a particular day in April, after a storm, it lay on a gravel bar where it was found and admired. Now it rests in my office, sheltered and coddled. I wonder what its next adventure will be?

Shortly after the collapse of the Roman Empire, a culture of mound builders rose to prominence, reaching its highest level of development at a place we now know as Cahokia, Illinois. Just below the confluence of the Mississippi and Missouri Rivers, in its heyday it was an urban center with a population of 20-30,000; while across the pond, London boasted 45,000 residents. Mound builders left substantial constructions and one of their mounds can be seen at Carrolton, Missouri just fifty miles to our north. No doubt, hunting parties from that settlement ranged outward to Brawley Creek. The river cultures collapsed early in the 13th century—about the time King John signed the Magna Carta.

Early in the 16th century North America began to feel the impact of Europeans. Cortez invaded Mexico in 1519 and repatriated the descendants of our Pleistocene horses as a part of the military technology of the day. They became a valuable commodity wherever they were taken, and they provided a quantum leap in the mobility of the Native Americans, particularly valuable for the tribes of the plains. With their speed and range, horses enabled hunters to travel with the buffalo herds and to ride among them to make their kills. Paired with the bow and arrow, the adoption of horses transformed the Plains Indians into powerful nations. We think of that time as the Golden Age of the Native Americans, and we are inclined to suppose that kind of culture extended into the distant past, but in fact it lasted little more than two centuries.

In 1541 Hernando De Soto traveled the lower Mississippi regions, leaving a trail of measles and smallpox that decimated Native populations. His entourage traveled with a herd of pigs, some of which escaped to become the wild hogs now abundant across the southeast and currently expanding into Missouri.

In 1673, just forty-five years after the founding of the Massachusetts Bay Colony, and 150 years after Cortez' entry into Mexico, Jacques Marquette (a Jesuit missionary) and Louis Jolliet (an explorer and fur trader) worked their way south along the Mississippi River in search of the mouth of the Mississippi. And they made First Contact

4.6 Dart points found in Brawley Creek. Left: ~ 3X. From the Middle Archaic Period (5,000-3,000 B.C.E.), the point has been broken off by impact. Right: ~ 2X This point is more recent, typical of the Late Archaic Period (3,000-1,000 B.C.E.) The chert from which it was fashioned has unusual freckling and banding that matches the Chouteau chert occurring in an outcropping of Mississippian limestone 25 miles to our east.

with the Osage people who lived on land that includes Brawley Creek. At that time, the Osage were adjusting to a new technology—horses had made their way north from Mexico and they permitted extended forays into the prairie to hunt buffalo. When we imagine restoring the land to its "original condition," this is the time that we seize upon as its Golden Age. But a longer view raises a pertinent question. Which original condition?

Restoring the ecosystem of a time before human impact is a fantasy. Not only is it arbitrary, it's impossible, as we would be unable to summon forth extinct animals. We can, however, simulate a time where the landscape appears much as it did before the arrival of European settlers by planting native grasses mixed with herbaceous flowering plants collectively called forbs; a very useful term. We will need to simulate the impact of the Native peoples with frequent burns, and by reintroducing some of the fauna, like bison. What we can construct in this way is a pale experience, essentially a living museum exhibit—still valuable but artificial in the way of a wildlife park. The most visible parts are there, but the diverse supporting ecosystem is not. Even so, even a few acres of prairie grasses and the most common forbs of that day provide an eye-opening experience, and we can begin to understand its impact on the first Europeans who were stunned by landscapes unlike anything in their experience. They saw it as untouched wilderness, but the Native populations had been shaping it for thousands of years.

Williams (2001) suggests that, "The general consequence of the Indian occupation of the New World was to replace forested land with grassland or, where the forest persisted, to open it up and free it from underbrush. … Conversely, almost wherever Europeans went, forests followed. The Great American Forest may be more a product of settlement, than a victim of it." And so it has been, here.

At the time of First Contact, western Missouri south of the Missouri River was occupied by the Osage. Following the Louisiana Purchase in 1803 and the epic foray of Lewis and Clark (1804 to 1806), the General Land Office (GLO) was tasked with selling parcels to settlers to recover the purchase price. But in order to sell land, it had to be surveyed—a staggering task. Surveying crews walked every section line[†] and their work remains the foundation of property descriptions on deeds today. The surveyors made observations about the character of

the land at every intersection, one mile at a time, producing a massive archive from which Walter Schroeder (1982) assessed the nature of the plant cover described at each intersection, and cobbled together a presettlement map of Missouri from which Figure 4.7 was extracted.

Sixty-one percent of our region (Johnson County) was prairie then, with strings of forest, particularly along streams. Tall grass prairie to our west graded into the Ozarks that sustained a forest largely free of the dense underbrush we see today. The Osage used fire to clear land and manage game, and the impact was so pervasive that their actions changed the character of the land they tended for centuries.

There was a lot of burning. Burning improved the productivity of the community, or at least it favored those parts of the community that supported the native peoples. Fires triggered by lightning are most likely in late summer, but spring was the best time for burning to improve foraging. Reading burn scars on the trunks of old trees tells a story of widespread burning that can discriminate between natural, summer/fall burns and spring burns.

It is now clear that the eastward reach of the prairie was enhanced by regular burning. An area the size of the Ozark Plateau (50,000 square miles) was burned every 21 years, the time between fires averaged just over 5 years. Clearly, the prairie and much of the Ozarks looked like they did because the land was altered by the Osage who engaged in farming and ranching in a minimalist way.

On the day after Christmas in 1820, a Mr. Thurston and his surveying crew were following an imaginary section line within Range 26 West and Township 45 North, and they stopped at the intersection of two section lines, about a half mile downstream from us, marked the spot, and he jotted down a few words (Figure 4.8). He found, "A brook 11 links wide (7 feet) flowing NW" into the prairie, the first record of what is now called Brawley Creek; he must have looked about and then written, "Land rolling prairie—second-rate."

One might ask "second-rate" for what? GLO Notes, for prospective buyers, were something of an old Sears Roebuck "wish-catalog" without the pictures. The survey was made to sell land, and they were de-

[†] A section of land is one square mile (640 acres). The GLO surveyors traveled every section line—every boundary of this checkerboard design—marked their intersections, and took notes at each. Those brief descriptions can be accessed online as GLO Notes.

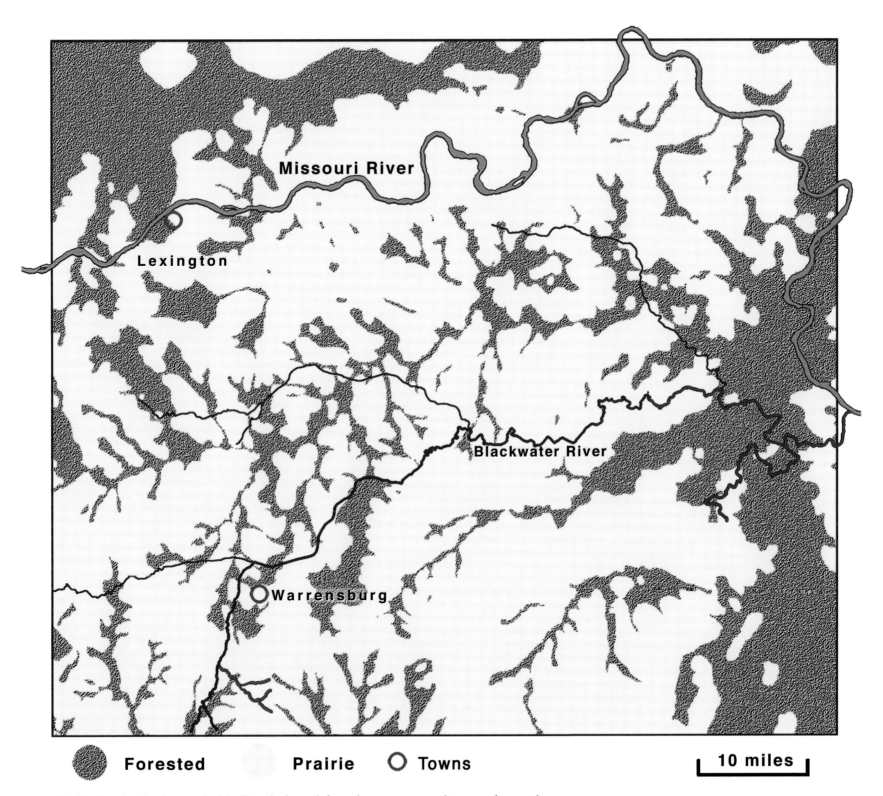

Missouri River

Lexington

Blackwater River

○ **Warrensburg**

● **Forested** **Prairie** ○ **Towns**

|__ **10 miles** __|

4.7 The Brawley Creek watershed (red) in the lower left quadrant appears on this map of pre-settlement prairie based on Schroeder's work, covering over 4,000 square miles of west-central Missouri.

scribing the product for prospective buyers, suggesting resources they might have at their disposal. Notes on nearby intersections reported "hickory and oak" or "thinly timbered with hickory, walnut, elm, and oak" and on occasion Black Jack Oak, Sycamore, and even grape vines. Because the settlers made nearly everything with wood—houses, tools, and eating utensils, and they burned wood to heat their houses, and cook—this was key information, along with a description of any water resources.

That world was very different from the one in which we live. The grid of imaginary lines projected onto the land, tacked down by surveyors, and now etched into it, has imposed our idea of civilization. We make straight lines where there are none—only spiders and humans make straight lines—but our straight lines become roads, dictate fencerows, and guide plows. The consequences of branding the skin of the earth in this way are obvious when seen from an airplane.

We drew these lines with little regard for the natural boundaries that separate ecosystems—watersheds, and ridges. Our efficient system of numbered and mostly straight roads further subordinate natural features. Motorized vehicles now allow us to climb ridges and cross rivers without our noticing them. This infrastructure is yet another extension of our cocoons.

Arriving settlers knew them all intimately, impediments to the traveler, but resources to the settled. Living things depend on water as much as energy, and streams are the core of the watershed in more ways than one, and the key player in determining which kind of ecological community will prosper. The prairie distribution map in Figure 4.7 doesn't adequately communicate this view, so I've prepared Figure 4.9, to suggest what confronted John T. Marr, when he stepped off the river boat in Lexington, Missouri about 1831, assembled supplies, and set out across the vast, rolling hills of un-marked prairie to establish a homestead. He followed an ancient path, then recognized as the Osage Trail, along a ridge of Warrensburg Sandstone laid down during the Pennsylvanian period, to arrive at Brawley Creek where he staked a claim, just across a gravel road from where we now live. That happened

4.8 Mr. Thurston's notes on crossing Brawley Creek.

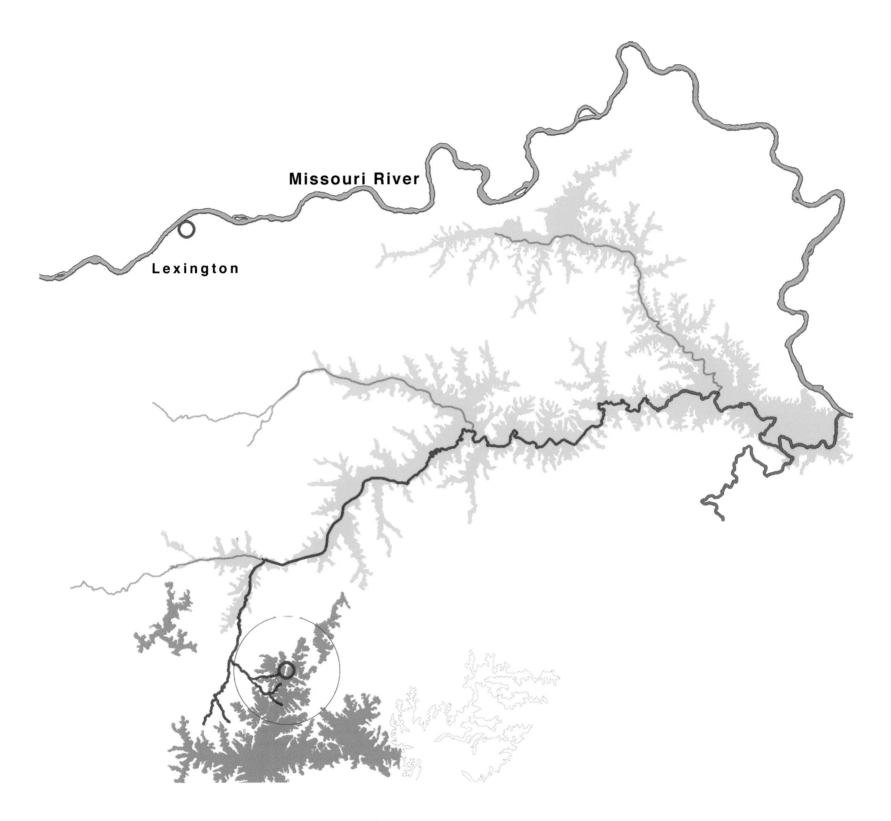

4.9 This map duplicates Figure 4.7, but it is uncluttered to suggest the sense of emptiness that a settler might have felt in 1830. No roads, no towns, no neighbors. Green identifies land below 700 feet elevation, brown (mapped in the vicinity of Brawley Creek), indicates elevations over 900 feet. The origin of Brawley Creek, at the tip of an insignificant watershed, is marked by concentric, red circles.

during the presidency of Andrew Jackson.

John Marr was among the first residents of the county. In 1833 Martin Warren set up his blacksmith shop along the Osage trail just south of the Blackwater. His location served travelers like an old time Quick Trip, and Warrensburg grew around him. By 1836, Marr had "possessed and cultivated" his homestead as stipulated in Preemption Act of 1830, and he filed on 80 acres, paying the going rate of $1.25 an acre.

The next year (1837) John Deere introduced his "Sod Buster" plow; a plow with a polished iron moldboard that permitted a settler to turn the incredibly dense prairie sod, effectively precipitating the end of prairie. Subsequent purchases of contiguous land by John Marr and his sons built a holding of 320 acres on Brawley Creek. In later years, they drove their hogs and cattle to market in Lexington by going back over the Osage trail, which soon became the Lexington Trail. Today we know it as Route 13.

We are fortunate that George R. Marr (1860-1942), the grandson of John T. Marr, spent his childhood during the 1860s and 1870s on our section of Brawley Creek, and that he shared his recollections in an interview with the local paper—The Daily Star Journal—in 1932. His observations are consistent with the conclusions of researchers, but more intimate. It is a place that we can scarcely recognize.

About prairie: *"When [John Marr] settled here, there were brush patches along the creeks and in or near these, the settlers located their homes. Their claims were broken and planted and all the rest of the land was left as range land. In the years following the first settlements, much of this range land grew into woods. … How this timber came to take the prairies has not been settled. Probably before the settlers came the Indian fires every year killed out all timber seedlings. The settlers did all in their power to prevent these annual fires. Protected for a few years these seedlings soon became saplings and grew so dense the prairie grass was killed out."*

About the water: *"The small streams that used to flow through the prairies … were hardly noticeable. The water was clear and holes generally only a few feet wide and forty to fifty yards long and deep enough to swim a horse. These narrow deep pools were full of fish and wild animals came to them for water. … As the prairies were broken and put into cultivation these streams soon became full of washed soil and today some of them are being plowed over by farmers who never guess that their corn and wheat are growing over places were fishing and swimming used to be good."*

In these paragraphs, Mr. Marr addresses the key ecological changes that came with settlement. The first paragraph illuminates the disappearance of the prairie and all of its diversity, attributable to new plow technology. All of that ecological diversity has been replaced with monocultures of soybeans, corn, and fescue pastures. Less than one tenth of one percent of the original prairie remains. If the land wasn't plowed or grazed, it reverted to woodland.

In the second paragraph Mr. Marr describes a system of waterways foreign to us. In addition to our plowed fields, we've increased the amount of arable land by systematically eliminating wetlands. Swale is a word that doesn't find much use today because they have been all but eliminated. All across the eastern United States—especially in the glaciated areas of Missouri, Iowa, Illinois, Indiana, and Ohio—streams and rivers, including the Blackwater, were "straightened" before the Dust Bowl arrived.

Water still flows in our waterways, but a much larger proportion of our precipitation quickly leaves our communities, channeled downstream in canyon-like stream beds. That was our intent. Ecologically priceless and very productive, these wetlands with their deep pools and clear water were seen as economically worthless.

5.1 An elm sapling is slowly swallowing a very old T-post along with a few strands of barbed wire that mark our property line. If the elm lives long enough, it will engulf the whole post. The property we think of as Brawley Creek fell under our administration around 1980. The T-posts were probably set before 1940 and haven't aged noticeably during our forty-year tenure.

5

Brawley Creek Today

"But that ball, though, it keeps on bouncin'… the ball keeps on bouncin'."

~ Charlie Wilson in "Charlie Wilson's War" (2007)

Geological history is punctuated by events that, in hindsight, we decide are important enough to separate into a time Before and a time After. The hallmark of a new period is that it makes tracks in the geology of the planet. Often, the forces that make those changes alter climate and are accompanied by a major extinction event. The Cretaceous Period ended, and the Tertiary Period began 66 million years ago with a major extinction event precipitated by the impact of a massive extraterrestrial body that left a thin layer of iridium marking the end of the Age of Dinosaurs. On a less apocalyptic scale, the Pleistocene Epoch transitioned into the Holocene about 11,300 B.C.E. As the Clovis people spread across North America, the geological impact created was minimal, but their activities fell on the heels of a retreating glacier that left such marks.

Recently, we've entered the Anthropocene Epoch, marked once again by a significant alteration of the geology and ecology of the earth, this time by a thin layer of isotopes generated by nuclear testing, and we've triggered a new wave of extinctions that we're watching in real time. It wasn't the nuclear devices that provoked the new extinctions, they were set into motion centuries ago when we learned to tap into archived solar energy and began using coal as a substitute for the power of wind, water, and muscle. We chafed at the limits on our solar energy allowance, and by learning to tap into fossil energy we obtained the combination to the vault. Thomas Newcomen demonstrated that access by building a coal-powered water pump in 1720. It was a little thing but, commonplace among physical processes, it grew exponentially and the energy from

this vault has fueled our exponential growth ever since. Now, after three centuries of incubation, the Anthropocene is born.

We've set about releasing genies on an industrial scale, and we've developed something of an addiction to massive projects because we have a genie to do the heavy lifting. The effects are global, but they make themselves felt here at Brawley Creek.

The shape of our land today has come about from the convergence of several forces. Settlers flooded into the land acquired by the Louisiana Purchase. Our predecessors applied agricultural methods developed in areas with different ecologies, and they increasingly made use of technological advances as they became available, particularly those that allowed them to manipulate waterways and turn the soil. We can look at those advances individually, but of course all of them are always interacting to create the world we live in.

As humans of European origin crept out onto the fringes of the prairies, we applied our mechanized technology. The manufacture of the Sod Buster plow with its polished steel moldboard ultimately permitted European settlers to turn prairie into cropland. That alteration produced far-reaching ecological consequences that dramatically increased our ability to extract resources from the ecosystem to support ourselves. As inveterate consumers, we are entitled but we extract a lot, not only enough for ourselves but enough to create the large surpluses required of the dollar economy.

At the beginning of the 20th century, the world view of our culture, viewed the land as in need of improvement, and with the growing power to impose that view, we began to tinker with the land intentionally in many ways. One of those was reshaping waterways.

In 1909, the Blackwater Drainage District No. 1 was formed and bids were let to move 1.25 million cubic yards of earth, "to drain and redeem 25,000 acres of land," and to straighten the river. Apparently, crooked streams were imperfect and could benefit from being straightened. George Marr's recollections echoed the sentiment of the day when he spoke of "subduing the forests and wild prairies and making this country wonderfully blest." By 1918, 27 miles of ditch and lat-

erals had been excavated from the bed of Blackwater River near Warrensburg. It drained wetlands, straightened waterways, and shaped them, "…the way God would have done it, if He'd had the money."†

The point of ditching operations—channelization—is to drain wetlands so that land could be used for row crops. Ditching was fashionable then. Nearly a quarter of Illinois was wetland before ditching and straightening, with similar proportions in Iowa and Missouri. The midwestern states embraced the idea so thoroughly that draining virtually every wetland was seen as profitable. Here in Missouri, most streams and rivers north of the Ozarks have been channelized, and contiguous states with large areas of prairie have been similarly modified. Wetlands are an important facet of prairie, but seeing those once ubiquitous wetlands is a rare thing today because they have been largely replaced with row crops. One would think that ditching the Blackwater 100 years ago would be relegated to the past, but the impact has been substantial and continuous, reinforcing one of the central ideas of ecology—that everything is connected.

A foundational rule of ecology (and all complex systems) was put forward by ecologist Garrett Hardin in just seven words, "We can never do merely one thing." We are ever alert to trumpet the immediate benefits of some project or technology without asking the next, and possibly more important question that has just three words, "…and then what?" The ball does keep on bouncin'.

Our collective attempts to revise the environment began much, much earlier—long before Thomas Newcomen. It began with the invention of agriculture, expanded with the development of irrigation, and advanced into ditching—irrigation in reverse—using ditches to remove water from croplands. Changes like these are driven by economics, seeking growth by bending the environment in such a way as to maximize profit. With our powerful machines, we do a lot of bending.

As terrestrials, we understand a lot about living on the land, but we are less familiar with riverine systems. They are more active than most people think, so a little primer is in order. A river has two pairs of banks. The inner pair fit well with picturesque sitting on the river bank, fishin'. These inner banks are the first land to be submerged as the river "surges out of its banks." But there are also a pair of outer banks that mark the edges of floodplains. Rarely noticed, they are conceptually

† This phrase originated with George Bernard Shaw on his visit to San Simeone in 1933. It has subsequently been attached to many organizations—most particularly to the Army Corps of Engineers, who performed most of the waterway modifications in the 20th century.

5.2 The active bed of the Mississippi River (1944) is shown in blue, suspended over a crazy quilt of its former lives. The map covers about 500 square miles of floodplain; the green triangle in the lower left corner marks the outer bank of that floodplain.

important. A floodplain is the area of dry land between the inner and outer banks, and they are integral to the functioning of rivers.

Floodplains are like guest rooms that sit empty most of the time; they are no less a part of the house because they are used only occasionally. Both provide for expansion when the need arises. The notion that a river has surged "out of its banks" says only that we don't understand rivers—a river in flood is using the land that it has shaped for that purpose. In undisturbed systems the river often reclaims its floodplain in the spring. They are ecologically rich and productive, but for their flooding, they'd make good cropland. The hitch is that flooding is integral to their fertility. Each year as the flood waters spread over the land, they slow, and drop nutrient-laden sediments from upstream ecosystems—nutrients that would otherwise escape downstream. Flooding also allows the recharging of springs that help to sustain the flow of water through the dry summer and minimizes the level of downstream flooding. Floodplains are enriched by flooding.

Rivers build their floodplains over countless millennia, forming a rich chain of wetlands—marshes, sloughs, swales, and wet meadows—connected by creeks in their upper reaches. These wetlands are pearls along the strand of connecting pools and riffles described by George Marr. Wetlands serve all aquatic life forms directly and all the rest of us indirectly.

Streams meander in their floodplains, leading to their undeviating flatness. On the scale of centuries, they swing back and forth, flopping about like a restless sleeper. Figure 5.2 shows the lower Mississippi floodplain near Greenville, Mississippi. The 1944 channel appears over a background of many older channels. Every square foot of the floodplain has taken its turn in the main channel.

Meanders like these form through purely physical forces. When a river turns, the distance along the outside of the curve is longer than the distance along the inside margin. As a consequence, water moves faster along the outside curve—necessarily. A marching band turning a corner demonstrates the same phenomenon, as the outside column must scurry to keep up while the pivot advances slowly.

Faster water carries more energy and cuts more effectively so that the outside bank erodes more quickly than the inside bank. In fact, the fragments cut from the outside bank, carried downstream, eventually find themselves along the inside edge of a curve where the slowed wa-

ter drops them, building gravel, sand, or silt bars, depending on the speed of the current.

The constant cutting on the outside curve and depositing on the inside is what makes rivers meander, and eventually they fold back on themselves until they cut through the narrow neck of land that separates them. Figure 5.2 illustrates this phenomenon. The river breaks though the neck, to take a short cut to a lower elevation, and the former main channel is retired from the flow except during flooding. It now becomes as an oxbow lake—with its crescent shape. The large loop of the Mississippi was not entirely cut off on the upstream end by 1944 when the map was made, but now, ~75 years later, the connections to the main channel are closed at both ends, creating Lake Chicot.

A hundred years after the ditching of the Blackwater River, we can address the question, "…and what then?" The aftereffects are substantial and they will continue unfolding for centuries. A Sorcerer's Apprentice—personifying those physical forces—has been set to deepening and widening the ditch and inevitably, to accelerate erosion upstream, and there is no wizard to stop it. The meandering bed of the Blackwater River is seen in Figure 5.3. It was formed by the physics of cutting and depositing as described, which is a property of waterways, so its channel meandered in its floodplain and followed a course characteristic of unaltered waterways.

The consequences of that ditching adventure are far reaching. They should have been evident before the first shovel broke ground, had anybody asked those three little words. The labor-intensive phase—the actual digging of the ditch—is the trigger for what follows. Before the machinery can be put to work elsewhere, those consequences have already begun. Within the ditched section, those consequences follow on the simple truth that a straight line is the shortest distance between two points. As applied to streams, straightening and shortening are inseparable. A 27-mile ditch replaced 72 miles of stream—a 60% loss. The river now produces about 60% fewer fish due to the loss of habitat alone, with equivalent declines in all of the other services a river provides, like water purification. And the quality of the active channel is degraded.

The starting and ending elevations are unaffected by shortening the distance between them so the grade has become steeper. The original drop of one foot per mile has been increased to 2.3 feet per mile, accel-

erating the flow of water so that it drains from the watershed faster and floods less in the ditched area as promised. But faster water cuts more quickly and accelerates erosion of the banks. Every rivulet draining the newly valuable fields along the ditch begins gnawing into them, creating gullies that grow longer, wider, and deeper.

The higher transient rate of flow also affects the waterway downstream and upstream from the ditch. Downstream the unnatural rate of flow overwhelms unmodified streams, bringing more frequent and more severe flooding, decreasing the agricultural value of those floodplains. Further downstream, flood waters from feeder streams, many of them channelized, add their excesses, first to the Missouri and then the Mississippi, creating flood crests that compound as they advance on river settlements. This outcome is of particular significance in St. Louis where the Missouri and Mississippi Rivers combine. Levees are required to protect towns built in the floodplain, and when there are levees on both sides of a river, they create a choke point, raising the already flooding river upstream and increasing pressure on the levees.

Upstream, the effects are less intuitive, but they have significantly altered the landscape of every feeder stream. Natural waterways are tree-like with their many branches, branchlets, and twigs. We live near the tip of our twig on Brawley Creek, 10 miles above the head of the ditch—that place the earthmoving machines ended their upstream advance. That's 7 miles up the Post Oak, and 3 more miles up Brawley Creek. Those effects are prominent here and they arrive through headcutting. When the last bucket of stream bed is hoisted, a small waterfall remains—it lacks the support of bedrock that stabilizes most waterfalls, and the flowing water begins cutting at the head of the ditch. That marks the second phase of ditching; it is labor-free and driven solely by natural forces. Headcutting continues indefinitely, advancing to the tip of every twig.

That Sorcerer's Apprentice keeps deepening and widening every tributary and every drainage that leads into them. The effect on Brawley Creek is seen in Figure 5.4, a cross-sectional representation of the stream bed near our house. The wave of headcutting in the main channel is long past us, having made its mark by dropping the stream bed at least 8 feet. We know the shape and elevation of a former creek bed because it lies abandoned, atop the old floodplain just a few yards from the current channel—like a dry oxbow. That old channel holds the trail seen on the opening page of the preface.

In this Figure, the flow of the creek between rains is shown in blue; its cross-sectional area is four square feet. That fills the current creek bed as shown, and also shows how it would have appeared in the old

5.3 The red line identifies 7 miles of ditch, a few miles northeast of Warrensburg, which has replaced 17 miles of the undisturbed Blackwater River (in blue.)

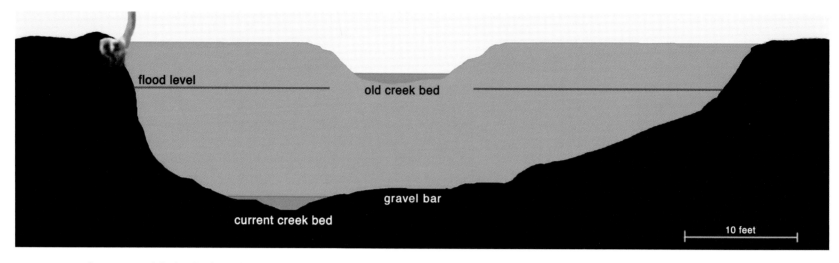

5.4 Former and current creek beds. The flow of Brawley Creek in the present creek bed is shown in blue at its normal level. Frequent "floods" raise the water level to the red line, but the water is confined to its narrow canyon and can't spread onto its old flood plain and work its magic the way it used to when it flowed in the old creek bed.

creek bed. A red line marks the level of flooding that occurs frequently; the gray area marks lost soil—floodplain soil that has washed downstream where it helped to expand the Mississippi delta. The creek continues to cut deeper, but more slowly now because it has reached the bedrock of Pennsylvanian-aged sandstone and shale. It is meandering as best it can, within the confines of such a narrow ditch, constantly making the channel wider, cutting into the banks of its now tiny floodplain and widening it. Knowing the endless meandering of waterways of all sizes unless blocked in some way, that tiny floodplain can be expected to widen until much of the old floodplain has been moved downstream. The photograph in Figure 5.5 shows the creek at the point where the cross-section measurements were taken—right by the undercut Sycamore on the left bank, its twisted features seen in detail in Figure 5.6 . Currently, the stream is cutting on the left and depositing its sediment load on the gravel bar on the right.

For the last 40 years, we've watched the tortured Sycamore perched on the creek's bank, appearing as an icon in Figure 5.4, and in the photographs in Figure 5.5 and 5.6. Sycamores often send up suckers from the base of parent trees that are dying as seen here. Those fragile looking shoots, with only a few leaves between them, could grow into mature trees like their parent. The large, gnarled opening at the base of the

trunk marks the position of an earlier trunk, now rotted, fallen, and washed downstream. A second trunk growing from the root mass managed to reach to the canopy, but now it too has died. The tiny suckers barely visible could be a new set of twins like the pair seen in the preface, now just at the outset of creating a third clone atop the old root system. But it is not going to happen because of continued bank erosion.

The consequences of that ditch, dug over a hundred years ago, explain much of what can be seen on a creek walk. Masses of tree roots and the dense, fibrous roots of brush and grasses create a marvelously, tough and tangled complex that reinforces the bank, but it is something of a Maginot Line—nearly impervious to direct assault but easily bypassed. The trees have no defense against undercutting—likely it was not important in their evolutionary experience. But below the level of stout tree roots, and below those fibrous rootlets, the bank is unprotected and vulnerable to erosion. The rate at which the bank erodes depends on the hardness of the substrate and the velocity of the water, which in turn determines the amount of silt or sand that it carries. Rotting Pennsylvanian sandstone releases a hard grit that sandblasts the downstream banks. Stream-side roots are scoured clean of soil, the trees begin to lean, and the sod that remains around their roots

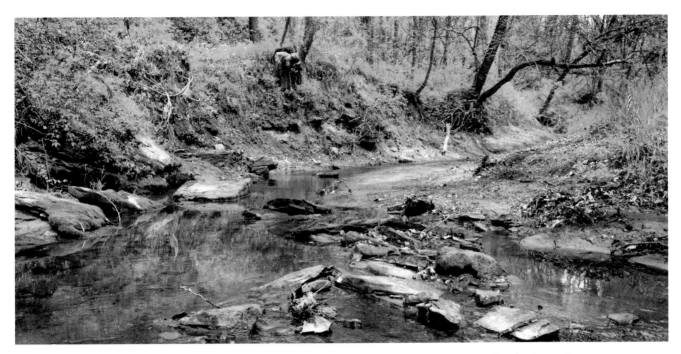

5.5 A photograph of the section of Brawley Creek diagrammed in Figure 5.4. The stream cuts into and under the weakest layers of bedrock, freeze/thaw cycles eventually cleave the layers, and large slabs of sandstone lose their support and drop into the creek bed.

begins to sag. After a sizable rainfall, the fast-moving water reaches high above normal levels, but the channel is now too deep for the floodplain to serve its function. Eventually the trees along the bank fall into the creek, taking with them what is left of their root balls. The leaning Walnut upstream from the Sycamore in Figure 5.5 will soon become one of them. Dislodged trees become battering rams, their branches and root stubs gouging the soft walls of the canyon. One by one, trees standing along the margin topple into the creek bed along its entire length, as predictable and unstoppable as a column of falling dominoes.

Missouri, Iowa, and Ohio are among the most heavily channelized regions in the country. Growing up in Ohio, my experience was with deep river channels that I assumed were natural. Still, I wondered how the indigenous people camped along such streams and made use of the muddy water flowing in them.

Well, they didn't. Figure 5.8 shows an oxbow on the old Post Oak Creek. The little pond lies just west of the ditch but it still holds water because the ditching operation blocked both entrance and exit, spar-

5.6 The iconic Sycamore.

ing it from the erosion suffered in the main channel of the Post Oak. The oxbow holds water at its undisturbed level while the muddy water in the main channel slides past, 20 feet lower than the water level in the oxbow. This bucolic scene opens a window to the past—before the ditching. It looks like a good place to camp. It would be even better if the water was "live"—part of a flowing stream fed by clean water that had percolated through an abundance of upstream wetlands.

With the ditching barely completed and its aftermath still in progress, the consequences of a different ecological intervention made itself felt. The second intervention wasn't a planned, goal-driven, industrial process—it was the impact of hundreds of farmers plowing their fields to grow crops, a seemingly benign action begun some 90 years before with the introduction of the Sod Buster plow. The plowing stripped the perennial grasses and forbs from the land. Their incredibly tangled, tough, and fibrous root systems were the source of its fertility and its anchor as well. The richness of prairie soil comes about through

5.7 Sycamores along the margin of the old stream have had an easier life. These are "the twins," from the figure in the Preface; the gap between them reveals the position of a parent tree now long gone. They too, lived on the bank of Brawley Creek, but they were protected by a functional floodplain.

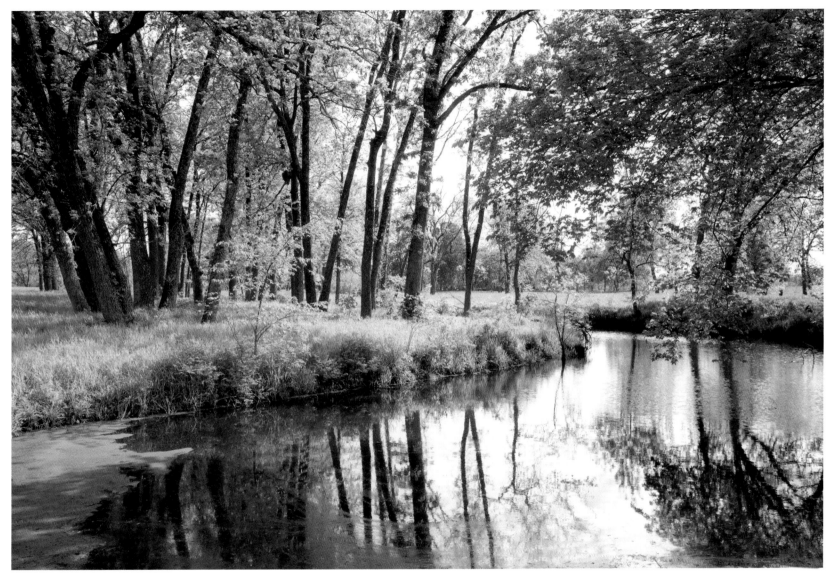

5.8 An oxbow in the old channel of Post Oak Creek can be seen just west of Warrensburg. Several miles downstream from us, it suggests what the creek looked like before the ditching.

the deep and regular fertilization of the soil over millennia by the death and regrowth of vast systems of roots and rootlets. That soil supported countless generations of nitrogen-fixing plants and a thriving community of decomposers. Now the prairie is gone like the wetlands.

This is a windy part of the world. It was obvious to all that the grasses fed the bison (and latter cattle), but the role of that dense prairie vegetation in anchoring the soil didn't register. The need to keep the ground from flying off was a novel idea for newcomers, and as we applied the techniques learned further east with row crops, they were problematic in these dry and windy lands. Turning over the prairie terminated both the enriching and anchoring benefits. The heat and severe droughts of the '30s produced the Dust Bowl. In congressional hearings, the ditching we've explored was identified by Assistant Secretary of the Interior Nathanial Reed as an, "… aquatic version of the dust-bowl disaster," so the plowing and ditching were an ecological one-two punch. Brawley Creek took them both.

Figure 5.9 shows the 30 acres of land along Brawley Creek—technically, along the North Fork of Brawley Creek—of which we are the current custodians. A careful eye can trace the location of the creek itself by the furrow in the canopy. This is now a very different from that land claimed by the Marr family—changes initiated by manipulating waterways and always changing land use practices. But even before all that, all along the eastern edge of the Great Plains, prairie must be maintained, or it converts to woodland. While they are cycling, ecological communities are also changing in linear time. They undergo succession, another seemingly random process that proceeds in an orderly and largely predictable fashion. The factors that drive succession are the same around the world, but the species involved vary greatly. But trees invade grasslands, grasslands do not invade forests, and all that happens is the playing out of the Rules of the Game and its corollaries. Anyone who has noticed that a field has become "overgrown" or watched a bare patch of ground turn to "weeds" has seen it happen. We've blocked succession here to retain and distribute open spaces and edge. The arrangement seen in Figure 5.9 is the way it is only because we've chosen to encourage diversity. We haven't used fire—the historical method—instead we've mowed those places along with a series of access trails; otherwise the entire 30 acres would be forested.

Except for fossils and dart points, the oldest visual record of the history of Brawley Creek is an aerial photograph taken mid-afternoon on October 7, 1940, and accessed through the National Archives. A small segment of that photograph is reproduced in Figure 5.10 showing these 30 acres as they appeared then. The resolution of the image is remarkable. The original photograph covered 9 square miles, arriving on my desktop as 6.5 million pixels, with surprising detail for the films of the day. I needed only 0.05% of them, and of course the resolution is never high enough, but a surprising amount of information can be extracted to reveal something of the character of that savanna-like landscape. The ditching of the Blackwater River had been completed over 20 years earlier, and the Dust Bowl had been in progress for 10 years—ending shortly after this photograph was taken.

Our 30 acres were acquired in three 10-acre strips—each a quarter mile long (east to west), and a sixteenth of a mile wide. Each section was used differently in 1940 and some conclusions follow easily. The northern third was savanna-like with scattered trees and the creek. Its advance into woodland was restrained by livestock rather than fire. The middle third holds the stubble of a harvested crop that was fenced, and the southern third has a small ridge that was pasture.

The livestock grazed everywhere, except for a fenced crop. Their hooves incised paths as they funneled through a gate at the northeast corner of the fenced field. The assaults on the creek bed were several. The ditching, and the Dust Bowl have had their effects, of course, but before them, we know that the Marr family ran cattle and hogs, certainly before the use of barbed wire, so one would not be surprised by the trampled stream margins seen here. The extended drought of the Dust Bowl exacerbated the earlier damage by forcing overgrazing.

There is more detail to extract. A dark, irregular patch in the crop field at its northwest corner suggests moisture. There is a crescent shape that was once an oxbow lying just beneath the bottom of the "North" arrow; a second, much less obvious oxbow lies just outside the northeast corner of the property; and the eye-catching oxbow-in-progress in the main stream nearby. The old oxbows in the floodplain sound like the sorts of places, perhaps the exact places, George Marr referred to when he said, "…these streams soon became full of washed soil and today some of them are being plowed over by farmers who never guess that their corn and wheat are growing over places were fishing and swimming used to be good."

The photograph is consistent with our observation that the middle strip was largely floodplain associated with a swale. Even now, parts of it remain wet long after the rest has dried. I suspect that the history of meandering left multiple overlapping and interwoven deposits of sand and gravel beneath the surface that serve as conduits and reservoirs of groundwater. It would explain why the meadow has a patchy distribution of wet places that persist.

That tiny smudge of gray, just 15-20 pixels in varying shades, located on the fence-line near the southeast corner, in a whisker draw, provides enough information to learn a good deal about it. It marks a tree that is still there and one that we can find. It is a Pin Oak with a circumference of nearly nine feet at breast height. For a Pin Oak that trunk diameter-at-breast-height (dbh) permits an imprecise estimate of its age—101 years. That estimate suggests that it germinated in 1920, and it was 20 years old at the time of the photograph. Most of the trees are not recognizable individually, but surviving trees can be recog-

5.9 Our part of the Brawley Creek watershed as it appears now. In 1980, the upper (northern) third was forested, the middle third was a hayfield until 1985, and the lower third was heavily grazed until 2000.

5.10 Brawley Creek, October 7, 1940. This photograph records the land after 100 years of farming with the most recent 10 years of Dust Bowl drought. The added contour intervals mark elevation increments at 10 feet.

nized and identified. Their ages tell us something about those overlapping, dark splotches on the photograph. Many of them have died of natural causes over the last 80 years, especially elms. Marketable walnut trees were harvested once, before 1980, removing a portion of the canopy that appeared in the 1940 photograph, and the creek has meandered, toppling trees along its banks. Still, we can extract an infor-

mative picture of the community at that time, summarized in Figure 5.11. It shows the location of trees 90 years of age† or older, that would

† Ages of the trees were estimated from their circumference at breast height, and multiplied by published "growth factors" that estimate the average rate of growth for various species. It is imprecise but useful.

5.11 A partial reconstruction of the tree cover, scaled to duplicate the facing page, with the background softened. White circles with white numerals give the average age of trees with daughter trunks. Black numerals indicate the number of trunks if there are more than two.

have been at least 20 years old when the photograph was taken. So, in 1940, the wooded area was of a mix of several kinds of oaks, Honey Locust, Sycamore, Black Walnut, along with Hedge, of course.

The most abundant tree is Hedge—Osage Orange. Hedges typically grow multiple trunks like the one in Figure 5.12, that frequently coalesce into a single massive trunk. Estimating the age of such trees is problematic, but their shapes tell us the story of their early years, proving that they grew up in the open—with full exposure to sunlight. They are easily recognized by their low spreading branches that announce that their formative years were in the open. But with the canopy now towering over them, those wide lateral branches are unable to make a profit and they are sacrificed in the way that most trees drop "dead

wood." But the wood of Hedge is so hard and resistant to decay that whole branches remain attached long after they have died, and they are so heavy that they sometimes split the trunks apart as if struck by a giant maul (Figure 5.13.)

I've used two symbols in Figure 5.11 to distinguish Hedge trees. The locations of trees with a single trunk at breast-height are marked by a large orange circle with its estimated age. Trees with multiple trunks tell us that they grew up in the open and those trees are marked with smaller orange circles, without age estimates.

Here at Brawley Creek, our wooded areas have not reached climax. In fact it is hard to say just what a climax community, one without human intervention, would look like in this region—no one has ever seen one, not even the Clovis people on their arrival. When they reached this place, there were still glaciers in Minnesota that seriously affected our climate. As the glaciers retreated north, they took the boreal forest with them, and grasslands advanced from the south and west. There is no record of tall grass prairie in Missouri without a human presence. The prairies discovered by Europeans on their arrival amount to a case of arrested succession. The ecology had been denied a conversion to woodland by regular burning as a way to manipulate free-ranging "livestock." Our history is one of succession denied. But looking at the species composition among saplings, one might guess that—lacking changes in climate—we would eventually live in a forest dominated by oaks and hickories. We can trace succession from the overgrazed, savanna-like conditions in 1940 to the present woodlands and beyond, to provide a glimpse of the future woodland by the kind of saplings that dominate and their densities.

Our successional story begins with grasslands that included a wealth of herbaceous plants in addition to the grasses. Collectively those are forbs, a very useful term that includes all the wildflowers: sunflowers, asters, and milkweeds among them. With the conversion from prairie to pasture, it is important to differentiate them. Both qualify as grasslands, but the pastures of today are a long way from prairie in the same way that a Christmas tree farm isn't really a forest. The grasses in our pastures tend to be monocultures of fescue that provide a matrix for which prairie plants and animals are poorly adapted. Some of them can tolerate the change and survive; a few thrive.

Grasses differ from one another in the same way that trees do. Our

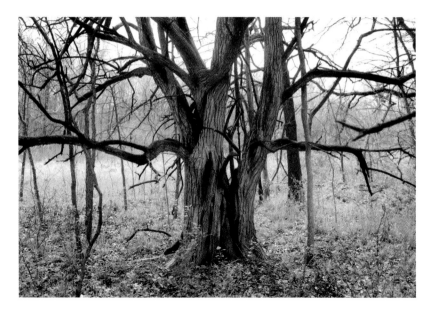

5.12 A field-grown Hedge is slowly drowning under a rising canopy that has grown through its branches. In its youth, its lowest branches spread wide to capture sunlight, but now the canopy trees have made them inefficient. They've already been sacrificed, but they still stress the tree as dead weights.

native grasses are maximally productive during the warm season, while Fescue, of European origin, is a cold season grass. Fescue pasture can feed cattle (also by way of Europe) who are right at home in it, but our native animals, now living in the only grasslands available to them, must make do in an environment vastly different from the prairie for which they are adapted. Collectively, the prairie supports armies of herbivores, their predators, and the parasites often confined to specific hosts. And, of course, all of them support the vast crew of decomposers that recycle everything. Meadowlarks and Dickcissels have done well in the new environments, but hundreds of the other species, like Prairie-Chickens, have been unable to adapt to the altered landscape, and they cling to existence only in the 0.1% of prairie that remains in Missouri. Collectively, they are a part of the tall grass prairie ecosystem that was maintained by the Osage and eliminated by plowing.

The details of succession have changed a bit from the Marrs' time, but its essence remains. Now there are hundreds of introduced species in competition for the sunlight—competition for that particular resource is, not surprisingly, the essence of succession. Communities pass through a sequence of seres: transient communities that are vul-

nerable to invading species who capture sunlight more effectively, usually because they are taller. Each sere is replaced by a taller one until a canopy forms. Each lasts longer than the one before, until a relatively stable, self-perpetuating community—a climax community—dominates. The details of the process vary but they are remarkably consistent within a climatic zone. Seres are named for their dominant plants, but each sere is represented by an entire flora and fauna.

Grasslands host a community of plants that require full sunlight. Other species with strong dispersal abilities will invade, and unless their success is blocked by fire, grazing, or mowing, they will crowd the low-growing grasses and forbs, denying them sunlight. Blackberries, Rough-leaved Dogwood, Poison Ivy, and Eastern Red Cedar are among the most common of them; their seeds are distributed short distances by resident birds, migrants take them for long rides. In a very few years, these species produce wood tangles that become dense and

often nearly impenetrable—for us. But for smaller species, they provide both food and sanctuary. This brushy community is also transient, and in 5 or 10 years it will be superseded by the next sere as a forest grows up around them, in the same way business districts invade residential areas, and high-rises eventually dominate. Those trees and vines will begin to tower over the brush, blocking sunlight and signaling the beginning of the next sere.

Superficially our woodland may seem like a dense forest come of age, but the transition from savanna-like to forest took only 40 years. Now, another 40 years later, we are still a very long way from a mature forest, as Figure 5.14 illustrates. We see an overabundance of low horizontal branches and bent trees, weakened and misshapen by the struggle to reach sunlight. The vast majority of these trees will never reach the canopy, but they persist. A grown-up forest wouldn't look like this.

Pioneering trees don't do well under a full canopy, so the presence

5.13 The multiple trunks of those young hedges, now old and still carrying that dead weight, have been torn apart. As the trunks split, those wide-spreading, rot-resistant branches, take saplings with them when they go, creating impassible tangles.

and the condition of these tree species indicate the age of the forest. In our adolescent forest, the junipers, relicts of an earlier sere, have become thin and ghostlike, and they will soon surrender to the inevitable. Naturally, the animal component of the community changes along with the vegetation—Meadowlarks and Field Sparrows will be replaced by Towhees and several woodpeckers. Long-lived trees that will eventually dominate—Red Oak, Pin Oak, Black Walnut, and a variety of hickories don't need to travel far, remaining competitive where they are. So, they can afford to produce heavy, energy-rich seeds. Even those spread out from the fringes, sprouting from seeds carried short distances by robust animals that stockpile acorns, hickory nuts, and other heavy seeds in caches often underground. Our floodplain no longer floods, but in places with a natural floodplain, floating seeds are spread widely.

When we arrived about 1980, the savanna-like landscape of the north 10-acre strip had reforested itself. The pace of succession in forest seres slows dramatically, and to my eye there has been little change over these last 40 years, and we still live in an adolescent woodland. The canopy is populated by oaks, hickories, Walnut, Sycamore, and Hackberry, along with a smattering of other species. Elms, whose airborne seeds invaded in such numbers, are still abundant, but by now they are of a certain age, many of them dying from the Dutch elm fungus. The death of mature elms creates gaping holes in the canopy that are a ray of hope for the saplings of slow-growing trees that can germinate and grow in full shade, but who must wait for an opening in the canopy that is unlikely to materialize except by the death or blowdown of taller trees.

Those dead elms have created a bonanza for hole-nesters, now experiencing a housing glut. When elms die, they begin shedding their arching branches and great slabs of bark—the bare trunks remain standing as they rot. Typically, they remain upright for 5 or 10 years, during which woodpeckers riddle the standing trunks with holes of various dimensions, leaving a large inventory of nesting sites for hole-nesters—Chickadees, Nuthatches, and many others. During the winter, those cavities provide sheltered roosting sites for mammals and resident birds who are less capable at excavating wood.

We restrain succession here with almost everything we do, creating a diversity of habitats in pockets large and small, encouraging a variety of life forms who can flourish in the small space that we control for the moment. At least every couple of years, before the spring plants have emerged, we block the success of woody species by mowing the areas we want to remain as grassland and savanna. The retention of these open areas has allowed less common forms to return to our fields, and each year brings the discovery of one or two species of plants new to us. We've scraped out two shallow, temporary ponds that favor frogs and toads, and perhaps someday Small-mouthed Salamanders. There is a small permanent pond that, along with the creek, serves all and provides an additional habitat type. We've cut trails throughout to provide access for maintenance, and for easy passage to enjoy the whole of it. We use these trails a lot but not as much as Deer, Coyotes, Bobcats, and a surprisingly diverse collection of others—birds find that the open trails ease their passage as well, and so do flying insects, and that makes them attractive to orb-weaver spiders.

We have the good fortune to have been provided glimpses of this land at widely spaced times. Beyond the fossils of the Pennsylvanian and the dart points of the early Natives, we have the pithy observation of Mr. Thurston, the GLO surveyor (1820). George Marr's recollections of growing up here on Brawley Creek in the 1860s and '70s, and we have the 1940 photograph. And finally, we have our own observations covering the last 40 years.

When we shift to circular time, we'll watch the seasonal changes wash over this community like the tides and we'll see the Rules played out in many ways through the relationships we have touched on; energy flow, food webs, predator and prey, and flowers and pollinators. Ecological succession is linear, but it describes an orderly transition independent of any particular place or time. It would have fit among other timeless phenomena, but this seems a better place to recognize a specific and very important variation in which The Rules direct things from behind the scenes.

The stratification of communities builds as the canopy expands upward in maturing forests. All of the seres are stratified, but it is best seen in forests, which are more spacious. We are all familiar with the forest at some level, more so than the other seres. All of us can name five native trees, but maybe not five native wildflowers or five native grasses, so there is no better place to look at that kind of organization, and we'll look at that next.

Figure 5.14 Young woodlands like ours have few stately trees, instead they are crowded with saplings vying to ascend, and inevitably, most of them failing. This is a picture of that struggle made prominent by a snowfall.

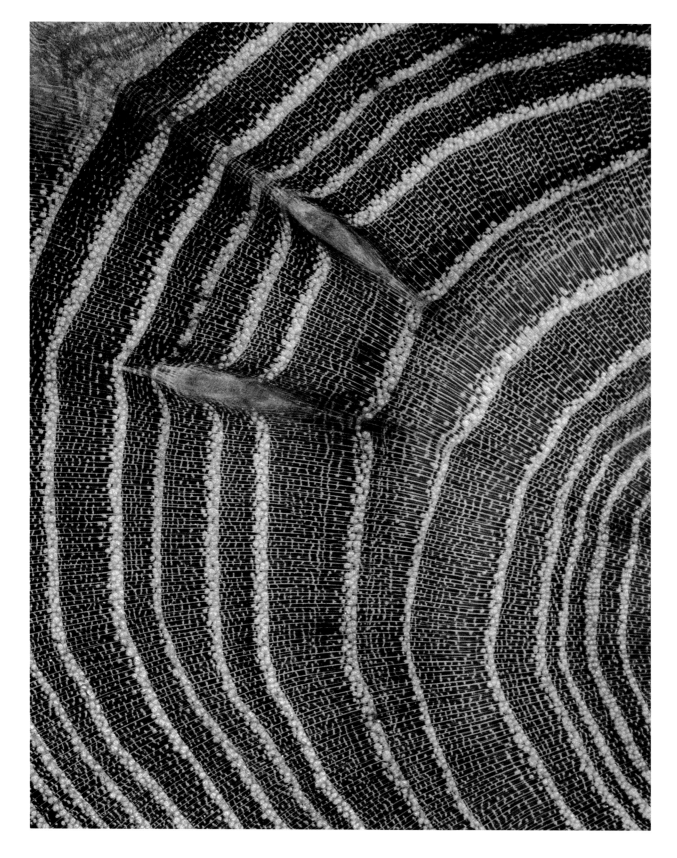

Figure 6.1 This history is told by a polished cross-section of a Hedge limb pulled from a stack of firewood. Hedge is the densest North American wood and the most energy rich. It is built of separate layers that read like the pages of an autobiography, telling of good years and bad. This image reads from right to left.

6

The Structured Forest

"I am the heat of your hearth on the cold winter nights, the friendly shade screening you from the summer sun, and my fruits are refreshing draughts quenching your thirst as you journey on. I am the beam that holds your house, the board of your table, the bed on which you lie, and the timber that builds your boat. I am the handle of your hoe, the door of your homestead, the wood of your cradle, and the shell of your coffin. I am the bread of kindness and the flower of beauty. Ye who pass by, listen to my prayer: Harm me not."

~ The Prayer of the Woods

Of the communities available to us, the forest is the best for exploring the interactions among its members. It is the least affected by human activity and most of us have spent some time there. Having evolved for millions of years to belong in the African savanna, our more recent ancestors, particularly those of European and Asian descent, became a people of the forest. With few exceptions, they depended on the forest to provide their needs and it has become our ancestral home in a cultural sense. "The Prayer of the Woods," thought to be a thousand years old and of Portuguese origin, elegantly calls our attention to that dependency.

Forests are the source of that miraculous substance that can be whittled, carved, sawn, machined, drilled, glued, and even threaded, to serve almost any purpose. It plants itself, grows untended, and, unless overused, it is there for the taking indefinitely.

That is why the first surveyors were tasked by the General Land Office with

describing the quality and quantity of timber resources available to settlers considering a move out of the forest and into the fringes of the prairie, where that resource was disconcertingly scarce. The information they provided was limited, but critical because at that time, if iron was not required to satisfy a need, it was met with wood and crafted on the spot—houses, tools, wagons, eating utensils and even the bowls that held the food. All of that and more were gifts of the forest whose value has been largely forgotten in this age of plastic and stainless steel. It's good to be reminded of that beautiful, flexible, and entirely biodegradable gift.

Accordingly, our culture and our myths have been shaped by the forest, but living in the modern world has degraded that long and intimate relationship, and it has been left behind like a teddy bear. We hold a mixed view of Forest. It is a bundle of resources ready for harvest, but the phrase, "a walk in the woods" usually calls to mind a relaxing experience, a place of solace where one can unwind and for some, experience the sacred. In fairytales, before the Disneyfication of the forest creatures, the mythical forest was threatening—a mysterious place of danger, dark, and forbidding. It was the lair of the Wicked Witch in Hansel and Gretel, the place Snow White was sent to die, and where the wolf waited for Little Red Riding Hood. The story of "Peter and the Wolf" is built around these traditional fears; Grandfather ominously intones, "It is a dangerous place."

This mythic forest still hovers in our minds, surfacing in phrases like "We're not out of the woods yet," but the living forest is far more interesting—a gem with many facets. There are deer, but deer flies and deer ticks too, somehow overlooked in the adventures of Bambi and Thumper. Getting to know the real forest, the one available to us as adults, doesn't tamper with our treasured myths, it only adds facets to this priceless gem.

The dominant organisms in northern forests are not the bears and wolves. Nor humans. The dominant creatures are the ones that capture the energy that supports the rest of the community. The African lions are terrifying, but they are subordinate to the grasses and a few trees—the pyramid of energy is also a pyramid of dependency. Trees dominate the rest of the community

through the power of the purse. We are awed by the size and beauty of trees, and for those of us who build with wood and split firewood, by their physical integrity, their density, and yet another kind of beauty.

Wood is made from the sugar produced in photosynthesis. But then that's true of the whole forest and everything in it. The wood of Hedge (Figure 6.1) is the most dense of any North American tree. It is 73% polymers of sugar—33% cellulose and 40% lignin. Other trees are built on variations of this plan, giving them different properties; they vary in energy content, flexibility, hardness, resistance to splitting, vulnerability to insect attack, and weathering, to touch on a few. All of those variations serve the needs of different species in their proper environment, but taken together, they provide a diverse tool kit for frontier families.

Here at Brawley Creek, a few species capture and channel the energy on which the forest ecosystem operates. These few species dominate by virtue of their height. As noted, oaks and hickories of several species are most common today, along with Walnut, Sycamore, and Hackberry. Elm and Honey Locust are also prominent but disappearing as the forest matures; their places taken by species better suited to a forest environment.

They shuttle fluids without a heart, they respond to stimuli without nerves or a brain, they move without muscles, and manage sexual reproduction, all very successfully while rooted in one place. They are a life form so foreign to us that in spite of their familiarity, almost nothing about them seems intuitive. Set aside for the moment what you know about how animals live, most of what you know about living as a human, and open yourself to ways of growing and aging that are utterly alien. We need to know only enough about how they work to appreciate how they cooperate with, and resist, the community of life that they feed while under attack on many fronts. It's complicated, so we'll restrict our observations to trees since they so capture our imagination.

Most of a healthy and robust tree is dead. In addition to leaves, the living, growing part of a tree is the vascular cambium and its immediate descendants that form a paper-thin layer of cells sandwiched between the bark and the wood, and in clusters

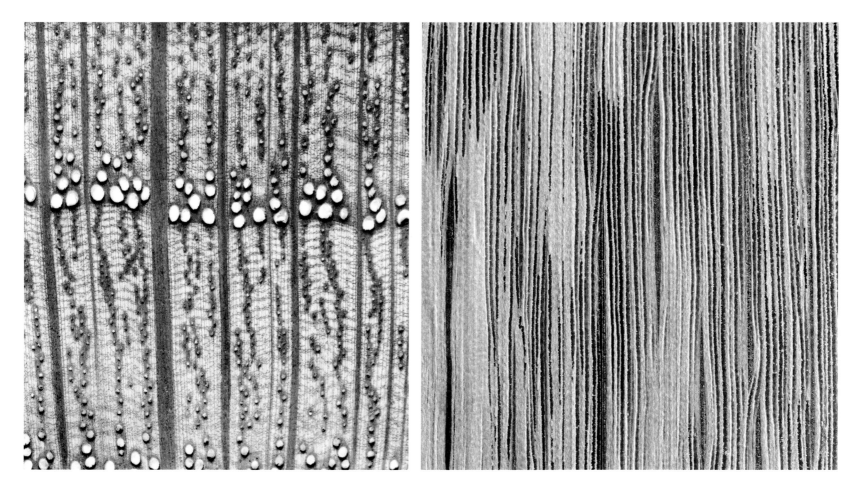

6.2 Left: ~ 8X. Oak end grain presented as a negative, image in sepia tones, tells of two years in the life of the tree. The horizontal band of large pores (appearing white) is a line of spring-growth xylem elements seen in cross-section. As the season advances, the cambial front advances (upward) and shifts to producing a dense matrix of rigid, interlocking fibers with modest flexibility. The pith rays that radiate outward through the years allow the radial transfer of chemicals. Right: ~ 6X. Xylem elements seen lengthwise on the surface of a freshly-planed board. Same kinds of cells, different point of view.

at the growing points of twigs and roots. Cambial cells are un-differentiated; they are embryonic tissue; in the oldest and craggiest trees, the living parts are still embryonic. The vascular cambium's role is pivotal and without an equivalent in animals. It produces cells with distinctly different futures. On its inner surface, cambial cells differentiate into wood, but its outer surface proliferates cells of phloem and bark.

Wood first. Several kinds of cells provide the all-important support that allows trees to reach the canopy and stay there to monopolize the energy source. Wood consists primarily of

fibers, rays, and xylem, which can be seen in cross-section and longitudinal section in Figure 6.2. Xylem elements form conduits through which water and nutrients are raised a hundred feet or more—much higher in Redwoods—from the roots to the leaves, twigs, and flowers of the canopy. They are micro-pipes that, stacked end to end like clay drain tiles, conduct water. They must become hollow to serve this role, so they sacrifice the cellular parts that control their physiological activity, and by the time they are mature and functional, they are dead, hollow shells. The vacant xylem elements are seen in Figure 6.2 as clustered voids.

6.3 Left: ~ 5X. A lateral Hackberry twig (*Celtis occidentalis*) cut from an understory sapling. It is less than a quarter-inch thick after 7 years of growth. The proportions of wood, cambium, and bark are characteristic. Right: ~ 16X. A closer look shows the phloem as a layer of green, rectangular cells just beneath the bark, and stacked like bricks. To see the cambium—that single-cell layer that marks the boundary between xylem and phloem—we'd need still more magnification.

Xylem elements produced during the rapid growth of spring are large, sized to accommodate the upward movement of fluids during that season. As spring turns to summer, and the growing cambial layer advances outward, the xylem elements it leaves in its wake are smaller and more widely spaced as the cambium shifts to differentiating its cells into fibers that serve as support. In oak, prominent channels (pith rays) radiate from the center of the tree. They are the only living parts in mature wood and they allow the passage of materials to the inner layers of wood for storage. The structural integrity of oaks serves those trees well and it has proven indispensable to us over the millennia. For all of their majesty, trees live in their skins. That is part of the reason that trees are so foreign to us in spite of our everyday encounters.

In temperate zones, the cambial ring, easily located in Figure 6.3, grows in pulses dictated by the seasons. It has the effect of making the wood of a tree into a journal written by the slow, seasonal heartbeat of the cambium, and it records more than the age of the tree. It responds differently to wet and dry years, records the birth and self-amputation of branches, and remembers insults like fires and insect attacks. That journal can be read and interpreted; many records from the same area help reconstruct past events, like the frequency and timing of fire prior to its suppression by Europeans.

"Why are trees tall?" is a child's question to which a harried parent might respond with the show-stopper, "Because they just are." But it's a good question and the answer is simple—trees are tall because they compete for sunlight, each one reaching to capture its share of the energy and a little more. The competition is intense but not at all obvious because it is so slow. Our canopy remains fixed at about 90-100 feet, because the competition—both intra- and inter-specific—has reached the optimum point in the benefit/risk spectrum, the same sort of calculation that accounts for the length of a Blue Jay's tail. Every foot of a tree's height is a big investment because growing wood is energy intensive. A tree that is a little too short is at a disadvantage despite its expensive infrastructure, and a too-tall tree has over-invested

6.4 None of the trees in this fence row were large enough to record in the 1940 aerial photograph. A mix of Hedge and Red Oak for the most part, this winter scene can be viewed as a reminder of the enormous amount of energy carried in the forest infrastructure. The visible portions of the trees in the foreground, hold the energy equivalent of ~90 gallons of gasoline.

and becomes disproportionately vulnerable to wind damage, excessive water loss, and to the increased leverage that tests not only the strength and flexibility of trunk and branches, but the anchorage of its roots. Standing head and shoulders above your forest colleagues carries risks.

Wood is a massive investment that is necessary to keep the leaves in sunlight and producing energy; it is expensive because it requires a lot of calories to make. It is so energy-rich, and available to us in such quantities, that for a very long time it was our principal source of energy. Following the money, we note that the energy was captured in the leaves, and then moved to the cambial layer where it has been spent in building the wood—making cellulose and lignin†—which are added in pulses and accumulate over many decades.

† The cellulose component provides flexibility; lignin, rigidity. Different trees control their strength / flexibility balance in part by varying the proportions and locations of these two compounds.

Because energy content can be reduced to calories, we can appreciate the magnitude of this investment by quantifying it. To most of us, BTUs (British Thermal Units) are nebulous quantities, so we'll convert them into energy units we encounter regularly—gallons of gasoline. A gallon of gasoline carries 580,000 BTU's—enough energy to drive a small, gasoline-powered car and its occupants 35 miles or so. A section of Hedge branch 20 inches long and 8 inches thick, a size we might toss into the wood stove, carries the energy of a quart of gasoline—enough to drive a car and its occupants 7.5 miles. Wood has to be very expensive, but it is an essential cost of doing business as a tree—still it must be profitable. Our other hardwoods—oaks, hickories, and Honey Locust—carry about 80% of the energy in Hedge and would yield only 6 miles of travel.

We rarely see the forest as units of standing energy. We see a fence row as a strip of wildlife habitat or shade but not energy, yet that standing wood is an enormous reserve of energy. We are properly terrified by the western wildfires—where that energy is released en masse—but here at home we enjoy the controlled release of a wood stove.

By now it should be clear that the energy requirements of life forms and the regulation of the energy flows that sustain them are the foundation of the invisible organization that regulates our lives. But it is as obscure to us as the concept of a population pyramid without a diagram to make it visible. We easily recognize order in geometric figures—straight lines like rows of crops, or property boundaries. Such arrangements are rare unless produced by human activities. The organizational structure in forests is a bit more visible, revealed as spacious layers—living zones—in which we can amble about, inside an active, exploded diagram. The layers are stacked under the over-arching canopy like pancakes. Sunlight bathes the canopy like butter and syrup. What isn't absorbed by the top layer, dribbles down to lower strata by one route or another, ultimately feeding everyone as it trickles down, reaching well into the soil.

Each stratum is a community in its own right, piled one over the other, rather than scattered about the landscape like a patchwork quilt. These habitats can be divided any number of ways but

in the interest of simplicity we'll combine them into just four: the canopy, its understory, the combined shrub and forest floor layer, and the sub-floor community. That last layer is filled with strange ghoulish creatures. It is mysterious because we know so little about it and because it is where dead things go. Death returns us to it. That's probably why the term underworld carries such baggage. Producers, consumers, and decomposers are found in every layer, but gravity brings everything to the forest floor eventually; the strategic position for decomposers. The more diverse the community, the more opportunities there are to specialize, and the increased diversity often increases its stability. On a grand scale, that's one reason why the global decline in diversity is of great concern.

Following the money, the defining role of energy makes the canopy the best place to begin. The lofting of the canopy is like raising the circus Big Top piecemeal as ecological succession advances, and soon enough it becomes a lofted surface with holes. It's an exceptional tent made of exceptional fabric; flexible and built anew each year with millions of solar collectors financed by last year's energy stores. Every sapling is searching for a gap in the canopy to plug, so it spontaneously repairs itself, creating a very tight surface through which only 3% of the canopy light penetrates to the shrub layer with even less reaching all the way to ground level in our adolescent woods.

With the deployment of leaves, life in the canopy proceeds with the feverish activity of a Boom Town where great wealth is captured by a few, surrounded by a diverse cast of characters using every imaginable means to get some of it. Once mined, real gold is gone, but green gold is restored every spring; its predictable riches drawing seekers like a flood of seasonal tourists.

The green gold rush begins with the emergence of a vast layer of tender green leaves. Before settlers cleared agricultural fields across the east, that layer was vast, spreading from western Missouri to the east coast. The canopy is where most of the food is found and therefore it's a great place for herbivores to concentrate. An army of consumers hatch up there—lots of caterpillars among them. We don't see any of this because they are tiny and the canopy is far overhead, but as the numbers of caterpillars ex-

plode, we can see evidence of it. Waves of warblers arrive to harvest this crop of flesh, their timing excellent. The caterpillars are concentrated among the leaves that are just beginning to expand. When the wave has passed and the leaves are fully open, several species remain, their force joined by spiders and other insects who are themselves insectivores, along with a stunning array of parasitic wasps. We don't see any of that canopy activity either, except for the tiny warblers. Almost all of that is available only to our imaginations, and based on information we process with our rational abilities.

There is a lot going on up there and none of it can be easily examined casually as we would consider the skeleton of a box turtle found along the trail, so we look to things fallen from the canopy like messages in a bottle. They are sometimes subtle, sometimes peculiar, but always worth noticing. Here are a few things that do come down—discoveries that make us wish for better access.

The canopy is full of scents and other odds and ends that suggest what we are missing. Every May about mid-month, we encounter scent islands with nebulous boundaries. We were never able to pinpoint a source as we can with a patch of Milkweed, but after several years, we happened on a fallen branch of a tree that had dragged down some grape vines. The grapes were in flower, and apparently that scent came to us through downdrafts as we blundered into those clouds of heavy, sweet fragrance.

In linear time, about mid-June of 2015 or 2016, while walking the trails, we began to notice a new event: a substantial drop of skeletonized grape leaves from the canopy (Figure 6.5). They were exquisitely etched—chewed actually—and concentrated in those scent islands. I suspected the larvae of the Grapeleaf Skeletonizer Moth, but we couldn't see anything, and the virtuosos remained a mystery until we found some skeletonized grape leaves with Japanese Beetles still chewing on them. The adults are accomplished herbivores but large and sluggish; one wouldn't think them capable of such delicate work. Japanese Beetles are invasives that we first began to notice as the western front of their invasion reached Kansas City in 2010, followed by the rest of the troops that passed through and left a smaller occupying force.

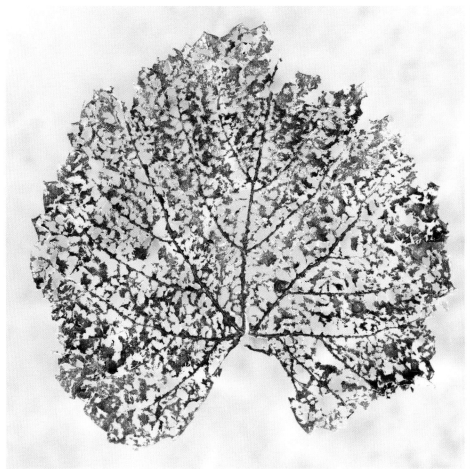

6.5 A grape leaf, one of a cascade falling from the canopy, was skeletonized by a party or parties unknown. Probably it was done by Japanese Beetles (*Popillia japonica*) who have appeared in startling numbers as they pass through this area like a frontal system.

Each fall a blanket of leaf litter falls to the ground to repatriate their nutrients, however indirectly; the foliage season is the precursor to that event, but the repatriation begins long before that. The hordes of tiny caterpillars that fuel the warbler migration are the ecological equivalent of a herd of cattle working the treetops, and like cattle they produce prodigious quantities of manure—almost dry fecal material called frass. That must be happening, but generally it goes unnoticed. It comes from the hindgut of caterpillars and it is a rich manure, already composted—manna for decomposers, and it comes down as a shower of frass. Tiny larvae drop tiny particles of frass, but they grow quickly and by August one can hear the frass striking leaves on the way down. Luna Moth larvae (Figure 6.6) provide an example. The eggs are less than 2 mm long, and release the larvae in less than two weeks, after which they binge on Walnut and Hickory; and we have lots of both. It is the start of a three-to-four-week eating binge, during which they increase their size by a factor of 4,000. Each female can lay up to 400 eggs and there are two generations per year. Hundreds of different species have similar trajectories and they support an equally broad array of insectivores; and all of their frass comes down as well. On a quiet afternoon in August, as the larvae approach their maximum size, one can hear a gentle rain of frass—tailings from the mining of

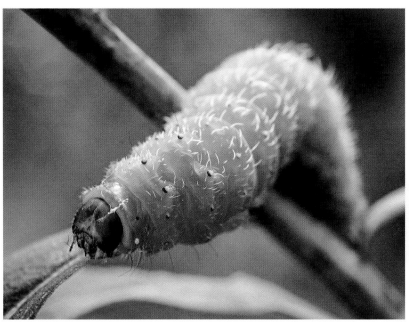

6.6 In late summer, this full-sized (fifth-instar) larval form of a Luna Moth, has come down from the canopy to pupate.

green gold overhead.

A rich layer of fertilizer is laid down before the leaf drop covers it, and in the way of natural systems, none of it is waste; it is raw material. It is fuel for the decomposers and adds a layer of insulation that extends the season of decomposer activity. It promotes a well aerated, richly organic soil, ultimately benefiting everything on and under the forest floor, including the trees who are the source of both components.

Figure 6.6 shows one of those caterpillars grown to full size (fifth instar) that has come down to ground level, giving us a chance to meet him. He's down here to pupate, sequestering himself in a cocoon of silk and dead leaves where he will overwinter. The larvae are not often seen near the ground, so his presence here, reddish coloration, and that wisp of silk on top of his head, all suggest that the time is near. The large terminal plate with the horizontal green bar is a source of frass. The plate raises and frass is forced out like the contents of a garbage truck backed to the rim of a landfill. One wonders at the attention-getting bright colors on his rear end. They remind me of the rear end of a school bus, missing only the flashing lights. More significantly, it bears

a resemblance to the triangular face of a Praying Mantis, augmented by simulations of large black arms, with light green lines, which mimic the powerful grasping appendages of mantids. Approaching from behind, a predator would find himself face to face with another, very aggressive predator. Possibly. There are other conceivable notions. The Bold Jumping Spider seen in Figure 6.7, is aptly named; he is as aggressive and pugnacious as a tiny dog, and he approaches any threat (like me) with a series of tiny, hoppy lunges, displaying bold black and white markings and iridescent chelicerae that flash like switchblades. Those chelicerae figure prominently in courtship displays, but both the shape and color are strikingly similar to the back side of a Luna Moth. Probably coincidental, but it makes a good "Just So Story", and it suggests that we take into account how well predators who threaten caterpillars can resolve images. Some of those threats are parasitic wasps who might well take into account anything approaching a warning pattern on that scale.

The nest in Figure 6.8 is another peek at life in that remote place. It was built by an Eastern Wood-Pewee who typically nests 40 feet above the forest floor and it's a beautifully engineered de-

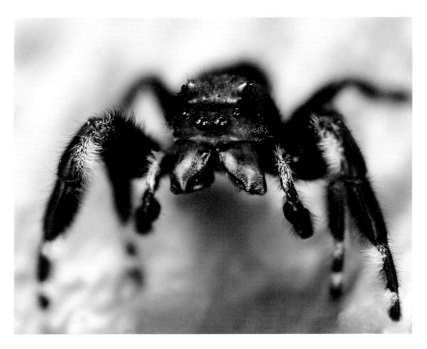

6.7 ~ 5X. A Bold Jumping Spider (*Phidippus audax*) confronts the threat of my approach… boldly.

6.8 The nest of an Eastern Wood Pewee is old and the vibrant blue-green of the lichens have faded, but its elegant construction can be found only in the canopy. The center is barely over an inch wide and she has only her bill and her body shape to construct it. I'm quite sure I couldn't do it using both hands (with opposable thumbs) and tweezers.

vice of elegant construction that takes about six days to build. We got to see it because we had to fell a live Walnut tree that held this nest with its full complement of eggs hidden among its branches, and they were destroyed. She builds the rim first—a foundation from which to hang the rest of the nest—then fashions the bowl and lines it with fine fibers, shaping it with her body. Finally, spider webs are collected to help anchor the nest in the fork and to adhere fresh bits of lichen to make it inconspicuous. The nest is perfectly embedded in its environment—Frank Lloyd Wright would have approved.

Another hint of life in the canopy is the caterpillar in Figure 6.9, often seen twisting and wiggling slowly and dangling on a long silk line like an earthworm on a hook. It is the larval stage of yet another moth, probably of one of the leafroller moths of the family Tortricidae. Like most caterpillars, eating leaves is his vocation. His special trick is to keep well out of sight by rolling up in a leaf and eating it from the inside. As with many residents of the canopy, the details of leafroller's lives are sparse, but among them, the Oak Leafroller Moth is the best known and

their evolutionary relationship permits intelligent speculation about the activities of other members of the family. Thank you, Charles Darwin.

The larva is not entirely safe in the rolled leaf. No one is entirely safe anywhere and predators and parasites have been developing their own neutralizing strategies for eons, but dangling in the open like this seems to be tempting fate. I don't know why this caterpillar is dangling here, but there is a parasitic wasp that specializes in leaf rollers. She is skilled in finding those refugees and she injects an egg through the layer(s) of leaf and into the body cavity of the caterpillar where it will hatch into a larval form whose vocation, like all larval forms, is to eat. A wasp walking about on the rolled leaf surface and possibly probing might justifiably alarm the leafroller who responds like many disturbed larvae by dropping toward the ground but still attached by a silk line—like bungee jumping. He hangs at the end of the silk, twisting and turning. As a defensive maneuver it carries risks, the woods are full of flycatchers and the caterpillar is something of a bon-bon—rich in calories, and now totally vulnerable. But there

6.9 ~ 4X. One of the leafroller moths, likely the Oblique-banded Leafroller Moth (*Choristoneura rosaceana*). Here he is seen climbing his long, silk thread back to its attachment. He is mostly transparent but appears green because of the leaf fragments in his gut. In passing, take note of the two, soon-to-be frass pellets in his hindgut.

is nothing to eat at the end of his tether, so at some point he must begin to climb back up the silk, many feet from his home leaf, a task that stirs painful memories for those of us who never excelled in the rope-climb. His movements look like he is doing crunches with his tiny thorax, while his long and heavy intestine dangles. As he climbs—this one moved at the painfully slow rate of seven inches per minute—he bunches the retrieved silk line that can be seen held in his thoracic legs.

Lots of simple questions remain that can't be answered while looking up into the canopy. How does one exit that rolled leaf with all of those legs? Does he scooch to the exit and drop like a mis-fired cannonball? Does he have that whole silk strand prepared for this event like a fishing line attached on a reel, or does he generate silk as he drops? If he doesn't generate that line as needed, there would surely be an issue with tangling, which seems like an innate property of every string, fishing-line, hose, rope, or extension cord. What does he do with that costly silk when he returns to the canopy? Does he eat it and reuse the constituents like a spider, or does he handle the issue differently? Lots of questions would be answered more easily if it were simpler to get up there and watch.

The canopy is a cloud of greenery that defines the upper limit of the forest—a cloud that requires an enormous and expensive infrastructure, as noted. Every community has members who use someone else's investment to reduce their cost—borrowing ladders and chainsaws—reciprocal sharing builds community in social animals like us so long as it is reciprocal. Outside the structured world of social species, however, if there is a way to gain value without paying for it, somebody will not only do it— they will make a career of it. Here, the most prominent and consequential of these are the grape vines that climb branches ascending high into the canopy so they can bask in the sunlight, without making the investment to join that exclusive club.

Grape vines avoid most of that expense with vines built largely of xylem elements, leaving them flexible—almost rubbery—and they hang on a host tree like a recalcitrant five-year old hangs on his mother as she tries to work. Much of the woody structure of canopy trees, like the White Oak, is devoted to sup-

6.10 ~ 2X. This cross-section of a 45-year-old grape vine tells the story. It looks like wood, the visible pores of the xylem elements and radial pith rays are there, but it is without stiffening fibers. Three inches in diameter, it compares to the 16-inch average diameter of a 45-year-old Pin Oak. Still, it is vulnerable to boring insects.

port rather than water conduction, as seen in Figure 6.2. Grape vines, built almost entirely of xylem vessels separated by pith rays, serve as little more than an umbilical connection to mother earth. Grape vines avoid the expense of a rigid trunk by clinging to host trees, but as dependents they are vulnerable to the health of the tree. When the host tree falls, it will take the vine with it.

An understory is deployed below the canopy like a safety net, but it has no such function. Here at Brawley Creek, it is a poorly defined stratum of Oak, Hickory, and Walnut saplings, that don't really belong in the understory and can't live there indefinitely. They are in limbo, effectively marching in place, subsisting, awaiting the death of their elders to open a space in the canopy. They are princes-in-waiting with the blood lines to reach the canopy, but they are not yet come of age, and highly unlikely to ever get there. There are many hundreds of princes and very few kings.

In contrast, understory trees belong in this stratum. Distinct from canopy hopefuls, they are constructed to live in understory conditions, and they thrive there where the canopy functions like an umbrella at the beach, blocking the burning sunlight from tender tissues. They play in a different league, and they live in an ameliorated climate. Redbuds, Dogwoods, and Pawpaws never reach the canopy, rarely growing higher than 20 feet. Their income is derived from trickle-down light but there are distinct advantages. Winds are gentle in the understory, so they don't spend on massive trunks and branches and so do well on a lower income. Nor do they need a root system that will resist those forces. They can make larger leaves with less stiffening, and because of the moderated wind, the humidity is higher, and they lose less water, particularly important during periods of drought. That is another inconspicuous cost that we rarely notice. A large Oak tree can evaporate from its leaves (transpire) 40,000 gallons

6.11 Pawpaw leaves are large and soft, but not so floppy that they can't orient themselves to hold a position that maximizes light uptake—not much gets past them.

in a year, all of which must be pulled from the soil and drawn to the height of the canopy. That's 167 tons of water.

We'll consider the shrub layer and forest floor as one layer—the layer in which we live. It consists of the surface itself, a mulch of leaf litter, and decaying wood, clothed in a variety of herbaceous plants and shrubs. The dominant factor shaping life on the forest floor is the twilight that pervades the layer during the growing season. That meager budget drives productivity.

Our most abundant woody plants are Buckbrush, Gooseberry, Greenbriar, and Multiflora Rose—they dominate this layer in the same way that the canopy dominates the whole. Even though I've grouped them with the forest floor, the shrub layer takes its bite before the light reaches ground level. They are a good height for deer to browse, and all of them are well defended with very sharp spines and thorns that you may recall from Figures 2.13 and 2.14. The herbaceous plants of the forest floor, the ones we most notice, are spring wildflower favorites—Phlox, Trillium, Virginia Bluebell, and Spring Beauty. They compress

6.12 Because they are last to lose their leaves, a Pawpaw patch defines the understory on their part of the floodplain, with a solo display.

6.13. When the mud is just right, passing critters leave high-definition tracks. A 'Possum's prints are unique; our only marsupial, his prints show a pronounced "thumb" on his hind foot—his grasping, great toe. Not surprisingly, that print overlays the front foot, with its uniformly spaced, equally sized digits. By mid-June we find tracks of deer, probably a doe and her fawn, possibly walking the trail together, but probably not. A better tracker would know.

their growing period to reach dormancy by the time the canopy closes in mid-May, so they enjoy full sunlight up until just six weeks before the summer solstice. Canopy trees have fully exposed leaves and with the whole summer ahead of them, there is no incentive to rush the season by risking their leaves to a late freeze.

The forest floor has patches devoid of leaf litter, mostly where standing water persists in depressions that lead to the creek. The trails that we maintain for ourselves cross those low areas and they record who passes and how often (Figure 6.13).

Each layer holds within itself the essential elements of an ecosystem. There are geographic variations as the players change—our Black-capped Chickadee is replaced by its southern near-twin, the Carolina Chickadee, but the filling of these niches is as predictable as choosing which players are going to fill the nine positions on a baseball team. This is true of all the strata in every ecosystem.

Stepping back to embrace the whole forest rather than its individual strata, we can see a multilayered community in which the citizens of each layer interact among themselves and with those from other layers, their interactions binding the different layers into a confederation. Residents often commute—birds nest in one layer and feed in two or three others. Caterpillars of the Luna Moth graze on leaves of the canopy, pupate in the leaf litter, return to the canopy to mate and lay eggs, and then, their energy supplies exhausted, they fall back to the ground to feed the forest floor. This layering of strata makes possible a rich and diverse collection of generalists and specialists in every level, all of whom eventually return to the forest floor—fallen leaves, branches, and eventually tree trunks, along with those tiny particles of caterpillar frass, the fecal material of their predators, and finally their bodies.

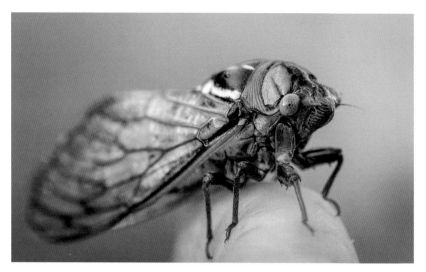 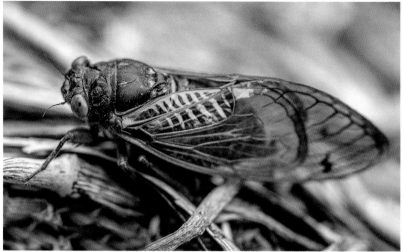

6.14 Adult Cicadas are different from their nymphal forms in every imaginable way because the two forms serve different functions. Left: The Dog-days Cicada (*Neotibicen* sp.) is our annual species. Right: This Periodic Cicada (*Magicicada* sp.) emerged in overwhelming numbers in 2015; any offspring will not be expected to surface here until 2032. There will be nine, total eclipses of the moon before the adults emerge again.

The fourth layer is the underworld. The earth beneath our feet, "common as dirt," so commonplace that we rarely think of it as a place at all, much less a thriving ecosystem akin to a coral reef, but with really viscous, dirty water. We can't just wander around in it, either. It is populated primarily by tiny life forms to which a mole must seem like a whale, swimming by overhead with a breast stroke. We see mole's tunnels but rarely the moles themselves or the shrews, and they are the top carnivores down there.

The subsurface community is very different from those above ground. For starters, there is no sunlight, therefore no producers, so all the energy needs to be imported. The soil is riddled with the roots of plants, but they can be seen as colonists that are sustained by the above-ground motherland. Naturally, the players in the underworld look very different, but within these limitations they interact in the usual ways. They live in a world that we are ill equipped to imagine. I've chosen to restrict our exploration to life forms available to a person walking a trail, so microscopic animals and fungi are excluded, except for those parts that reach up into our world to disperse spores. The details of the underworld food web are sketchy, but we can be certain that The Rules apply there too, and that decomposers will be well represented and diverse.

The buzzy, rhythmic song of cicadas is the sound of late summer (Figure 6.14). Those are usually Dog-day Cicadas but as is often the case, the mental image of them that we carry is only the terminal phase, brief but essential. For Periodic Cicadas—17-year locusts—we're overlooking the 99% of their lives in which they live underground, nourished through a tube like humans in The Matrix. It seems a bizarre way to live but their strategy is to flood the market, emerging in overwhelming numbers—enough to feed to satiation all of their above-ground predators. These nymphs have been found at unimaginable concentrations—more than several hundred thousand per acre.

Females lay their eggs in twigs, the hatchlings drop to the ground, enter the underworld, and find a root somewhere in the top 8 feet of soil. There, they tap into the fluids of roots, establishing an umbilical-like feeding connection—like a mosquito that the plant can't swat. Little is written about nymphal life and one wonders what it would be like. What happens down there as all of those nymphs feed and grow for 880 weeks in preparation for a summer fling? What was his exposure to predators, bacterial

disease, fungal attacks, death of the host? What kind of defenses does he have to deploy? Does he move around much, and if so, how does he choose which roots to probe, and what sensory inputs does he use to make the choice? The answers to all of these questions have to be teased out by researchers using the increasingly sophisticated tools at their disposal. Notably missing among these questions is, "What do they think about during those solitary 17 years?" years that seem to my sensibilities like an extended, sensory deprivation experience.

Taking a look at the whole of this underworld, we can imagine it alive with rich and diverse—if homely—populations in a miniature world of consumers and decomposers, but no producers. It's an upside-down world in which the roots of trees form an inverted forest, the roots of the shrubs mirror the above ground shrub layer, and the whole inverted landscape is populated by many kinds of worms, rather than birds and squirrels, and in unexpected densities. Under each square meter of soil, earthworm populations amount to a few hundred, roundworm populations (nematodes) in the millions, and single-celled forms in numbers that stagger the imagination, the whole infused with fungal strands (hyphae). One wonders how there can be any room for the dirt.

It is a matrix that anchors the above ground world, stores water, and releases minerals. Together, the residents complete the chain of decomposition begun by life aboveground. The soil becomes mixed and aerated through the activities of mammals of all sizes, tunneling and excavating dens, and the activities of the larger invertebrates.

Increasingly, we are finding that the idea of independent, free-standing organisms (like ourselves) is simply naive. We think of each body as the smallest component of an ecosystem, but each of us is an ecosystem in ways that, like the outside ecosystem, are not immediately obvious. Each of us is a mobile community of diverse species that are essential to our normal functioning. We're increasingly learning that, like all ecosystems, ours can be healthy and functional, or distressed in lots of ways. Diversity and populational balances in our bodily flora and fauna are essential for us to function properly. Current estimates indicate

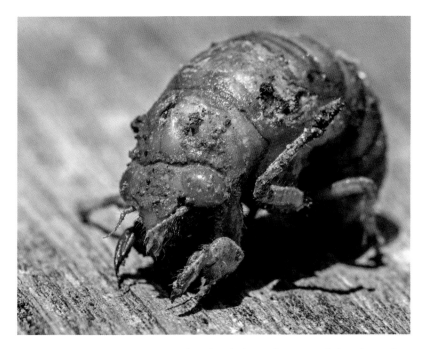

6.15 A Periodic Cicada nymph was found at the base of a tree, just below the surface, inadvertently turned up with a shovel. His gargoylesque shape and threatening red eyes reinforce fears of the underworld that are congruent with our mythology.

that we host 10 microbes for every cell with our own DNA, but because of their small size they represent only two percent of our body mass. We'll understand ourselves better if we think of ourselves as an ecosystem with a lot of diversity that we sometimes imperil. Imbalances in our internal ecosystems express themselves more immediately and more intimately than in the ecosystems outside of our bodies. They protest as diarrhea, food intolerances, and autoimmune responses, among others. Our internal ecosystem can become distorted and decimated by the introduction of antibiotics—internal pesticides that create the same kind of collateral damage to our complex system that pesticides do to the outside ecosystem. We are not susceptible to Chestnut blight or Dutch Elm disease, but we have our own fungal infections, and our own unique parasites. Head lice without human contact have the future of a fish out of water.

It is not surprising, then, that other ecosystems that we are now learning about are changing our view of the world. The underworld matrix of a mature forest is one of them. That matrix is

thoroughly impregnated with fungal hyphae, the organs of large, sometimes enormous fungal bodies, that like cicadas, live on imported energy. They are so tiny that a "teaspoon" of dirt can hold several miles of hyphae, and they penetrate soils so thoroughly that their density is equivalent to capillary beds in human tissue. Unlike capillaries, they are not tubular; instead they are built of single cells arranged like beads in long, branched strings. Grasping for anything equivalent, because of their ability to transmit information, we might think of them as similar to a fiber optic network. It is hard to envision such a creature without drawing on the imagination of the best writers of science fiction.

Fungal hyphae penetrate the root hairs of plants and dramatically increase a plant's ability to take up water and nutrients. In compensation for this service, green plants feed the fungus with energy captured through their photosynthetic activity. The partnership creates a conduit through which solar energy penetrates into the underworld and fuels it in ways far more mysterious than the suckling of cicada larvae. Some trees join physically with other individuals, using these fungal hyphae as conduits. Commonly, both nutrients and information are shared through those connections—information about insect attacks and other hazards. Trees of different species also form connections, their relationships far more complicated than we had imagined.

We can draw several conclusions. The first is that trees are social life forms, evolved to exist as a part of a group. We most often think of social life among animals—a pack of wolves, a herd of elk, a tribe of humans. For us, living in a group is our nature, hugely beneficial to our survival. The same can be said of forest trees. While competing for sunlight, they depend on each other and assist each other, both within and between species, a characteristic of communities of all kinds.

It follows that our common view of a tree as a solitary individual that can be dug up and transplanted to a solitary life without effect is mistaken. Trees removed from a forest may survive, but they are living outside the norm for the species. An isolated tree is compromised, like a Hedge tree that grows into a sprawling shape when not disciplined by close neighbors. Isolated trees lack protection from winds and they have no "pack-members" to

whom they give and from whom they receive information, and with whom they collectively resist environmental forces.

Eventually, a second idea presents itself. We assume that trees are insensate—senseless, unfeeling. But apparently that is not entirely true. Clearly, they send and receive messages and act on those messages despite having no nervous tissue as we recognize it. One can try to imagine a hydraulic nervous system driven by osmotic differences rather than differences in electrical charges, but that is well beyond our understanding.

We need to enlarge our sense of a forest to accommodate the idea that it is not just a bunch of trees. It is a structured body with many organs connected through a hyphal network. It takes a long time for such a network to form, and our adolescent woodland here—especially with the lack of a robust and mature soil component, likely doesn't have much of one. It is another reason to view undisturbed forests with respect. They are not easily replaced by the first few trees that rise to form a canopy. It is yet another dimension in which our woodland is not truly a forest. It will be a long time getting there and our climate is changing. Again.

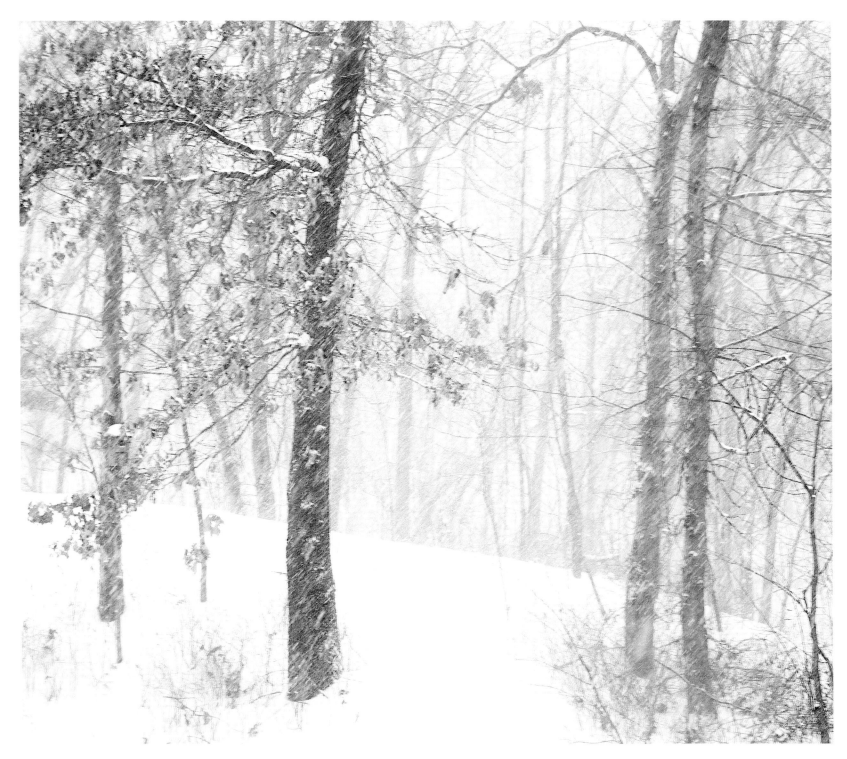

7.1 A late snowstorm arrives and with it the essence of winter—beauty and a palpable silence made deeper, somehow, by the clatter of ice pellets peppering the Red Oak leaves that still cling to their twigs. The snow crunches underfoot. We feel the bite of a cold wind and wonder at the tiny creatures that will be sleeping in it. We walk softly to honor an almost-silence that is so rare as to be precious.

7

Winter: Living on the Edge

"Winter is not a season, it's an occupation..

~ Sinclair Lewis

Entering circular time is joining a work in progress, so looking for a spot to jump in, is like looking for the weld mark on a steel ring. Winter is a good point of entry because it is the only season initiated by a single, physical event that impacts the entire temperate world. That is the first hard freeze. Its biological impact is powerful because ice crystals forming in living tissue destroy cell structure, and energy capture comes to an abrupt halt across the ecological spectrum. The date varies, but the end of productivity, arriving as a blanket of death, is unquestionably a singular event.

For those of us living in our cocoons and supported by our vast infrastructure, Jack Frost is a blithe spirit who paints the leaves with his brilliant colors. For every other species, he is the Angel of Death who brings a seasonal apocalypse. A lot of life forms die as he crystalizes water. Photosynthetic activity, already in decline because of shorter days and cooler weather, comes to an abrupt halt except for a few evergreen plants, and the flow of calories into the ecosystem essentially stops until spring. Everyone knew it was coming. The open air pantry is stocked. Now it is Winter.

For Gina and me, the coming of Winter is something of a relief—a season of rest that is viscerally felt, as strongly as the arrival of spring. We may not actually settle into a comfortable chair by the stove, but with the firewood split and stacked, we feel relaxed—even smug—being ready for what is to come. There will be the cold, and snow to shovel, ice storms, sleet, and slippery surfaces, but those are inconveniences, not existential threats. In the world outside, a restful silence prevails. It is one of the compo-

7.2 ~ 4X. In 2008, winter began on October 28th. The large leaves of a Mulberry (*Morus* sp.) respond to the first frost triggering their abscission layers to release the leaves that now carpet the ground like outsized, yellow and green rose petals. The fine hairs on the underside of the leaf act as the nuclei around which ice crystals form.

nents that encourages rest, a silent lullaby that is a welcome respite after the cacophony of spring, summer, and the early part of fall that fades to the chirping of a few crickets before the silence.

Circular time is ancient time, and it has penetrated all aspects of biology so thoroughly that communities of every kind have been shaped by the cycling of seasons that are the foundation of time as perceived by living things. Our culture sees four seasons, sanctioned by the earth's orbit, but those seasons reflect the biases of an agricultural way of life with the endless repetition of its four phases: sow, nurture, harvest, rest. Those phases connect us with our food sources; cultures with more diverse food supplies require more seasons. Native American traditions recognize 12 seasons that serve their needs, timed by the lunar cycle.† The Ojibwe welcome the Strawberry Moon (~ June) that announced the ripening of strawberries, and the Hunter's Moon (~ October) timed to lay in dried meat for the Winter. We recognize four seasons, but there are only two objective events; an energy zenith that we recognize as the summer solstice, and an energy nadir marked by

the winter solstice. The equinoxes have no biological significance, but they provide markers that give us our traditional four. They are deeply ingrained in tradition and celebrated with poignant prose, "To every thing there is a season, … a time to plant, and a time to pluck up that which is planted." Sage, simple, agricultural. Living in our cocoons, we've become disconnected from the biological impact of the seasons, but the tradition is deeply embedded and we observe them religiously as cultural seasons.

Our four seasons accommodate our foundational agricultural activities so well because they originated in natural ecosystems with corresponding phases. These are best seen from the perspective of the producers. The functions I've listed as agricultural have been adapted by those of natural communities, that we might think of as the originals: reproduction, growth, dispersal, and dormancy. There are still four functions but tellingly, we gather rather than disperse.

Watching the seasonal activities go by, I recognize five different stages that I will present as biological seasons. The fifth season is Early Fall, which begins as Summer closes, and leads into Late Fall. It is ostentatious and possibly irreligious to fly in the face of such a hallowed tradition and you may prefer to think of them as stages rather than seasons, but I think five stages qualify as seasons and I've given each its

† Sometimes—once in a blue moon—there are thirteen seasons. The Ojibwe calendar resets annually with the Wolf Moon, first full moon (~January) after the winter solstice.

own chapter. To ease the confusion, I'll capitalize biological seasons when I refer to them (as above) to distinguish them from cultural seasons.

<div align="center">***</div>

During Winter, the ecosystem functions without any noticeable income, drawing on stockpiled profits. It is an economic depression, that many life forms escape by migrating or hibernating. We can remain active because we stockpile food in enormous silos and warehouses. A few other species also gather food stores—squirrels, jays, and some bees and ants. Overwintering birds are particularly vulnerable, spending their nights huddled in some sheltered place and their days searching for sequestered food that is dormant, each day working to find enough to live through the night. For them, Winter is indeed an occupation.

Those sequestered foods may be dormant but they are still living. I'm sure they don't see themselves as food and they have hidden themselves cleverly to avoid becoming food. Moths pupate in the leaf litter or in upper layers of the soil. Grubs are found inside the wood of branches and twigs, or wedged deep into crevices in the bark, perhaps under a false bottom fashioned of silk. If they escape capture, they must still survive the elements. Seeds avoid damage by greatly reducing their water content—drying out. Others tolerate below-freezing temperatures, while sequestered, by producing an antifreeze that drops the freezing point of the water in their cells. Some freeze solid but reawaken with the spring. Surviving the Winter requires good adaptations and good luck, and nobody is safe, certainly not the "sleeping" insects or their sequestered egg masses. Or even the predators that search for them, because they too are on somebody's menu and they must be forever alert for their own predators.

We'll focus primarily on the birds that overwinter here at Brawley Creek because they are active, accessible, easily seen, and they tweak our empathy releasers. And we experience the world like they do in important ways. We're both diurnal and we interpret the world primarily through visual and auditory channels. In trying to imagine their experience of Winter though, we have to recognize the gulf that separates us; their physiologies, coupled with their small size and the limitations that come with flight are particularly important. The small-est life forms are at the highest risk, living on the edge with the finesse of a high-wire artist. That is where mathematical relationships become critically important as we shall see. There is no give in those relationships either. They are right there, in the fine print of The Rules.

Perching birds maintain high internal temperatures. The core temperature of Cardinals is 109 °F, and they must avoid hypothermia during subzero temperatures. As in our buildings, the warmer they are inside, the faster they lose heat. The second challenge comes into play as a matter of scale—smaller birds are not only unable to hold much heat in their small bodies, but they lose it faster, a fact that derives from a simple mathematical relationship. The ways in which they navigate these issues is a study in thrift and success; it depends on pinching every calorie they expend, and jealously guarding every one they manage to capture. Two metrics come to the fore and both have consequences that go far beyond their pedestrian descriptions. The first is energy yield per unit effort, which relates to choices a predator makes. The second is the ratio of surface to volume.

The first metric is quantified common sense. The energy required to capture and eat a food item determines how valuable that kind of food is for a given consumer. A proper food will yield more calories than required to catch it, process it, and eat it. "Is it worth it?" is a variation of "Follow the money." We don't eat the black sunflower seeds we put on our feeding stations. They probably taste good, and they hold calories, but we don't find them worth our time. The old bromide, "Time is money", is apt because warm-blooded animals are leaking calories every second, like a leaky bucket dribbling water. As privileged, first-world humans, our problem tends toward too many calories, so it is worth being reminded that most of the world has the opposite problem.

We are mismatched for eating black sunflower seeds as an energy source. There is plenty of energy there, but our fingers are far too big and our bodies too expensive to operate, for those seeds to be profitable if there are alternatives. Cardinals, however, are made for seed-cracking as we will see. On a scale closer to our experience, we unwrap the foil on Hershey's Kisses, but the process is tedious, and the rate of caloric gain is slowed by the processing time. Those kisses make the perfect courtesy snack for office counters because they require a lot of processing and can only be eaten slowly. Peanuts would work too,

but the shells would get messy.

A Phoebe, sitting on a branch and watching for insects, decides which of those insects are worth the effort. The decision rests on the energy content of various tiny insects, compared to the cost, in both time and energy, of capturing and processing. Plucking off the wings is quicker than removing foil, but all insects are not the same. There are risks in taking a poisonous insect, or a stinging insect, and during a flamboyant aerial capture, the bird is vulnerable to his predators. The bird makes the calculations instantly and acts according to the probabilities.

We make such decisions all the time—anybody who has stood in the batter's box facing a decent pitcher has only milliseconds to make the same kind of decisions as the Phoebe. Let the ball pass, swing at it, or get hit. Those impossibly fast decisions are made in a very old, nonrational part of the brain to which all vertebrates have access. It is our good fortune that those decisions are about winning or losing rather than living or dying.

All consumers are properly scaled for the foods they require and equipped with tools to make use of them—being specialized for one food type necessarily makes us ill-suited for others. The outcome is that communities are a fabric of generalists and specialists that we can make sense of through the far-reaching Principle of Competitive Exclusion: species with similar needs will evolve ways to minimize competition between them. The principle is especially noticeable in adaptations that relate to foraging for food, but they apply to nesting sites and more. The meshing of skills is so extraordinary that we can imagine Mother Nature convening a council—as in a child's "Just-So-Story"—where species negotiate their various boundaries with an outcome not far removed from gerrymandering. Endless millennia of competition and natural selection have brokered these arrangements that minimize competition and maximize efficiency. The outcome of those endless and continuing deliberations is another part of the nebulous, barely-detectable organization to which I've made reference. Every consumer has differentiated from his competitors in body and behavior.

Related birds, like the Downy and Hairy Woodpeckers (Figure 7.3) are a case in point. They were recently moved to different genera, but their gene pools diverged from a common source at a time not so long

7.3 Two photographs have been merged to allow a direct comparison of Downy and Hairy Woodpeckers (left and right, respectively) while they feed on a "peanut butter log"—a short section of Elm, with holes drilled and packed with peanut butter. The best distinguishing character is bill size as a proportion of head length.

7.4 Black-capped Chickadees forage at the tips of twigs with astounding agility. That position provides an unobstructed view of their world, from which they can sound a predator alarm.

critical resource that feeds them all is that vast array of sequestered, overwintering invertebrates. Members of the feeding guild work in their prime foraging zones. The partitioning is as structured and sophisticated as a zone defense with each position filled according to the strengths of the player. Beyond minimizing turf wars, the primary benefit of a guild, with many eyes watching from many positions, is to alert members to the presence of a predator so that members can feed undistracted until an alarm sounds. Vulnerability to predators is a risk that is outside of our common experience, so we are particularly insensitive to it and inclined to undervalue its significance.

Here at Brawley Creek, five familiar species form the guild. Black-capped Chickadees (Figure 7.4) are one of them. Terminally cute and sassy, they are everybody's favorite. They weigh only 11 grams, the weight of two sheets of low-end copy paper, and in the words of Aldo Leopold they are, "a small bundle of large enthusiasms." Along with Tufted Titmice, they work the open areas and the two of them vie for the titles "most excitable," and "most vocal." That makes them excellent sentries. Chickadees are the aerialists of the troupe, equipped and motivated to inspect any likely space, often hanging upside down to inspect the less accessible underside of twigs, the sheltered half that, after all, makes up half of all the twig surface area.

They are looking for invertebrates ranging from very small to nearly microscopic—small enough to take refuge in any irregularities of which there are a lot more than we often imagine. One wonders that a Chickadee can feed himself in his foraging zone. Most of the twigs we see are new growth with a smooth, almost waxy surface that offers no hiding places. But, by the time two or three years have passed, a lot of twigs have died and become covered with lichens and fungi, or they've suffered injury and are cloaked with loose bark, opening protected spaces—crevasses that can hold overwintering egg masses or adult invertebrates. They hide in tiny spaces between the bud scales or in the micro-forests of lichen and fungus that are abundant on the branches of trees, especially Honey Locust and Walnut, of which we have an abundance. If you are tiny—nearly microscopic—the number of hiding places is vast and more three-dimensional than we usually imagine. Figures 7.5 and 7.6 present a few examples of the micro-wilderness that amounts to many acres of surface area in which Chickadees can forage.

ago. As woodpeckers, they have similar needs and abilities, and one would expect them to compete on every level. If they did, though, one or the other would have won by now—there are no tie scores. That both species live here, is testament to the success of their partitioning of resources, and not only here; both species live together all across North America.

Larger birds are more efficient with larger foods. Living as we do, that distinction may seem inconsequential, but it isn't. Size classes of this sort develop everywhere in many kinds of animals. Hairy Woodpeckers, at 66 g, are 2.4 times heavier than Downy Woodpeckers at 27g. Beyond that size difference, the proportions of their bills—their food capturing apparatus—differ markedly. That tells us something about the prey upon which they are dependent.

With interspecific competition minimized, some species are able to work in interspecific cooperatives, foraging together with little competition. This loose organization is recognized as a feeding guild, and the

7.5 ~ 2X. Twigs to scale. Left to right: Sycamore, Grape, Hackberry, and American Elm.

The bills of birds say a lot about how they find food, how they capture it, and how they consume it—it's why the shape of the woodpeckers' bills seen in Figure 7.3 is so telling. Chickadees have straight bills that are short, stout, roughly cylindrical in cross-section, and cone-shaped. They function as probe and forceps that are used to inspect any spot that might conceal something edible. They pry between the bud scales on twigs, where their light weight allows them access and room for their extraordinary acrobatic maneuvers. Working there, they have a largely unobstructed view of the world and they are often the first to sound the alarm if a predator makes an appearance. Chickadees are excitable and extremely aware of the world around them. They seem curious about everything, and are among the first to find a new feeding station, but because guild members are exceptionally aware of each other, soon everybody else knows too.

Tufted Titmice are as common as Chickadees. Functionally they are heavy-weight Chickadees with everything scaled up. They are not as flighty as a Chickadee, but then neither is anything else. At 22 g, twice the weight of Chickadees, their foraging zone centers on the

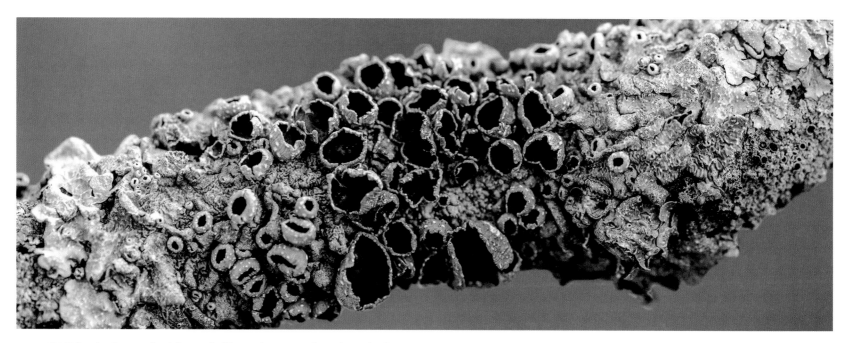

7.6 ~ 8X. It's hard to know what life is really like on those twigs, but a long-dead Walnut twig fallen from the canopy, shows the lichen load covering the twig, creating a surprisingly complicated landscape with an endless supply of hiding places for overwintering invertebrates.

thicker branches, more manageable for a bird of their heft. Comparing the size and shape of their bills says nearly everything about their roles. Titmice can also see widely while working their zones. Along with the Chickadees, they function as sentries when the guild is at work.

The three remaining species of the guild, White-breasted Nuthatches (21 g), Brown Creepers (8 g), and Downy Woodpeckers (37 g), work the branches and trunks of trees—it is close work in a rough, fractured landscape. The sizes and shapes of their bills differ wildly, consistent with harvesting different prey from different parts of that landscape. Their bodies are proportioned to cling to bark rather than grasp twigs and that keeps their noses close to the grindstone where they are less apt to sense an approaching predator. The tail feathers of woodpeckers and creepers are modified to support their bodies by triangulation while they work.

Nuthatches are mid-range—birds of the tree trunks. They don't have stiff tail feathers for support like woodpeckers, but they hop along—literally hop—up and down the trunk as well as sideways, and that kind of tail support would only get in the way. Their solution is to substitute large, strong feet for that tail brace, equipped with a strong, oversized rear claw (Figure 7.10). The bill is long and sharply pointed with a slight upward deflection (Figure 7.9). It makes a weak excavating tool, but it is an excellent probe/forceps with which to work the crevices in the bark of mature trees. Their trademark upside-down posture is remarkable. Gripping the bark with just their toes, they carry the entire weight of their body at right angles to their support. Because they hop rather than walk, an action that I'd really like to see in slow motion, their ability to move up and down the trunk is unsettling, especially when they hop rapidly along the underside of a branch. They work the same areas as Downies and Creepers but their tools and their upside-down orientation provides a different view of the bark. Any hiker who hopes to return to base can attest to the idea that things look different on the return trip, and that must also be true at this scale.

The fourth member of the guild is the Brown Creeper (Figure 7.11) known for its unique feeding behavior. Tyler (1948), writing for the National Museum elegantly describes the action this way: "… as he hitches along the bole of a tree, [he] looks like a fragment of detached bark that is defying the law of gravitation by moving upward over the trunk, and as he flies off to another tree he resembles a little dry leaf

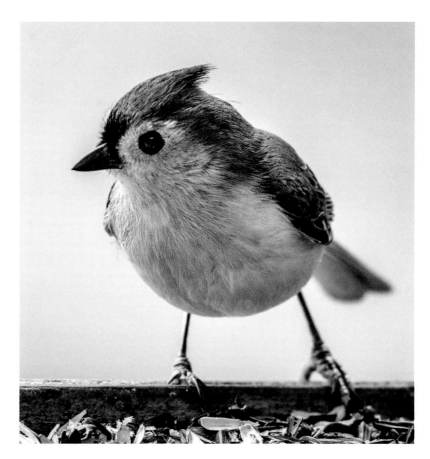

7.7 A Tufted Titmouse looks over the selection of black sunflower seeds in our feeding tray, always hyper-alert, for him, this is leisurely.

blown about by the wind." That description is remarkably accurate. Scientists don't write that way anymore, but Creepers still act that way. They fly to the base of a mature tree, where the bark is most deeply furrowed, and begin foraging by hitching their way up the trunk, drifting around it as they go—feet and tail forming a three-point platform of support from which to probe the crevices.

Their combination of plumage and behavior makes them stealthy, but it is their other characteristics suggest how the bark-foraging species of the guild can extract arthropods, differently enough, so that all three can forage on the same tree trunks without undue competition. Those characteristics include their small size, very thin, decurved bill, and eyes that certainly must focus to an inch or less. Nuthatches are 2.6 times the weight of Creepers, a ratio that pops up in many competitive scenarios around the world. It is the same proportional size

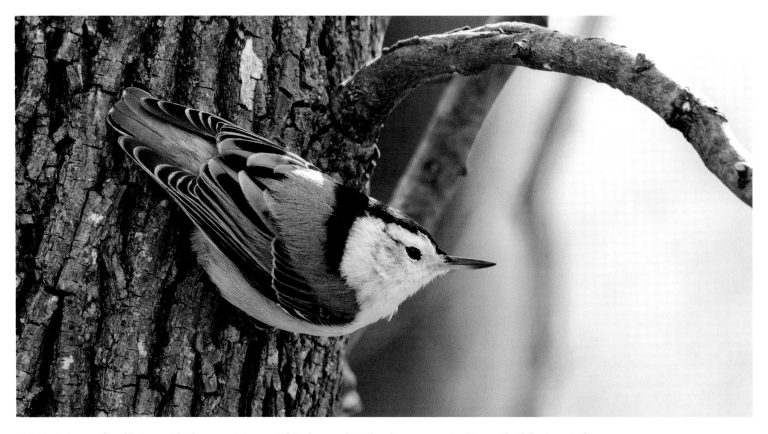

7.8 Entirely comfortable in upside down positions, a White-breasted Nuthatch, unconstrained by stiff tail feathers, is free to roam about on the trunk in all directions more easily than woodpeckers.

7.9 Close inspection of a Nuthatch, details their forceps-like bill. The loosely feathered area immediately behind the eye covers the ear canal, functioning like the porous cloth over stereo speakers.

difference of Downy and Hairy Woodpeckers. A Creeper's bill functions like a micro-forceps, ideal for extracting tiny prey—less than 3 mm. I've examined a few tree trunks very carefully, finding nothing, and subsequently watched a Creeper busily feeding in the same area. The bills of Nuthatches, which are thicker, and straight to slightly recurved, can't reach the same places, and they prefer larger prey in any event. Woodpeckers could excavate those crevices, but they too would likely find the prey not worth the cost of extracting them.

Downy Woodpeckers (Figures 7.12 & 13) work those same areas, along with smaller branches. When they detect an overwintering grub under the bark and estimate that the unseen prize is worth the cost, they engage in demolition and excavation. Their robust assault on the bark and sometimes into the wood is supported by stout feet that, along with the stiff, supporting tail feathers provide a sturdy platform

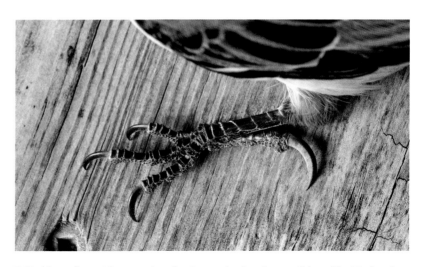

7.10 A large foot with a rear claw that is oversized and powerful, enables Nuthatches to move about on tree trunks, anchored only with their claws.

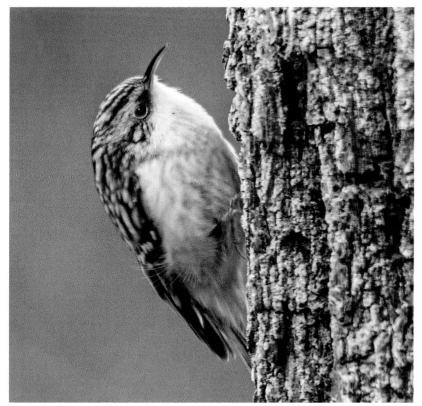

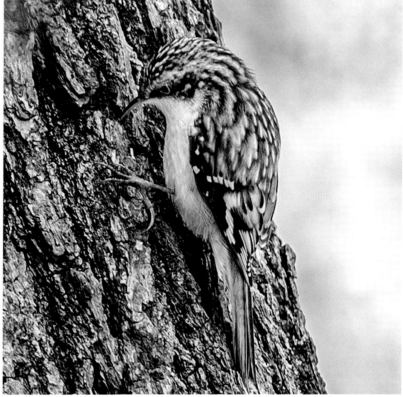

7.11 A Brown Creeper is shown here near life size. They are uniquely suited to close inspection and extraction; their bills are tiny, curved forceps, the long rear claw and support by stiff tail feathers provide the required leverage to poke and prod. Their patterned back enables them to effectively disappear into the bark.

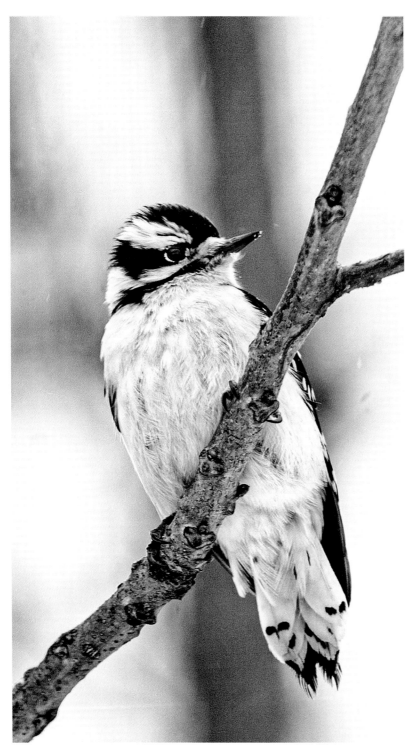

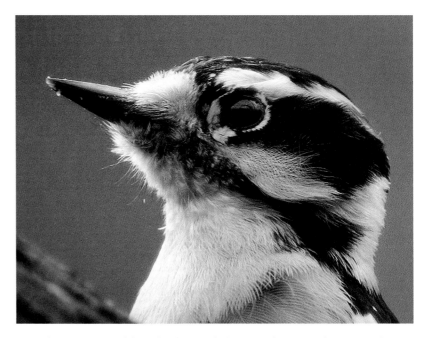

7.13 The upper mandible is chisel-shaped, the vertical cutting edge so thin that it is translucent. The nostrils are buried in dense tufts of feathers, said to keep them from inhaling wood fragments as they work.

7.12 Downy Woodpeckers are the excavators of the gleaning crew. A female has adopted a semi-crossways position on a Walnut branch, waiting for a slot on the peanut butter log and showing her two forward directed toes.

for the assault. The toes of woodpeckers are arranged to maximize their grip. Two toes point forward and the other two backwards, so that each foot has opposable digits configured in an "X" shape and equipped with very sharp, curved nails. They provide a firm grip on almost any bark and with those stout tail feathers, enhance their stability in the way that we take a broad stance to swing an axe. The whole package makes of their body a formidable excavating tool.

The bill is straight and stout like a chisel, beveled at the tip on both sides. His head becomes the hammer that drives the chisel. It's hard for us to imagine such a routine battering of the head. Our brains are way too heavy, our necks too flimsy, and even the most robust nose inadequate. Woodpeckers manage because they are built for it in many ways, including fat deposits in the skull that cushion the brain on impact.

Members of the guild make a living in the Winter by probing bark crevices and poking into any other places that might house tiny invertebrates that provide both fat and protein. Gleaners will have access to higher levels of both when insects become active and widely available. That is when growing chicks need a lot of protein, but for now the

adults need calories more than protein. Fortunately, prospectors by nature like the other gleaners, they quickly find a new supply of calories even if presented unnaturally, on a feeding tray. The high caloric content of carbohydrates and oils in the masses of sunflower seeds on our feeding trays and peanut butter logs, supplies it to them. In exchange, the feeding stations provide us a close look at their interactions.

The rest of the birds who eat seeds—and a few mammals—are alert to the action of those prospectors, and that brings them to our feeding stations as well. The circumstances of their interactions are distorted in that context, but we can watch their interactions and develop some insight into their personalities. The size differences among our visitors shape those interactions. At 11 grams, Chickadees avoid everybody else. If the tray is crowded when they approach, they flit to the guttering on the house or another nearby perch to study the crowd, waiting for a space into which they can dash, lift a sunflower seed with the skill of a pickpocket, and escape to a branch where they open it. Their attack on the seed is classic. They clamp the seed to a branch using the toes of both feet, lean back slightly on their haunches, and strike the hull solidly with the bill closed. Their bill is an excellent splitting wedge too, that together with the muscles of the head and neck, effectively splits the hulls after a few strikes and the meat is extracted. Chickadees are high-strung and rarely stay still, but if the tray is unoccupied, they may pick and discard several seeds—"thumping the melons" I suppose—to find a good one. For them, that means choosing a seed of the right size and shape to handle well and heavy enough to suggest a worthwhile meat. Taking those extra seconds yields the most calories per sortie. More energy gain per unit effort.

Titmice (22 g) are twice the weight of the Chickadees who defer to them. They process the same seeds with the same method, although their splitting wedge is larger and the maul heavier, as required for their natural foraging niche. They are more likely to open seeds on the edge of the tray where they remain in position to take second and third helpings without a commute—it is more efficient.

Nuthatches (21 g) are equivalent to Titmice in size, but with that formidable, stiletto bill and aggressive nature they carry a large presence: when they burst onto the scene, the smaller birds scatter, especially the Goldfinches (9.5 g) who startle easily anyway, though the larger birds stay put. Nuthatches begin their approach by studying the feeder from an upside-down position on a nearby tree. If all is well, they drop from the trunk and begin their bounding flight to the tray. A Nuthatch picks one seed, often discarding a few, and bounds off to the nearest sizable tree. He can't access the meat like the others, because his legs are positioned so far back on his torso and his bill is long. Instead, he forces the seed into a crevice in the bark that holds it like a vise, and he splits it open with his sharp bill, extracting the meat as he would extract a spider from a crevice—he's perfectly suited for that method. Downy Woodpeckers use the same procedure. Creepers almost never appear at our feeders. I don't see how they could open a seed either way, but they are not above picking crumbs of sunflower meat left in the bark-vise of Nuthatches and Woodpeckers.

The birds of the Guild are insectivores that eat seeds in the cold seasons. All of our birds take insects in the warm months—growing chicks require protein-rich foods to build flesh, bone, and feathers. But seed-eaters—cardinals, finches, and sparrows—are "professionals" with heavy bills that are equipped crush seeds and tongues built to manipulate them. They may not be the best insect-catching bills, but food is plentiful in the summer, and their needs during the challenging cold season are what has shaped them.

Most of us have become so accustomed to Cardinals that we rarely notice how extraordinary they are—how striking the plumage of both sexes. They are the largest of our seed-eaters. Watching them process seeds is like watching a card trick. You know something is going on, but it happens so quickly that you can't quite see how they do it. You can watch them carefully as they pick up a seed, then their bills move at a furious pace, faster than a football coach chews gum on the sidelines. They look like they are nibbling at the seed, but the shells quickly dribble out the sides and the meat disappears.

The secret lies in a specialized bill, that can be seen at work with a Purple Finch performing (Figure 7.15). The edges of the upper mandible have grooves along their length that receive the single ridge of the lower mandible so that the upper and lower mandibles nest perfectly. The bill picks up a seed, the tongue moves the seed into position, the mandibles close, and the seed coat cracks, but they use multiple closings that I've characterized as nibbling. Like our own, their lower mandible can move forward and backward, and from side to side. The high-speed nibbling is the process of separating the shell fragments

7.14 The family Cardinalidae includes the aptly named grosbeaks, who like these Cardinals, have exceptional power in their bills.

from the meat so that the shells fall away, leaving the meat inside. A heavy, reinforced bill, scaled to the preferred seed sizes, is essential for this work and clearly identifies a seed-eater. Their mechanism is much more efficient than the nutcrackers that we use to open walnuts and pecans, but then they are professionals and the right tools are important.

Seed-eaters like the White-throated Sparrow in Figure 7.16, are primarily ground feeders that forage for seeds and invertebrates. They have adopted a peculiar but effective foraging style that is common among ground feeders and that works well for removing cover to expose whatever lies underneath. It is a lightning-fast, two-foot shuffle that looks a lot like the "both feet in, both feet out" part of the hokey-pokey. The forward hop (in) places both feet into undisturbed territory, immediately followed by an abrupt raking action with both feet

(out). This scatters the leaf cover behind them, exposing whatever was under the leaves—seeds of course, along with pupae and any still-active or dormant invertebrates. Several raking actions in quick succession can clear a proper area. It makes a lot of noise but at the end of the series, the head is perfectly positioned to grab fast moving insects before scanning the cleared area for seeds, pupae, or egg masses. The birds are solidly grounded, well balanced, and postured for a quick exit should their activity attract attention. This foraging behavior allows them to work inside brushy tangles and other relatively safe places.

People buy food for birds in a bag labeled "Bird Seed." But it is clearly mammal food too, and squirrels respond to the call, apparently unaware that they are eating bird seed. Some people take offense and initiate an un-winnable battle against highly motivated animals with nothing else to do. They are preternaturally clever and in the end, they

7.15 Purple Finches cracking seeds. The sunflower seed in his bill shows the initial lengthwise crack—additional manipulation will expand the crack and separate the hulls which will fall to the ground.

will have their share of the banquet and maybe a little more. They are Winter-stressed too and undeniably cute for gluttons. After dark, the night shift shows up at the feeding station. We are on the circuits of Raccoons and 'Possums, and mice pick over the spilled and rejected seeds and take them under the porch and other protected spaces. All of the species that take our food are interesting, and being able to observe them so closely, and to learn about who they are, is well worth the expense.

These birds survived the Winters before people began feeding them, but arctic fronts move through, bringing sub-zero temperatures and the natural pantry becomes steadily depleted. Occasionally, heavy snows or ice storms can interfere with birds' access to food for days and sometimes a glaze of ice locks the seeds in a glassy case, but it is a common occurrence of Winter and the natural residents have evolved to survive those conditions through a suite of adaptations. Warm-blooded animals who are active through Winter are always skating on thin ice. The smaller they are, the more difficult the challenge because of another fact of life that is of critical importance and applies across a broad spectrum of circumstances. It shows up here in the guise of controlling heat loss, but the same phenomenon applies to the exchange of gases and nutrients through membranes, and water loss. Shrews and

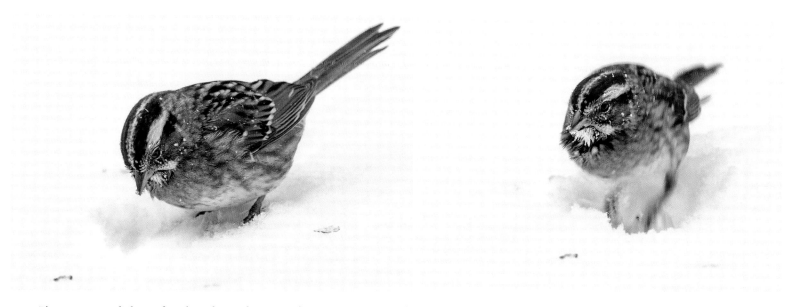

7.16 The tan-crowned phase of a White-throated Sparrow demonstrates that shuffle, scattering the snow to reach the spilled and discarded sunflower seeds.

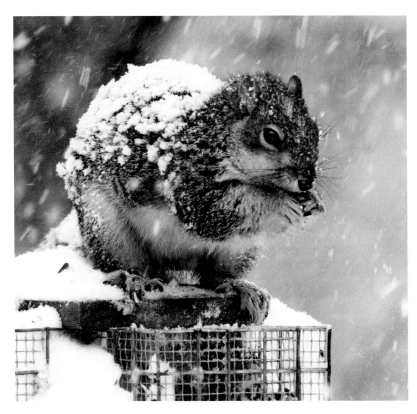

7.17 Fox Squirrels are bigger than the Gray Squirrels we also serve. Unlike birds, there is no reason they should avoid putting on a little fat.

chickadees, as different as they are, have this same problem. Both are small and warm-blooded, and during the Winter there is a big difference between internal and ambient temperatures. It's their small size that makes them particularly vulnerable.

The phenomenon in question is the mathematical relationship between surface area and volume, usually expressed as a surface/volume ratio. Black-capped Chickadees are an excellent model to bring this fuzzy idea into focus because they are so small, their energy budgets have been studied, and they overwinter as far north as the Arctic tundra. Brawley Creek is at the extreme southern edge of their range, beyond which their role is assumed by Carolina Chickadees. Still, they experience temperatures colder than -10 °F, and while active they maintain an internal temperature of 107 °F. The question before us is, "How can a Chickadee live in this environment?" How can an 11 gram ball of fluff, survive?

Surface area is effectively two-dimensional. Of course, their bodies

are three-dimensional, but the thin layer of skin that wraps the body is still two-dimensional, like wrapping paper, even if it is wrapped around a vase. Chickadees are hot inside and separated from the outside cold by nothing more than a very thin membrane and the feathers it makes.

Chickadees are constantly losing calories, as are all warm-blooded animals. With every breath they heat the cold air they inhale, and then exhale calories (water too) in the form of warm, humidified air. They lose fewer calories through the skin, but the feathers are not distributed like hair is in mammals. Birds arrange their feathers in tracts with large gaps between them. I'd guess that must feel drafty as the bird engages in acrobatic foraging, the feather tracts shifting to accommodate the movements—maybe it feels like a too-short jacket in cold weather.

Birds can't stockpile much fat even if food is abundant, because every gram limits their efficiency in flight, and they do a lot of that. For Chickadees, carrying an extra gram of fat is an 11% weight gain—equivalent to my gaining an extra 20 pounds. Like a tourist who has over-packed, that extra weight is costly to haul around, and it also compromises the bird's agility. They can't afford to metabolize the protein in their large muscles as we can. So, if their fat supplies run out on a cold night, Chickadees die as surely as the migrating Garden Warbler from Chapter 2, who drops into the sea if he runs out of fat. Starving and freezing are much the same. That's living on thin ice. This phenomenon is covered in some detail in Heinrich's book, Winter World (2003), and it is well worth a closer look.

After a successful day of foraging, a Chickadee's fat reserves amount to 0.8 g. By morning, only 0.3 g remain. Every day they must find enough food to generate 0.5 g of fat in addition to the calories they spend while foraging. The colder it is, the more calories must be captured, and yet Chickadees remain abundant. This is how they do it.

1. Their plumage is very dense and the dead air space between lofted feathers is a major barrier to heat loss. Those lofted feathers give them that little butterball appearance that we find cute, as in the sparrow in Figure 7.18. Being cute is not irrelevant—it triggers our empathetic response, making us care about them and spend our resources to put calories into them. Our reaction is not much different than the Cardinal feeding goldfish noted earlier.

2. The bare feet of birds are kept only a few degrees above freezing.

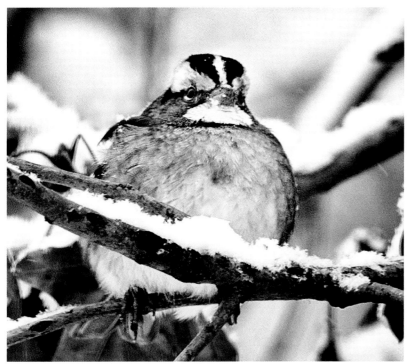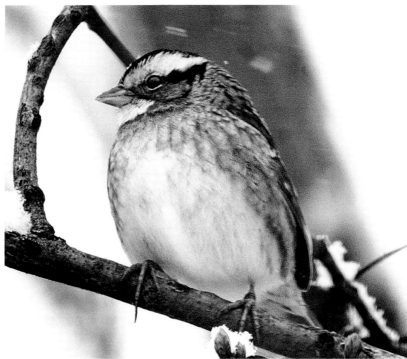

7.18 Left: The White-throated Sparrow looks fat but he's not—he is cold, and he has lofted his feathers to trap air that will improve his insulation. His feathers engulf his bare legs—only the toes are exposed. Right: This sparrow must be cold too, but anticipating a move, he has compressed his feathers, sacrificing a little heat for better mobility.

It's a neat trick. They can do it because the feet themselves require little oxygen; they are controlled by long tendons as if by a puppeteer. It is the muscles that require a substantial blood supply and the muscles that control them are in their tiny drumsticks and thighs, both of which remain tight against the body and well within the heated envelope. But they are still living tissues and they need some oxygen. Like many birds, Chickadees have heat exchangers built into their circulatory systems that allow them to keep the feet cooler than the body even while they share the same blood supply. The arteries and veins that serve the feet are bound together in a sheath of connective tissue so that the outgoing arteries and veins lie parallel, separated by only thin tissues. That arrangement allows for some heat exchange, pre-chilling the arterial blood to minimize the temperature difference from the outside cold, as it transfers its heat to the returning venous blood.

3. The thinly feathered face suffers the greatest heat loss. They've not solved that problem anatomically, but during those long, Winter nights, they bury their face beneath their scapular feather tracts like the Carolina Wrens in Figure 7.19. That posture, with the feathers lofted maximally, not only reduces heat loss directly from the face, but preheats the air they breathe.

4. Chickadees turn down the thermostat for the night, entering torpor to drop their body temperature by 10 to 15 °F.

5. They get out of the wind and they fluff their feathers in the extreme, sometimes sleeping in close contact with others of the same species in unoccupied woodpecker holes and tiny crannies where their naked feet are engulfed by their plumage. Sometimes they emerge from cramped overnight quarters with tail feathers bent, like the Chickadee in Figure 7.4, but the feathers eventually straighten, and it is profitable even with a tiny loss of aerodynamic efficiency.

6. They shiver vigorously most of the time they are asleep. Using those muscles without going anywhere is the mechanism by which they release heat from stored fat. Most of us have spent a night shiver-

7.19 A pair of Carolina wrens huddle together on window trim over the hot tub. Good choice. Those white spots are not frost, but part the feathers normally hidden when the bird is active.

ing and found it really uncomfortable, but that doesn't mean that birds experience it the same way. We are, after all, a pampered, tropical, mammalian species, while they are none of those things, and they evolved here. It doesn't seem likely to me that an activity evolved as routine maintenance would cause discomfort, but of course we have no way of knowing what the bird feels.

We enjoy our feeders, and our motive is clear to us. We don't undertake the effort and expense to feed the starving birds—they did quite well before we arrived. We do it for our own enjoyment, and a big part of that is enlarging our understanding of the world outside of our cocoon. We can bring these birds into our lives, learn about the personalities of each species, coming to know them in a way that is hard to imagine otherwise. By providing resources for birds (and more than a few mammals) during extreme weather events, we increase the populations of these birds. We recognize that it has an impact that interferes with the natural state of things. Feeding the birds doesn't "do just one thing" either, but we've made that choice.

There is probably no better place to consider predation—not the

distant food chain with hypothetical owls and mice, but the real thing. Attracting small birds brings them into the open and attracts small-bird predators, and sometimes the guests become the banquet. Our most visible predator of songbirds is the Sharp-shinned Hawk, to whom the gathering in Figure 7.20 must seem like the picture menus ubiquitous to fast food drive-throughs.

Predation improves species in ways that are counter-intuitive because we empathize with individuals but not populations. Gene pools are never cute, although I confess that nobody has ever seen one. They are not only entirely real, they are the principal evolutionary unit. But we are invested in individuals—the pawns of gene pools—who pay the price and when we see that, it's difficult for us to embrace—our empathy at work. We invest in the birds that visit our feeders, we are entertained and amazed by them, we feel like we know them, and we care about what happens to them. However, they are prey for the Sharp-shins who live here too, and it must be this way. The earlier chapters were placed there and dissected in sufficient detail to make clear exactly why it must be this way. Accepting this reality, at least intellectually, is critical to a mature understanding of life. But that doesn't make it comfortable. As sheltered, top-of-the-chain predators, we don't experience that kind of vulnerability and so it is easy for us to misinterpret some of the things they do that seem peculiar to us. That vulnerability has shaped their bodies and their behaviors in ways that improve their gene pools. Certainly, we've never been stalked by a Sharp-shin equivalent, who for us would be a fast and agile predator, specializing in human flesh, who kills efficiently by ambush and pursuit, and who, scaled up to our size, weighs well over a ton.

We cringe on seeing a kill up close, when a Sharp-shin takes a Chickadee just inches away on the other side of the window. It is shocking, but it happens so quickly that it takes your breath away and one can't help but be in awe of the grace and skill of the predator, before feeling an empathetic response to the death of the prey. At least that is our experience. We need to get beyond our gut reaction. At Brawley Creek, we mourn the loss of the birds we feed, but we also admire the skill and speed of the hawk who must kill or starve. The same can be said for all consumers, Chickadees, Cardinals, and Humans. Predation is an absolute essential if the energy wheels are to keep turning, so these deaths are as pre-ordained, as are our own.

An intellectual grasp of the situation doesn't carry the appropriate gravitas. For the vast majority of us, being present for a kill is entirely beyond our experience. We see it in videos and experience it vicariously through books and films (with popcorn), but the real event is an everyday experience for mice and small birds, year-round, so let's make an effort to experience it in unusual detail, still vicariously of course.

Our songbirds, including our 11-gram Chickadees, live with a Sharp-shinned Hawk in the neighborhood and they are fearsome predators. The hawk is 13 times the Chickadee's weight, and even at that he weighs considerably less than a cup of sugar. But this is everyday life for Chickadees, Cardinals, and the rest.

One afternoon a Chickadee streaked by me—just over my right shoulder—to land in a Washington Hawthorn, a shrubby tree noted for its red berries. At that moment, however, its critical property was its tangled branches with their abundant, two-inch, dagger-like thorns. The Chickadee seemed panicked and with good reason, because right on his tail, a Sharp-shin plunged into the tangle after him. The Chickadee flitted about frantically, like a pinball moving in three dimensions. The hawk, right behind him, reaching and grasping, the whole event passing in something of a blur—where is the slow-motion video when you need it? But we can animate the encounter in our minds if we know a few things.

Katrina van Grouw (2013) writes about the anatomy of the killing feet of Sharp-shins. "It is all about reach," she says. "[They have] long thighs, long tibia, long tarsi, and long toes." But the pièce de résistance is the flexibility of the claw at the tip of his unusually long middle toe. That claw can flex far enough to fold back under the toe and make firm contact. If he can reach the bird with that claw, at the end of those long thighs, long tibias, long tarsi, and long toes, he can grasp the bird with this pincher-like apparatus and his reach is extended by several millimeters. It becomes clear once again that life in the little infinity is a game of millimeters, milligrams, and milliseconds.

7.20 Cardinals don't flock, but they aggregate when snow hides their natural foods. There are 19 Cardinals, 4 Juncos, and 2 White-throated Sparrows all sitting within 25 feet of the window feeder.

7.21 Sharp-shinned Hawks are superior predators who eat their kill where they take it, this time he has taken a Cardinal near our feeder. But I unsettled him, so he left, taking the last edible parts with him (Figure 7.22). He eats everything—bones, bill, and feet—so that when he leaves the spot of the kill, there are only feathers and a little blood.

Back to the Hawthorn. There was furious flapping and wings colliding with branches, but no other sounds. I don't know how either bird avoided being skewered by the thorns. Maybe they were, and in the fury of the action neither noticed. Or maybe, because they live in a different scale there was much more room in that tangle than I can imagine. In the end, the Hawk's reach, even with his prehensile claw, was no match for the Chickadee's agility in the maze, and after a few seconds, the Chickadee flew off and into the woods—in what I saw as a leisurely way with his unhurried, bounding flight. I halfway expected him to whistle a happy tune. The Hawk stood in the cage of thorns a short while and then moved on. Then there was silence—no hint, no echo of the life and death struggle that had played out just a few feet from me. I replayed the event in my mind to assure myself that it really happened. It did.

I drew two conclusions. First, I'm fairly confident that the Sharp-shin had been led by the Chickadee into a "hawk filter." He knew exactly where that tree was, how quickly he could get there, and how to use it when he did. That speaks to the value of cover for a prey species, and for their knowing what cover is suitable for each kind of threat, and how to get there quickly. One wonders whether, if the Chickadee had been a few tenths of a gram heavier, if he would have made it.

The second conclusion is broader: it was just another day at the office for both of them. Small birds like that must live with a level of awareness rarely required of us. I wonder what it would feel like to live in that world.

Communities have effective warning systems of which the feeding guild is just a part. When the sentries of the feeding guild detect a predator, alarm calls are issued—the most strident and persistent come from Black-capped Chickadees who begin their dee-dee calls to announce a level of threat that also discriminates between high-approach or low-approach predators. Other species: juncos, sparrows, and nuthatches understand these warnings—no small issue—and they deliver their own, and they respond to those from a variety of sources. Apparently, they talk to each other often and it seems like we are the only species deaf to them, although surely our distant ancestors were not.

Jon Young (2012) writes eloquently about communication among species, and he describes a "zone of silence" that slides through the for-est with him like a "wave" propagates through a crowded stadium. As a Sharp-shin passes through a forest, alarm calls from various species precede him, and his prey are shielded by that zone of silence. What do warned birds do? They move to high or low cover depending on the warning, but if they find themselves in an exposed position, like our Nuthatch in Figure 7.23, they become absolutely still. Absolutely still. This one, holding a choice sunflower seed in his bill, froze in mid-launch and remained entirely without motion for at least four minutes. As the seconds ticked by, I became aware that nothing else was moving either, and that all was quiet. Seconds became minutes. I never saw the hawk but I'm certain he was there, that the nuthatch heard the network's alarm, and responded properly. Eventually activity resumed—the Nuthatch turned his head slightly as if waking from trance, quickly scanned the sky, and after a few careful seconds began to look around. Only after that, did he resume his launch and fly into the woods.

Winter may seem endless to all involved but the earth is advancing in its orbit and eventually Winter and Spring scrimmage, long before the vernal equinox, pushing each other back and forth across the lati-

7.22 This is a revealing photograph even with the detail blurred. Those very long legs, not even fully extended, reveal the approximate proportions of a Snowy Egret.

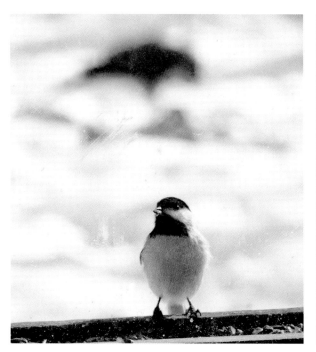

7.23 Living with Sharp-shins. Left: The Sharp-shin has made his kill so the Chickadee knows he is not at risk, and he can't afford to just sit around, idling. He is always burning fuel and he must gather enough calories to live through the night. Right: An immobile Nuthatch is a rare sight in real life, and it says something. His response to a detected hawk is to become absolutely still but for the occasional blink of an eye.

tudes, contesting an outcome with a foregone conclusion. Eventually, the days grow longer at an increasing rate, easing the chill and the stresses of Winter, and the community stirs prior to awakening.

For us, the December solstice that ushers in a Winter of privation is a curiosity, but for our ancestors who lived close to the land and experienced it, it was a promise that however much misery lay ahead, an end was in sight. It was the major event of the year—nothing less than the birthday of the sun. The significance of its existence to all life cannot be overstated. Today, we celebrate this event through a complex of traditions, including an unequalled spending binge, while the solstice remains a footnote. Our failure to connect the celebration with the event and its ultimate impact is perhaps the most telling indicator of our disconnect from the world outside of ourselves.

But our Chickadees know. And all the rest of our active residents, or at least their bodies do. Their pineal glands, those unassuming nubbins of brain cells that in birds reach all the way from the brain stem up to the paper-thin roof of their skull, are just what they look like. They are light sensors that religiously monitor day length. And like competent assistants, they send daily reports. By mid-January, only a few weeks after the solstice, the pineal notices and reports the change, issuing a chemical message that triggers birds' testes to swell, stimulating the release of sex hormones, and generating in males the need to sing. They are not very good songs. They are fragmented and the birds seem indifferent, but they have unambiguously begun awakening to the start of their reproductive season. In two months, they will be nesting, but that's a different season.

7.24 The warmth of the sun reflects from a pool of melted ice along the shoreline. It is a promise of Spring.

8.1 A Red-winged Blackbird is caught at the ultimate moment of his "songspread" display. The costume, posture, and intensity of the performance is operatic and serves as an aggressive territorial challenge to males. At the same time it is a sexual display directed at females who are tasked with evaluating his quality as a mate. The females, through their choices over many thousands of generations, have created his colors, choreographed his display, and corrected his voice into a composite fantasy come to life.

8

Spring: The Awakening

"Behold, my friends, the spring is come; the earth has gladly received the embraces of the sun, and we shall soon see the results of their love!"

~ Sitting Bull

Spring is the most visceral of the five seasons—a community-wide awakening that begins as impulsive flirtation and progresses to the heady excitement of an adolescent crush. It is an ebullient, high-spirited progression that will reach its peak in early May as the canopy deploys and floods of migrants arrive like surfers on the crest of an enormous green wave. The atmosphere is Carnival, and it is particularly exhilarating for us here at Brawley Creek. That's because in addition to the strengthening sunshine and balmy weather that all of us enjoy, we see ourselves as part of a community and we celebrate our successful passage through Winter and the arrival of times of plenty. Their excitement as they advance into spring is palpable and infectious, and the early days of Spring eventually lead into a reunion with migrants, returning from far-flung places, some of whom are just passing through like a troupe of entertainers, and some that will nest here. They have been away, and their return defines Spring as powerfully as the scent of woodsmoke in the fall.

Life awakens in the Spring when the time is right, but that leads to the question of when is the right time, and for whom? Day length increases in a reliable progression, but temperatures fluctuate. Returning birds, emerging plants, and hatching insects all gamble on weather that is notoriously capricious, especially in the Spring, and their

lives hang in the balance. Some years, the arrivals are running a week or two behind schedule and the last of the migrants haven't punched in yet. That may be because of a cold wave or stalled weather front, but it feels like they are well beyond curfew and that's when we begin to worry that they won't come back this year. That was unthinkable before Rachel Carson's Silent Spring, but a few of our species don't come back anymore. Whip-poor-Wills, Grasshopper Sparrows, and Pine Siskins were once common in their seasons, but we've not seen or heard them in more than a decade. Populations of migratory birds are suffering major declines, and every spring our anxiety becomes more credible. But eventually, most of them come dragging in. Spring is indeed visceral, and we revel in the spectacle, the broad sweep of activity, and in renewing relationships as the season unfolds.

Unlike Winter, Spring begins without a singular opening event. There are so many events that its beginning can't be linked to any one of them, least of all to our Groundhogs who are smart enough not to come out on Groundhog's Day. Even so, we celebrate Groundhog's Day as the nominal beginning of Spring: by that time the stirrings are apparent and much more tangible than the guarantee of its arrival "someday" as the winter solstice promises.

The first events of Spring come in the dead of Winter—mid-January—just weeks after the earth passes its winter solstice. We hear a few notes from the resident birds—uninspired bits of song tossed off here and there. The phrases are incomplete and feel tentative, as though a lapsed musician was tinkering with the idea of returning to the stage, and maybe it isn't such a good idea. Chickadees and Titmice are first, and now and then a Cardinal. They aren't serious about it, they are simply responding to hormonal changes triggered by lengthening days, but their songs become more frequent, more complete, and they are delivered with more conviction as day length continues increasing. Nuthatches and Downy Woodpeckers begin to take part. From the frog ponds, we hear a few tentative and questioning peeps from the Spring Peepers, and now and then the slow creak of a cold Chorus Frog. They are lethargic and it's all talk—no one is serious about it yet. Before long though, it becomes serious, even deadly serious, and all-consuming because success is the guarantee of continued existence and that is reason enough.

Those questioning peeps soon surge into a deafening chorus, as

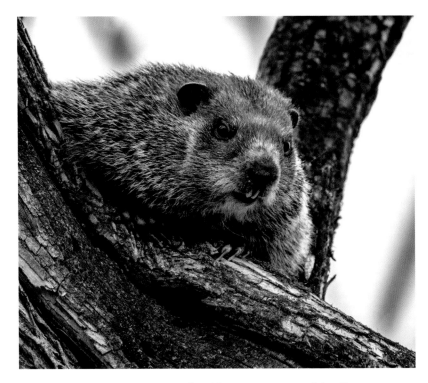

8.2 We don't have an iconic Groundhog like Punxsutawney Phil. Still, seeing one up and about, even as a disgruntled neighbor perhaps rudely awakened by carousing wildlife, marks the beginning of Spring while the winter solstice was just a promise.

anyone who has stood in the middle of a breeding aggregation of frogs will tell you. Frogs are well into their season by early March when the first migrant birds, looking to settle, arrive. That's the first real commitment to spring. That's when our Phoebe returns to claim his spot under the bridge. His return is more of a commitment than song, no matter how passionate, because they feed on insects, particularly flying insects that require warm-enough air temperatures to be active and the Phoebe must maintain enough fat to survive late cold snaps.

Immediately on his arrival we hear him barking his name like a vendor in a stadium, but somehow with a lot more charm. At his peak, he sings about every second in 10- or 20-second sets, snapping out a terse, buzzy expletive that is more sneezed than sung. It isn't something one might miss, and they are the first of an entirely pleasurable wave of safely returned species. Soon, he will attract a mate who will build a characteristic nest of mud and moss under that bridge. Our trolls are back for the Summer.

A couple of weeks later a Red-bellied Woodpecker fractures the

serenity when the length of daylight passes his threshold. Unconstrained by tradition, males have found a powerful amplifier in the sheet metal guttering on the house. He positions himself in it lengthwise or on it crosswise, and fires off a few bursts of a dozen rounds or so. He is an early riser, and the sound resonates throughout the house, but it a sign of spring and worth a smile, even from under the covers.

The unstoppable warming trend continues, and the number of active participants swells with the newly aroused and newly arrived species. The active community here is always changing; this year will not be quite the same as last, and yet the activities each year are synchronized within the community—they rhyme with previous years.

There is a coda. As spring begins, the Dark-eyed Juncos, White-throated Sparrows, Purple Finches, and others who nest far to the north also begin to sing indifferently as they prepare for a migration into somebody else's Spring. One day they're gone and in the flood of arrivals we barely notice, but we look forward to their return with the first freeze that marks the arrival of Winter.

Spring advances within the producer class as an entirely predictable parade of Spring flowers accompanied by their pollinators. They are thoroughly interdependent, so that the rolling out of the season must be coordinated. The warming soil stirs action in its surface layers, triggering the germination of seeds and awakening perennials, each responding as conditions trigger their individual wakeup calls. Spring Beauties venture into the overworld barely above the leaf litter, and open their first flowers, soon to be followed by the other familiar Spring wildflowers of the forest floor: Violets, Wake-robin Trilliums, Virginia Bluebells, and Phlox, in that order.

All of the above are important parts of our experience of Spring: it is exhilarating and stimulates an emotional response from anyone who is paying attention, but even that is just the icing on the cake. However sweet, rich, and rewarding, it's only the surface. The underlying cake is the part with substance, the part that nourishes. It is full of complexity achieved by the mixing of component parts in the right proportions, in the right sequence, and allowing time and temperature, physics and chemistry, to create complex flavors with enough texture to support the icing. To enjoy that, we'll need our rational parts—our intellect—to access those pleasures, and to answer the cornucopia of "why" questions that spill out in such abundance.

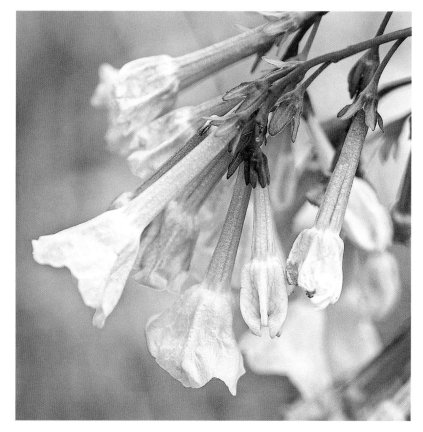

8.3 ~ 2X. The pastels of spring. Flowers of the Virginia Bluebell (*Mertensia virginica*) begin pink but turn blue on maturity, the change brought about by shifting the pH. Their aesthetic is that of a fairytale, brightly colored gowns swirling like the animated flowers in Disney's Fantasia, moving gracefully to Tchaikovsky's Waltz of the Flowers.

Why do Spring Beauties flower so early, risking severe, cold weather? And why does a female Phoebe choose a particular male? What exactly does he proffer through his song and his courtship display, and what is she looking for, anyway? These questions all have answers, and they are embedded in the cake like chocolate chips. The more deeply one grasps the whole of it, cake and icing, the more powerful the reward. Only a few samples fit into a book of this size, teasers really, but enough to establish patterns, and the kinds of interactions to look for, as the seasons pass. A little knowledge may be a dangerous thing, but it is also the key to opening the vault.

Winter is a test of endurance, but Spring is about sex. Just to be clear, I'm referring not only to the suite of activities that precedes the joining of sex cells, but to the whole edifice. Among humans, sex and its asso-

ciated activities have become an intimidating maze of behaviors so elaborate that it has become a major preoccupation of our species year-round, manipulated almost entirely through our emotional brains, and so inclusive that it engulfs everything from eye-shadow to sports cars. When we look at sex as a phenomenon and extract the rational elements shorn of detail, it is entirely un-romantic: it is a business deal, and it is negotiated as such. Not even sex can escape the Rules of the Game, especially not sex.

In that way, we are not so different from Red-winged Blackbirds. Looking at the display in Figure 8.1, a fragment of a song† I once heard rings true, "…a wild, strange music of forgotten rhyme, speaking to the heart without a word…." The lyricist didn't have courtship in mind, but her words capture this moment. The language-without-words is powerful, and it goes so directly to our emotional selves, that I've taken pains to distinguish it from our rational responses. Imagining what is really taking place is possible only in the context of our own experience and as an exercise in empathy. We think in words, so we can't even think about the breadth of courtship behaviors without confining them by words. But we can witness the outcome of courtships among life forms and determine cause and effect as best we are able.

To an evolutionary biologist, reproduction is the reason for being. The extraordinary defenses of plants and animals that have amazed generations of observers are about survival, not reproducing, but all of them must survive to adulthood before they can reproduce. Surviving is a prerequisite, and surviving with distinction comes from having better genes and good luck. The life forms so blessed reproduce more effectively. That is success—it is the only success that matters to the species.

Neither a Brown Creeper's coloration, coupled with careful behaviors that help him escape detection, nor the elegant physiological adaptations of a Chickadee that help her avoid freezing to death during the Winter nights, have any lasting value unless they reproduce. The Red-winged Blackbird's glorious performance is irrelevant unless fertilization and the successful maturation of the young ensues. The

strict dietary limitations of caterpillars and the toxins of milkweeds, none of them is significant in themselves. Evolution is very single minded; the production of viable offspring—reproduction—survival of the species, is not just a big deal, it is the only deal.

The offerings of flowers, the gamut of songs by frogs or birds may not all be attractive to us—especially those that are croaked or sneezed—but then we are not the target. To a female Phoebe or a gravid Chorus Frog, they are exactly the sounds they are looking for and they may well be experienced with rapture. They trigger responses that move them—inflame might not be too strong a word—and direct their actions. How they experience it, what they feel, we can only suppose.

Enhancing reproductive success through algorithms, natural selection has shaped the bodies of sexual beings and their behaviors: the phenomenon of sexual reproduction is the overarching mechanism that has shaped every sexual being, and the season of sex is an appropriate time to explore it. Sexuality is ancient. Living things have been exploring variations on this theme for billions of years and in so doing, have created a vast library of relationships such that the diversity of ways in which male and female gametes are put into contact beggars the imagination. The birds and the bees are just the tip of the iceberg.

Once upon a time—about two billion years ago, and fully a billion years after plants learned photosynthesis—sexual reproduction made its debut. It requires the bringing together of two sets of DNA, compatible but not identical, to create a new, unique being. With reproduction the reason for being, the invention of sex was a singular success and generated immense diversity among sexual forms. Inherent in the plan, driven by the same forces that dictate competitive exclusion, is the evolution of the two kinds of gametes produced by forms that we can now call sexes. It is an early specialization, where the two sexes have different roles.

Initially these two cells were nearly indistinguishable, but over time, and long before anybody thought of terrestrial life, multicellular forms settled on the design with which we are all familiar. It requires that one of the two forms, now recognized as female, provide the supplies—the cellular machinery, the initial energy for development, and half of the DNA. Within its scale that single cell is massive, an unwieldy combination that is more or less immobile. The male sex provides the

† "Gone Away" by Robin Frederick and Marideth Sisco, as performed by Blackberry Winter.

missing half of the DNA in a mobile, light-weight vehicle that must be eminently disposable and highly redundant. Evolution smiles on efficiency, but it is entirely insensitive to equality. Ultimately, in the non-human world, these prototypes end up as models that yield promiscuous males and reluctant, choosy females. In the human world, those same prototypes produce caricatures that everybody recognizes, brought to life in The Music Man as the reluctant Marion the Librarian, and the itinerant and persistent salesman, Professor Harold Hill.

With the ovum immobile, the challenge of making contact falls to males. We think of vertebrates with their self-propelled, wiggly sperm that often arrive with the medium as well as the message, but a staggering number of other arrangements have evolved over a couple billion years. Some gametes are passive, but move because of wind, water currents, or insect carriers that provide a delivery service, as we've noted. And there is an incredible array of self-propelled bots that function in liquid mediums. In every case, species that adopted a sexual format have evolved unique anatomies and integrate them into their behaviors in ways that have created the extraordinarily diverse world in which we are privileged to live.

We're going to focus on what this system has wrought among the most accessible plants and animals here at Brawley Creek. There is no better place to begin than with flowers whose function is purely sexual. They have ova housed in an ovary, and sperm transported in pollen. But the way they achieve fertilization is so vastly different from our familiar vertebrates that the commonalities are not often noticed. Then, we'll see how this all plays out in Chorus Frogs with no parental care, and with White-breasted Nuthatches, who, like us, spend a significant portion of their life spans devoted to it.

Flowers are the exposed sex organs of plants. It strikes me as ironic that they are considered a proper male-to-female gift on many occasions, but males giving gifts to females is widespread in the animal world, although the boundary between romantic and utilitarian quickly becomes blurred. Some plants live as male and female forms, much like most animals, but they often house two sexes in the same individual, sometimes in separate places like the White Pine in Figure 8.4, but often in the same flower.

There are two broad strategies to ensure that they are properly and dependably introduced to each other. Wind pollination is a widely used and highly impersonal strategy. For wind pollination to succeed, plants must release astronomical numbers of pollen grains that may travel thousands of miles, usually for naught—in the 18th century, the broad belt of White Pine forests in New England were said to have turned the surface of the Atlantic yellow for hundreds of miles. With such immense waste, making them cheaply is a primary focus. The tinier they are, the less expensive they are to mass produce and the more effective their dispersal. Pollen grains ride the wind and fickle air currents connect them to their sexual partners. It seems haphazard and wasteful, not to mention unsatisfying, but clearly it works very well. Many grasses and trees are wind pollinated, and many wildflowers as well. Those flowers, however, are small and nondescript, and rarely show up in wildflower guides. They don't need to manipulate other species into transferring their pollen, so they don't invest in glamour: fragrances, nectar, or large, colorful petals. Those elements are persuasive to pollinators but the wind is indifferent.

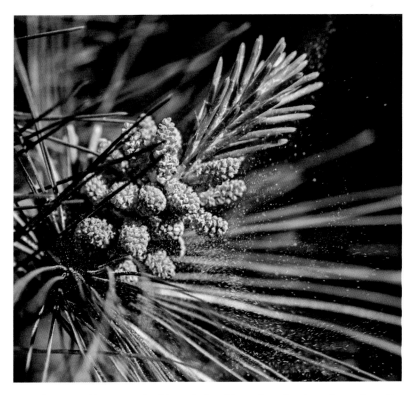

8.4 White Pine (*Pinus strobus*) is a wind-pollinated species that releases its pollen from male cones. In this figure they are mostly discharged, but the flick of a finger still releases perhaps a thousand pollen grains from the tip of this branch. The amount of pollen released by this one tree is unfathomable.

 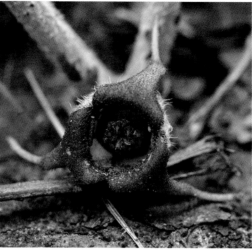 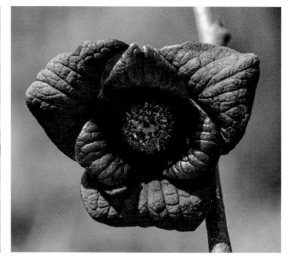

8.5 The Wake-robin Trillium (*Trillium sessile*), Wild Ginger (*Asarum canadense*), and Pawpaw (*Asimina triloba*) are our maroon-hued wildflowers. All of them flower in mid-Spring, appropriately, right around April Fool's day.

Plants that are not wind pollinated must invest in manipulating animals and they do it with glamour and largesse, and disinformation. Their challenge is to create circumstances whereby some animal will transfer their pollen for them—most commonly flies, bees, beetles, and butterflies. Most of these species produce flowers with both male and female parts, recognized as "perfect" flowers. By definition they produce both the mobile pollen, and the staid ovum that sits on a receptacle. I think it really ought to be called a tuffet, but it isn't. The rest of the flower consists of protective cells that influence access of the pollen in many ways.

Nobody works for free, and these reproductive assistants that mediate the transfer of pollen, are paid for their services, or tricked into making the transfer. Not everything is as it seems, and the insects being tricked are being misled because of their imprecise behavioral triggers. The Trillium in Figure 8.5 provides no benefit for its pollinators, its color, scent, and textures are similar to the carrion that flies and beetles seek out to deposit their eggs. While the pollinators are looking around for the corpse, they become dusted with pollen. For this to work, the "mule" must be fooled at least one more time before she finds real flesh in which to lay her eggs. Textured, maroon-colored flowers are rare among wildflowers and limited to this seasonal slot. It works every year.

For flowers that deliver what they advertise, the currency of the realm is the calorie. Pollen is abundant and energy-rich, and it yields protein and important nutrients. Nectar is calorie-rich, and it is synthesized solely to pay pollinators. The flower must ensure that insects taking their nectar are likely, in their comings and goings, to leave some pollen on female parts, preferably on a different plant from where they got it. Their scents, colors, and markings function like a barker to cajole passing customers to "step right this way!" Such flowers are sometimes large, showy, and fragrant, but all promise a reward to the pollinators which, include birds and bats in addition to insects.

Pollinators, in the course of gathering pollen (as nutrition) and nectar (as fuel), follow the signage. Where we are attracted to colors, lines, and scents, they see instructions as plain as footprints painted on the floor of a dance studio. If a bee follows the signage on her way to and from the nectaries, she will brush against the pollen source (anthers) and get dusted with pollen. Bringing pollen from previous flowers while in pursuit of more nectar, she will also brush up against the pollen receptor (stigma), and if the flower is receptive, the transfer will have been made. The Violet in Figure 8.6 is a case in point. The lower petal has a white landing pad marked with carefully arranged dark lines that direct insects toward the yellow throat of the flower where the nectaries are positioned. Most violets are vertically oriented like

this one, so that an insect, following directions, will release a shower of pollen on landing, and brush against the anthers on entry. The stigma is at the top, behind the anthers, and the transfer takes place according to design.

A fascinating array of contractual relationships between flower and pollinator emerge as Spring turns to Summer. Some flowers shape themselves, or release scents that are species specific. A long tubular flower usually positions the nectaries at the end of the tube, so they can be reached only by the long tongue of a moth or hummingbird. Figure 8.7 shows two flowers that limit the approach of pollinators who must hover directly under the anthers to access the nectar, and where they create a downdraft. The stigmas project beyond the anthers and are likely to be bumped by the forehead of the pollinator who will then be dusted with fresh pollen that he will transfer to subsequent flowers. The red of Columbines attract hummingbirds in particular, but also moths; the much smaller Gooseberry uses the same construction for a class of smaller but also long-tongued pollinators.

Flowers market their products to the public. That is an important perspective because it opens the whole field of advertising that targets consumers—all of it arranged to appeal to foundational instincts long before there were humans. What is the best mix of ingredients to appeal to the most effective pollinators at the lowest cost? What is the best way to catch the eye of a potential consumer? Every aspect of marketing and sales applies.

In following the money, species present their products in synchrony with consumer demand. Flowering is as seasonal as valentines and pumpkins and the flowers open to match the availability of their most effective pollinators. Trilliums holds a narrow slot in the spring, while Dandelions flower nearly year-round. In all cases, the volume of transactions rises and falls with the duration of sunlight, the time keeper that pulls environmental triggers.

Plants are so diverse that recognizing the fundamental parts of "a flower" is sometimes a challenge, but they all make pollen and ova, and they all receive the pollen on a stigma—everything else is marketing. Because they vary so much, knowing flower parts is important—it makes it easier to appreciate how these few simple parts have been adapted so broadly to serve this one goal in so many ways. The Spring Beauty (Figure 8.8) is a "perfect flower" as defined, and we'll use that to

8.6 ~ 8X. Johnny-jump-up Violet (*Viola bicolor*) shows the signage described. The flower is small, just over a half-inch wide; the tiny yellow spots scattered about on the petals are clumps of semi-sticky pollen that have fallen.

refresh our collective memories of flower parts.

All flower parts sit atop a receptacle hidden by the other parts; being unable to see it clearly, makes it seems abstract, but you can't go wrong imagining it as a pedestal. The bald head of a Dandelion that remains after the seeds are dispersed provides a good mental image of a receptacle. A Spring Beauty has only two leaves, easily mistaken for blades of grass amid the leaf litter on the forest floor. That seems inadequate but apparently it is not. Their flowers, only 3/4 of an inch in diameter, open in early March, along a stem called a raceme,† that will support perhaps two dozen individual flowers by the time the wave of

† A raceme is a kind of inflorescence characterized by a central stem with flowers on only one side like a Gladiolus. Typically, the lowest flowers open first and a wave of flowering advances to the tip of the stem.

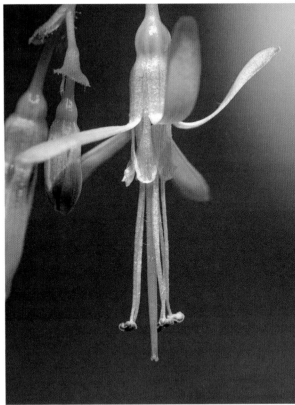

8.7 Two very different flowers reserve their nectar for long-tongued pollinators who can hover, using the same design. Left: ~ 2X. The red flower, Columbine (*Aquilegia canadensis*) appeals to hummingbirds and long-tongued moths. Right: ~ 6X. Gooseberry (*Ribes missouriense*) markets itself to long-tongued moths.

8.8 ~ 2X. Spring Beauties (*Claytonia virginica*) open sequentially. The flowers in the upper half are both first-day, stamens erect, stigmas closed and unreceptive. The lower flower is second-day, its stamens lying flat against the petals and the stigma open to receive pollen.

maturation the begins at the bottom, reaches the tip. The petals are typically white with pink stripes radiating from the center; pollinators see them as converging, pointing toward the center.

The female part—the pistil—has three subdivisions: a stationary ovary sits on the receptacle, a style projects out of it, and a stigma is mounted on the tip of the style. The ovary is visible in the oldest of the three open flowers pictured in Figure 8.8. It is a small, pale-green bulb deep in the throat of the flower, the style extends from it like a flagpole, changing from green to pink near the tip. Spring Beauties have three stigmas, mounted atop the style like the payload on a rocket. When the flower first opens, the stigmas are tightly closed and unreceptive, as seen in Figure 8.9. But on the second day, they separate to expose the inner surfaces specialized to receive pollen much like a mammalian uterine lining is specialized to receive an embryo.

The male part is the stamen. Spring Beauties have five, each with a pink anther that sits atop a thin filament. Anthers produce the pollen; the filaments control their position.

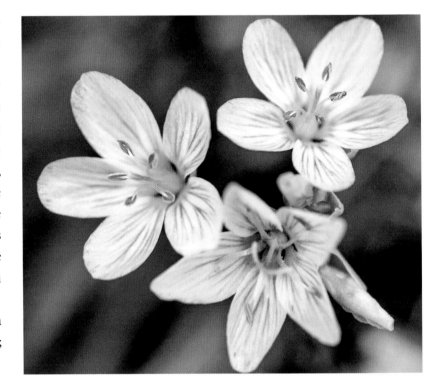

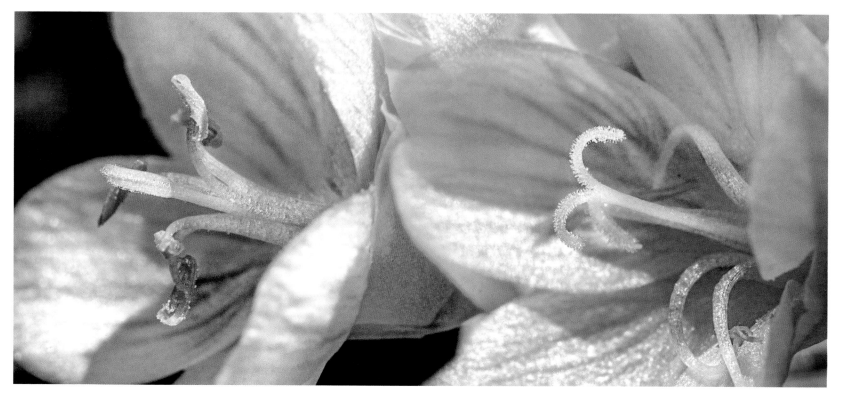

8.9 ~ 5X. This is a composite image, assembled to show sister flowers side by side. The younger sister (left) is first-day; her three-part stigma closed, the filaments holding the anthers well above the petals. Her sister (right) is a day older; the style has lengthened, the three parts of the stigma are open, their surfaces receptive to pollen, while the anthers, now spent, have been lowered to the petals.

Flowers do more than open and close; there is a schedule of events. When a Spring Beauty opens a flower, the petals unfurl and deploy with the grace of a dancer, becoming a vendor open for business—the doors unlocked, the awnings cranked open. The five petals act as landing zones, welcome mats, and open doors. Each petal is marked with pigmented veins called "nectar lines"—signage that points to the nectaries. The five stamens arch over the landing zone, their brightly colored anthers held in place by filaments that are strongly reflective in the ultraviolet part of the spectrum. We can't see the UV part of course, but insects can, and we can expect that the anthers and nectar lines will stand out prominently with brilliant filaments, also directing attention toward the nectaries in the manner of landing lights and painted lines on airport runways.

It works like a mousetrap with happier results. The first day is for disseminating pollen. An approaching bee lands on one of the flexible petals: wing vibrations, micro-gusts of air, a heavy landing, or bumping any part of the flower, is likely to dislodge pollen, dusting the bee with it. The stigmas are closed, blocking self-fertilization, which usually is not in the best interest of the plant. Self-fertilized ova often produce fewer viable seeds and sometimes none, so plants minimize self-fertilization in a variety of ways, and this is one of them. By late afternoon, the petals close over the parts, ending the first day.

When the flower opens on the second day, the three stigmas open to expose their sticky, inner surfaces (Figure 8.9) and they are ready to receive pollen. The UV-reflective filaments collapse, pulling the depleted anthers out of the way by holding them against the petals, while still pointing toward the nectaries. To the knowledgeable consumer, that configuration announces that the sugar content of the nectar has doubled. The stigma is open to pollen from a couple dozen different species of invertebrates, mostly flies (Figure 8.10) and bees, among the

earliest flying insects of the season. The stigmas remain receptive for another day or two as more flowers open higher up on the raceme, but in a few weeks, all of the flowers are spent and closed, busily maturing and provisioning their newly fertilized ova and preparing to release them as seeds, just as the forest canopy begins to close. Their seeds, equipped with elaiosomes have matured and dropped to the ground— delivered to the ants really, so that they can carry them underground and plant them, according to their unwritten contract. The above ground parts die, and the Spring Beauty slips into quiescence to await the return of spring some ten months away.

We don't usually think of flowers as having sexual displays, because to our eyes, they don't move—they don't have obvious behaviors. The term is used primarily for birds because they have the most flamboyant and attention-grabbing sexual displays, complete with songs, postures, dances, and aerial displays, directed toward the opposite sex as they flaunt brilliant color patches and patterns. Usually, sexual displays are performed by males, the judging done by females. This outcome is congruent with the division of labor established at the origin of sexuality.

Females are said to be very choosy in selecting a male. Their responsibility is to gather the best genetic kit for their chicks. Their own genetics is already determined of course, so their only control is the choice of a male. If they choose well, they can maximize their own success, even with the limited number of eggs they can lay in a season. Turkey toms and hens will serve to sharpen the point. Toms live only two years on average; even so there are plenty to service the hens, but the hens live for four years. Producing only a dozen eggs annually, the additional two years allotted them are important.

The calculations are simple and direct. A hen's annual investment buys her a 50% interest in 12 embryos. A tom, with no physiological restraints, mates as many females as his status allows. Mating a dozen hens would give him a 50% interest in 156 embryos. Big difference.

In many chicken-like species, males gather to form a lek, an open area where males display, and where females observe and evaluate. If a Turkey tom is healthy and vigorous enough to achieve a position of dominance in the lek after a long Winter, his genetic constitution has been tested and approved. This is a specific instance of the generalization that evolution smiles on efficiency, but it is entirely insensitive to equality.

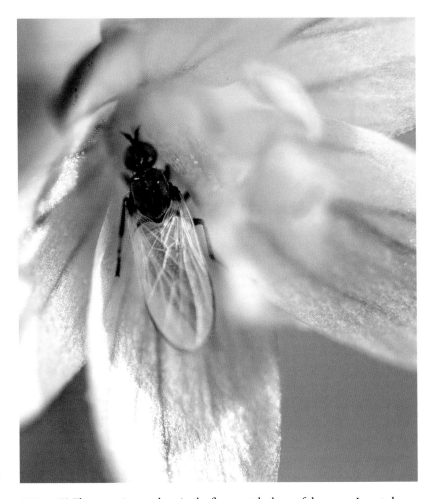

8.10 ~ 8X. The nectaries are deep in the flower at the base of the ovary. Insects know where they are, but the nectar lines will direct them anyway. This fly has access to the stash on a first-day flower. He doesn't show any pollen—maybe these pollen sacs have not yet burst open.

The lek structure in turkeys permits females the advantage of a "focus group" that ranks the candidates. Such choices are often made through an evaluation of his symmetry and the quality of the display space he controls. Symmetry provides a "quick and dirty" assay of genetic quality, as most displays feature spreading of wings and tail that exhibit their symmetry. It is well established that genetic "irregularities" interfere with the development of symmetry, and there is a vast and fascinating literature on this subject across a broad range of species. Barn Swallow males display in flight, and females evaluate. Males with longer and more symmetrical tails father more progeny. Both symmetry and length speak to the genetic quality of the male and the female's ability to notice and to choose accordingly.

8.11 Turkey eggs in late May—a baker's dozen. This nest was soon destroyed by a predator so her genetic contribution for the year was zero, unless she tried again as about half of them do.

The signs of Spring that we enjoy in birds—the seemingly joyous song, and the elegant and sometimes bizarre displays—have two functions. The first is to secure and defend a quality territory, both males and females recognize the importance of that even in their first year. A male with a good territory demonstrates his vitality and in so doing his genetic qualifications, in the same way tom turkeys do in securing a dominant position in a lek. Females evaluate the value of the male in part, by the value of his defended territory, one with suitable nesting sites and high ecological productivity that will support her and her brood.

A second function of the male's display is the seduction of females by the quality of song, usually accompanied by posturing, where they present themselves to females for the evaluation of their symmetry as does the Cowbird in Figure 8.12. Competing males assume telling postures—raised crests, elevated epaulettes, and spread wings or tails—that demonstrate their stamina, display their genetic quality (symmetry), and sometimes showcase brilliant colors that result from proper nutrition. This display is powerful enough that it speaks to humans, even without the accompanying vocalization, although I'm sure it loses something in the translation. With few exceptions, males display and females choose, as in a beauty contest with the men on stage to be evaluated by the females.

Females respond to those displays in various ways that alter their internal physiology and influence their behavior far beyond an expression of interest. In Whooping Cranes, dancing is a critical event. If they don't dance, the females don't ovulate—a much deeper impact than we ordinarily suppose. I wonder if there are any similar effect in humans?

These displays clearly have an innate component, because related species exhibit similar behaviors—rhyming behaviors. Red-winged Blackbirds and Brown-headed Cowbirds are both in the blackbird family (Icteridae) and both embrace the general form and mood of blackbird sexual displays; wings and tail spread, feathers raised, and a bow taken, accompanied by vocalization. Figure 8.12 records a male Cowbird on a window feeder, displaying to/at his reflected image. He sees his reflection as a competing male I suppose, as many birds seem to, and he gives the same display in the presence of a female that apparently is supposed to cut both ways. Looking at the figure, one has the

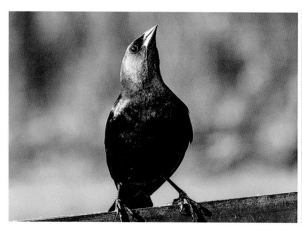

8.12 A Brown-headed Cowbird makes a vigorous display to his image.

sense that a demon is in ascendance and the Cowbird is powerless to stop it, as though he is morphing into The Hulk. He looks impaired, but the behavior is about power. Sexual behaviors can often be recognized because those actions have no obvious function. The first frame is an aggressive display called "bill-tilting," seen in higher resolution in Figure 1.13. The body is rigid, the bill held high, as though he is displaying a sword—which he is. The plumage is held tightly against the body emphasizing the proportions of the bill, and of course his reflection responds with exactly equal aggression. The rest of the figures are sequential over a span of four or five seconds. Behaviorists call this display "topple-over," and it is accompanied with a song that is guttural, bubbling, and screeching all at the same time.

<p style="text-align:center">***</p>

The sexual displays of birds are well documented, but when those of very different species are dissected and examined, we find strong underlying motivations—the behaviors look very different but all of them adhere strictly to their mission statements. Chorus Frogs are different enough from birds to illustrate the point. The last ancestor they have in common was reproducing 360 million years ago in a slimy skin. The commonalities between frogs and birds is expected because they are operating by the same Rules. Of course, we can't really get inside the minds of animals and tell their stories as they would, but it's worth a try. Maybe we can gain some insight into what it must be like to be a Chorus Frog, or at least we can recognize some of the con-

straints they experience. Part of the research behind this story has been drawn from the study of related toads and tree frogs, but all of it is relevant because of their shared genetics.

Our earliest frog choruses are a mix of Spring Peepers and Chorus Frogs—temporary pond breeders. We had a shallow pond scraped out about 100 yards from the house to bring their festivities closer to us. Those begin with the first warm, Spring rain—a climatic event that follows naturally in the wake of longer days. It takes a good dousing to light that fire, but once started they sing day and night (Figure 8.13). The combined chorus is incredibly loud. Standing in the breeding pond, one is embedded in a matrix of endless sound that comes from every direction and feels like being pummeled with sound.

A lot of energy is released as sound and immediately dissipates. Following the money, we note that the energy was gathered over a year of feeding, stored as fat, expended here in muscular contractions, and dissipated as sound. It is equivalent to birds spending their fat on migratory hops. Both activities can proceed until the fat runs out. That matrix of sound emanating from a robust chorus of a thousand males can easily be heard a half mile away. And it comes from frogs an inch long with vocal cords of only a few millimeters. But the sound resonates, is amplified and broadcast by a single, highly expandable vocal sac nearly a half an inch across. They are not easily seen, because they are tiny, and they sing while partly submerged, often from hidden locations inside tufts of grass or up against the tufts so that the cacophony appears to come from everywhere at once.

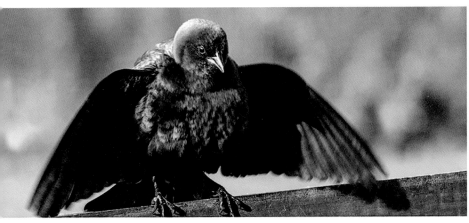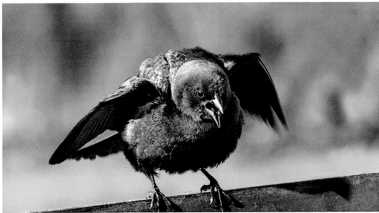

8.13 ~ 2X. The Western Chorus Frog (*Pseudacris triseriata*) is drawn to temporary ponds in late February or early March, where they chorus in large numbers—an amphibian Mardi Gras. These images show a frog, first inflated and in song, and then deflated and silent (taken from a higher angle.) All that remains of the tightly stretched, vocal sac amplifier, is a shriveled bit of yellowish tissue below his tympanum—a testament to its elasticity.

8.14 An American Toad (*Anaxyrus americanus*; formerly *Bufo americanus)*, uses his huge vocal pouch to amplify a melodic trill that can last 30 seconds or more. Sonograms show four pulses per second. His whole body vibrates, accounting for the ripples around his body as those pulses are converted into visible waves.

Chorusing 24/7 is exhausting, but the males manage by singing intermittently, so that deafening sound could be even louder. Singing loudly for extended periods would wear us out, but it is even more taxing for frogs because they lack a muscular diaphragm to propel their breath like we do. They use their trunk muscles like a bellows to force air past their vocal cords so that singing becomes a full-body effort. They have lungs, but with their skin as a second respiratory surface, singing and breathing are not bound together as they are for us. The males don't limit their singing by running out of breath so much as by having exhausted their supply of glycogen, a long-chain carbohydrate, stored in muscles, that can be broken down into glucose very quickly, and served up as energy on demand. Glycogen is replenished from stockpiled fat. Those trunk muscles deplete their glycogen supplies in just a few hours of singing, but they can be recharged from fat until that too is exhausted. When the fat supplies run out the males are spent, and the season is over for them. Because of all this, singing is a test of endurance. A powerful singer is something of an athlete, and like long-distance runners, they must choose when and how long to expend energy for maximum effect.

With the first rain, many hundreds of frogs emerge from their Winter seclusion to compete in the amphibian Olympics. Males arrive first and begin the chorus that serves as a beacon for the rest. Eventually females arrive, choose their mate, deposit their eggs in small masses that cling to the submerged vegetation, and leave for more secure locations where they can feed. As with Turkeys, males display and females choose.

Females enter the pond with 300 to 1,500 eggs each. The most fecund females have established their genetic superiority by arriving at the pond plump after a year of successful living. Accordingly, the best eggs will be the most abundant. Now they must find a symmetrical male in the dark. Male songs say much more about them than their abilities as a crooner; their performance is full of meaning, "speaking to the heart without a word."

Females evaluate the pitch and duration of the male's song by dissecting the audio frequencies embedded therein. They favor a larger male, recognizable in the dark by the lower pitch of a call that is loud and of long duration. A low pitch reliably indicates a large body, proof that he has survived previous seasons, and a song of long duration confirms that he is in good condition, arriving with an adequate supply of fat. The loudest calls draw the most females. Louder calls are more expensive and provide another indicator of a quality male (at least in frogs). In summary, loud, low-pitched calls of long duration identify large vigorous males with high quality genes—a strong, healthy animal that has entered the pond in top condition. Physical symmetry is but one indicator of high fitness, and a female evaluating the song in the dark will find, when the lights come on, that her male will likely be found with good physical symmetry too. Females are looking for a genetically fit male to optimize the prospects for their own genes—turkeys or frogs, it is the same game for the same reasons.

A prominent male is likely to have a cluster of satellite males around him. Some are exhausted males taking a break, recharging their glycogen supply between sets, but often there is a gaggle of smaller males, unable to make a competitive call. Occasionally, they intercept a female drawn to the singer. One can't help but notice that the whole of the operation has the feel of a high school prom.

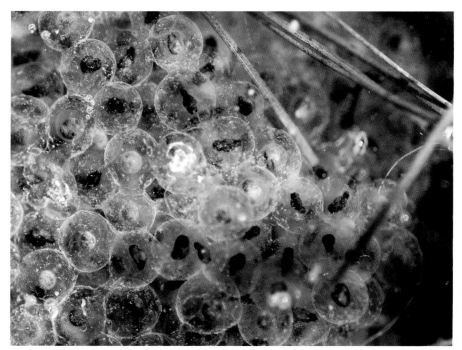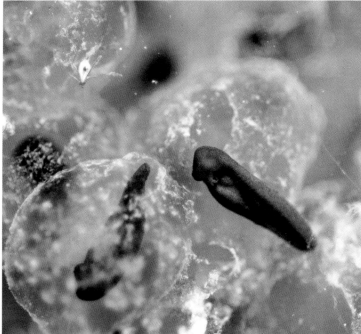

8.15 Left: ~ 4X. The surviving embryos of the Leopard Frog (*Lithobates* sp.) are passing through the tail-bud stage at the tender age of three-and-a-half days. Right: ~ 12X. On the sixth day, the embryos break out of their personal ponds to enter the wider world.

Picking a good male and laying quality eggs is not the end of the story. The adults leave the pond, but of course life at the pond continues and a lot of hatchlings will compete for available resources. Each female Chorus Frog lays upwards of a thousand eggs, the Spring Peepers too, and they aren't the only frogs in the pond. Their contribution to our temporary pond of only a few hundred square feet, is followed in quick succession by the eggs of Leopard Frogs (five thousand per female), American Toads (ten thousand per female), and finally the Gray Tree Frogs (two thousand per female). Each spring, our little pond is asked to support 20,000 tadpoles, from just one female of each species. It can't; and the mortality is extreme—a substantial proportion won't survive to hatch, and among those who do, the competition is severe. It is that high mortality rate that makes so many eggs necessary. A death rate of 99% or higher is required because in a stable population only two of them will reach adulthood—two in the lifetime of a female, to replace their parents.

Breeding aggregations of Leopard Frogs overlap with Peepers and Chorus Frogs, their eggs are larger, but otherwise similar. They are laid in large clusters that eventually rise to the surface like the one in Figure 8.15, providing a remarkable opportunity to watch embryos develop. On release, each egg is covered with a transparent jelly that swells on contact with water, creating a primitive, gelatinous womb that protects the embryo, spaces the siblings, and eases the exchange of the respiratory gases—the uptake of oxygen and the elimination of carbon dioxide. These embryos present another case where the physics of surface/volume ratios play a role—this time affecting gas exchange, rather than heat loss.

In each stage of maturation, the mortality is astonishing. The left panel in the figure looks to me like more than 50% mortality even before the first tadpole hatches. At four days, the embryos will begin twitching inside their individual private ponds, probably a vertebrate thing, like the kicking of a human fetus, but without appendages they just wriggle. Their yolk supplies, that yellow pot-belly seen in the left panel, is now nearly exhausted. Their hearts have been beating for 22 hours. They celebrate their six-day anniversary by hatching, blood begins to circulate through the capillaries in those stubby, external gills.

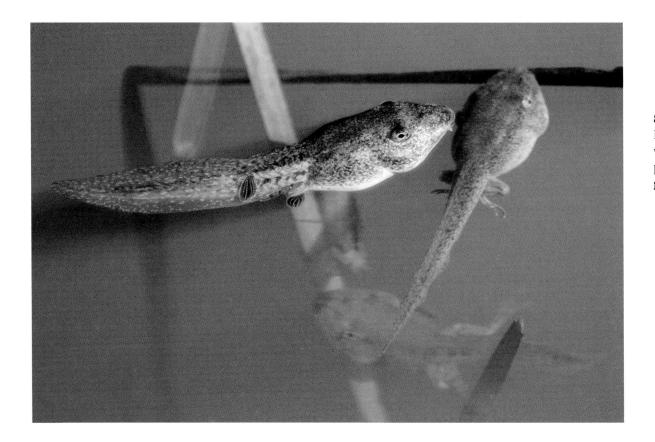

8.16 ~ 2X. These three tadpoles of the Leopard Frog (*Lithobates blairi*) overwintered in a cattail pond to metamorphose in April, the one in the foreground is carrying two leeches.

They wriggle out of the egg membrane and into the world, blind, without arms, legs, or sexuality, little more than a living GI tract. But they are not helpless, they have enough parts to immediately begin rasping at the algae that surrounds the eggs.

Peepers and Chorus frogs have adopted an early in, early out strategy. The ponds are temporary, and as the pond dries the concentration of tadpoles increases, providing strong pressure to develop, metamorphose, and leave the pond as quickly as possible. Yet another wave of mortality is initiated as masses of froglets and toadlets mount their amphibious assault on the fringes of the pond amid drastic transformations. Both the mouth parts and gastrointestinal tract are being restructured "on the fly" as they convert from rasping vegetarian to carnivore. The tail is being replaced by legs, the gills by lungs, and the importance of the skin as a respiratory organ changes; and all of these changes require a remodeled circulatory system. The new legs require a new kind of locomotion that they must master while learning the art of predation. They are invading a foreign habitat, having limited fat re-serves, as part of a mob in the midst of a really bad adolescence. I think they could benefit from a pupal stage, but that isn't a vertebrate thing. Seen as a whole, an army of frail novices invade the land like a miniature D-day. The mortality rate is enormous but, with so many eggs, it is essential. One way to avoid that stress is to overwinter as larvae, like the three tadpoles becoming adult in Figure 8.16. Their external gills have grown markedly but they are hidden from view by a protective flap of skin. The forelegs are developed too, but they're hidden next to the gills by that same flap of skin. All three are the same age, but they are maturing at different rates. The most prominent, and least advanced tadpole hosts two leeches, one on the side of the tail and a second near the just developing hind legs.

The vast majority of sexual life forms lay eggs and abandon them like these frogs. Eggs are the launch vehicle of the next generation. That is true whether they are dropped into a cold, temporary pond or re-

leased from a mammalian ovary to nestle in a private, climate-controlled, luxury suite with room service. We have more in common with birds than with frogs, so while they're not any more interesting, it's easier to see ourselves in them and we do like that. Like us, birds maintain a high internal temperature. They are diurnal, share our sensory abilities with color vision as primary, and use sound and posture as major mediums of communication. For them, as for us humans, family life involves building a home and feeding the kids. Rearing young is an expensive proposition, and we invest a significant percentage of our lives and resources in that effort. Accordingly, we produce few offspring. Like every other life form, if our populations are stable, only two of us will reach adulthood in the lifetime of the mother.

The lives of song birds are short compared to our own and so they seem highly compressed. Humans experience the empty nest after twenty years or so, but for small birds like White-breasted Nuthatches, it's twelve weeks from the time the female begins laying eggs until the young leave the nest. We'll see how they negotiate one season.

You've met the White-breasted Nuthatches in the previous chapter (Figure 7.8)—those odd little, upside-down birds with the big feet who, like the other members of their feeding guild, nest in cavities. They pair in the first Winter of their two-year life span and their first cooperative event is to find a nesting site. At this latitude they begin in March and family activities will consume them until early May. In that short time, they build a nest, lay eggs, incubate, brood, feed themselves and their chicks, and clean up after them. If the first nest is lost, they don't try again, so the events that follow represent half of their lifetime reproductive effort. One wonders how such novices, beginning at 10 or 11 months of age, manage to negotiate their responsibilities as first-time parents.

The accompanying figures for the rest of this chapter amount to a family scrapbook, with some annotation.

March 9th: Figure 8.17 This box has hosted several species, but no Bluebirds since it was set 17 years earlier.

March 14th: Figure 8.18 Nuthatches engage in "bill-sweeping," an unusual activity that involves collecting a brush of mammalian fur, and sweeping the entrance, roof, and the adjacent trunk of the Red

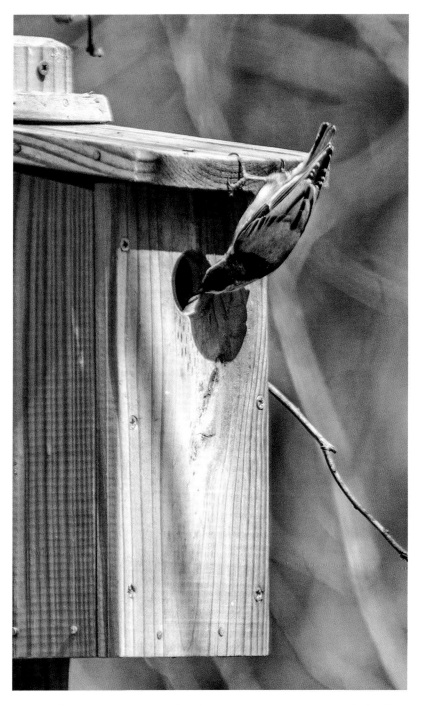

March 9th Figure 8.17. A pair of Nuthatches inspect an unoccupied Bluebird box from all angles, examining it inside and out, to satisfy some inner sense that evaluates its suitability.

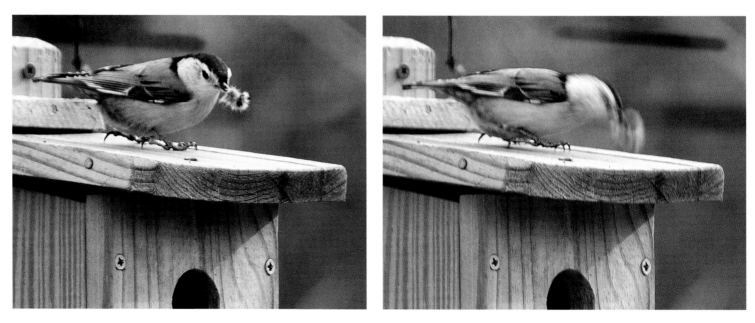

March 14th Figure 8.18. "Bill-sweeping" is an energetic, even furious activity that seems important.

April 5th…the year before. Figure 8.19. Western Rat Snakes (*Pantherophis obsoletus*) are excellent tree climbers and they have good reasons to climb. This one is leaving the box where he enjoyed a bed but no breakfast one year before the Nuthatch occupancy.

Oak. It looked like a ritual cleansing without incense or the smoke of sage and there was chanting—the gentle "urk, urk, urk" of a Nuthatch talking to himself. The activity may spread scent that could intimidate a snake, which has excellent olfactory senses. Nuthatches have been known to crush a beetle and use its noxious fluids for the cleansing, and someone reported their use of a discarded cigarette filter. It's curious that a Nuthatch with such poor olfactory capability would have learned to do this. I suppose we would find it something like painting with pigments that reflect only ultraviolet light.

April 5th, 2004: Figure 8.19 This event has been inserted into the Nuthatches' year. It is out of sequence; a year before the Nuthatches arrived. A Rat Snake, an excellent climber even without any appendages, spent some time in the box a full year before the Nuthatch family arrived. This one enjoyed a bed but no breakfast. This doesn't say anything about the efficacy of bill-sweeping, but sweeping costs energy, and likely it has been favored by natural selection toward some end.

The Nuthatch's nest is lined with fine vegetative fibers and finished with mammalian hair like that used in the broom for the bill-sweeping ritual. They are known to pluck hair from carcasses, and even live animals, but I see some fur from our golden retriever, Jodie, who shed enough annually to endow scores of nests. The lining is not only soft but also excellent thermal swaddling. Most of this appears to be rabbit hair, but that single, guard hair—the one with the black tip laying over the central egg—began its life on a raccoon.

Eggs appear simple but they are wonders of architecture. Our first-hand knowledge of eggs comes mostly from chicken eggs in a skillet. Everybody recognizes the two parts, and perhaps wonders just how this thing was supposed to work, but the thought passes when the toast pops up.

Cradling such a tiny, fragile bauble in the hand, a bauble that holds the potential of immortality, can be a powerful experience—if one attends to it. A "simple" egg is one of the most perfect and complex structures of which I am aware. The yolk is a single cell loaded with calories in many forms that provide for the needs of the embryo. It must con-

tain enough energy and supplies to complete the journey from ovum to a complex life form competent to breathe and process food, but not much more. The albumen is rich in proteins and serves as a stockpile of amino acids, from which the embryo can make all the proteins it will require while inside the shell. It also buffers jolts and serves an immune function for the embryo.

On release from the ovary, the single-cell ovum (yolk to the chef) is fertilized and drawn into an oviduct with "rifled" inner walls that rotate the ovum as it advances, like a bullet passing down a rifle barrel, but the yolk spends about four hours in transit. The rotation assists in swaddling the newly fertilized ovum in layers of albumen, after which the package comes to rest in a uterus where the shell membrane is added, and finally the shell itself. If there are to be any spots on the egg, they are added here. It is an efficient assembly line—one of many that function in the organs and cells of living things across a wide range of scale.

The shell must be thick enough to resist crushing from incubation, turning, and in some cases being walked on, without cracking, and yet thin enough that oxygen and carbon dioxide (but not water) can easily pass through the pores. And of course, it must be fragile enough from the inside so that a very weak embryo can break out of it. From start to finish, a released ovum is ready for deposition in 24 hours. Only one egg is in preparation at a time and that accounts for the practice, common in birds, of laying one egg per day.

The eggs are costly. Nuthatch eggs weigh about 2 g and this female laid seven eggs in seven days, which cost her 14 g of protein, fat, calcium, and other nutrients. She weighs only 21 grams, so by accomplishing this feat, she has passed 2/3 of her normal body weight through her cloaca in those seven days.

Figure 8.20 (April 5) Counting back from the date of hatching and depending on average values, the first egg was probably laid about March 17. Seven is the median number of eggs for this species.

Figure 8.21 (April 8) <u>Hatching Day 1</u>. The female midwifes the hatching of her "first born." By the time I lifted the top of the box, she had already moved that half-shell to the corner and soon she left abruptly, providing a clear view of the event.

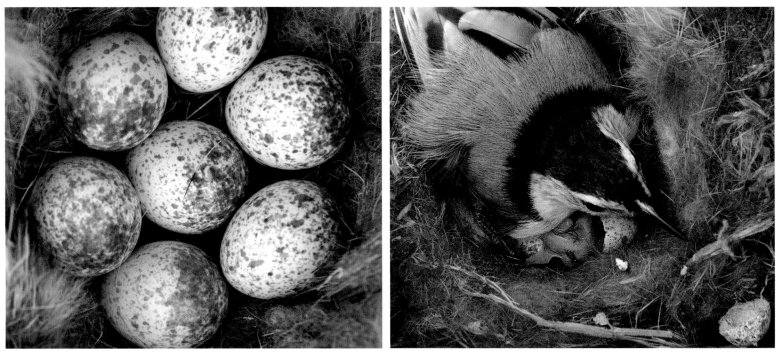

Figure 8.20 (April 5th)

Figure 8.21 (April 8th)

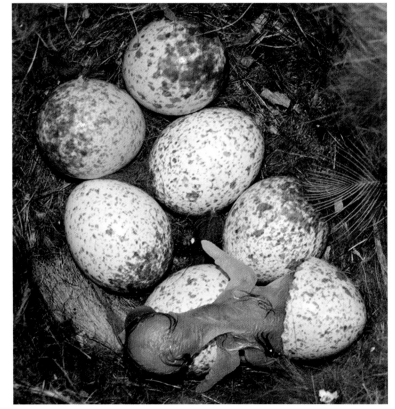

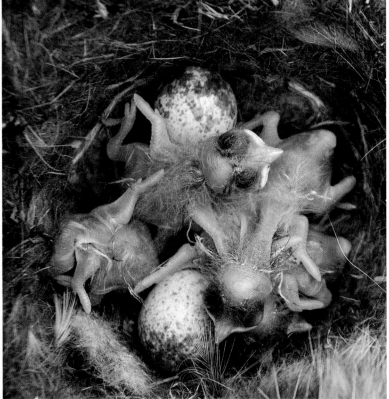

Figure 8.22 (April 8th) moment's later

Figure 8.23 (April 9th) Day 1

Figure 8.24 (April 13th) Day 5

Figure 8.22 (April 8) <u>Hatching Day 2</u>. With his rear end still in place, the hatchling looks like a weeble that has wobbled. And he lies exhausted.

Figure 8.23 (April 9, first day) Such a tangle of helplessness. Five eggs hatched—and already a 29% mortality rate. The two failed eggs were removed by the parents soon after.

Figure 8.24 (April 13, 5 days) His still pathetic wings have become more robust and those white spines on the back edge of the bird's hand (manus) are the first hint of the primary flight feathers. His exposed back is covered with down that traps air, and when the five of them huddle in their nest, the down forms a fog-like insulating blanket that resists the loss of heat until the mother's body crushes it, allowing heat to flow easily from her body into her

nestlings. Clearly there is a lot of maturing to do and that requires a constant stream of food—the raw materials from which these Nuthatches are built. On detecting the approach of a parent, the chicks gape, forming a bright ring around a red center into which the parents load raw materials.

The newly hatched nestlings are essentially naked, their skin transparent, and they are spectacularly homely. Initially, they are unable to do anything but squirm, raise their heavy, trembling heads on those spindly necks, and gape on signal. But then, that is all that is required of them. They are unable to thermoregulate yet, so the female broods them, raising their temperature and speeding their development. That shortens their time in the nest when they are particularly vulnerable. Soon, they become large enough and feathered enough to claim their warm-blooded birthright. The rictus—the fleshy, clown-like "lips" at the corners of the mouth—is a powerful releaser, as noted earlier. It surely catches the eye. In that tangle of nestlings (Figure 8.23) the rictus of the chick on top of the pile draws the eye, even without displaying his gape.

Like newly hatched tadpoles, they too are little more than GI tracts, except that the chicks are going to be fed. They have the muscular capacity to breathe, circulate blood, and open their front ends, and they have enough functional organs—heart, lungs, nervous system—to remain alive and to metabolize the food put into the front end. This one is a picture of helplessness and one wonders how he might even manage that.

The transition into the outside world is no less complicated for birds than it is for mammals, and hatching/birth, like many other processes, is at once both incredible and routine. Hatching is equivalent to cutting the umbilical cord in mammals. Before hatching, gas exchange was accomplished by a placenta-like array of vessels distributed just beneath the shell membrane, but on hatching that connection is broken and now the hatchling must quickly drain its water-filled lung tissue and reroute the circulation of blood to the lungs.

Figure 8.25 (April 18, 10 days) Birds aren't uniformly covered with feathers in the way that mammals are covered with hair. Even as adults they have feather tracts (pterlya) separated by naked tracts

Figure 8.25 (April 18ᵗʰ) Day 10

(apteria), but the feathers spread out, covering and hiding the unfeathered parts. By now, the chicks have enough mass to begin maintaining their own body temperature, freeing the female from brooding, so that she can join the male in finding the ever larger quantities of food they require–something like getting back into the work force after the kids are off to school. The nascent primary and secondary flight feathers have formed, wrapped in sheaths. The over-sized legs and feet are much stronger, but it will still be a week before they can support the bird. And the tail? Well, it is never going to be much.

Figure 8.26 (April 22, 14 days) Wing structure 1. The crook in the wing at the far right is the wrist. The flight feathers are anchored to the bones; primaries to the bones of the hand, and the secondaries to the ulna in the forearm. The ulnar attachments can't be seen in this figure because they are hidden beneath the secondary coverts, but they are the dark-tipped feathers (light blue sheaths)

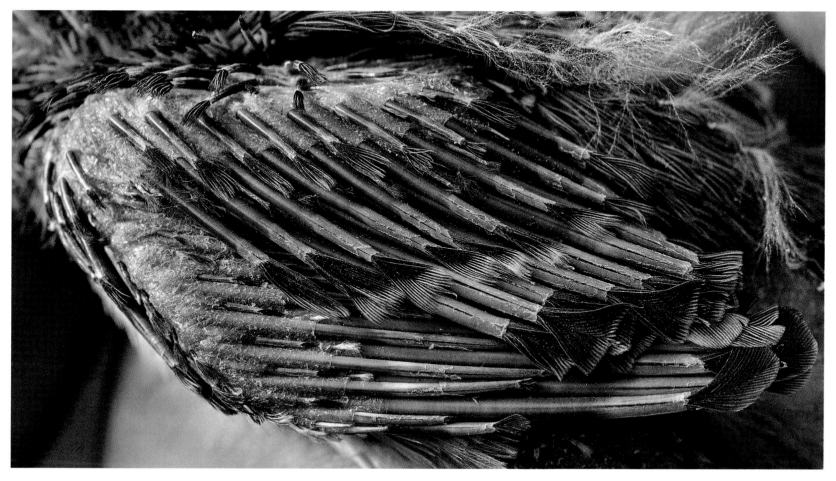

Figure 8.26 (April 22nd) Day 14 Wing structure 1

that project from beneath those secondary coverts, which have white-tipped feathers (dark blue sheaths). The sheaths protect the feathers as they grow, but become brittle, eventually crack along the top seam, and the fragments fall away like the nose cone of a space probe. At rest, the primary flight feathers are always folded underneath the secondaries.

After the young have fledged, the parents tend them for several weeks. Three months of their short lives have passed. The pair maintains an association through their second Fall season and the following Winter, and they will raise another brood in their second Spring. They have just two chances to bring off a successful brood and they spend a quarter of their lifetime doing so, pretty much like we humans do. These juveniles are not yet an evolutionary success. Their parents have poured in resources to get them to this point, but unless at least one of them survives the next nine months and successfully reproduces, their parents haven't been successful.

Other perching birds' family lives are much like this, and spring is a busy place in every woodlot. By the time the Nuthatches fledge, the forest's canopy is closing and becomes nearly opaque to us terrestrials, but singing birds tell us who is active up there. Spring Beauties have retired for the year, and the Chorus Frog tadpoles are not far from venturing onto land as froglets.

The army of tiny caterpillars have begun feeding on the newly plump leaves of the canopy and they will grow rapidly. The warbler migration has passed its peak, the Wood Pewee has returned to his favorite perch over the creek, and the Yellow-billed Cuckoo's odd "cuc-cuc-cuc…" song comes out of the dense foliage as if from the trees

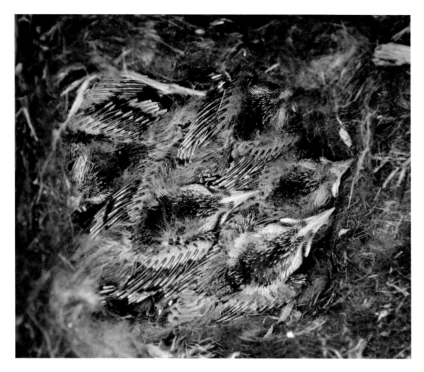

Figure 8.27 (April 22ⁿᵈ) **Day 14** <u>Wing structure 2</u>

Grassland communities are relatively indifferent to spring. Both annual and perennial plants require warming soil to stimulate their awakening and that is a slow process beneath the dense thatch of last year's grasses. And besides that, everything above ground must be built anew—an entire green city that grows to heights of ten feet and more, rising each year like a phoenix from the debris of last Summer's abundance and it takes a while. Grasses are wind-pollinated and their seeds are wind-dispersed; their height is important for those functions as well as for solar gain. The forbs, most of which are insect-pollinated, find no advantage in earlier flowering either, so the peak flowering periods in open areas, begins with the Summer and extends well into both Fall seasons, taking full advantage of the long, warm stretch that produces hordes of insect pollinators. Woodland or grassland, the great machines of photosynthesis come online after Spring, presaging the full-bore, mass production of Summer.

themselves. Those sounds are among the familiars that tell us the transition into Summer has begun.

Figure 8.27 (April 22, 14 days) <u>Wing structure 2.</u> One wonders how these five nestlings might have managed if the failed eggs had made two more siblings. They are packed in the nest as though poured in, and with a matrix of down they retain heat well, with very little surface area through which to lose it.

Figure 8.28 (April 24, 16 days) Sixteen days after hatching, he is built like one of those Italian Smart cars, but he is clearly a Nuthatch and the posture shows something of a Nuthatch's attitude. He can support himself on his feet but he is still days from his maiden flight
.

Figure 8.29 (May 18, 27 days) The family hangs together for a few weeks after leaving the nest. This pair of siblings, not long from the nest, are in the business of learning how to use their peculiar abilities with the easy skill of an adult.

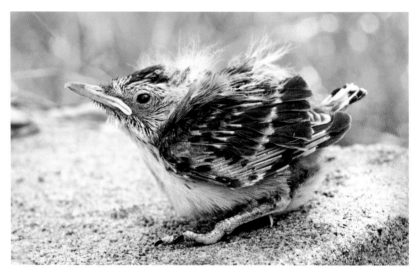

Figure 8.28 (April 24ᵗʰ) **Day 16**

Figure 8.29 (May 18th) **Day 27**

9.1 Black-eyed Susans (*Rudbeckia hirta*) approach their peak in mid-June. The rest of this bouquet is a wispy matrix of last year's grasses, with Hedge Parsley (*Torilis arvensis*) taking the place of baby's-breath.

9

Summer: The Season of Production

"Summertime, and the livin' is easy..."

~ Ira Gershwin, "Porgy and Bess"

Summer arrives as a subtle shift in ambience. Birds ease their aggressive activity as territorial boundaries have been resolved, mates have been chosen, and females are incubating as inconspicuously as possible. Late arriving birds are in place and the ecosystem hums, operating smoothly and efficiently as it enters its period of peak production. A prominent part of that ambience is the sonorous, pompous, chugging of bullfrogs, audible to us from a pond about a quarter of a mile downstream, and the singing of Wood Thrushes, our local nightingales, that comes to us out of the woods in the evening as we enjoy time on the deck. Their song is rich and textured, and it seems to trail its own echo as it wafts out of the forest. Along with the other regulars, they are the sound of early Summer as surely as the buzzing of cicadas mark the latter part of Early Fall.

The first signs arrive in a synchronized pulse visible as the producers, who occupy open areas and brushy edges, begin flowering. Those places are fully or partly free of the canopy's shade; Summer species flower as the Spring wildflowers fade. Within a period of just a few days, a dozen or so flowers add splashes of color to an otherwise green landscape. Spiderwort opens for a long run of one-day performances, and Green-flowered Milkweeds, the shortest of our milkweeds, take advantage of the brief window of opportunity before the surrounding vegetation begins to block their sunlight. Within days, Multiflora Rose, Black Raspberries, Red Clover, and Showy Early Primrose appear.

While the flowers make these subtle changes visible to us, they are just the flags of

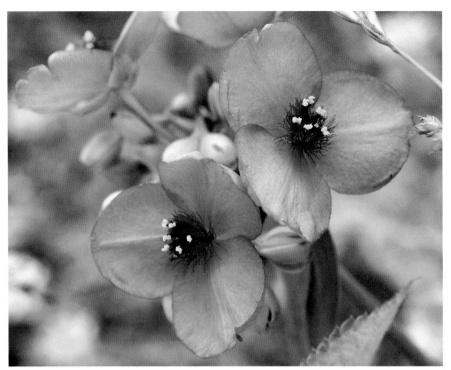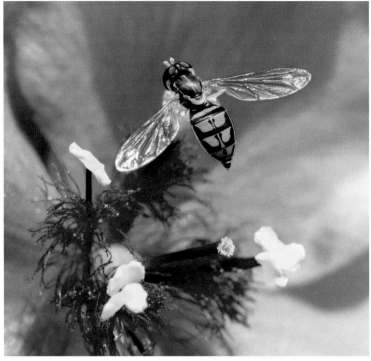

9.2 Left: ~ 1.5X. Ohio Spiderwort (*Tradescantia ohioensis*) bursts onto the scene by mid-May, abundant along the roadsides, it attracts a variety of pollinators. Right: ~ 10X. The hover fly resting on one of five, brilliant yellow stamens, isn't a pollinator—he is a pollenivore. Being so small, he's not likely to contact that pale, blue dot (stigma) that his abdomen points toward. He's taking the pollen without performing a service.

an ill-defined army whose advance is less conspicuous. The pink of Prairie Rose and the dusty rose of Common Milkweed are added to the palette in early June, and by mid-month the fields take on the appearance of a pointillist painting as more colors are spattered on the green background. Queen Anne's Lace and Black-eyed Susan introduce themselves as flecks of white and yellow. Figure 9.1 shows a small patch of that canvas where Hedge Parsley, a diminutive kin to Queen Anne's Lace, provides a stippling of white amid a dash of other hues. Just as much a part of the experience is the sweet, heavy scent released by patches of Common Milkweed growing in dense colonies. They provide one of those ephemeral sensations, like the scent of Lilacs, which can be enjoyed for only a few weeks.

Showy flowers are signaling insects that pollen and nectar are available—that's why they're showy—but thousands of less memorable species fill roles that permit the intricate functioning of the community, populating all the higher tiers of the pyramid; all kept in their proper proportions through interaction, everything bound together by adherence to the Rules of the Game.

Now it's Summer—biological Summer with a capital "S"—and the massive economy that has been building for months has come online. It is the full-bore flow of energy and the community experiences elements of an old-time gold rush, as the workforce expands to fill the interdependent niches. For every omnivore like ourselves, there is an array of specialists that can thrive only where wealth flows freely. Super-specialists—a leaf miner that feeds exclusively inside the leaves of Sweet Gum trees, and parasites that feed only on that kind of leaf miner. That super-specialization allows the miner to fine tune its metabolism to work at peak efficiency in its exclusive host. The same can be said of those parasites, but in their specializations they both tie their futures to that of the host.

Summer, with its long days and the high angle of solar incidence, brackets the summer solstice, but not symmetrically. According to my

reading of the community, Summer begins about the middle of May, some six weeks before the solstice, and ends just two weeks after it, around July fourth. The asymmetry comes from inertia. The producers cannot respond in direct proportion to solar input. It takes time to build infrastructure and the producers can't begin in a major way until the danger of freezing is past. The economy responds to the increasing input by shifting to something like a war-time footing, but it takes a while to ramp up production. These phenomena shape the trajectory of the seasons that follow and keep them eccentric in relation to the four symmetrical points of the earth's orbit.

Part of the joy of a rich diverse community arises from the occasional, sweet moments that appeal to our sense of the absurd—cartoons without pen and ink. Since they are cartoons, we are permitted to unabashedly project ourselves onto the characters. In Figure 9.3, a Ruby-throated Hummingbird assumes the perfect position to defend a prime "nectar" source, the hummingbird feeder that hangs below the Praying Mantis sculpture. Note the cocky pose, chin high, like an avian FDR with his cigarette holder, totally oblivious to the threat from the Mantis we see, but which is too abstract for him to notice.

And there are similes worth a smile. The flower in Figure 9.4, is a

Great Blue Lobelia. It forms a convincing mimic of a Long-eared Owl with his streaked breast, squinting eyes, and erect ears. The flower is tiny and blue, but the posture is a perfect mimic of the Owls who slenderize themselves with a posture very much like this.

In Figure 9.5, a Monkey Flower looks back at us through illusory

9.4 ~ 4X. Great Blue Lobelia (*Lobelia siphilitica*) was once considered a treatment for syphilis, accounting for the second name of the binomial.

9.3 A Ruby-throated Hummingbird sits on a pretty respectable Praying Mantis sculpture without an apparent care in the world; probably the likeness is too abstract to trigger a response. Real Mantids eat Hummingbirds on occasion.

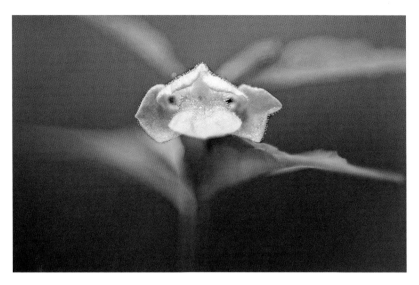

9.5 ~ 3X. The Monkey Flower (*Mimulus ringens*) could scarcely be called anything else, but to see the monkey, you need to look at the flower at exactly this angle.

green eyes. They look like eyes because of their placement, but they are only gaps in the flower through which we can see the dark-green background. Humans need only two dots and a line to imagine a face. :)

<div align="center">***</div>

The living architecture of plants and animals is one of the under-appreciated facets of life. It is critical to the way we live, doubly so because it is the foundation of both our bodies and our technology. The biological application of spars and beams provide strength and rigidity, but they are lightweight, flexible, and efficient, doing no more or less than is required for optimum results. Body parts are strengthened by replacing joints with fusions, and at the other extreme, breakaway connections are fashioned to release with the right trigger. There are exotic materials like the silk of caterpillars and spiders. The warm seasons provide the best time to see them because of the abundant diversity.

I've chosen a few species in our size range to enlarge on these ideas, focusing on architectural detail that is visible to the naked eye, perhaps with the aid of a hand lens. Microscopic architecture is equally wondrous but beyond our scope. It depends on the same physical properties—shape, tensile strength, and other properties that are familiar to us because we use them to build houses, bridges, and vehicles. Appreciating the tricks of the engineering trade as they function in biological structures, is a good way to savor their elegance, but these devices have the advantage of self-assembly, and they do it from the inside out, rather than being cobbled together with welds and rivets. And of course, they are biodegradable, perfectly recyclable, and in many cases served as models from which we learned. While we can't experience the sensations of a female Bullfrog on hearing the persistent and repetitive "Chugarum!" of a large male, we can appreciate the elegant design that permits him to deliver it, and we can equally appreciate the other half of the equation—the capacity for a female to hear it, interpret what it says, be stimulated by it, and respond.

All of the species we'll see are common and can be found along the right-of-way of any country road. They are the tip of the proverbial iceberg and they provide us with a wide range from flexible architectures and fusions, demonstrating a broad array of fabrications—arches and triangulation—that provide rigidity with little material investment. And those allow defense, broadly defined, and reproductive functions. All of these are dependent on shape and the physical properties of the material used to execute them, but reproductive functions are the most visible and arguably the most important, and we'll begin there.

We generally see flowers as frail and congenitally unresponsive, but they move in ways that control their reproductive fates. They move very slowly, but all biological machines exercise control over their behaviors and much of that ability is built into their architecture. Flowers are a kind of performance art, the movements much slower than Tai Chi but just as fluid and purposeful. Chapter 8 introduced you to the movements of stamens and the opening of stigmas by Spring Beauties that are typical of most flowers. They move their parts to control when and where the pollen is released, and they couple their richest nectar offering with receptivity of the stigma. Summer is replete with variations on that theme.

Queen Anne's Lace is abundant along roadsides and throughout pastures in Summer. It is the same species as the carrots you buy in stores, although those have been altered by centuries of selection. Queen Anne's elegant underpinnings serve the same function as the steel beams and struts we employ in building skyscrapers, but these are

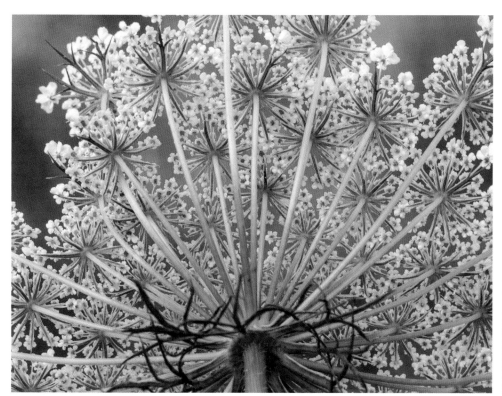 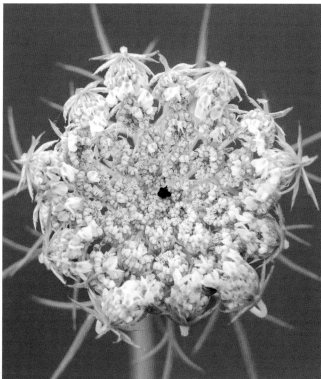

9.6 Left: Queen Ann's Lace (*Daucus carota*) seen from below, shows the strong but flex-able umbel struts, each terminating in a scale model—umbellar struts. Right: Opening is a complex action. In this frame, the umbel, umbellets, and florets, are all in motion.

flexible, and the movements of the undercarriage controls the shape of the flower to optimize the several phases required to successfully pro-duce seeds.

The inflorescence is an umbel, from Latin for "shade." Botanists have appropriated the word to define a flower architecture built of multiple flower stems, all of which originate at one point like the ribs of an upside-down umbrella which would collect rather than deflect. Queen Ann has increased her fecundity by making a compound um-bel—each umbel supports an umbellet, tipped with 20 or so florets. One can imagine the ancestral inflorescence as a single umbel that has vastly increased the number of seeds it could produce by repeating the program that produced the original form. It is as if the plant intro-duced a developmental stutter—making umbel struts and then repeat-ing the process by adding umbellets to each of them. The struts emerge from a nest of dark, wiry bracts (Figure 9.6) such that when fully opened, the flower is seen from above as a broad, flat, and nearly solid

field of florets—something like the heliport on a towering building that supports the coming and going of aircraft, a term that is equally applicable to a variety of flying insects who (not incidentally) coat the stigmas of the florets with pollen with their comings and goings.

Seen from below in Figure 9.6, the major struts control the opening of the disk with carefully coordinated movements. Seen from above, before it is fully opened, the flower reveals a complex cup of florets with inward-facing umbellets, that show the complexity of the living lacework. They often have a single burgundy floret at the center of the field, a drop of Anne's royal blood, it is said, from a mishap with a tat-ting needle.

Queen Anne doesn't require choreographed behavior of its polli-nators, she benefits from any bumbling insect or spider who arrives on her landing pad. But some flowers, like the Columbine and Goose-berry, form partnerships; they specialize. Their flower structures are built for a very few effective pollinators. Their size, shape, nectar con-

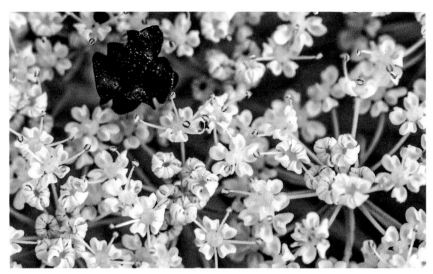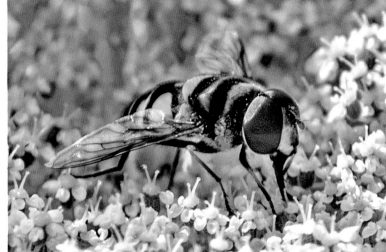

9.7 Left ~ 12X. A field of just opening florets next to the dark floret at the center of a pink variant of the species. Each floret has five petals, a few opened to reveal the filaments with pink anthers at the tips. The floral disk consists of many hundred, conventional but tiny, flowers. Right: ~ 12X. A hover fly has landed on the more common white variant. The paired styles are prominent, but the anthers are gone and the petals are dropping.

tent, and scent, effectively target just those few. They build a facility with a floor plan that coaxes, persuades, or forces the pollinator into places that serve the pollination needs of the flower. Tall White Beard-tongue is one of those, its nectaries deep in the throat of the flower.

Looking down the throat of the flower in Figure 9.8, one can see the essentials arranged to serve Bumble Bees, their primary pollinators. Both flower and bee are native species and they've had a long time to perfect this sophisticated interaction. The tube is shaped and reinforced by four stout, rib-like filaments, tailoring its bore to fit a Bumble Bee. Four stamens with their black anthers are positioned at the peak of the entry arch. A fifth stamen, sterile, lies along the floor of the tube where it acts as a high threshold—a traffic bump—with bristles that force the bees upward, into better contact with the anthers on the ceiling.

The three lower petals create a landing pad decorated with narrow, purple nectar guides. The style, tipped with a stigma, curves downward between the anthers. When the furry Bee enters the tube, it is a snug fit—a test tube brush in a test tube—and pollen is effectively transferred from the anthers to the back of the Bee, and subsequently, from the Bee to the stigma. It's as automatic as a car wash but done without moving parts.

Such exceptional matching of flower and pollinator takes a long time to evolve, and introduced forbs like Queen Anne's Lace don't have special relationships like these. Still, they have been very successful immigrants because they are generalists that attract a broad range of insects.

Milkweeds produce umbellar flowers like Queen Anne's Lace, but they are single umbels, which are more common, and they produce a spherical array of florets (Figure 9.9). Here at Brawley Creek, we have five congeneric species of milkweeds; Figure 9.10 shows a floret of each. Having evolved from a common ancestor, they show clear familial likenesses. The last floret in the panel has a decidedly different presentation, but they all work the same way. Milkweeds have radically reconfigured their florets to create a flower in which nothing looks familiar to us. But we can take heart from the fundamentals: anthers make pollen, stigmas receive it, and pollen must be delivered to the stigma by an insect. Though none of those parts look familiar, it is reassuring to see that all of them originated from the parts with which we are familiar; and in the end, pollen is delivered to the stigma and seeds are produced. Their oddity is a lesson in the power of evolution to complete fundamental activities using old parts, reconfigured into unrecognizable shapes.

9.8 Tall White Beard-tongue (*Penstemon digitalis*). Left: The flower is fully open, the bud behind it, looking ready to burst, shows the ribbing from a second point of view. Right: The fit is perfect for rotund Bumble Bees. With her hind legs dangling, the anthers and stigma barely clear of the wings. As she goes deeper, the high threshold, that fifth stamen, will force her furry thorax up against both sexual parts.

Figure 9.11 shows a floret of the Common Milkweed. It's pretty. The white center that looks like a drumhead is the stigmatic disk and it sits atop the stigmatic column—the rest of the drum. The stigmatic disk is the stage upon which this tiny drama plays out. Surrounding the stigmatic disk are five pink vessels with the look of fine porcelain. They are the nectar wells called "hoods" and leaping out of the hoods, like dolphins in an Italian fountain, are five "horns" that arch over to hover their points over the stigmatic disk. None of these visible parts are sexual; they function strictly to manipulate and reward insects.

Hoods and horns don't appear on other flowers, but they grow from the same embryonic tissue that in a simple flower would have produced the hair-like filaments that support their anthers; and like those, they have nectar wells at the bottom of the hoods, as any butterfly will tell you. It strains the imagination to accept the idea that their ancestors were wire-thin filaments, but such changes are routine—fins become legs, legs be-

9.9 The characteristic umbellar structure of a Prairie Milkweed (*Asclepias sullivantii*) creates a spherical, rather than disk-shaped, inflorescence.

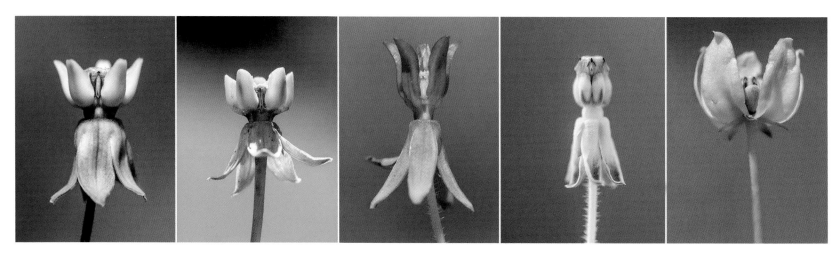

9.10 ~ 3X. A floret from each of our Milkweeds (*Asclepias*) Left to right: Common Milkweed (*A. syriaca*), Prairie Milkweed (*A. sullivantii*), Butterfly Weed (*A. tuberosa*), Tall Green Milkweed (*A. hirtella*), and last, the Green-flowered Milkweed (*A. viridis*), calling to mind the iconic image of Marilyn Monroe in The Seven Year Itch.

come arms, arms become wings. Filaments become hoods and horns. The horns are there to serve as an impediment to insects that land on the stigmatic disk to access the nectar wells.

The sexual parts are inconspicuous, and they are positioned on the sides of the stigmatic column between adjacent hoods (Figure 9.12); they look more mammalian than floral.

Female: The small, vertical opening at the center of the image is the stigmatic slit. It opens into a stigmatic chamber that houses the stigma, positioned just inside the chamber at the top. No pollen-laden insect is going to accidentally stumble into it, so the floret has to make that happen by attracting insects to the stigmatic disk and choreographing their movements, so that they unwittingly carry pollen into the stigmatic chamber and force it into contact with the stigma. It seems impossible.

Male: The spindly filaments are bloated into the prominent hoods and horns, and the anthers are every bit as atypical. They are also concealed on the sides of the stigmatic column, appearing as that faintly green sac straddling the stigmatic slit like saddlebags. The pollen is presented in the form of a two-lobed, waxy mass called a pollinium, that hangs in those saddlebags. The lobes are held together by a shiny, black clip perched above the stigmatic slit—each lobe hangs loosely in its pouch. A pollinium is quite different from the powdery pollen produced by anthers.

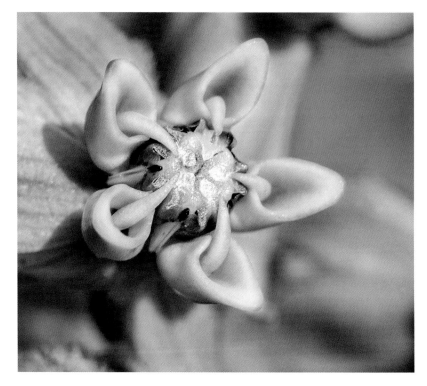

9.11 ~ 9X. Floret detail of the Common Milkweed revealing the familiar sexual parts, all either hidden or modified beyond recognition. At least the petals, filling most of the background, still look like petals.

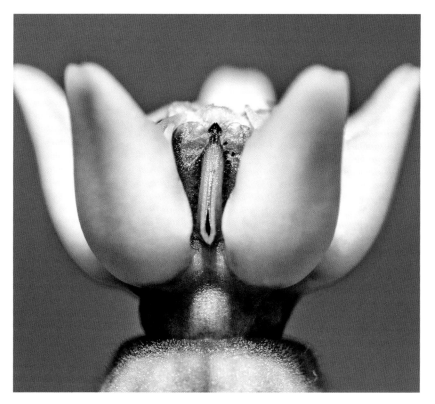

9.12 ~ 14X. There are five sets of sex organs, each set can be seen on the side of the stigmatic column between the hoods. One of the five pollen-producing parts is visible, draped like a shawl over both sides of a vertical, stigmatic slit.

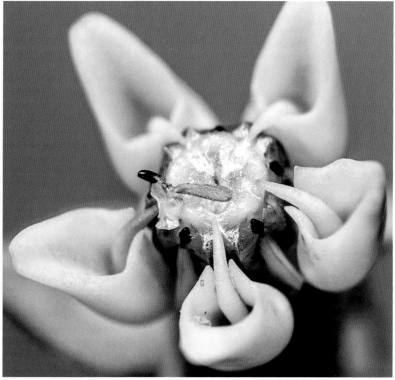

9.13 ~ 13X. One lobe of a yellow pollinium has been extracted from its sac and lies intact on the stigmatic disc—a misfire. The other four black clips are still in place.

The formerly familiar parts have been given new names to account for their novel forms, but they still function the same way. Now we know enough to describe the exotic way in which this biological machine works. Like other flowers, they require two tasks of their pollinators: acquiring the pollen and applying it to the stigma. Milkweeds have made a simple job complicated with this impossibly complex Rube Goldberg device that clearly works.

Part 1: An insect lands on the stigmatic disk, or several stigmatic disks as in Figure 9.14, to draw nectar from the nectar wells at the bottom of the hoods. Moving around on the disk to get at the several nectar wells, she has to step on, over, and around the horns. Eventually one of the visitor's six feet will slip over the edge of the disk and on recovery, it will be directed into the stigmatic slit. On withdrawal, the leg is guided upward, bringing it into contact with the clip that connects the two lobes of the pollinium. The clip functions as a leg-hold trap, and when the leg is finally withdrawn, the pollinium is attached to it like a briefcase handcuffed to a courier.

Part 2: For Part 1 to benefit the plant, the insect must go to a different floret and slip the same leg, with the attached pollinium, into a different stigmatic slit. This time withdrawing her foot brings the attached pollinium forcefully into contact with the stigma. If the insect is too weak, she may be unable to extract her leg and she will die there (Figure 9.16).

The Fritillary in Figure 9.14 is too large and strong to be trapped, but he can still transfer pollinia. Hummingbird Moths (Figure 9.15) take nectar without ever landing on the floret, and one would think they'd be of no use to the Milkweed, but the flowers bob and weave unpredictably with any breeze. Should the Moth extend a foot to synchronize his movement with the flower, he can still serve the Milkweed, as evidenced by a single pollinium on the tarsus of the Moth's front leg. Not surprisingly, the success rate is not very high, but it is high enough.

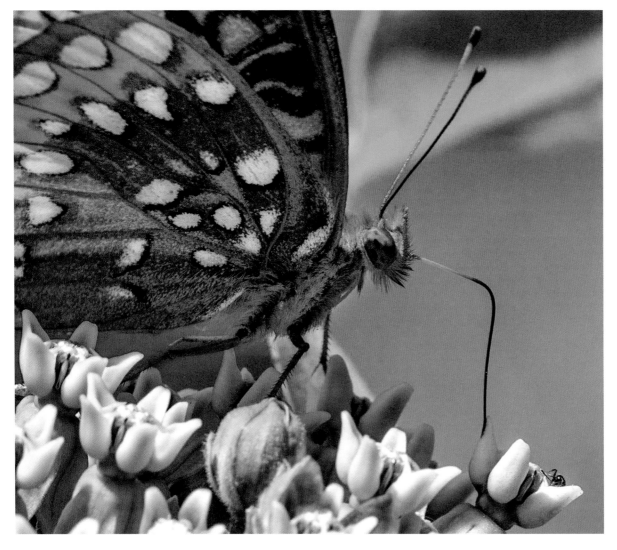

9.14 The Great Spangled Fritillary (*Speyeria cybele*) on Common Milkweed, draws nectar from all five of our milkweed species, and will inevitably pollinate them.

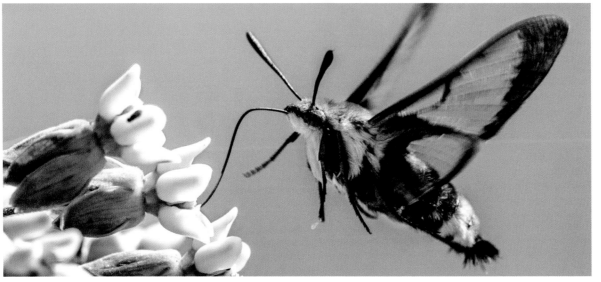

9.15 Feeding from the nectar wells, a hummingbird moth (*Hemaris diffinis*) extends his long proboscis to reach into the nectar wells from a safe distance. Even so, a pollinium has been clipped to one of his legs like a color-coordinated clutch.

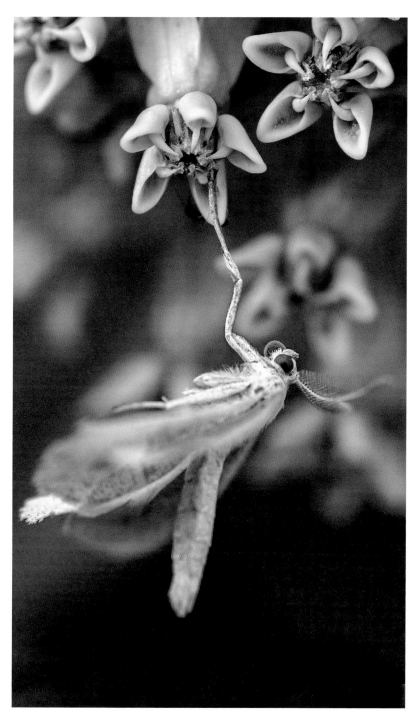

9.16 ~ 7X. A dead Geometrid moth hangs from the floret, at least one of its tarsi trapped in the stigmatic slit. Study of the original image shows that in fact two feet are caught, the second likely captured in the struggle to extract the first and more than one pollinium is visible.

9.17 A Prairie Milkweed has managed to produce just one fruit, a seed pod held rigidly in place by the stem that grows amid a cluster of scars that mark failed florets.

The flowering head of the Prairie Milkweed, seen earlier in Figure 9.9, has 14 florets by my count. A nearby flower achieved just one successful fertilization from its entire umbel with 70 traps set for pollinators—a success rate of about 2% per umbel. Each of those small, brown, wart-like scars in Figure 9.17 marks the abscission layer of a failed floret, but one successful fertilization has turned a once-slender floret stalk into a muscular arm that supports a blimp-like seed pod. The enormity of the seed pod, swollen to well over a thousand times its size when fertilized, and preparing hundreds of maturing seeds, makes more credible the claim that anther filaments can bloat into hoods and horns.

Part of the success of every life form derives from architectural excellence, and that reaches into every aspect of life. The life forms that

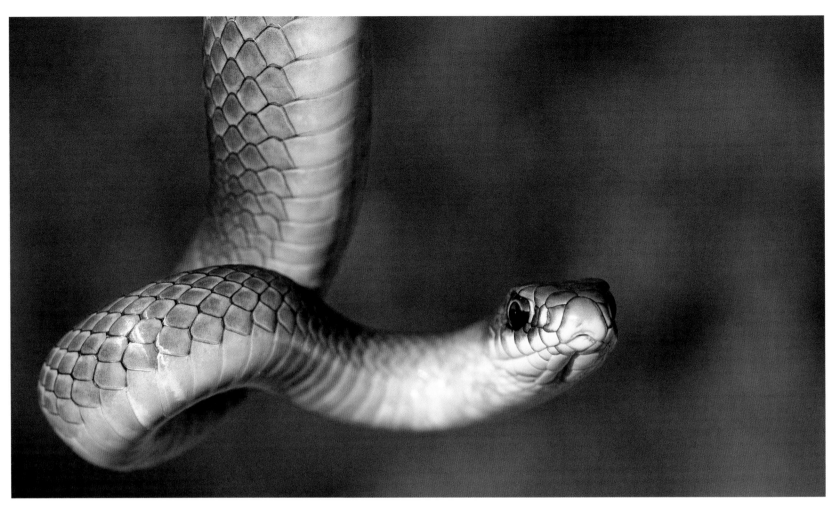

9.18 Don't try this at home. An Eastern Yellow-bellied Racer (*Coluber constrictor*) is a master of power and grace. The ease with which he holds this position is astonishing to anyone who has ever dabbled in gymnastics.

surround us today have created shapes and materials with properties that serve their needs (well enough), using design features familiar to any engineer. But anatomy alone is not sufficient, they need adopt specific behavioral patterns.

The anatomical structures enable offenses and defenses built of muscle and bone in vertebrates. Invertebrates use chitin and silk most often, some use bubbles. There are countless ways to use internal structure and external appearance to accomplish these ends. Noxious chemicals can be weaponized, and mechanisms evolved to meet the demands of securely holding onto other creatures in every way imaginable.

One of the less common ways to securely grasp prey is suggested by one of our constrictor snakes. We can't see the skeleton of the Racer in Figure 9.18, but holding that position without apparent effort is made possible by his remarkable skeletomuscular architecture. If you can look at him without prejudice, he is more beautiful than jewelry. The subtle colors of those burnished scales make a dry, frictionless surface that is pleasantly cool to the touch on a warm day; but more to the point, his extreme flexibility is built on the many articulations required of a complicated skeleton. He has more than 200 vertebrae and two ribs for each. Muscles connect every rib to the next so that not much is required of any one muscle; and while most vertebrates have four ar-

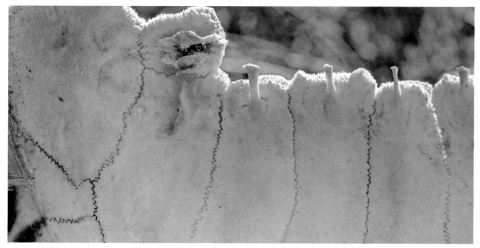

9.19 Left: ~ 1.5X. The backbone and ribs of an Ornate Box Turtle (*Terrapene ornata.*) The heads of the ribs have been fused to a string of vertebral plates, only one of which remains, anchored to what is left of a very small pelvic girdle. Right ~ 3X. The marginal plates skirt the rim of the carapace. One suture is intact, the other has been separated.

ticulating joints between each vertebra, snakes have six.

Every articulating surface is controlled by a pair of antagonistic muscles that provide flexibility and fine control of their movements. The flexibility and power displayed here is sufficient to make movements like this effortless and they enable the tight constriction Racers use to suffocate their prey.

Snakes epitomize grace and flexibility—offense—Box Turtles play defense, withdrawing all their parts into a castle made of ribs, and raising the drawbridge. They plod along and across our trails and occasionally we happen on the ruins of an old castle—a bony shell (cara pace) thoroughly cleaned by scavengers and decomposers of every size. Their skeletons expose their architectural innovations, telling us of the dangers they've experienced and the way they've addressed them. A highly domed carapace denies a predator the use of his crushing teeth. They were never going to outrun predators anyway, so they doubled down by fortifying their bodies.

Making a carapace with maximum strength and minimum weight—getting the most with the least—is the classic engineering problem. Skeletons are vulnerable at moveable joints that require muscles and muscle attachments. If two bones that abut don't really need to move, they can be fused, and become both stronger and lighter with the sacrifice of flexibility at that joint. It is the essence of the diverse

paths by which a common ancestor diverged into racer and box turtle.

Their rigid, domed carapace seen in the left panel of Figure 9.19, is built of fused ribs, a repurposing of primitive reptilian parts that is the exact opposite of the direction taken by snakes. It's a repeating theme in evolution, body form changing through the modification of existing structures, sometimes making them unrecognizable, as the milkweeds have done. We are swimming in examples. By altering the developmental process, we can change the size and shape of bones, and by fusing adjacent ones, the primitive, five-digit appendages used by shrews for walking have been converted variously into horse's hooves, bat's wings, and primate's hands and feet.

The strength of the carapace lies in the force distribution inherent in arches, leveraged by fusions. The belly plate (plastron) is derived from abdominal ribs like those embedded in the belly muscles of alligators, which become expanded and fused to form the flat, hinged belly plate. The dorsal ;ribs are broad and fused to the vertebrae which are themselves fused, making a single unit of the carapace. With these fusions, there is no need to nourish intercostal, intervertebral, and trunk muscles, nor to supply their consumption of energy and oxygen, nor to carry their weight.

Those joints are greatly enhanced by a maze of interlocking projections that vastly increase the surface area available for adhesion (Fig-

9.20 ~ 4X. Skull suture of a male White-tailed Deer, bonding the frontal bone at the top of the image that holds the antler, to the parietal at the bottom of the image.

ure 9.19). The sutures between ribs are most elaborate near the vertebrae where the pressure from crushing would be greatest. The vertebrae act as keystones that transfer force into right and left halves of the arch. The entire carapace, which can be seen as a series of arches, rests on aggressively interlocked marginal plates that form a thick rim. They are shaped like angle-irons to resist bending, so that the dome of the carapace rests on that rim like a bridge span rests on its abutments. The thicker the rim, the more resistant the parts are to separating. It is an engineering masterpiece.

And so is the reinforcing of a deer skull (Figure 9.20) which we should remember is yet another mass of fused bones where rigidity is prized over flexibility. Antlers are extensions of the frontal bone, backed by the parietal bone, the joint greatly strengthened by a maze of interlocking projections far more elaborate than the interlocking bones of Ornate Box Turtles. This degree of sophistication hints at the severe demands placed on that joint. When two 300-pound males lock

antlers, that joint must hold to keep the bones of the skull from being pried apart by the leverage applied by the antlers that project from their frontal bones.

The highly domed carapace of Box Turtles is engineered to withstand the crushing jaws of a predator small enough to want it, but with a gape too small to get a good, crushing grip on it. Foxes and Coyotes fall into this category. The high dome keeps predators from moving the turtle deep into their mouths where the crushing teeth can be brought to bear. I can't speak to the issue of Box Turtles survival during the Pleistocene when there were really big jaws here—Dire Wolves and Saber-toothed Cats—possibly box turtles were too small to be worth "shelling."

What do you suppose it's like—walking on all fours, your hips and shoulders confined within a bony box, your legs projecting out of slots like oars on a Roman galley? Obviously it's slow and labored, and painful to watch as they drag that boxy, mobile-home-without-wheels through vegetation and over downed branches for about 25 yards a day. But this is our empathy run amok. Surely, they don't miss the flexibility we take for granted, and I'd probably make that choice too, if the alternative was having my body crushed or my arm chewed off by a Coyote.

Some architectural devices bind to form connections rather than fuse. They are the biological equivalent of the wires, ropes, and threads we find so useful. Their natural equivalents are vines and tendrils. As with other phenomena, they can be divided according to scale, like the weight classes of boxing. The heavyweights are the enormous grape vines that climb trees to the canopy like you'd climb a ladder, reaching out to grasp whatever is available and eventually severing those connections as they move higher, ultimately to be supported by the canopy as a flimsy tree that hangs rather than stands. Virginia Creeper and Poison Ivy are featherweights, who cling to the trunks of trees like snakes and slither their way to the canopy, never breaking their connections. And then there are the fly-weights: Morning Glories, Bur Cucumber, and Climbing Milkweed among them, that have a light touch and a firm grip.

Tendrils are modified leaves that have become sensitive to touch. Sometimes, the long stem of the vine is itself sensitive and acts as a tendril wrapping around any found support like the Climbing Milkweed

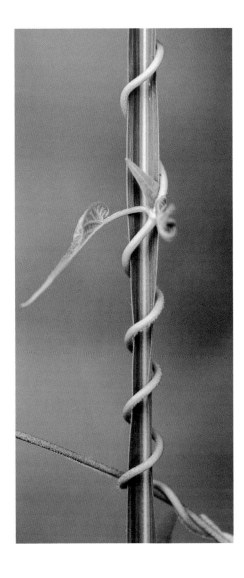

9.21 Climbing Milkweed (*Cynanchum laeve*) wraps around a blade of ornamental grass. It can also wrap around itself (lower right) to produce a tough cord with multiple strands.

(Figure 9.21). But the tendrils of the Bur Cucumber (Figure 9.22) are the sensitive midribs of leaves, freed from the webbing imposed by the blade of the leaf, they are now free to evolve into to grasping tentacles. Spread wide like a grappling hook, they slowly weave about, eventually touching a nearby object—a grass stem, a leaf—an occasional breeze will increase their contacts. The touch stimulates cell elongation in the side of the tendril opposite the contact, and it curls around the object, holding onto it with the intensity of a constricting snake. Once the object has been firmly secured, the long straight tendrils coil tightly, as the Burr Cucumber draws the object of its attention closer.

Their grasp is surprisingly intimate, and their ability to capture and fix their attachment is remarkable. One of the refinements of Bur Cucumbers is the insertion of one or two kinks, which allow them to pull an object closer without twisting either end of the tendril, avoiding tensions that could easily dislodge a flimsy attachment like the one in Figure 9.22. In a living connection like this one, the twist is neutralized by those kinks, reducing the stress on the perhaps tenuous attachment to the host. That is the function of the kink in the cord of old telephones that looked just like this tendril.

Strong arches, interlocking joints, and coiled springs are consistent with our sense of orderly, planned architecture and good design. We also find bubble wrap useful. We don't generally think of it as architecture but suppose a whole house was made of it. The bubble house in Figure 9.23 was built by a nymph of the Meadow Spittlebug. Aptly

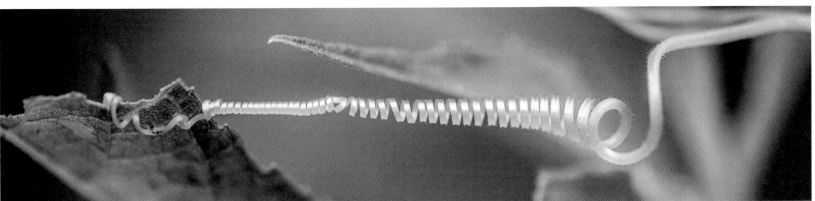

9.22 ~ 7X. A Bur Cucumber *(Sycios angulatus)* tendril has grasped a partially-eaten leaf of Wingstem. It is a difficult capture because of the shape of the leaf and incidental initial contact, but the grip is strong enough to pull the Wingstem closer where other tendrils can slowly secure it.

9.23 ~ 8X. The Spittlebug nymph (*Philaenus spumarius*), is odd enough to have garnered a number of colorful names—cuckoo spit, snake spit, frog spit—almost any kind of spit. This one has had his house blown apart by my huffing and puffing. Exposed but not gobbled up or sunburned, he retains his inverted position and is already rebuilding.

named, Spittlebugs live on a wide variety of plants, but they favor grasses. Adults are recognized as froghoppers—a small bug about half an inch long that can make astounding leaps of 100 times their body length. They do it by using design features that give a cross-bow its power, but that mechanism is too small for consideration in our slice of the little infinity.

As true bugs (order Hemiptera), Spittlebugs have piercing mouth parts and make their living by tapping into the vascular systems of plants with a needle-like stylet; the operation is a lot like giving blood. Unlike most bugs, Spittlebugs bypass the nutrient rich phloem to tap into the xylem vessels that have the poorest supply of organic molecules in the plant; and that begs for an explanation. That choice means that they have to process a lot of fluid to get the energy and nutrients they need. Each day Spittlebug nymphs pass up to 200 times their body mass through their GI tracts, having extracted the nutrients, they use the fluid to build their bubble houses. We might suppose that he blows bubbles the way we would, but he doesn't have lungs or diaphragm, and his mouth is otherwise occupied. Anyway the fluid emerges through his anus. Here's how the bubble machine works.

The nymph positions himself anus up, as in Figure 9.23—an important point. The nymph extracts the few nutrients and passes the xylem water, which flows down along his body where a viscous fluid is produced and added. To make the bubbles, he needs air from the paired openings in each abdominal segment. Air is pumped into the mixture by muscular action of the abdomen, and as it moves upward along the body, the air mixes with the fluid, producing a cornucopia of bubbles that cascade over the body, sticking to everything and covering everything. In less than a minute, the larva can obscure himself entirely. These are not ordinary bubbles. They are tough and not very soluble, so they don't disappear in the rain. The bubble house hides the larva from his predators, particularly ants and spiders, blocks UV light, mitigates temperature extremes, and keeps the larva from drying out. Plenty of reason to make a foam house even if it looks like spit. The foam has an acrid taste (I'm told). His food comes to him through a plumbing system connected to a main supply line, and hidden in the bubbles, and he can remain in seclusion and feed at will.

Moving from architectural to chemical defenses, we'll begin with plants that are the most diverse producers of intentionally unpleasant

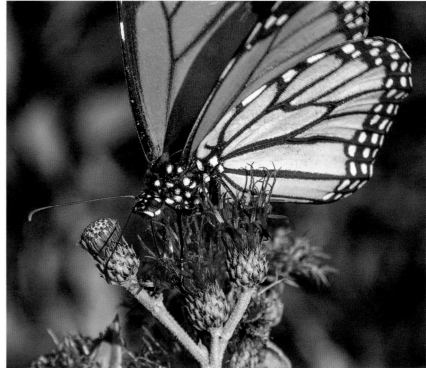

9.24 Two Monarch caterpillars (*Danaus plexippus*) just before pupation are eating the entire seed pod of Tall Green Milkweed, decimating the reproductive effort of this plant. As adults, Monarchs feed where they can get nectar; which is only sometimes on Milkweed. This one is on Ironweed (*Vernonia* sp.), so that this time, Ironweed nectar will fuel her flights to search for a mate and for milkweed leaves to place her 400 eggs, one at a time.

compounds. Plants are not helpless before the onslaught of herbivores—a common response is to make themselves unpalatable with simple chemicals, or with sophisticated chemicals ranging from toxins to adhesives. Pines produce resins, oaks produce tannins among other compounds, and Coffee trees make caffeine to discourage insect attack, but none provide immunity—not even the serious toxins of milkweeds. Many toxin-producers inadvertently create niches for those few species that have managed to defeated their defenses in some way. They manage by minimizing their exposure, by detoxifying the poison, or sequestering it within their own bodies. The toxic plants then become a resource with few competitors, but also defense against their predators.

Bright colors scream for attention and serve as attractants: flowers advertise for pollinators and brightly colored fruits sound a visual dinner bell for their seed dispersers. There is always some reason to draw attention, the methods varying from one life form to another. The use of color in animals is mixed, sometimes serving as a sexual attractant,

sometimes as a distractant like the blue tail on a Skink, or with bright flash colors to startle predators. Commonly bright colors and bold patterns are warnings of toxins on board, sometimes weaponized as a venom to be delivered by sting or bite. It is very important for omnivores like us, to respond to those colors and bold patterns discriminately. Predators learn by experience: a toad who takes a Bumble Bee into his mouth doesn't forget, and a Blue Jay who eats a Monarch, gets a cocktail that is both emetic† and a seriously toxic cardiac glycoside.†† They don't forget the bold patterns and memorable colors. We can learn

† Lincoln P. Brower studied the Monarch-Milkweed connection for decades. He chose Blue Jays as the visual predator in his experiments and they became widely known as Brower's barfin' Bluejays.

†† Cardiac glycosides are steroids coupled with one or more molecules of sugar. They inhibit neural activity by disabling the sodium-potassium pump that is integral to transmitting a nervous impulse.

Unexpected Cycnia (*Cycnia inopinatus*)

Red Milkweed Beetle (*Tetraopes tetrophthalmus*)

Large Milkweed Bug (*Oncopeltus fasciatus*)

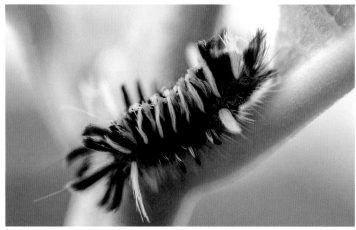

Milkweed Tussock Moth, (*Euchaetes egle*)

Dogbane Leaf Beetle (*Chrysocus auratus*)

Oleander aphids (*Aphis nerii*)

9.25 A collection of toxic Milkweed aficionados, roughly to scale (overall ~ 1.5X).

by instruction or be taught, although learning by experience is more robust.

Brightly colored Monarch Butterflies are sequesterers. They get their poison from their caterpillars, who get it from the Milkweed plants they eat; a relationship as widely known as anything in biology. They are so tightly linked in our minds that we are inclined to think of them as cooperative species, but only the Monarch benefits in that relationship, the caterpillars slipping inside the plant's defenses to eat it. It's an herbivore/producer relationship much like the predator/prey relationship of owl and mouse. There are risks to specializations, most prominent among them is that the health of the butterfly population depends on the health of the Milkweed population. Such a narrow base leaves them increasingly vulnerable as our continuous expansion encroaches on their habitat.

Enjoying evening walks in the warmer weather, Gina and I have found at least six additional eye-catching insects (Figure 9.25) that have weaponized the cardiac glycosides of milkweeds, and who advertise their status with flamboyant colors that amount to flying the Jolly Roger. Feeding while fully exposed during the daytime, their bright colors and bold patterns warn predators, especially those with color vision—birds.

In Figure 9.25, the adults of the Unexpected Cycnia and the Milkweed Tussock Moth have plain gray wings, that help them avoid detection during the daytime. But in both cases the wings cover a bright orange abdomen that they flash when disturbed. The Milkweed Bug and Milkweed Beetle are two very different species, both of which eat in plain sight during the day. The Bug pierces Milkweed pods with its long rostrum to digest the seeds while still in the pod, then extracts the juices through his rostrum. The Beetle eats the leaves. Dogbane Leaf Beetles don't venture onto Milkweed, but Dogbane is related and carries similar toxins. Their grubs feed on Dogbane roots and the adults on the leaves—they can afford to stand out. Oleander Aphids feed on Milkweed pods too, but they insert their tiny stylet into the vessels and avoid the milky latex, but take on the toxins. The Aphids are newcomers that illuminate some complications that arise locally as a result of our global travel. They are invasives who evolved to feed on Oleander plants that grow around the Mediterranean. Oleander is related to both Milkweed and Dogbane and produces cardiac glycosides too.

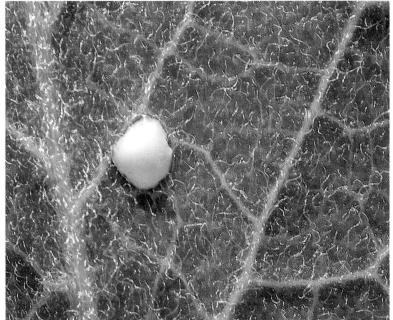
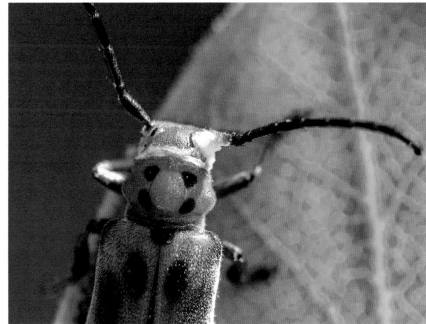

9.26 Left: ~ 9X. A pin-prick on the underside of a Common Milkweed leaf releases a bead of latex that, to small insects who trigger the release, must be like getting slimed, and it gums up tiny mouth parts. Right: ~ 5X. Milkweed Beetles clean themselves, but they don't always get it all—dried latex covers one eye and spreads across the back of the head.

When Oleander was brought to the U.S. as an ornamental, the aphids came with it. They discovered Milkweeds as an entirely satisfactory food source, and they've recently become widespread, attracting attention by forming bright yellow masses, like the one in Figure 9.25.

Beyond the toxins, Milkweed and many others have an additional line of defense: they produce a thick milky sap with a high latex content. Milkweeds move fluids in the conventional ways: xylem elements carry water up from the roots, and phloem carries sugars down to feed non-green parts. Some species have developed a third system of vessels that carry only latex. That latex, under pressure, releases when the plumbing is damaged, triggering the abrupt release of viscous latex—a physical threat to small insects (Figure 9.26). To us that fluid just means sticky fingers, and if you aren't careful, burning eyes, but hatchling caterpillars and small beetles live in a world of different scale and the latex may well glue their mouth parts together and many die from it. In one experiment, 30% of first instar Monarch larvae (hatchlings) died mired in latex. Add to that the usual threats—internal parasites, bacterial and fungal infections, and insect predators, and you begin to realize that none of these insects are as safe on their host plants as we generally imagine. But there are defenses against the latex too. Red Milkweed Beetles cut the vessels in the petiole of the leaf on which they are about to feed, and they clean off their mandibles quickly before the latex can harden and effectively block the mouth. Milkweed Bugs avoid the latex system by inserting their rostrum through the surface and reach for the seeds. Aphids are tiny enough to puncture the phloem vessels without triggering a release of latex.

Typically, plants are defensive because they are the bottom tier of the entire energy edifice. There are carnivorous plants, and you can argue that vines play offense, but by virtue of their foundational role, producers adopt primarily defensive strategies. They have developed methods—weapons—to protect themselves from the next higher tier. The same can be said for each tier except the one on top. Unavoidably, organisms in every tier play both offense and defense at once. They are both hunter and hunted and their defenses are similar to those of animals with antlers, claws, and teeth, rather than thorns, and targeted venoms rather than general toxicity. For non-lethal penalties, the noxious smell of a skunk works along the lines of tannins in acorns and unripe Persimmons. If you think a skunk's spray is simply unpleasant,

you've not been close enough to the source. In dogs, whose sensitivity to scent is estimated at 10,000 times more acute than ours, a strong exposure leaves them temporarily disabled. At least that is my observation.

Our view of the world is from the top of the pyramid. We are hunters and we relate to other hunters. These days we hunt mostly in the aisles of supermarkets, but we were shaped by more challenging circumstances. Perhaps the closest we can get to understanding the activity that fed us then, is to watch subsistence hunter-gatherers. As they walk, they scan the panorama of living things. They are looking for anything to eat—grubs or the indication of grubs, the track of a deer, a bird's nest where there might be eggs. At the same time, the hunter is alert to danger—thorns, wasps, vipers, the track of a lion. His senses of smell and hearing are fully engaged. Naturalists can benefit greatly from relearning this skill.

E.O. Wilson describes this state of hyper-awareness as the hunter's trance:

"The naturalist is a civilized hunter. He goes alone into a field or woodland and closes his mind to everything but that time and place, so that life around him presses in on all the senses and small details grow in significance. He begins the scanning search for which cognition was engineered. His mind becomes unfocused, it focuses on everything… his eye travels up the trunk to the first branch and out to a spray of twigs and leaves and back, searching for some irregularity of shape or movement of a few millimeters that might betray an animal in hiding…."

Surely, we share that searching behavior with other predators like Sharp-shinned Hawks. Imagine him flying low through the woods doing exactly this sort of scan, looking for any movement in his field of view, searching for "some irregularity of shape," perhaps the bump of a Brown Creeper flattened against the bark or a patch of red in the brush—a Cardinal whose curse it is to carry his bold, red plumage even in the gray-brown world of Winter.

Every hunter must achieve some equivalent skill. A warbler, highly animated and flitting from twig to twig, is actively scanning in all three

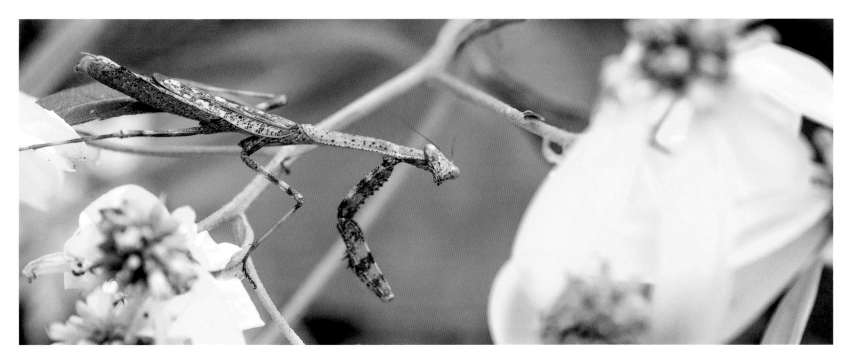

9.27 This Praying Mantis (*Tenodera sinensis*) introduced from China in the early 1900s is both predator and prey.

dimensions, searching for caterpillars, spiders, and anything else edible. We can assume that they too search for something uncharacteristic—a leaf with missing parts, a tiny twig that moves differently from the branch to which he is attached. The hunter becomes sensitized to rewarding shapes, as we do when scanning the brush for Blackberries, Strawberries, or some other target with a well-defined shape and color. When we focus at that level, we find berries more effectively, but at the same time we become less likely to see anything else. That skill is a bit rusty in most of us, but it is at the heart of any search and practicing it adds a new dimension to time spent on the trail.

For those of us who move when we hunt, understanding the nature of the hunter's trance is important, but most predators are also prey. The Praying Mantis in Figure 9.27, remains stationary or moves very slowly while hunting. Sometimes she adopts a rocking motion as she approaches nearby prey. That may be to simulate the movement of branches, or to achieve better depth perception, or both. Escaping notice is doubly to the advantage of species who must avoid being detected by either their predators or their intended prey. These relationships model an arms race, where predators and prey are constantly improving both their camouflage and their camouflage-detecting abilities as they maintain a kind of stalemate. That hunter/hunted model resonates with us in a way that the chemical interactions of plants and insects do not. We've all played both roles in hide and seek, although for us, being found was of little consequence.

White-banded Crab spiders are lunge-grab-and-bite predators with four powerful, matching arms spread wide and cocked like a mouse trap. They are a predator archetype but tiny—a scaled down model of a Crocodile waiting in the water hole for a Wildebeest. Insects must come to the flowers as surely as Wildebeests must come to the water hole. All of us can find the Crab Spiders in these pictures (Figure 9.28). We have excellent eyesight, and we are looking at a bounded image that we know has a subject in it—a subject that can likely be found near the center of the frame. There might as well be a flashing, red arrow pointing to it. But a fly, with not-so-good eyesight, wandering into his eleventh squash blossom for groceries, might be excused for not noticing the spider; but that won't help him.

The ubiquity of crab spiders and the perfection of their camouflage continually surprises me. So perfect are their color matches, it's almost

9.28 Two differently camouflaged White-banded Crab Spiders (*Misumenoides formosipes*), lie in wait for their prey. left: ~ 5X. …waiting in a flower of Butternut Squash. Right: ~ 3X. Nestled in the floral disk of Queen Anne's Lace, the spider's radiating arms are lost in the confusion of florets.

as if they are a product of the flowers themselves. Misumena, a relative of the Spiders in these figures, becomes yellow by secreting a liquid yellow pigment into the outer cell layer of the body. The color change is induced by visual feedback, so a neutrally colored spider could become as yellow as the one in the squash blossom in about six days. The color match is uncanny. Sometimes they hide in the supporting umbel below the floral disk of Queen Anne's Lace, and pop up through the floor of florets to grab an unsuspecting insect. It is the stuff of nightmares.

White-banded Crab Spiders are so variable in color that it is hard to accept them as color changes within a species. "White-banded" refers to the light-colored stripe positioned like the mask of a cartoon burglar, although it is jaundiced in the yellow spider.

Prey species with no toxic defenses often try to disappear. We can afford to be amused by this, but for the entire range of prey, predators, and parasitic insects it is not a game—their lives depend on escaping the detection of a motivated hunter who has made finding them the

focus of his life at that moment. I've been amazed at how difficult it is to relocate a clutch of Killdeer eggs, or to find the incubating Woodcock, knowing perfectly well that she is sitting within ten feet of me, and still I am unable to find her.

There is an incredibly broad array of strategies, the most intriguing are found among the hunted hiding in plain sight, either by disappearing entirely into the background, or by passing as inanimate objects like Walking Sticks, or the Praying Mantis in Figure 9.27. Their perfection of shape, color, and behavior is astonishing. One wonders how they could become so convincing. The process of mimicking a substrate must be fairly direct because it is so common. Vulnerable species don't need to begin with a convincing likeness, they just need to be a little less obvious than the average. A success rate of only one-tenth of a percent over their peers will eventually polish the mimic through a series of tiny changes. Millions of years of perfecting has produced an incredible diversity of frauds. The Schlaeger's Fruitworm Moth in Figure 9.29, shows us a bird dropping mimic. At rest, the body and legs are

hidden by long tent-like wings.

Appreciating the workings of the hunter's trance is important to appreciate the attention to detail that creates a good mimic. A moving insectivore, scanning as she hunts, can't afford to stop and examine every bird dropping. It would be costly, especially if the "dropping" is small and doesn't look like it would be much of a caloric prize anyway. This is not the best of the bird dropping mimics, but the details of how he does it can teach us something about perception.

Success depends on being very still for obvious reasons, and mimics need to avoid give-away signals the defeat their ploy. Droppings don't have legs, nor are they perched on a substrate and so cast a shadow. Shadows make them appear as something resting on a substrate, rather than just substrate. Droppings often appear flattened against the substrate, so a successful mimic flattens himself—assuming a position where all edges touch the ground goes a long way. This Moth configures herself like a pup tent with her wings in contact with the substrate so that there are no shadows, and her legs are hidden under the wings.

All of us seem acutely aware of eyes that might be watching—paired spots that could be the forward-directed eyes of a predator. That accounts for our sensitivity to any figure that could be a face, like the Monkey Flower in Figure 9.5. Whip-poor-wills and Nighthawks have very large, black eyes that serve their nocturnal activities, but at rest they close their eyelids to leave only the barest of slits and those eye-catching, black orbs disappear under mottled eyelids. Moths don't have eyelids to close. Instead, working with the parts available to them, they fold patterned antennal bases back over the eyes, as seen in Figure 9.29, the rest of the antennal length tucked under the tented wings.

The master achievement of this Moth, however, is the hump. A bird dropping consists of urinary waste in the form of a white sludge (precipitated uric acid) along with digestive waste that is more coherent and dark—the latter forms the lump in the splat. Our Moth not only produces a single lump, but she moves it off center, a good trick for a body plan based on symmetry. Symmetry is one of those things that catches the eye of a hunter as well as a prospective mate. It is a property of living things, and most animals are symmetrical, so avoiding symmetry is consistent with presenting themselves as an inanimate objects. Another fine point? Semi-fluids run downhill, so they drape their

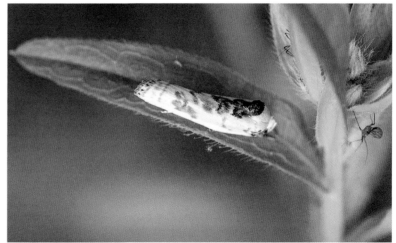

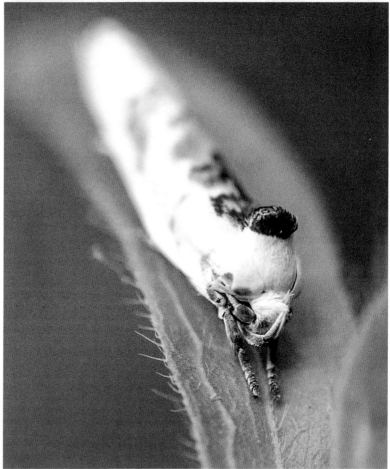

9.29 Schlaeger's Fruitworm Moth (*Antaeotricha schlaegeri*). Top: ~ 2X. A convincing bird dropping can't be too large. Bottom: ~ 6X. She folds her flattened antennal bases back over her eyes, shielding them from view, but leaving them functional. The iridescent, off-center hump is the pièce de résistance.

9.30 ~ 10X. Larvae of the Scarlet Oak Sawfly (*Caliroa quercuscoccinae*) are actively skeletonizing the underside of an oak leaf.

bodies to mimic the effect of gravity.

Caterpillars of many species mimic bird droppings, some right down to a shiny surface that makes them appear wet. I once watched an experienced and exceptionally knowledgeable naturalist talk about just such a caterpillar that he had found on a trail walk. When he tried to pick it up, he found that it really was a bird dropping. This Moth doesn't have a shine to mimic a wet surface, but it has an iridescence confined to the scales on the dark hump suggesting that it is wet.

Living in the open and eating leaves creates visible damage, and a skilled hunter will notice. So, if you are palatable, you will benefit by taking steps to minimize your presence. You don't want to stand out like a cow in a pasture. These lessons are genetically coded as illustrated by the careful, systematic nibbling of the Tomato Hornworm† seen in Figure 2.18. As noted, hunters are looking for "some irregularity of shape or movement" that might suggest a meal.

If an insect finds a successful strategy, they often speciate, specializing to feed and hide in different species, each seeking a unique niche. Leafrollers are a kind of moth (Tortricidae) that we encountered earlier as a dangling, green caterpillar in Figure 6.9. They have learned to roll a leaf around themselves and stitch it closed with silk, living like a little green burrito. There are over 1,400 species of Tortricids in the U.S. and Canada and they have achieved such diversity by specializing in the leaves of different species of plants. And besides the Leafollers in their burrito-like shelters, there are Leaffolders hiding in taco-style shelters.

There are other ways of minimizing the likelihood of detection. Scarlet Oak Sawfly larvae (Figure 9.30) skeletonize the leaves of a variety of oaks by eating the lower epidermis and rich mesophyll while leaving the upper epidermis intact. A better name for what they do is "window feeding," but to me it looks like a herd of tiny, upside down cattle grazing on the underside of a leaf . Turning the leaf over reveals the lot of them, but a passing predator would need to see the leaf from below or detect the subtle damage that doesn't become discolored until later; and when it does it produces a scattering of false positives.

Figure 9.31 shows the work of a different sawfly. Dusky Birch Sawfly larvae work in family groups. They eat all three tissue layers, leaving visible damage that a predator is not likely to miss, but if successful, the predator will see the damage, but not the larvae. The scam works because the larvae create a patchwork of holes but leave some bridging vessels still in place. When threatened—a small bird landing anywhere on their branch would be enough—they swing their rear ends away from the leaf margin they are eating and become motionless in the S-shaped postures seen in Figure 9.31. Their bodies are green with birch leaf fodder, and when frozen in identical postures, they mimic, in color and shape, the vein structures of the leaf that they left in place.

Leaf Miners have adopted an even more secure way of eating a leaf; they are a diverse bunch too, each species confined to only a few hosts. One thinks of a leaf as impossibly thin, but everything is relative, and

† Tomato, Tomahto, Tobacco. Tobacco and Tomato Hornworms are two names for the same species—both are *Manduca sexta*.

9.31 Progeny of a Dusky Birch Sawfly (*Croesus latitarsus*) consume a leaf of River Birch (*Betula nigra*) leaving clear evidence of their activity. On being disturbed, they adopt an odd posture: gripping the leaf with their legs, they hoist the rest of their bodies, including their prolegs, into the air and remain motionless.

it is not too thin for flat-bodied Leaf Miners. They spend their entire larval period "between the sheets," eating the nutrient rich mesophyll without disturbing either the upper or lower epidermis. The female moth, fly, wasp, sawfly, or beetle—there are many kinds of leaf miners—inserts an egg into the mesophyll that on hatching, begins to eat, leaving visible traces that look random. Probably they aren't random though, because different species leave characteristic trails. Protected from drying or being dislodged, and swimming in food, it seems a remarkably secure life for an herbivore.

Figure 9.32 maps the entire larval period of a Leaf Miner, that was spent inside a single leaf of Pale Indian Plantain wandering about like the Israelites in the wilderness. Beginning with that tiny white line (bottom, right of center) where the egg was laid, his journey follows the white trail that I've lightened a little to define the route of single larva. The trail grows in width as the larva grows. He intersects his own tunnel and that of a different miner, and the trail ends in an empty pupal case from which the adult moth took flight, beginning an entirely different kind of life, for which his genetic instructions have prepared

9.32 ~ 2X. The lifetime travels of a larval Leaf Miner (*Phyllocnistis insignis*).

9.33 ~ 4X. An occupied pupal case presents a bit of irony. Her extensive wandering ended just millimeters from that tiny track that she began excavating when she hatched.

him. None of his experience as a larva is applicable. Unpigmented and translucent, the larvae assume the color of the leaf by virtue of a full gut, but the visible track littered with a lifetime of his fecal material, identifies his position precisely. They are protected from a wide range of predators while inside the leaf. Those big enough, and strong enough to extract him, are too big to bother with him. It's not all easy-livin' though: they are vulnerable to parasitic wasps and the usual run of bacteria, viruses, and molds that torment the rest of us.

As days become shorter, the heat of Summer persists. The principal activity of Summer is production—Late Fall is about dispersal. But between them there is yet another full season of warmth during which the climate becomes even hotter and dryer. The input of solar energy is still substantial, and all of the machinery of production is still humming. The community responds to the change by beginning its long, slow transition toward the season of rest that seems distant. Early Fall includes the dog days of Summer and we might think of it as an interim session—after this, but before that.

Life forms that dominate in those hot, dry times are adapted to excel in them. During Early Fall the energy stockpiled by the hyper-productivity of Summer works its way through the long, braided chains of

consumers, and the consumers of consumers. It is a time to wind down and prepare for Winter. This period of transition has its own mix of plants and animals that I think deserve a season of their own. Accordingly, I've given them a separate chapter.

10.1. It's early July, just weeks after the solstice and Honey Locusts (*Gleditsia triacanthos*) have already begun dropping their leaflets. These, still with a smidgeon of chlorophyll and caught on the floral disk of Queen Anne's Lace, signify the beginning of Early Fall.

10

Early Fall: Winding Down

"Summer passes into autumn in some unimaginable
point of time, like the turning of a leaf."

~ Thoreau

Thoreau's claim may not be quite unimaginable, but it is surely indefinable. Leaves begin turning with the subtlest of changes and they have turned only when we decide they are brown instead of some compromised shade of yellow or red. The transitions among the other warm seasons are determined with equal precision. Following the excesses of Summer, productivity during the remainder of the warm season becomes less and less until it comes to a nearly complete stop with the well-defined start of Winter. Declining productivity is the hallmark of that entire period and I've decided to recognize the first part as a separate season that I'll call Early Fall, and it begins long before the autumnal equinox. The facing page shows Queen Anne's Lace, one of the flagship flowers of Summer, littered with the yellow leaflets of Honey Locust, their programmed leaf drop already underway in early July, and it indicates the very subtle beginning of Early Fall. In the broad sense then, Early Fall is characterized by a continuation of the fundamental functions of reproduction and growth, while Late Fall focuses on achieving dispersal and dormancy. Those two seasons are centered around different functions and that is reason enough to separate them.

Summer continues out of sheer inertia for a few weeks following the solstice, like Wile E. Coyote who was always slow to realize that he has chased Roadrunner off a cliff. Solar energy dwindles as days shorten, the angle of incidence lessens, and diminishing rainfall allows more dust in the atmosphere. Solar collectors, newly minted for the

Summer bonanza, are showing signs of wear and their output is increasingly compromised by a population of herbivores that are growing, each of them eating substantially more. All of that slows the machines of ecological productivity, like the U.S. economy slows with a decrease in government spending.

The textbook definition of a recession is, "A period of declining economic performance across an entire economy lasting for several months." Seasonal jobs begin disappearing as the flowers of Summer, like Beard-tongue and Milkweed, close up shop and turn their efforts to maturing seeds, and the fleet of pollinators must now find other employment. New species are flowering but by the end of Early Fall, not much is left.

Recession is a loaded word with bad connotations and the ecological consequences of decreased productivity are consistent with that diagnosis, but natural systems are inherently cyclical—only humans carry the expectation of endless growth, and we might misunderstand this time as a setback, rather than as a prescribed period of rest and retooling. As the season passes, the usual activities of the ecosystem persist, but the business of turning a profit is slowly redirected toward preparing for retirement, and some species begin to drop out of the work force in advance of an entirely predictable Winter. It is parallel with agricultural cultures where work dwindles as the various crops have been harvested. It's a long, slow glide that slips into Late Fall, "at some imperceptible time." Early Fall includes part of July and August; both are hotter and dryer than any month during Biological Summer, and that occurs even as sunlight is decreasing. That's due to thermal inertia.

The life forms of Summer are characterized by an array of composite flowers adapted to compete well under these circumstances. They made their appearance before the extinction event at the close of the Cretaceous Period, survived that crisis, and have since flourished. They appeal to a broad range of insects, and the interactions with their pollinators are such that it is hard to imagine the existence of one without the other.

The flowers generally recognized as composites begin to eclipse those with single flower heads as Early Fall advances. Like a wildly successful internet startup, they've gotten rich on a new technology† that gives them a competitive edge in the climate of Early Fall, and they dominate in part, by crowding their florets cheek-by-jowl so the num-

bers of seeds they can produce increases dramatically. Composites evolved from simpler flowers with one ovary per receptacle, however many seeds it might eventually produce. Evolution saw that as a waste of space; something like single-family homes giving way to a clusters of apartments.

Composites are gathered in the very successful family Asteraceae, which includes the Asters themselves, along with Daisies, Sunflowers, Dandelions, Thistles, and more. Figure 10.2 shows a few familiar composites of Early Fall. They seem to favor yellow, accounting for the predominance of yellow flowers then. There are also magenta to purple hues and some white, but to my knowledge there are no red or notably blue flowers among our native composites.

Composites are sometimes difficult to identify; there are a lot of kinds—39 kinds of Asters and 27 kinds of Goldenrods found just in Missouri—each of them crowded into their own genus, so quite naturally they look very much alike. Understanding simple, perfect flowers is necessary but not sufficient to understand how these advanced types work, because like the Milkweeds, those familiar structures are greatly modified in composites. Still, they must serve those same functions—cell phones don't look like the old dial-up phones, but you still have to enter a string of numbers.

Composites typically produce two kinds of florets in the same head. The petals are ray florets, often with a stigma, style, and ovary. Disk florets are crowded together on the disk, often in the hundreds, each with its own stigma, style, and ovary; all of them a few millimeters long or less. They are still flowers though, and they are fertilized by the transfer of pollen to stigma—the fundamental parts are there, but as in the Milkweeds, recognizable more by function than appearance.

We first learned "The Anatomy of a Flower" using "perfect" flowers like the Spring Beauty. Pokeweed provides an example of one that flowers in Early Fall—the image in Figure 10.3 has been modified to include mature fruits, so that the whole range of perfect flower reproduction can be seen at a glance.

† They have developed a compound called inulin. It's a starch-like polysaccharide that assists energy storage in roots along with other benefits that adapt this group to the predictably warm, dry conditions during July, August, and September—Early Fall.

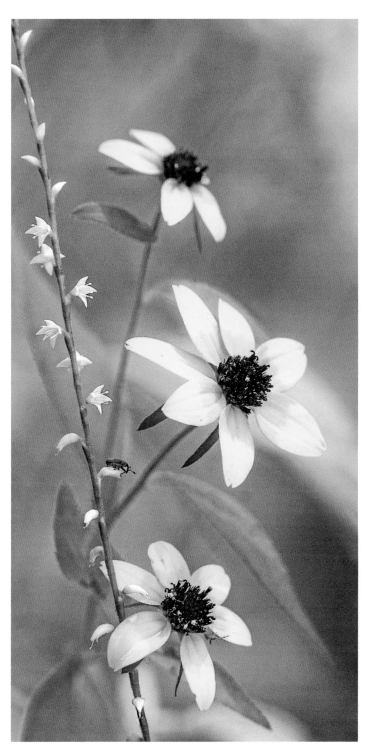

Brown-eyed Susan (*Rudbeckia triloba*). ~ 2X

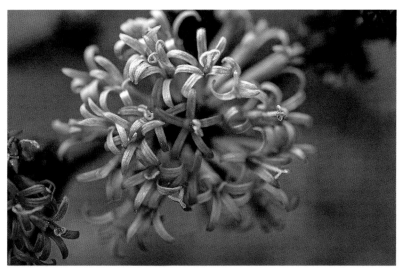

Western Ironweed (*Vernonia baldwinii*) ~ 4X

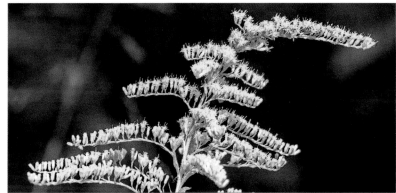

Tall Goldenrod (*Solidago altissima*)

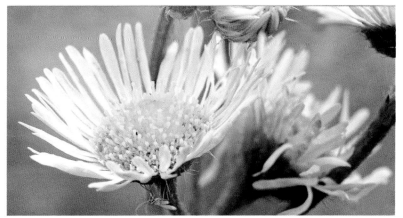

Fleabane (*Erigeron* sp.) ~ 4X

10.2 Common composite flowers (except for the tiny, white Knotweed flowers with the even tinier weevil perched on one of them.)

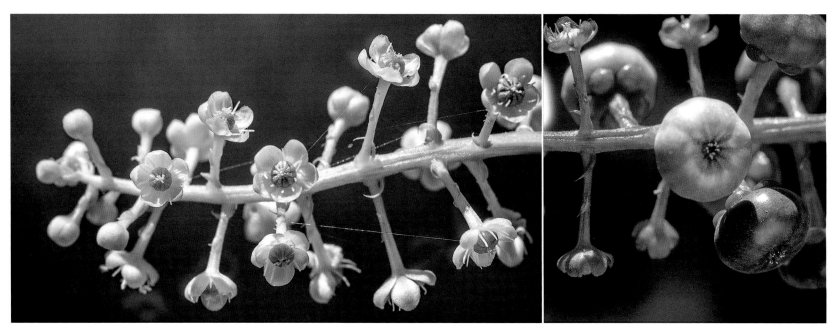

Figure 10.3 ~ 3X. This merged image of Pokeweed (*Phytolacca americana*) reveals newly opened perfect flowers with their prominent green ovaries and ten white stamens (left). On the right, those stamens persist, nearly engulfed by the hugely swollen ovaries of the ripe berries. Their remnants form a tiny tiara that surrounds the location of the now engulfed stigma.

10.4 ~ 7X. A few seeds are still attached to this nearly vacated Dandelion receptacle. Each seed is the swollen ovary of a single floret. The serrated seed covering will help anchor the seed when it's time to break off its parachute.

On the whole, composites are built of these same parts, miniaturized and compressed. The receptacles of a flower can often seem abstract because they are usually unseen, covered with active parts, but Figure 10.4, shows the nearly naked receptacle of a Dandelion—that white, vaguely opalescent field to which some seeds are still attached. The ovary of each floret has matured into a seed carrying an embryo and its stored energy supplies. Most have already dispersed, hoisted aloft by their parachutes, but their attachments to the receptacle, their individual connections for "utilities" (water and supplies) are so prominent that the vacated receptacle looks very much like an empty RV park with its water and electric stubs prominent in its empty spaces. The few seeds that remain are connected through the equivalent of an umbilical cord that is drying and now brittle, they may break loose as the next puff of wind tugs at the parachutes.

Daisies are the iconic composites. Figure 10.5 shows the formerly "underutilized" receptacle packed with florets of both types—white ray florets, and yellow disk florets. Hundreds of them are crowded on a receptacle that was occupied by just one in those Pokeweed flowers.

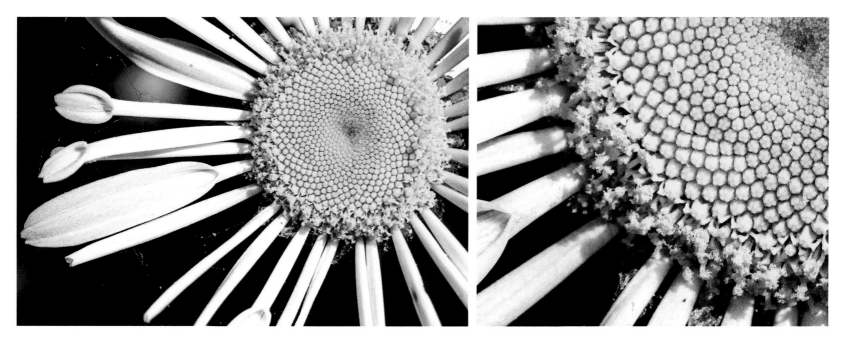

10.5 The Oxeye Daisy (*Leucanthemum vulgare*). Left: ~ 3X. The disk florets are sexually active at the edge, releasing pollen and opening their stigmas as is typical of perfect flowers in general. Right: ~ 10X. A closer look at the rim of active florets.

Each floret is individually nourished through its connection to the receptacle. Ray florets, distinct from the rest in size and shape and often sterile, are in the marketing department, tasked with making a spectacle that attracts the attention of pollinators and points them toward the disk florets in the center. The disk florets mature as a wave of sexually active florets converge on the center. This allows each head to be reproductively active for an extended period.

The enlarged panel shows rank upon rank of florets, each complete in itself, each a chamber that will open, release pollen and then extrude a stigma-tipped style as if sticking out its tongue. The familiar parts, reduced to microscopic dimensions, are too small to see even with this substantial enlargement. All of the composites in Figure 10.2 work this way, though their diverse anatomies obscure the common design.

Daisies are too small to see in detail, so we'll look at Chicory (Figure 10.6). It's a composite in which the head lacks disk florets, consisting entirely of ray florets—a dozen or so—widely spaced, fertile, and blue—unusual for local composites, but then it is non-native. As in many flowers, the filaments and anthers are fused to form a tube.

10.6 ~ 7X. Chicory (*Cichorium intybus*) is a composite made entirely of ray florets—a disk is not present. The stigmas of the ray florets are open wide and liberally caked with pollen.

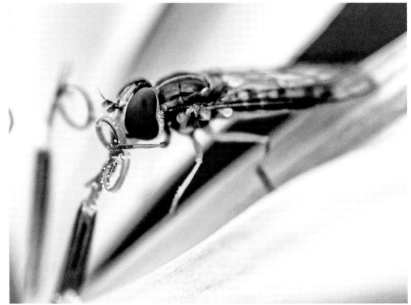

10.8 ~ 14X. A hover fly eats pollen directly from one of the stigmas where it is easily accessed.

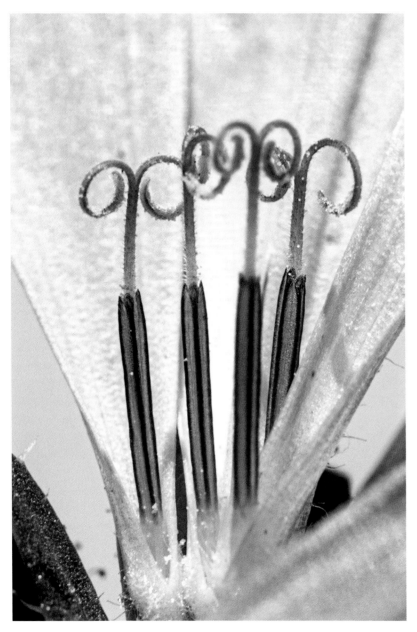

10.7 ~ 21X. This Chicory flower has been plucked (She loves me not, it turns out) allowing an unobstructed view of the internal structure of one floret. The prominent, dark blue columns are the fused anthers. The styles project from the center of each, and the stigmas curled back on themselves to expose their receptive inner surface, with a little pollen.

Pollen is released inside the tube and as the style elongates, it pushes through the tube forcing the pollen ahead of it like the plunger in a syringe. The stigmas are closed and unreceptive. In due time, two lobes of the stigma separate—there are just two—to become receptive. They bend in opposite directions to form two full circles. Figure 10.6 shows most of the flower, pollen scattered widely and coating the stigmas.

With the players and processes in place, we can explore some of the characters that populate the community in Early Fall—summer stalwarts like Queen Anne's Lace and Common Milkweed fade, their flamboyant sexual stage over, and they turn inward to mature their seeds. They no longer need pollinators, but they remain fair game for chewing and sucking insects.

Life goes on but the participants are constantly changing. Those few fallen leaflets nestled on the disk of Queen Anne's Lace in Figure 10.1 are the earliest tremors of that tectonic shift. There are just a few, but like those first gray hairs that mark another transition, they have meaning far beyond themselves.

As the season advances, the avian population will have increased markedly with its seasonal pulse, but their visibility becomes a shadow of their earlier days when they displayed, defended territory, and fran-

tically fed their nestlings. Now, the emancipated young are quietly learning to capture food in their characteristic ways—learning the tricks of their trade—and they must master the skill sets of adults quickly.

By mid-July Rough-winged Swallows begin to gather on nearby power lines, already staging for their eventual migration. But for the size of their aggregation and their exposed position on the wires, they wouldn't attract attention. At first, there is only a family or two, but by September the numbers will have swollen to more than a hundred. They hang out in a predator-wary flock just across our road from a large hayfield with abundant flying insects, the perfect place for juveniles to master low-level, aerial foraging—the special skill of their species. They sweep low over the fields at high speed, feeding on insects invisible to us.

Most birds accomplish their annual molt during this period, the replacement of feathers requiring additional protein intake to build the new ones. While they molt, there are gaps in the flight surfaces that surely must compromise their aerodynamics, but this extended time of plenty allows migrating birds to prepare for wherever they are headed—these Swallows are destined for southern Mexico. Other migratory species inconspicuously undergo the same preparations in the woods and brushy areas, building their skills and fat supplies which must remain limited because of weight considerations.

The progression of seasons and the complex of interactions triggered in the community can be accommodated with a relay race metaphor—passing this baton is more complicated than a simple one-to-one handoff, and even that isn't as simple as it seems. A relay race has four laps with four runners who carry a baton. You'd think the quartet with the fastest runners would win the race, the sequence in which they run, irrelevant. After all, the total is the sum of their individual times, but apparently each leg of the race requires a different sort of excellence.

The first leg needs a reliable starter, quick off the blocks, and not susceptible to false starts. The runner should be comfortable with a right-hand-carry. That will save milliseconds during the handoff, provided that the second runner is comfortable with a left-hand-carry.

10.9 Rough-winged Swallow families gather into assemblages during Early Fall to molt, preen, and to do their stretches, while the young perfect the art of low-level, high-speed foraging over the adjacent fields.

The anchor—the runner of the final lap—is not necessarily the fastest of the four but the most driven—a runner who can't quite tolerate being second or being overtaken, and who is able to reach into the last bit of her reserves when called upon.

Seasonal transfers work like that. The producers set the pace with their different abilities. The Spring Beauty is one of our earliest wildflowers. It runs in the first leg and it is quick off the blocks, not vulnerable to false starts (late freezes), and it completes its lap early in the year before the forest canopy closes. There is no baton—but there is a handoff to the next runner—for plants, it's a handoff of space to grow, passing that space to other species better able to compete in the second leg with its diminished sunlight.

Runners in the second leg must have a tolerance for lower light levels and be capable of infrastructure that will position their leaves higher above the forest floor and have the right stuff, like the Gooseberries in Figure 8.7, to attract their pollinators who will be active then. In the ecological relay, each participant finishes her leg of the race by making embryos in properly formed seeds that by next year will compete in the same slot. This seasonal race has more legs than a centipede, and the life trajectories of all the runners have been honed to a fine edge to compete in the time frame for which they evolved—they have perfected the execution of their segment of the year. But the race, as it plays out in the entire ecosystem, is vastly more complicated. The number of batons multiply and they are carried along pathways that intersect and diverge like the channels of a braided stream; with such large numbers of runners the idea of a winning team loses its applicability.

The relationship between Cardinal Flower (Figure 10.10) and Hummingbird illustrates one such coordinated transfer; a double transfer in this case. It is an exchange of nectar for pollen that takes place in a small window of time. Cardinal Flowers create the purest and most saturated red to be found around here. We get an aesthetic buzz from it, but the flower isn't trying to please us—it's red to please Hummingbirds—and we are privileged to enjoy the conversation between flower and pollinator. Cardinal Flowers mature late in the race—mid-August through September. Like Gooseberry and Columbine, it has a contractual arrangement with long-tongued feeders like Hummingbirds and moths, who transfer pollen in the now-familiar way. The plants grow their infrastructure for months, gathering energy for the big event, but they don't require help from other species except during flowering. And so, they advertise. Their message impacts us too because we can see those same wavelengths, and like Hummingbirds, we have innate responses to red.

Each flower is a device—a functional bit of machinery. For a Cardinal Flower, being attractive to Hummingbirds is a necessary part of its mission. How the mission unfolds is intriguing, even elegant, and in the end the flowers are fertilized and the Hummingbirds fed. The flower's anatomy includes five, very red petals, two thin lateral ones, and three broad prominent petals arranged as a landing pad. Hummingbirds hover and don't use a landing pad, so those eye-catching petals, having caught their eye, serve as nectar guides, directing their attention—and eventually their tongues—to the nectar well, which must be accessed through that tiny opening where all five petals converge. The nectar is about an inch below that opening, limiting participants like a ride in an amusement park—"you must have a tongue this long to harvest this nectar."

In Cardinal Flowers, the organs of pollen transfer are anthers and stigma and they are housed in a tube, as they are for each floret of a composite, but there is just one per flower. The tube is formed by fusing the five filaments and it sticks straight up over the nectar well like a periscope; it could be mistaken for a sixth petal. The anthers are formed into a ring, appearing in the Figure as a white "mustache" that dispenses its powdery pollen as effectively as a powder puff. Cardinal Flowers are not composites but like them, the long style remains hidden inside the tube until the pollen is spent, and then exposes the stigma on its tip by pushing it out through the anther ring. The stigma itself is a tongue-pink knob at the end of the style, that now becomes sticky and receptive to pollen.

This is how that anatomy functions. Hummingbirds are attracted to the red flower. They know, somehow, that the tiny hole—only 1/16th of an inch in diameter—provides access to the nectar, and they thrust their bills into the opening as swords are thrust into scabbards. While hovering, they collect nectar with their tongue, another elegant and remarkably complex device. This coupling is much like the refueling of aircraft by tankers. The expertise required to maintain position between bird and flower must be even more sensitive—the bird, sup-

10.10 ~ 3X. The Cardinal Flower (*Lobelia cardinalis*)—another elegant and striking bit of architecture. It sets its cap for hummingbirds, having learned that they have a thing about red.

ported on a column of air by furiously beating wings must maintain a coitus-like connection, often in a breeze that makes the flower, atop a long and flexible stem, bob and weave. And the stem has to be long in order to extend above the surrounding vegetation of Early Fall and provide room for the pollinators to maneuver. It is an everyday event but still a delicate union.

As the Hummingbird thrusts his bill into the nectar well, the forehead of the Hummingbird comes into contact with the flower, and the "mustache" of anthers gently taps him on the head, transferring pollen from flower to bird, and subsequently from bird to stigma. It is to the flower's advantage to engender a kind of monogamy; keeping Hummingbirds involved solely with other Cardinal Flowers will keep their pollen at the highest concentrations on the foreheads of Hummingbirds.

<center>***</center>

Metaphors are supposed to link unfamiliar, complex events, to a simpler event with similar elements. Because of their simplicity, all metaphors fail eventually, and now we need new one. We'll abandon the relay race and turn to a different phenomenon, steppingstones. This model depends on the familiar experience of crossing a creek by hopping from one safe place to another. Steppingstones work only if they are sufficiently stable and appropriately placed.

Migrating birds use geographic steppingstones as key points to rest and refuel during long migrations. Probably the best-known steppingstone is the string of sandy beaches on the Delaware Bay near Cape May, New Jersey. That is a critical steppingstone for Red Knots—a midsized Sandpiper that winters in Tierra Del Fuego and then migrates 9,000 miles to their nesting grounds in the Arctic Circle.

About 80% of the Red Knots in the Western Hemisphere stop at those beaches on their way north, and their numbers are stunning. It is a safe place to rest and refuel before attempting the long flight over the vast, sandpiper-unfriendly boreal forest to their nesting grounds. On those beaches they refuel, tanking up on the astronomical numbers of Horseshoe Crab eggs† laid on those sandy beaches. That egg-laying

period is brief and takes place during an alignment of sun and moon during May that causes the highest tides, and Horseshoe Crabs gather from many miles around for this event. Red Knots would call it the Horseshoe Crab Moon.

Metaphorical steppingstones like this one, are created by synchronous, transient events: the warming temperatures of May, the position of the moon relative to the sun, and a healthy Horseshoe Crab population, all of which, taken together, trigger a brief but essential egg-laying binge. The complex of events produce a critical steppingstone for Knots, but only for a week or two, and then the resource disappears.

Steppingstones like this are everywhere, although few are as spectacular as the one on Delaware Bay. The eastern deciduous forest can be seen as an enormous steppingstone for spring migrants. Such a vast region stretches the metaphor a bit—this "steppingstone" is a mobile, green wave that warblers surf, carrying them all the way to the boreal forest. Rising temperatures trigger the abrupt leafing-out of the canopy, which coincides with the hatch of untold numbers of eggs that unleash their caterpillars. The crest of that wave is the short period during which the canopy is awash with invertebrates concentrated in the opening buds amid tiny leaves.

The Beard-tongue/Bumble Bee partnership addressed earlier (Figure 9.8) also qualifies as a steppingstone but on a local scale. Bumble Bees don't migrate, but they do surf the floral landscape as it advances under them. Beard-tongue's reproductive period is available in May and June but then it closes to pollinators and the Bumble Bees move on to other sources, like migrant workers harvesting cherries, and then , and later, apples, as the season progresses. There are many sources for the Bees, as suggested in Figure 10.2, but few are so perfectly structured to receive them.

Cardinal Flowers (also called Red Lobelias) are steppingstones for Hummingbirds. The peak of their flowering period is around mid-August. Male Hummers begin their migration well before females and juveniles, so the proportion of migrant males spikes during the Cardinal Flower's availability when they are the only red flowers. Females and juveniles leave later, but while they are resident, they also serve the flowers during this period. For Hummingbirds, those flowers must light up like neon signs. The pairing is mutually beneficial, and the flower has adjusted the timing of its display to serve the highest con-

† Females dig shallow openings in the sand and over the course of the mating season, a single female may lay 80,000 to 100,000 eggs.

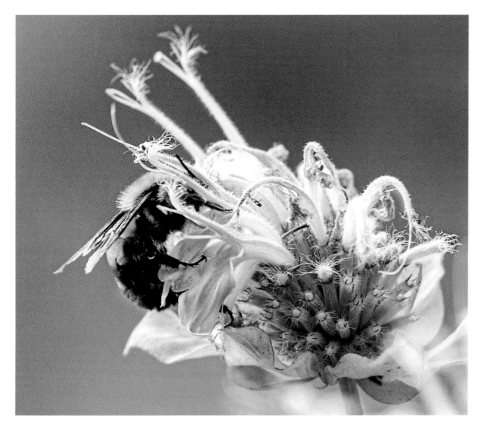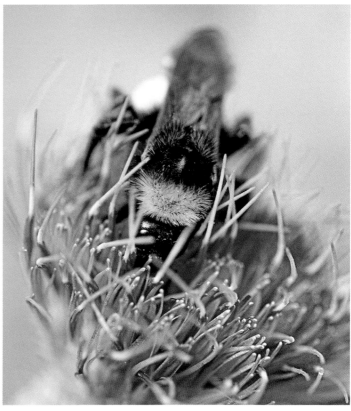

10.11 The schedule for Bumble Bees begins with the June-flowering Beard-tongue, continues in early July with the flowering of Wild Bergamot (*Monarda fistulosa*, left) and shifts to Tall Thistle (*Cirsium altissimum*) early in August (right). And then on to the Great Blue Lobelia.

centrations of Hummingbirds. That's the view from one of the steppingstones.

The Great Blue Lobelia (Figure 10.12)—a congeneric of the Cardinal Flower—is also a steppingstone. Not surprisingly, it has similar habitat preferences and flowering periods to the Cardinal Flower, and a strong family resemblance that would be more apparent if they were both red. They are structured the same way too, with two high laterals, three central petals, and a long tube made of fused filaments, through which they extend the stigma as it becomes receptive to pollen.

Bees can't see red, but they are sensitive to blue, and with their girth, and short tongue, a flower who needs them must provide a much larger access to its nectar well, like Beard-tongue does. Great Blue Lobelias attract them and accommodate them. The three central petals are fused to form a landing pad for Bumble Bees. They are heavy enough to depress the landing pad and expose the nectar well, the floral tube is

much larger to accommodate their body size, and the stigma is sharply curled to comb pollen from their hairy backs. One wonders what the common ancestor of Red and Blue Lobelias looked like, and who pollinated it?

The vast numbers of flies, bees, butterflies, and beetles, form an army of pollinators that move from source to source, changing partners without benefit of a square dance caller. New partners come into position just in time, and then are replaced by others. Scheduling an ecosystem with such complex interactions, taking their narrow or broad affiliations into account, would be a logistical nightmare, much worse than seating people at a wedding reception, and all of those intersecting paths and the precise timing of events vastly overshadow any choreographed performance on any stage. The evolution of these partnerships, piecemeal over the eons, is another part of the biological

10.12 ~ 4X. Great Blue Lobelias (*Lobelia siphilitica*) are close relatives of Cardinal Flowers, but their architecture functions more like that of Beard-tongue.

world that elicits awe in a way that is inaccessible without a blending of rational and emotional responses.

In July and August it becomes "buggy." Insects that live through several generations in the warm seasons contribute to the population explosion. Each mosquito female lays 100 eggs, and in a short ten days, half of them emerge as females ready to drop another hundred. The eggs from one female who becomes adult on the first of May could (theoretically) produce 125,000 biting females by the first of June†— happily, those theoretical projections never materialize because of a high death rate in all phases of their lives. We are saved by an army of aquatic predators that harvest the larvae, dampening the growth curve from the start. The earlier that predation begins, the more powerfully it dampens that exponential increase. After they take wing, their numbers are reduced by dragonflies, damselflies, bats, flycatchers, swallows, and spiders. We often look at the diverse lives around us in terms of their value to us, but it is worth noting that they are simply in the business of feeding themselves. Those predators benefit from a large supply of mosquitoes, and if they had the power, they might well create mosquito breeding farms. It's something we would do.

Spiders, particularly the orb weavers, are an important part of the group that preys on flying insects. The trails we maintain have wide use and we find the tracks of 'possum, deer, turkey, bobcat, coyote, and more. All of us use the trails for the same reason, even flying insects, and it is that traffic flow that makes of them a profitable location for Orb-weavers to set up shop. The Spiny-backed Micrathena†† (Figure 10.13) is the most abundant here. The waiting spider sits at the center

† Only females require a blood meal. The female numbers are of most interest to us, but an insectivore will benefit from the additional 125,000 males that will also hatch during that month. By Labor Day, the size of the theoretical population would be astronomical.

†† Among her many other gifts, Athena was the Greek goddess of weaving. The genus name that translates "tiny Athena" is something of a tribute to her.

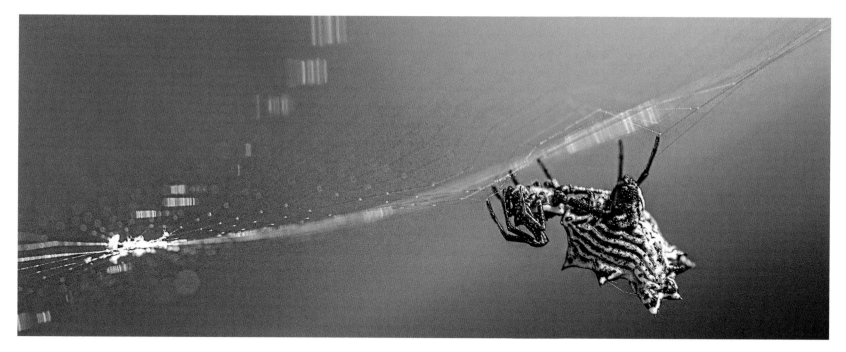

10.13 ~ 4X. The Spiny-backed Micrathena (*Micrathena gracilis*) is variable in color—many nearly all black. But she is distinctive—five pairs of sharp, stout, spines project outward from her abdomen. That would make her a prickly pill for a Wood Pewee.

of her web, often about face-level of a person walking the trail. That is high enough to avoid being destroyed by most passing mammals while still at a productive level. Accordingly, anyone walking woodland trails will have face-to-face encounters, walking into a web while their focus is farther out, and there is an even chance that the prickly little spider will be trapped between her web and your face. Seen from a better distance, each web is a masterpiece of complexity far beyond its geometry, and the spiders have a fascinating story to tell us.

Their eggs hatch in the spring, releasing a couple hundred spiderlings from a single egg sac. They immediately begin to disperse as seen in Figure 10.14, breaking out of their egg sac and expanding into the environment like debris from an explosion. Hanging around home base is not a good idea because spiderlings will eat their brothers and sisters, practicing their kill technique, limiting competition, and getting a good meal, all in one stroke. No empathy at all.

Spiny-back spiderlings grow from a tiny egg to an adult only half an inch long. During most of that time, they are too tiny to notice, but by Early Fall the females have grown in size and their characteristic, full-size webs begin to decorate the corridors we've made; the timing coin-

10.14 ~ Life size. Orb-weaver spiderlings enter the world in May and immediately disperse.

10.15 ~ Life size. Micrathena is busy laying down sticky silk in a decaying orbit. Each day, she'll build a new masterpiece before she rests.

cides with the growing population of flying insects that make it profitable to construct their expensive webs.

Watching her spin her web with the delicacy of a Navajo sand-painter is mesmerizing. The spiral part of the web seen in Figure 10.15, is the sticky part. It is 15 inches in diameter, but dry (non-sticky) supports must be put in place first. She begins with a few long, mooring strands, each 8 feet or longer, and oh-so-thin: just 0.003 mm (3 µm) in diameter. Within the mooring strands, she builds a frame that amounts to a peripheral foundation, narrowing the playing field to a roughly circular shape, within which she fixes 36 radial silks, and then adds a widely-spaced spiral strand that spaces and stabilizes the radials, fusing to them on contact. Taken together, they create a framework of dry silk.

Over this scaffolding, she spins her parlor—that tightly arranged spiral of insect-catching strands, and as she lays down the sticky silk, she orbits the center like a needle tracking the grooves of a vinyl record.

Spinning and placing the sticky silk requires precise manipulation while clinging to an elastic mesh. She spins and arranges as she goes, anchoring the spiral strands to each of the radials, making welds at the rate of one per second. At the moment this photograph was taken, she had completed 18 laps, (about 70 feet of silk) and made 650 welds. She has the practiced, efficient movements of an expert—smooth, steady, and unhurried—and there are no wasted movements; her work advances with the patient consistency of a knitter. Her legs are busy controlling the position of the strands as well as her own movements while in motion. All of the strands are flexible and stretchy, and some are sticky, so it must be something of a challenge to coordinate all of that activity; sometimes in a breeze.

One might suppose that laying down silk is something like laying down the center stripe on a highway, but it is vastly more complicated. She is equipped with six spinnerets in the cluster, each releasing a different kind of silk. Among them are structural silks for mooring and framing, the radial strands, and the widely spaced, dry, spiral strands that stabilize them. That is the architecture; this is how it functions.

Seen closely, sticky silk has little globules along the strand—those are the adhesive components, that with magnification and strong backlighting look like pearls on a spring (Figure 10.18), each pearl a droplet of liquid silk with remarkable properties that allow it to act as

10.16 ~ 2X. She needs her eight legs, and she requires precision movements from all of them in a dance that is done upside down. This exposure of 1/30 second is too slow to stop the wobble of her abdomen, as she moves about on the dry silks, spinning and making welds.

an elastic solid. It is stiff like a pencil eraser when hit at high speed, but sticky when encountered at low speeds. Furthermore, the web itself interacts with its victims, making use of minuscule charges of static electricity. If small insects fly too close, they are drawn into contact because of a charge differential.

Liquid silk doesn't remain sticky for extended periods, so our Spiny-backs must spin a new masterpiece each day. The constituent amino acids that form the protein are too valuable to discard and they are recycled when the spider eats the old web, or whatever is left of it. I can imagine her gathering in the silk like one would gather parachute lines—the legs pulling and compacting the older lines that are now, not-so-sticky—wadding them up like used masking tape and funneling the whole mass into the mouth to eventually be spun again as virgin silk. That is how recycling works when it is done right.

The spider in Figure 10.17 is feeding on some unfortunate that looks like it was a fly. When she captures a prey item, she bites it quickly to kill it, minimizing damage to the web by its floundering, and to begin digesting it from the inside. Then she wraps it in a multi-fibered silk to secure it. That silk emerges from an additional spinneret at the

10.17 ~ 7X. Capturing and wrapping prey.

front that creates hundreds of fibers as thin as 0.03μm. Taken together, they resemble a plume of smoke.

And then there is sex. Males are small and they don't make a web, but they hang out nearby. Even with eight eyes, orb-weavers have poor eyesight—so when a small, prey-sized male approaches a female in her web, he is cautious. He gets her attention using a four-tap pattern that identifies him as a suitor—hopefully. It is a risky, one-time event with no do-overs. Eventually, the female wraps him in silk, he transfers his

10.18 ~ 6X. A string of pearls—beads of liquid silk appear as tiny arcs, because the spider is jostling the web and shaking the highlights, as she spins.

sperm to her and dies shortly thereafter anyway. Then she deposits her egg mass, after which she dies. The plot is the stuff of opera, but this drama advances in silence, without audience or spectacle.

<p style="text-align:center">***</p>

In Early Fall, the center of activity turns increasingly from woodland to grassland, where the sunlight is more equitably distributed. In the woods, the aristocracy in the canopy monopolizes the flow of energy by taking advantage of its infrastructure, that extraordinary investment in wood that the tree has produced over many years, through the work of many generations of leaves. In grasslands there is no aristocracy, and all life forms begin their year at ground level.

I've made a distinction between adolescent and mature woodlands and a similar distinction should be made with respect to grasslands and mature prairies. Our fields had been severely overgrazed for decades and their natural succession into woodland has been blocked, first by grazing, and now by mowing.

Two centuries ago, when this area was first surveyed, the ecological community members that evolved together had optimized their relationships in the ways we have seen. But the grasslands, much more than the woodlands, have become a melting pot such that a grassland like ours is a mixture of native and introduced plant species, often more introduced than native. Our agricultural lands are built on grasses of European origin as is the livestock that feeds on them. That's how European Fescues came to dominate the pastures here in Missouri.

The core producer-consumer match remains undisturbed, the Bison that fed on Bluestem grasses, have been replaced by cattle feeding on Fescue. When the Fescue seeds were harvested in Europe, the seeds of European forbs were mixed with them, such that a substantial proportion of our wildflowers today are of European origin. The result is a mongrel grassland with large parts drawn from different communities. It is a mismatched gathering of species, and loving it is something like loving a rescue dog of complex ancestry. So, the community that now occupies our grassland is made of producers that did not evolve as a group, and the non-native flowers are pollinated by insects that are mostly native.

I imagine living within this arrangement is akin to working with a haphazard mix of metric and standard tools, where the mismatched tools hamper the efficiency of the work; the socket on the wrench doesn't quite fit the bolt and the Phillips-head screwdriver doesn't fit the hex-head screw. They were shaped to work in different systems. Consider the Cardinal Flowers that now compete for their place in the grassland with a broad array of introduced and often aggressive species. One would expect that they will be more crowded and less abundant than they were before the new species arrived. They compete with strange forms for sunlight and for access to the essential nutrients and water they draw from the soil through their root systems. Surely the energy available to them for flowering is compromised. If that is true, Hummingbirds will notice the loss, and they won't find alternate sources among the introduced species because Humming-

birds are unique to the New World, and their Old World equivalents, the Sunbirds, don't reach into Europe.

Native bees are more effective pollinators of native plants than European bees. One need only to look back to the fit of a Bumble Bee's girth into the flower of a Beard-tongue to appreciate why that would be. On the other hand, the familiar sight of Honey Bees on Dandelions and Red and White Clovers is a reunion of ex-pats—all of them European and well-acquainted. Other ex-pats include Queen Anne's Lace, Oxeye Daisy, Wild Parsnip, both White and Yellow Sweet Clover, and Day Lilies, to name a few.

Fescues are tough, cold-season grasses that are available to domestic stock early in the year, but their growth pattern presents a challenging habitat for small native vertebrates like Quail. Fescues are inclined to form a dense sod unlike native prairie grasses that tend to grow in bunches. Looking over a burned prairie, the most obvious elements are the large clumps of charred stubble separated by broad spaces—avenues really—where animals can interact easily, move about quickly, and harvest seeds that collect there. Local mice, rabbits, quail, and grassland birds evolved to live in the open structure of our native grasslands. As our prairies were replaced with Fescues, the open prairie structure disappeared, and along with that, the marginalization or disappearance of native species adapted to use those spaces. This is the current new normal. It is still a robust community, but it lacks the elegance of an evolved unit achieved by mature forest and tall grass prairie. Those differences continue to play out as wave after wave of newly introduced species join the mix, particularly insects like the Japanese Beetles (Figure 6.5) and Oleander Aphids (Figure 9.25).

At Brawley Creek we have reintroduced warm-season grasses here and there: Big Bluestem, Little Bluestem, Switchgrass, Indian Grass, and Eastern Gamagrass; major components of the tall grass prairie that covered over 60% of Johnson County when the Marr family bought their claim in the 1830s. Warm-season grasses flower in September, by which time they've reached their normal flowering height of 7 to 10 feet. Their wind pollinated flowers stand above the competition where their anthers release pollen into the wind and their pistils are deployed to receive it.

Early Fall is not only the peak of composite flowering, it is the peak of arthropod activity as well; particularly for the species with more than one brood per year. As insect populations build, the tiny caterpillars that took microscopic bites in May grow into big ones that eat whole leaves. The growth curve of Luna Moths is characteristic of large moths, and they increase their volume a thousand-fold in the six weeks between hatching and pupation. As they grow, they collectively destroy foliage in a way that is hard to miss. That is a small part of the decreasing productivity of Early Fall. Their mission in life is to take in food as fast as they can and build a fat supply that will fuel them through their metamorphosis and adulthood—they can't replenish their energy when their supply dwindles, like birds do. Their last meal is taken before they begin pupating and they die when that supply runs out. Females must provision hundreds of eggs from this energy cache and males burn their fuel searching for females until it is all gone.

Many adults can eat, like the Sphinx Moth that takes nectar from Milkweed, but every caterpillar approaching pupation is a bundle of energy working in a world of predators, and they take steps to protect themselves. The toxic ones adopt bright colors or mimic toxic forms, or they disappear into their environment one way or another, as we have seen. Fall Webworms become obvious toward the end of Early Fall, but they make no effort to avoid detection, instead they build elaborate silk fortresses (Figure 10.19). Like the domed communities envisioned by futurists, they rely on tough, nearly transparent walls to keep trouble at bay. The walls of the fortress can be expanded to annex fresh leaves, and the edifice is heat trapping; caterpillars can manipulate their body temperature by moving about in their space. It looks messy, but it holds off many predators while providing for its residents. A look inside one of their constructions shows a cluster of Webworms (and their frass) that appears as a swirling vortex of caterpillars, but there is no sound of rushing air, they are moving along silk strands that run throughout the structure like a light rail system.

Few birds are likely to penetrate the fortress walls, so their primary danger comes from spiders and flies. And from parasitoids, a vast but little known group that occupies a space between parasite and predator. Nearly every insect species has a parasitoid wasp specialized to extract a living from it, so there are many kinds of them, but they keep a low profile, and we rarely see them because the adults appear as just another tiny, dark wasp, they don't accumulate around houses, and the larval stage is undetectable inside of its insect host. Well-known para-

10.19 The "fortress" of Fall Webworms (*Hyphantria cunea*) encloses the decimated branches of a robust, young Persimmon tree about 10 feet tall.

sites, like tapeworms and ticks, pilfer resources from their hosts and cause damage that can be severe. Parasites and parasitoids that live inside the bodies of their hosts must be intimate at the chemical level, avoiding immune responses and a unique chemical environment, in the same way that prey species in the outside world must negotiate the hazards of their environment, which we can more easily imagine.

Parasitoids don't just pilfer from the GI tract; they consume the host from inside. They are larvae living inside other larvae, and when it comes time to pupate, they escape by eating their way through the body wall. It is ghoulish enough and piques a panorama of human fears so perfectly that Hollywood discovered it and created the "Alien" franchise. It is a masterpiece of evolutionary advance that we happened upon just once, here.

I noticed a caterpillar behaving strangely (Figure 10.20). A Fall Webworm was pacing back and forth on a strand of ornamental grass, if one can pace with six legs and ten prolegs. She galumphed as caterpillars do, moving back and forth and turning around at the end of her track like a sentry, but awkwardly because the track is so narrow, and she is shaped like a bus (Figure 10.21). Watching her move back and forth, I noticed a small bundle dangling on a kinked strand of silk attached to the same blade of grass. That was a new find for me, and I paid attention to it.

That bauble turned out to be a Braconid Wasp just beginning its pupation. This species is a parasitoid—a Fall Web Worm specialist—and I could piece together a backstory. The Webworm, only about an inch long, had been attacked by a Braconid Wasp about three weeks earlier. How the Wasp gained access to the caterpillar I don't know, but she had to negotiate the Webworm's bristles, whose functions include defending against exactly this kind of attack. They are tiny bristles but to a wasp one-third the size of the caterpillar, those projections must seem like the fortifications defending the beaches of Normandy. Once astride, she must hold on to the muscular caterpillar, who bucks and twists like a bull out of the chute while she attempts to inject an egg into it. The conflict has the flavor of gladiatorial combatants equipped with different weapons, but this time the caterpillar was defeated.

One egg from the wasp passes down the thin ovipositor to be tucked into its nutritious crib along with some viruses that appear to fight the caterpillar's immune response. A few days after the wasp has

10.20 ~ 2X. As the Webworm moves along the blade of grass, the tiny, dark, exit hole of the parasitoid can be seen between the last two abdominal prolegs, near her dorsal surface, and just over the white, side stripe.

moved on, the newly hatched Wasp larva begins feeding on the caterpillar's body fluids. After about three weeks of growth, the wasp chews her way out of the caterpillar and spins a kinked, silk cable from which she will dangle far below the blade of grass for the nine days of her pupation. It's been suggested that dangling below the caterpillar minimizes the likelihood of attack by ants and lessens the likelihood of hyperparasitism—an attack on the pupa by yet another kind of wasp, specializing in Braconid pupae.

Her pupal case, shown enlarged in Figure 10.22, is formed first as a basket of large loops. As the Wasp larva moves back and forth inside, with a deliberate, repetitive motion that is innate much like that of a moth larvae, she creates an elegant basket that any artist would be proud of. She continues to line the inside with finer silk that hardens, the large loops reinforcing the cocoon walls. Figure 10.23 shows the pupa several days later, when the outer surface has dried and hardened.

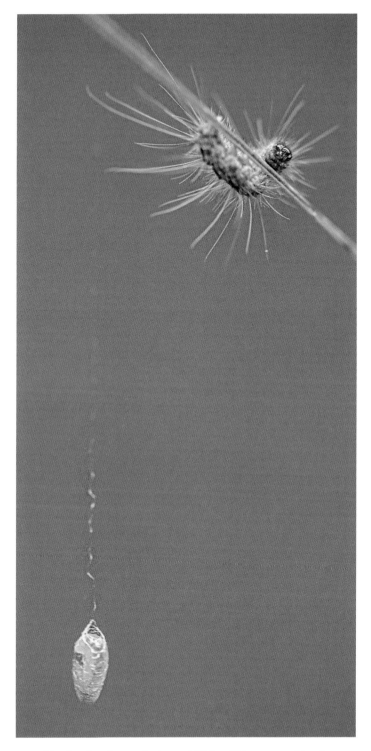

10.21 The dangling larva of a Braconid Wasp (*Meteorus* sp.) has just exited the caterpillar and has begun spinning its pupal case. The former host, mortally wounded, effects an about face.

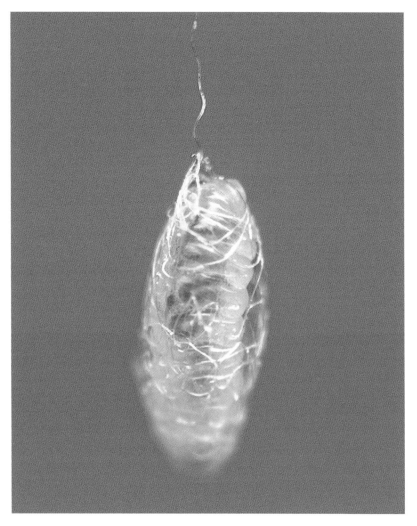

10.22 ~ 8X. She first spins a loose shell, using coarse loops, before filling in the spaces with a finer silk.

The caterpillar will live a while yet. His nervous and muscular systems still function, but robbed of his fat supplies, and with a gaping wound, he will die. But he is not yet done helping the wasp. He may continue pacing for days, blocking access to the pupa dangling far below. It is well known that parasites can alter the brains of their hosts and manipulate their behavior so that the host assists the parasite. An intriguing example of this is the peculiar inclination of humans with a cold virus to seek contact with other humans during the 48 hours before becoming symptomatic. Our caterpillar, one of the walking dead, creates a distraction with his pacing, making a target of himself and increasing the survival prospects of the wasp that killed him. The adult

10.23 ~ 4X. The pupa, a few days later, has solidified the pupal case and developed eye-spots.

wasp (Figure 10.24 & 25) emerged from her pupal case nine days later, and died in custody.

The sheath on the ovipositor serves to protect it, but surely it keeps the ovipositor clean, wet, possibly slippery, and (not unknown among insects) perhaps even carries some anesthetic. As the ovipositor is moved into the injection position the sheath retracts—with an egg teed up, she would be ready to thrust the ovipositor into the victim as her mother did. The egg must be unimaginably tiny to pass down such a small ovipositor.

We should recognize that interactions like this are commonplace, though we rarely encounter them. Our empathic response is visceral, but knowing how things work, it should be clear that is fundamental to the way life works. Energy moves from one player to another, usually by one player ingesting parts of another.

The beauty and elegance of this world is dependent on an enormous diversity of ways to live. This one doesn't fit comfortably within our sensibilities, but that's just us. Leaves, caterpillars, parasitoids, and hyperparasitoids are all bound together by complicated interactions and we can take note of only the few that we encounter. There are so many variable, interacting forces that the head swims, but somehow it works. All of them, acting in concert, bring things to an organized conclusion with the transition into Late Fall.

By then, plants look well-used. Many have already completed their

10.24 ~ 26X. The adult Braconid Wasp has emerged from her pupal case having lost her baby fat and is now equipped with a long, sheathed ovipositor.

10.25 To implant the egg, she brings the ovipositor to a vertical position. Stripped of its sheath, it can be seen as a very sharp, necessarily hollow, dagger.

activities and died, annual species existing only in the form of seeds, while perennials withdraw into their root systems to enter a period of dormancy as the Spring Beauties have done long since. The active producers have been damaged by the struggles of a long season and they are used up. The leaves of a Black Walnut in mid-July model the damage incurred by disposable units as they near the end of their useful life (Figure 10.26). Walnuts drop their leaflets early. They are made for a four or five month run, after which they are in decline, with their solar collectors decimated, riddled by caterpillars, and losing water—their productivity falls, but Black Walnuts are dong very well here, in spite of the damage and their short season.

Early Fall looks like summer and feels like summer, but nearly every kind of solar collector is wearing out in many ways, not only from chewing insects, but also browsing from deer and other herbivores that consume wholesale. There is also physical wear, mold, and galls. Leaves are functioning at a reduced rate, and by the time Late Fall arrives, abscission layers have been built in preparation for the leaf drop.

We evaluate the worth of an old car partly by how much it costs to keep it running, compared to how much value it can return to us. Because dollars are a form of calories, trees must evaluate at which point the cost of running a photosynthetic operation is worth the effort. Eventually that will no longer be profitable, and we'll drift into Late Fall as ambiguously as we entered Early Fall. For those species who have not already prepared for the coming winter, Fall is a last call, and it is marked by the fourth function—Dispersal.

10.26 The leaves of a Black Walnut (*Juglans nigra*). By the time the mid-point of Early Fall has arrived, significant proportions of the leaves have been converted into caterpillar flesh and frass. The canopy begins to look moth eaten, which I suppose it is. It is more of a sieve than an umbrella.

11.1 Common Milkweed has matured its seeds and is now feeding them into an October wind. The dispersal function reaches its peak in Late Fall.

11

Late Fall: Closing Up

*"Flowers that were once bright as a box of crayons
are now seed heads and thistle down."*

~ *Barbara Crooker*

The thing about Late Fall that grabs our attention is the wondrous color change of the foliage season. It's the most visible step toward dormancy, and it happens as the result of an orderly withdrawal of valuables from those leaves—the sort of valuables one would extract from a burning home given a little time to do it. But this change is programmed and adaptive; we enjoy the spectacle and take great pleasure in it. It begins ambiguously before the autumnal equinox and ends abruptly with the first frost that closes the circle, ushering in Winter. It lasts only five or six weeks but for most of our residents, excepting the few species that remain active overwinter, it's their last chance to achieve the final functions in their life trajectory: dormancy and dispersal. The need for dispersal is universal, its importance made clear by imagining a manufacturer of automobiles whose production, lacking a mechanism for dispersal, accumulates endlessly outside its factories.

Tree leaves pick up the warm tones of the foliage season as they break chlorophyll into its components and take them "inside"—into the body of the tree for the Winter. Phosphates and amino acids are key components in terrestrial ecosystems, both are essential to the synthesis of DNA, RNA, chlorophyll, and a host of energy transfer molecules. The recovered molecules can be seen either as valuables in Winter storage, or rats leaving a sinking ship, but they are valuable rats, scarce and well worth withdrawing be-

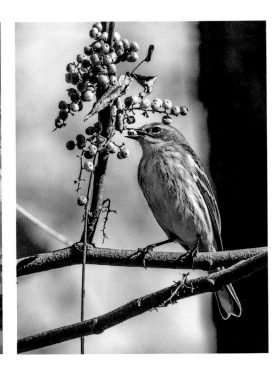

11.2 The positive side of Poison Ivy (*Toxicodendron radicans*). Left: It begins decommissioning its leaves in Early Fall (mid-July) with a scattering of subtle, unsaturated colors. Center: Now in mid-October, the seasonal defoliation is in full swing. Right: An insectivorous Yellow-rumped Warbler fuels his migration with Poison Ivy berries.

fore the leaves are scuttled. Cellulose, and simpler pigments that give us such pleasure, are left in the leaves. Carotenoids provide the brilliant yellows that serve dandelions and goldfinches too, and reds and purples come from anthocyanins.

By Late Fall, a significant proportion of those leaves have been eaten outright, nibbled, mined, skeletonized, and/or perforated. Still, enough of the canopy remains to put on a good show. In western Missouri, we don't get a lot of brilliant reds, although Smooth Sumac makes a showing along the roadsides and Virginia Creeper wraps tree trunks and branches like shaggy leggings. But overall, our colors run from strong yellows through russet and into burgundy. Poison Ivy (Figure 11.2) displays all of those hues. Humans have little good to say about this abundant and multiform species; only humans generate an allergic response, but everyone else finds it a valuable resource—the leaves are eaten by deer, rabbits, cows, goats, and more, and the berries feed many kinds of birds who disperse their seeds for them. Their vines carpet the ground in places, climb fenceposts like this one, and

where there are trees it climbs their trunks, often reaching into the canopy.

Leaves have been growing their abscission layers for a while by now, in anticipation of releasing them. They will close off the connections, isolating the leaves, and ultimately release the carcasses that have been stripped of valuables. The leaf drop is good for everybody. The tree loses worn leaves that would in any event be killed by the frost, and if retained, they would jeopardize the tree's investment in its infrastructure through the accumulation of snow and ice. The energy remaining in the leaves advances one more tick around the cycle, building valuable habitat for life on the forest floor before passing the baton from producers to decomposers who will ultimately enrich the soil. Recycling properly done.

The flowers of Early Fall, the brightly colored composites, have been pollinated, their seeds matured, and now they require dispersal. By Late Fall, white composites predominate, standing out against a background of fading vegetation, the colors becoming less and less sat-

urated as they fade into the familiar hues of Winter—weak magentas and yellows mixed with soft gray-browns, tans, and everything in between. These composites predominate in Late Fall because they are optimized for this set of conditions, and they squeeze their reproductive activities into the last weeks, in spite of the failing light, before closing time, when there is little competition for it. The trees, already thinned, will soon lose the rest of their leaves, providing a brief window of sunlight that penetrates to the ground—a pale reflection of the Spring window of activity. Plants that are usually in the shadow of trees now take advantage of it after the canopy thins and drops. Temperatures remain warm enough for pollinators to work, and overwintering bees are still building their winter supplies with last minute shopping. For them, these late bloomers are the only sources of nectar and pollen and they qualify as steppingstones.

Asters predominate in the Late Fall as they take center stage with their small but abundant flowers. Like other composites in this season, most of our common species are white or nearly so, like the showy White Heath Asters and White Snakeroot seen in Figures 11.3 and 11.4. Late Fall is also the preferred flowering time for two of our three kinds of Ladies' Tresses Orchids that like sunlight in the pastures, while White Snakeroot prefers wooded areas and edges.

Preparation for Winter is written into the DNA of all living things. They "know" that it's coming and they prepare for their survival—most of them through some kind of dormancy, although some migrate while others tough it out; one way or another, the family line continues. Warm-blooded animals who work the skeleton crew, like the birds in feeding guilds, will depend on those dormant forms, seeds, eggs, and pupae, and they will spend the Winter looking for them as in a prema-

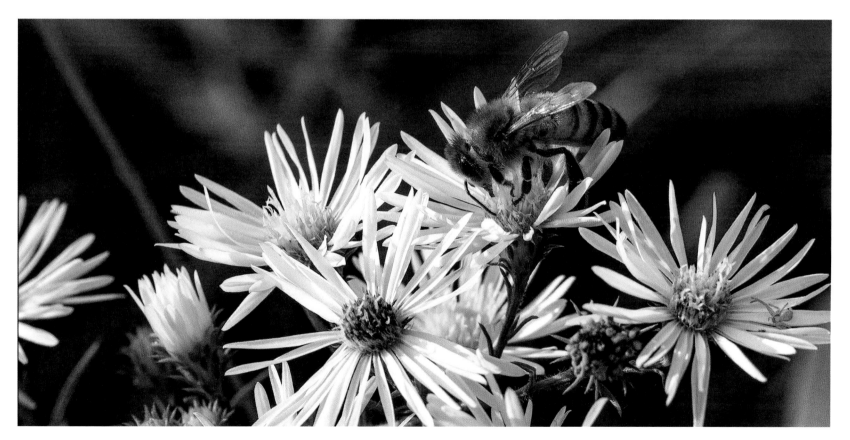

11.3 ~ 3X. White Heath Asters (*Symphyotrichum pilosum*) in their prime as September turns to October. Newly opened disk florets are yellow, turning to purple as they age. Honey Bees and Crab Spiders are still active; the spider at the far right is waiting for something more manageable than the Honey Bee.

11.4 ~ 2X. White Snakeroot (*Ageratina altissima*) is a shade-loving relative of the intensely purple Ironweed.

ture Easter egg hunt. The larger consumers, like squirrels and jays, stockpile essential energy in caches, especially acorns, walnuts, and hickory nuts. Caches are vulnerable to pilferage, but the gatherers can afford to lose some; average losses are built into the business plan. In contrast, hibernators hold that cache in their bodies where it is safe from pilferage (parasites excepted) but not predators.

Birds can't afford to stockpile fat because of weight issues, so they become thrifty—even miserly—in the business of heat conservation, taking energy saving steps that allow them to retain their agility. They complete a full molt usually in Early Fall, because worn feathers are less efficient at retaining heat and decrease aerodynamic efficiency. That is part of their preparations, equivalent to our weather stripping and caulking of loose joints. We are inclined to help out, because we are an empathetic social species. We feed them sunflower and thistle seeds—dormant embryos and their energy reserves, stockpiled to endow a new life. We've chosen to intercept these reserves and divert them into alternate paths—help that comes about according to the whimsey of a quirky social species, but that nevertheless helps get them through Winter.

Cold-blooded forms like snakes find a way to move below the frost line; others survive sub-freezing temperatures by modifying their internal chemistry in ways that protect against freezing, or that allow them to freeze solid and return from the "dead." Not really dead of course, but it is hard to see the spark of life in a frog, frozen as solid as a brick. Their ability to return to activity is astonishing to us warm-blooded types, subject to death by hypothermia if we drop a few degrees below our very narrow range of operating temperatures.

We humans actually do know what is coming, so we winterize our cocoons and get out heavy coats and gloves, but for us the coming winter is not an existential crisis. Energy is readily available to us, so our response to seasonal change has a cultural tilt: Homecoming, Thanksgiving, and Christmas, embedded in a matrix of football. Instead of laying in a store of fat, in times past we used to lay in a supply of firewood or coal. Other species walk a fine line between living and dying, and it will help us understand their lives if we recognize that enormous difference.

Dispersal is more of a phenomenon than an event. Like so many other phenomena, we imagine it as highly random, as in the scattering

of chicken feed. And sometimes it is, particularly when mediated by the wind, but that doesn't make it simple. The DNA that shapes all aspects of the lives of our residents includes dispersal in their "last will and testament," a plan to distribute the estate according to the dictates of the deceased.

The executor of that will is the architecture that the DNA created to serve that function. It is the executor who mindlessly carries out their last wishes, relying on physical forces, surviving members of the community, and probability. The estate consists of the deceased body of the creature, bequeathed to the decomposers of the community, and their progeny in perpetuity. In many life forms, at the death of the parents, only seeds and eggs remain to carry the baton. In them there is not much—a bundle of resources (yolk or endosperm), an embryo, holding a copy of the family lore in its DNA, along with something of an Owner's Manual that must include a section on how to disperse progeny.

We can return to Spring Beauties to review their solution. Even though they enter dormancy in the Spring, their seeds carry an elaiosome (seen in Figure 2.16), rich in lipids, in order to pay the ants to plant them. One payment for each seed burial. They depend on those ants to feed the elaiosome to their larvae rather than eating it themselves, and they depend on the constancy of the entire complex of environmental variables to make this elaborate scheme work. And it does. There are many ways of achieving dispersal and the remainder of the chapter will focus on the myriad ways in which these "last wishes" are carried out.

It becomes important to distinguish between the vehicle and the passenger. The joining of sperm and ovum triggers the development of an embryo—itself a thing of awe—and provisioning it. In plants, that amounts to setting aside a nest-egg of energy in the form of endosperm, but it also includes building the vehicle that disperses the seed. The embryo is the passenger, and it has baggage—its endosperm—that will nourish it when it is time to germinate; until its development has advanced enough that it can capture energy from outside. The vehicle provides for dispersal—carrying the embryo on an odyssey with no plan to return. The advance of Europeans across the prairies in the 19th century provides a solid metaphor. Travelers took with them the bare minimum, along with the tools required to sink

their roots into the soil at some unknown destination. An oxen-drawn covered wagon was the vehicle that transported the travelers and supplies.

Wind dispersal has much in common with wind pollination. Large numbers of travelers are produced and released, and the weight and aerodynamic qualities of both passenger and vehicle are critical. Pollen is unicellular and produced in astronomical numbers. Seeds, are very different—they are much heavier, produced in much smaller numbers than pollen. They are multicellular and usually several orders of magnitude larger, so they require a vehicle to take them away. The heavier seeds require sophisticated vehicles in which the weight and relative proportions of seed and vehicle have been selected for favorable weight distribution, increased loft, and eventually for the separation of vehicle and passenger. An orderly departure of seeds may become important, particularly if the lofting vehicles are elaborate, aerodynamic, and released over a short period of time. The tiny Cattail seeds in Figure 11.5 require only a bit of fuzz to catch the wind. They

11.5 ~ 2X. The number of seeds in just one of the ubiquitous Cattail heads (*Typha latifolia*) staggers the imagination. This photograph includes only a small portion of one head among hundreds in our temporary pond only 30 feet across. It was just beginning to release its seeds to the wind in early January. Winter seems to be the preferred time for Cattails to begin dispersal.

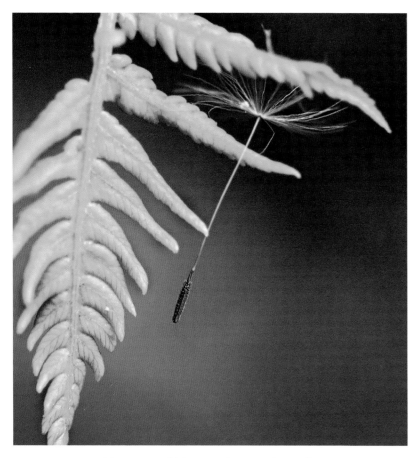

11.6 ~ 4X. Most of the tiny, wind-blown seeds are rarely seen having come to earth. Here, a Dandelion seed has caught on the newly unrolled frond of an Ostrich Fern (*Matteuccia struthiopteris*).

response to normal conditions in the regions where they live. They do that by controlling the structure of the seed and parachute and the mechanism of release. Each habitat requires a different balance of passenger weight, energy supplies, and the aerodynamics of the dispersal vehicle. In turn, that sets the optimum size, shape, and numbers of progeny that they can produce. The Milkweed pod on the opening page of this chapter, leaves the impression of vehicles haphazardly flung to the winds, but the release of those seeds to the winds is not random. It is as orderly as a parachute drop into a target zone.

Lacking anything equivalent to muscles, plants move their parts by other means, even when dead—often a prerequisite with seed dispersal. They achieve this delicate task through carefully engineered parts that split along structurally weakened channels—the equivalent of "tear along the dotted line." Dying is only a step toward completing their reproductive mission, as is seen in the afterlife of Milkweed flowers (Figure 11.7). Milkweeds make far fewer seeds than cattails, but each is larger, heavier, and requires a more elaborate vehicle. Both species are perennials, but success for a cattail seed lies in reaching the next pond, while a successful milkweed seed needs only to escape the cluster of plants in which it originated.

The architecture of the Milkweed pod organizes the successful launch arrangement mediated by the sequential exposure of the vehicles as they dry. Abiding by its seasonal schedule, the seed pod dehisces—dries and splits along a fracture line that, in this case, faces down, such that as it opens wide, it looks much like opening the doors of a bomb bay prior to the release of ordnance. The downward orientation keeps their silky fibers dry, otherwise they meld into a mass that feels something like felt.

According to plan, each vehicle peels off like the loose pages of a manuscript in a strong wind. Increasing the time required for all of the seeds to dry means that, as weather systems come and go, the seeds will disperse in all directions, although predominantly in the direction of the prevailing winds. The design is not only beautiful, it is an exquisitely choreographed release triggered by death and drying. The dispersal is achieved by harnessing physical properties that will reliably work only after the parent has died, so it is the work of the executor.

Pollen and seeds are not the only life forms to use the wind for dis-

experience air as a more viscous medium than we do, and it doesn't take much for them to be swept away by the current. All of us are familiar with the lofting vehicles of Dandelions. Their seeds are heavier than most that are dispersed by wind, and that requires a more elaborate design, and a more sophisticated lofting device (Figure 11.6), but we don't ordinarily think of the seed and vehicle as separate entities with different functions.

"Blowin' in the wind" is the idiom for things random and unknowable, but that is not entirely true for wind-borne vehicles. Our prevailing winds are from the southwest, and if a milkweed releases seeds over a period of several weeks, the field of dispersal is likely to be a broad plume reaching toward the northeast. Parent plants have no control over the wind, but they can respond to the probabilities as a

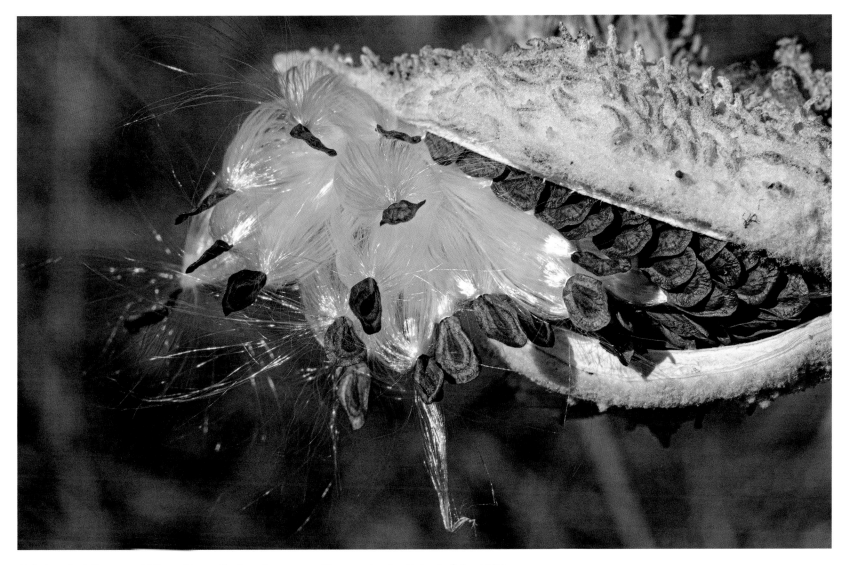

11.7 A pod of Common Milkweed has split along its seam, and begun releasing its load of about 200 seeds in an orderly fashion—its late September.

persal. Spiders send silk balloons aloft using air movement for dispersal. They find elevated positions and feed out tufts of silk like we'd let out the string of a kite. Eventually that balloon lofts them and takes them downwind, as if they were off in a hot-air balloon. It is a fanciful method of dispersal made more credible by recognizing that tiny life forms experience air as a weakly viscous fluid. Because of our size, that is something we can't easily envision but to them it must be something like being swept away by a flow of water.

The most interesting dispersal methods don't require wind. All of us are familiar with seeds that cling to our clothes after we take a walk in Late Fall. Stick-tights of several kinds attach themselves, some quite aggressively for an vehicle that can't move. Queen Anne's Lace will serve admirably as an example of seeds that mature and disperse in this way, and we have the advantage of familiarity with the flowering stage. The design of the seed doesn't need to be elegant, but one can imagine the selective advantage of seeds that have just the right cling—one that won't fall off too soon, and one that will release without being crushed by as a dog or cat tries to remove it. The flowering phase in

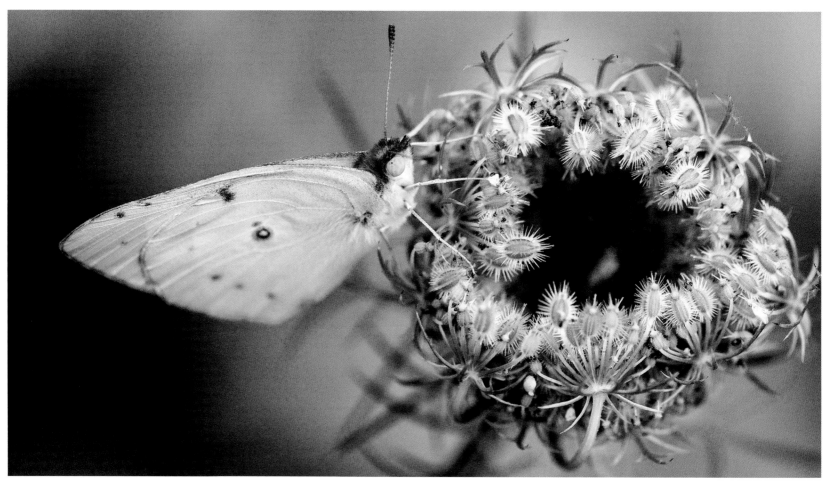

11.8 A Sulphur (*Colias* sp.) rests on the "bird's nest" of a closing Queen Anne's Lace in Early Fall. The maturing seeds are confined in a cage made of the struts of both umbels and umbellets.

Figures 9.6 and 9.7, shows the flexing of the umbellar struts that open the florets to insects. Those prickly, pineapple-like ovaries become prickly seeds. As the flowers fade, those struts close again, creating a "bird's nest" (Figure 11.8), an excellent drying facility made even better by the hot air of September and October blowing through it. In the course of maturation, the pale, white bristles on each ovary lengthen, dry, and harden to become spines with tiny hooks (Figure 11.9).

There is the matter of escaping the cage, and that is accomplished as the consequence of a particularly elegant aspect of the design. As the season progresses the bars of the cage—the struts—become increasingly brittle as they dry alongside the seeds. The umbellar struts begin to break first, leaving gaps. The staged fragmentation of the bird's nest takes place over several months and it becomes an elevated dispenser—like a salt shaker—that releases a few seeds at a time through those gaps, especially when bumped by passing mammals. The dissemination of seeds will continue slowly through the Winter, a little at a time.

Their dispersal depends on hook and loop technology that predates Velcro by many millions of years. Queen Anne makes the hooks but relies on a passing animal to provide the loops in the form of fur. They have a particular affinity for Polartec even though they honed their effectiveness with the fur of mammals—particularly wide-ranging mammals.

Every plant requires some method of dispersal, and hitchhiking has

 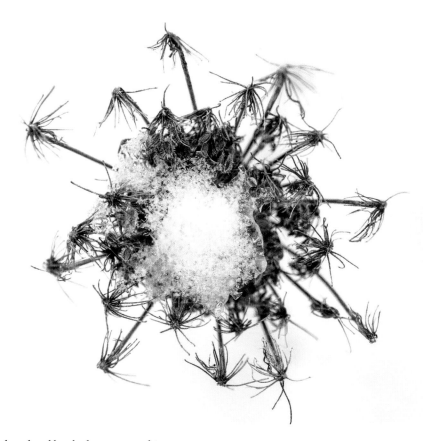

11.9 Left ~ 9X. By August, the seeds at the rim of the bird's nest, their bristles hardened and hooked, are approaching readiness for dispersal, but that comes gradually with the piecemeal fragmentation of the cage. Right: By February, only a few seeds remain, kept in place by the strong umbellar struts that persist.

proven widely successful; the necessary structures for it to work developed independently in different families. Here at Brawley Creek, at least four families are represented: Legumes (Beggar's Lice), Asterids (Beggar's Ticks), Gourds (Burr Cucumbers), and Roses (Agrimony). We humans interact with a broad range of roses, as all members of the Rose family can legitimately be called. The roses are a really diverse family about which we have a really narrow perception—such that while Gertrude Stein's famous line has such a great rhythm, it isn't exactly true. Outside of a greenhouse, a rose usually isn't a rose. It may be a peach, cherry, apple, blackberry, or strawberry, to name just a few of the better known roses. Naturally, those roses depend on consumers like us to disperse their seeds in the time-honored fashion.

The most abundant of our roses here at Brawley Creek aren't edible or symbolic—they are clingy. Agrimony is one of them and it answers to three common names, all appropriate; Swamp Agrimony (it grows in flood-plains), Many-flowered Agrimony (it flowers along a six-foot stem), and Harvest Lice, because its seed is clingy. Figure 11.10 shows three stages of Agrimony maturation as it converts from delicate flower to no-nonsense vehicle.

The importance of dispersal has resulted in more elaborate mechanisms. Catapults and exploding seeds are not beyond the powers of dead flowers and they are the most interesting of the architectural methods. They require the ovarian wall to build elaborate structures far beyond the universal role of nurturing the embryo through what is essentially a vegetative placenta. Wild Geraniums, also called Cranesbills, have built into their ovarian tissue a spring-action launch vehicle that, as it dries, builds stress, such that when it releases the energy stored in that tissue, it catapults a seed some small distance from the parent plant.

11.10 ~ 5X all. Three stages of Agrimony (*Agrimonia parviflora*) in which the hooks are worn like an Elizabethan ruff. Left: Flowering begins in Early Fall, the nascent hooks behind the petals. Center: maturing vehicle, flowering complete. Right: The matured seeds in their vehicle, ready to be broken off and catch a ride.

Spotted Jewelweeds, familiar to many as Touch-me-nots, are larger but they use a similar kind of dispersal, only it is a broader, explosive release, rather than a directional one like a catapult. Jewelweeds require moist areas that often occur in small patches, so that wide dispersal would be counterproductive. And they are annuals, so they need to reclaim their home turf each year. Still, they represent a kind of accidental hitchhiker when the trajectory of the slightly sticky seeds land on the backs of passing animals—an outcome more probable than it sounds at first blush.

The Jewelweed flower (Figure 11.11) is pollinated by hummingbirds, as suggested by its red color, and it has a long nectar spur behind the opening, curled like a pig's tail—just made for them. But the large bore also invites Bumble Bees in the same way as Beard-tongue and Great Blue Lobelia. Jewelweed does not reach the level of specialization seen in Cardinal Flowers, although its anthers and stigma are somewhat similar. The anthers are wrapped around the immature stigma, forming a ring that releases pollen before the stigma protrudes and becomes receptive. During fertilization, the Hummingbird's forehead and the backs of furry bees transfer pollen, as seen elsewhere. When the stigma pushes through the ring of anthers and becomes receptive, the anthers shrivel and drop off, followed in a few days by the loss of that bright, fusion of petals and sepals, the latter dropped as one might shrug out of an overcoat, leaving visible only the tiny ovary with its developing seeds (Figure 11.12). On maturation, the ovary swells to many times its original size. Not only are the seeds growing, the ovarian wall needs to be muscular and taut because it is the force behind dissemination. There aren't any muscles, of course, and the release is achieved by drying like the Cranesbill's catapult. The ovarian walls of Jewelweed split open as they dry out, but unlike most such releases, Touch-me-nots peel back the ovarian walls explosively.

A ripe, ready-to-pop ovary is pictured in Figure 11.12 along with one already discharged. The ovarian walls are formed into five sections (valves), and as the seeds mature inside the seed pods, the pods do too, the valves swelling and becoming thicker.

The plant regulates this process by generating strong hydraulic forces though the control of osmotic activity, keeping them swollen

11.11 ~ 3X. Spotted Jewelweed (*Impatiens capensis*). A family portrait: mom, with a bun in the oven, dad (the anther ring) has already dropped out of the picture, and there are three kids of various ages on a different branch of the family. The swollen ovary of the eldest (bottom center) has reached the age where it is about to burst.

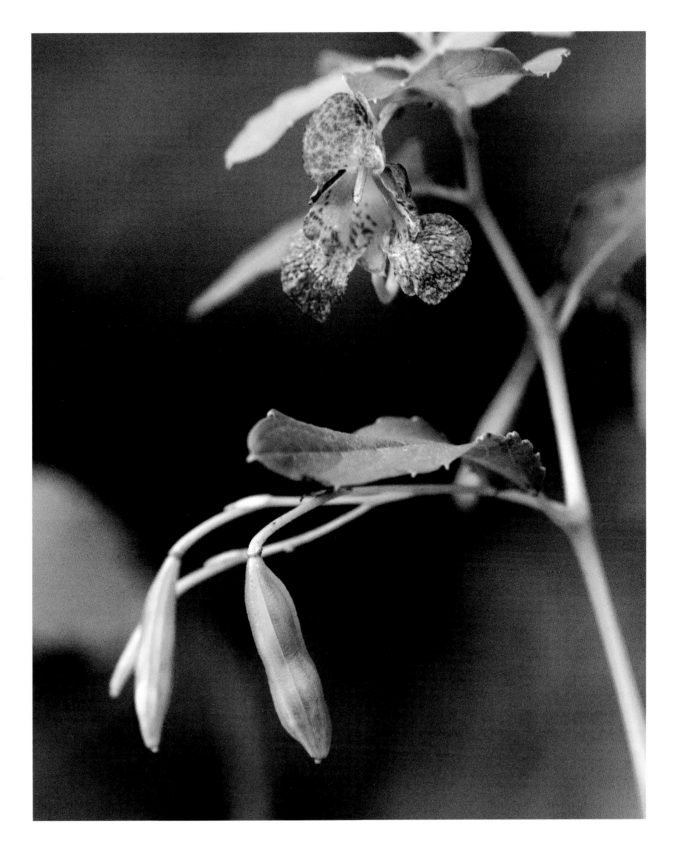

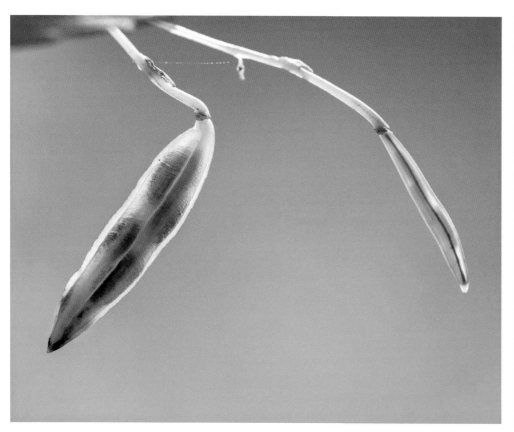

11.12 ~ 4X. Left: A mature seed pod carries at least four seeds, its ovarian valves prominent. The thinner seed pod recently dispensed with its advertising parts. Right: an exploded seed pod reveals the component parts. The valves are curled inward tightly, still joined where the pod attached to the stem. A long, central columella remains; a recovered seed placed next to it.

and turgid. Those valves are surprisingly powerful, reinforced with strong fibers that store more potential energy than spring steel. As the valves age, they dry, their restraints weaken, the energy stored in the fibers overpowers the resistance of the ovarian valves, and their energy is released. In that instant, the ovarian walls open along their seams like banana peels, except that their valves curl inward with great force, and at high speed. They complete their movement in less than 3 milliseconds, flinging the seeds into ballistic trajectories for up to 6 feet. That is the hand grenade model of dispersal, but the seed trajectories are not entirely random as the model suggests. To achieve optimal distribution, the supporting stems must be at optimum height—tall enough for good distribution of seeds, but not so tall that their hollow stems are vulnerable to breaking. The seeds pods don't hang limply either; they are firmly angled so that the ejected seeds go up and out in a ballistic trajectory that maximizes their dispersal.

Often that release is triggered by touch, (hence the name) or a breeze—the downdraft of a hummingbird's wing, or a coyote trotting through the patch and bumping the stems. Any of those triggers can set into motion a sizable chain reaction, where flying seeds trigger other pods, and the seeds fly everywhere. Some of them are likely to land on the back of a mammalian intruder, thereby becoming a not-entirely accidental hitchhiker. Most of them, however, drop to earth within the habitat that supported their parent, reseeding the crop for next year.

Other methods of dispersal offer longer distances of dispersal and they usually require animals as conscripted participants or as fee-for-service employees much like the transactions that evolved between flowers and their pollinators. Oaks, hickories, walnuts, and particularly

hedge trees, produce very heavy vehicles with initial dispersal limited to the drip line of a parent tree. A Hedge apple that weighs upwards of three pounds (Figure 11.13) doesn't fall far from the tree, and in fact makes a decisive "thud" when it strikes the ground. All of these species employ animals to carry their seeds away from the source.

Elms and cottonwoods produce light, wind-borne seeds suitable for wide distribution and they readily move into disturbed areas as pioneers. But long-lived oaks and hickories grow up in forests where they want to stay. The seeds they produce germinate in a world of furious competition, all of them pretenders to the throne, living in the shadows, and waiting for the death of a nearby patriarch to open a place in the canopy. But there is a huge oversupply of saplings, and the likelihood of reaching that position is equivalent to wining a lottery. It is a long shot, but it is open to saplings that by quirks of genetics and chance, persist to reach the canopy.

Any number of animals move heavy seeds for short distances. Some of the seed crop is eaten immediately and the embryo destroyed. But many creatures, most notably jays and squirrels, bury some as a food cache—"squirreled away" is the common phrase. Months later, they remember with extraordinary efficiency where they put them, even when they are blanketed with new leaf litter and a few inches of snow. But they don't recover all of them, so their economic relationship is part fee-for-service, and part sharecropping—planting in exchange for a percentage of the crop.

Collectively these large seeds are recognized as the mast crop. Mast falls from trees like manna from the heavens, except that rather than something like hoarfrost, it is a fusillade of walnuts, acorns, and hickory nuts. Further east, the mast crop includes beechnuts, and before the chestnut blight arrived a century ago, chestnuts were a major component of it. From the perspective of mast producers, the strategy is to flood the system with food in such quantities that the consumers can't eat it all. It is worth noting that the same strategy is used by periodic cicadas. It is expensive for the trees, but they are long-lived forest trees, and they need to give their seedlings a good start for the competition ahead of them.

Such an outpouring doesn't happen every year. If it did, the consumer population would rise to the occasion. Intermittency is the key. Red Oaks, of which we have plenty, produce a large crop every 2-5

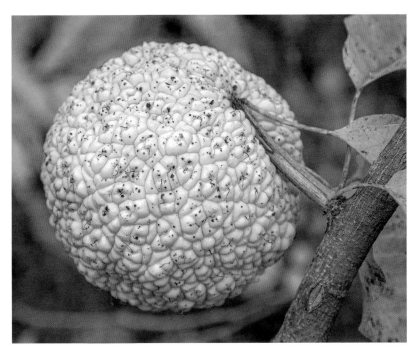

11.13 Hedge trees (*Maclura pomifera*) are related to mulberries but the fruit they produce is enormous and has no native consumers that could justify its 3-pound heft. An expensive banquet has been prepared for no apparent guests.

years, White Oaks every 4-10 years, so from time to time those two species are synchronous. What determines the synchrony is not well known but mast trees are wind pollinated and therefore influenced by climate, and quite possibly they communicate through the hyphae of soil fungi. In those years when several species release a bounty of seeds, they fuel population growth in all their consumers—deer and turkeys of course, but also Wood Ducks, squirrels, and every lesser rodent—mice, voles, and rats. The populations of those with short lifespans burgeon, along with their predators: several kinds of hawks and owls, foxes, coyotes, snakes, and others for whom rodents are the primary food. Increased population densities of all of those consumers stimulate the transmission of their pathogens, and level of illness increases. Parasite numbers, including ticks and mites, swell as the wave of energy ricochets about the ecosystem before dissipating until the next mast year triggers another cycle.

Finally, we come to the dispersal strategy that requires that the seeds be eaten. These relationships are more intimate and require us to discriminate between seed dispersers and seed predators, unambigu-

ous categories that nevertheless overlap. Squirrels are seed predators. They destroy seeds, but they bury some too. The fact that burying nuts and "forgetting" some seems to be characteristic of squirrels, so they are dispersers also.

We are often seed predators (e.g., pecans and walnuts) but more often we are seed dispersers. When we happen on a patch of ripe Blackberries and help ourselves to a couple of handfuls, we take the offspring with their blessing—they were, after all, made for creatures like us. It's why they make their fruits sweet. It's bait, like making nectar for bees, and that puts us in the employ of Blackberries, and we do it for the money/calories. Modern plumbing nullifies the best laid plans of such fruits, but during our long history as hunter-gatherers, we were reliable seed dispersers, along with a diverse crew of birds and other mammals. This relationship requires the plant to reconfigure its ovary so that, besides the seed and its endosperm, it produces a sweet, energy-rich pulp that can assume a broad array of sizes and textures to please any palate. And that pulp is the vehicle.

In botanical terms, a fruit is the swollen ovary of a fertilized flower. Fruits contain the essentials, the embryo and their specialized embryo food (endosperm), wrapped in a seed coat. That is the passenger and baggage. Everything peripheral is also part of the ovary and it serves as the vehicle, which may be enormously variable. Different dispersal strategies require different vehicles; the cattail's fuzz, a dandelion's parachute, hooks and barbs of many sorts, the tensioned valves of touch-me-nots, and the delicious pulp of fruit.

Seasonally, we occupy the ecological role of frugivore (fruit eaters), taking blackberries, strawberries, and tomatoes, and passing the seeds in exchange for pleasurable flavors coupled with energy—sugar in particular. The ultimate success of a fruit with a fleshy vehicle is for the vehicle to be eaten without the seed being crushed—it is the difference between being eaten by a seed distributor and a seed predator.

Fruits are marketed to birds and mammals and the occasional box turtle—all of which swallow both seed and pulp. Birds don't chew of course; instead, the ingested seeds soak in a crop before passing into a gizzard. That muscular organ is equipped with selected grit, so that the seed coats become abraded. Abrasion enhances the germination of seeds by weakening, but not breaking, the hard seed coats that protect the embryo and endosperm. Then they pass into an acidic stomach and through an alkaline intestine where they soak some more before being voided. Think of your last ride through an automatic car wash and you will get a sense of it from the perspective of a seed. For some seeds, this sequence is an essential rite of passage, a prerequisite to germination.

Fruit and distributor are matched as carefully as flower and pollinator, not only in their size and palatability, but also in their timing, and that brings us back to steppingstones. Wild strawberries, blueberries, blackberries, raspberries, mulberries, cherries, crab apples, and more, create a steady sequence of edibles, all in the Rose family. The spread of time when they are edible depends on the nature of the plant and the energy content of the seeds.

The fruit season begins in the Spring after the last frost, with the production of flowers and their fertilization by insects. Then the parents' energy supplies are devoted to making food for the embryo and endosperm, and to enriching the ovarian walls to make them marketable (calorie-rich). A Spring Beauty does it in record time, but it is not until the Early Fall, and sometimes into Late Fall, that many fruits mature, and some of those last overwinter—the least desirable fruits last the longest.

Earlier in the year, birds need protein and fat to grow and fledge their young and to prepare themselves for their molts, and they need invertebrates of all sorts—worms, spiders, flies, and butterflies—to access such nutrition. As Summer turns to Early and then Late Fall, a Summer's worth of energy capture is made available to distributors as a banquet of fruits come on line. The ground under a grove of persimmons hums with fruit flies on the warmer days of Late Fall, after the fruit begins dropping from the trees; but it doesn't last long. The scat of 'possums, `s, and even foxes, consist largely of persimmon seeds—indicating a successful strategy that is mutually beneficial.

Figure 11.14 shows one of the items on the buffet. Rough-leaved Dogwood is abundant here as a shrubby tree that by mid-August produces plump, juicy berries that look like tiny apples—they go quickly. Wahoo shows its readiness to be eaten in late October, the seeds open their pink coverings in a way that reveals their kinship with American Bittersweet, both declaring themselves ripe for the taking as Late Fall passes into Winter.

All of such fruits are steppingstones, less essential than some we've

seen, but many last through the winter. The softer and juicer they are, the more perishable, while drier and less nutritious fruits that are also less palatable, have the virtue of durability. We can evaluate their desirability by how long they remain on the plant before fruit-eaters are driven to them. The Dogwood berries in Figure 11.14, are as juicy as a grape and go quickly. The Wahoo opens for business in December. Grapes and their kin (Figure 11.15) are still abundant and in demand in November and December, now taken in their dried form when juicy fruits with higher water content are long gone. We might think of them as wild raisins.

Buckbrush (aka Coralberry), is among the least desirable, treated as a starvation food by many. It serves deer, turkeys, and others, but many of its dried and shriveled berries remain on their twigs as Spring arrives. Buckbrush berries are like the last person chosen for the team.

While these plants are maturing seeds and preparing the pulp, they post Do Not Disturb warnings in the form of dull green skins, very firm flesh, and tart flavors. Persimmons are eaten only when quite ripe because high levels of tannins persist until then, but when ready to be eaten their skins turn an eye-catching orange, signaling consumers with color vision that the time is ripe.

Of the fruits we enjoy most, the juiciest and sweetest are the stone fruits—Apricots, Peaches, Plums, and Cherries—all roses. Stone fruits wrap the passenger in a hard casing (the stone), ensuring that the embryo and its endosperm will survive some rough treatment. Outside of the stone, there is an energy-rich pulp, overlain with a thin skin. Stone fruits have made a very solid wall between food for the distributor (pulp) and food for the embryo (endosperm). Our ecological role in enjoying these fruits identifies us as "pulp thieves." We take the payment without performing the service in the implied contract. There is of course, no moral dimension to this transaction, but the coining of the term says a lot.

The genetics of stone fruits have been manipulated for so long that their wild ancestors are barely recognizable, and some probably extinct. Recognizing the extent of this manipulation is important here, because having brought them into our cocoons, now modified to please us, we have acquired a distorted view how they work (or worked) in the community in which they evolved. Their ancestors built their fruits to entice some appropriately-sized animal to swallow the sweet parts along with the embedded pill. The pill pocket sold by veterinarians to slip an undesirable lump into and animal's belly, is re-

11.14 Native fruits. Left: Rough-leaved Dogwood (*Cornus drummondii*), Center: Eastern Wahoo (*Euonymus atropurpurea*), and Right: American Bittersweet (*Celastrus scandens*).

11.15 Left: A Pileated Woodpecker is harvesting shriveled grapes (*Vitis* sp.)—essentially wild raisins—along with a much less prominent, Red-bellied Woodpecker. Right: A flock of vagrant Cedar Waxwings stopped by to take advantage of the berries of Virginia Creeper (*Parthenocissus quinquefolia*), a close relative to Grape.

ally a very old idea. We've been taking strawberries and raspberries with their seeds, for a very long time. The animals that shaped fruits before humans began to modify them, wouldn't recognize the fruits that we've created from their genetic stock—what they initially prepared for us.

Peaches originated in China; their manipulation began about 4,000 B.C.E. They were olive-sized, waxy fruits, smaller than a persimmon, and the stone occupied about a third of the volume. It could have been swallowed by humans or any number of fruit-eaters like the ones that eat persimmons here, including a variety of primates besides ourselves. We brought Watermelon into our cocoon about 3,000 B.C.E., enlarged greatly from an extremely bitter, South African ancestor two inches in diameter, that required a blunt instrument to open. Something must have found that tasty once. We expect that plants who expend a lot of energy making large fruits, don't do so unless there is some animal that is enticed to eat them and so distribute their seeds. It has to be worth their while.

Wild Grapes attract Cedar Waxwings and other birds of similar size (Figure 11.15.) The Waxwings take the offering and if the fruit pulp is tightly adhered to the seed, they are more likely to take the seed along with the pulp than if it is loosely attached. Removing all of the pulp that clings to a seed is an expenditure. Compare our experience with freestone peaches as opposed to clingstone peaches that won't release the last of the pulp. Pulp that clings makes stones slipperier and more likely to be swallowed. One would expect that the original peaches were of the clingstone type.

Some plants instruct their consumers to be gentle with the seeds through a carrot-and-stick approach. They've added a compound to their seeds, but not to the pulp, that releases a toxin when subjected to the acidity of a mammalian stomach. The seeds of apples, crabapples, and grapes are of this type, along with the seeds of the "stone" fruits: cherries, peaches, plums, and apricots. They contain a compound called amygdalin, that on digestion, releases cyanide. Its only function appears to be the instruction of animals who chew—mammals—to be gentle, along the lines of "we aren't going to hurt each other, are we?" Other seeds contain a little arsenic. Plants like strawberries with 200 tiny seeds per fruit can afford to have some of them crushed, but plants with few seeds per fruit, maybe just one, protect the embryo in this

way—yet another instance of plants producing toxins to restrict or control herbivores.

Outside the seed coat, ripe fruits contain several kinds of sweeteners that are structurally similar. Glucose, fructose, and sorbitol are three that are often found in the pulp of fruits in roughly equal proportions. We like the sweetness, and we readily absorb them through the intestinal wall; except for sorbitol. When fruit-eating animals take these sugars into their GI tract, along with the seeds, the quick absorption of the other sweeteners concentrates the sorbitol, which has the osmotic power of sugar and draws water into the intestine. That creates a laxative effect that moves the properly abraded seeds out of an environment that becomes increasingly hazardous to them in time.

The initial sorbitol concentration in the fruit is controlled by the plant to pay the consumer. Adjusting the various levels of those sugars allows the plant to regulate the amount of time the seeds spend in the intestine of the targeted consumers. It really is the birds and the bees all over again. The formula is written in their wills. In dried fruits, the sorbitol concentration increases markedly—as with prunes.

Understanding something of the economics of fruit production and distribution, the very large fruits of hedge apples, raise economic questions. Why would a Hedge tree invest so much energy in a fruit that is largely pulp, weighs a couple of pounds, and that nobody eats? Cui bono? Squirrels and mice eat the seeds, not the pulp, so they are no help to the trees, unless they cache some of the seeds. Hedge apples are made for animals that could eat them like popcorn. We don't have any of those, except for horses which became extinct in North America, until reintroduced by Cortez early in the 16th century. Several kinds of horses evolved here along with Hedge. The horses have been absent for a short ten thousand years, but they retain a taste for Hedge apples. The most likely disseminators of Hedge seeds were the elephantine mastodons and gomphotheres, along with the enormous ground sloths that lived here for millions of years, before the lot of them—including the horses, became extinct. For them, the ratio of pulp to seed would be not much different than we experience with strawberries.

There are other signs of missing animals. Honey Locust trees have enormous thorns on their trunks (Figure 2.14) and lower branches, but not high in the air where the fruits are produced. One wonders

who they were intended to defend against. Perhaps they were positioned to discourage an assault by animals of elephantine proportions with sensitive noses. Kentucky Coffee Trees are legumes that produce a few really large seeds in a leathery pod. The pod has a thick, sweet pulp and contains a laxative component. The seeds themselves contain an alkaloid that is toxic to some animals and the seed coat requires scarification to germinate. Clearly this fruit was made to be eaten, and I've seen deer eating them in the Winter. African Elephants browse legumes and nick the seeds with their teeth, enabling germination, so it is highly probable that the missing half of the partnership was lost with the extinction of the megafauna.

With Late Fall drawing to a close, we've come full circle and we look for the first frost that abruptly terminates most activity, and ushers in a period of rest for most living things. The stark empty Milkweed pod in Figure 11.16, is testament to the success of all of the seasons past. The earth's orbit complete, it begins yet another lap and we do it all over again—it's the nature of Circular Time. The endless cycling of the seasons is deeply embedded in us and in the world around us, and the inevitability of the changing seasons is comforting. All of our environmental variables fluctuate—cool, wet Springs are followed by hot, dry Summers. Some years, Brawley Creek is without flowing water, its aquatic community decimated, only to return with the following Spring. These vacillations hone the ability of each species to fit into its niche for a full cycle and survive within the normal bounds of our climate. The ecosystem pictured in these pages will change again—changing as the fickle climate does. But whatever those changes will be, they will follow the rules of succession and most certainly the Timeless Rules of the Game.

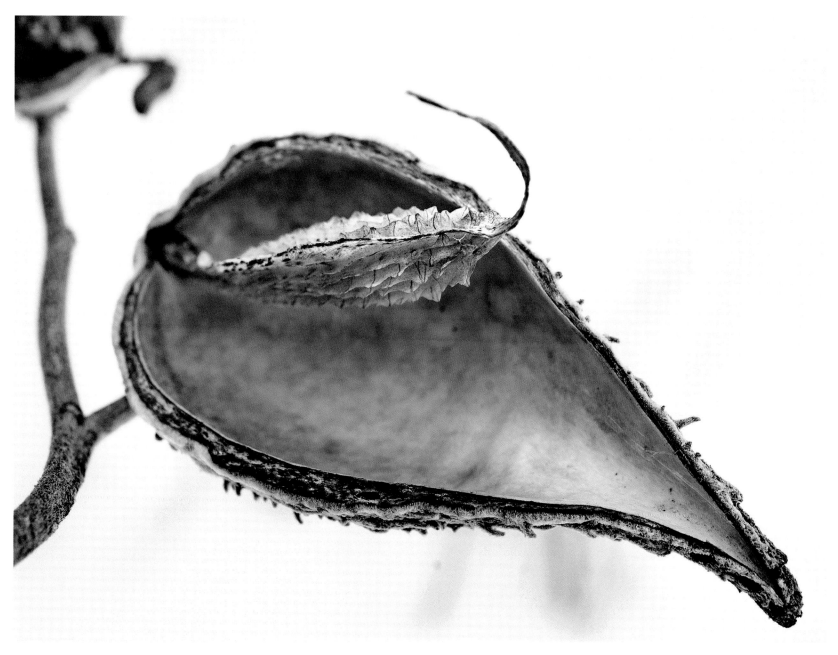

11.16 Empty nest. A Milkweed seed pod with its hard, slick lining is the final scene of a successful life lived. In keeping with circular time, it provides both beginning and end to our Milkweed story, the subtle colors and the sleek perfection of the pod are rich with meaning. If you know the story.

Fig 12.1 Something familiar can always be seen in a new way. This is one of those invisible instants that photographs can provide. Even though it's just a trickle of water, it moves too fast for us to see so in making this instant stretch out indefinitely, we see something new and beautiful.

Seeing the Forest and the Trees

"In the end, we will conserve only what we love. We will love only what we understand."

~ Baba Dioum

The background of the photograph on the facing page is detritus at the bottom of Brawley Creek. Like everything else we've seen in this book, it too is perfectly ordinary, although we've lived on Brawley Creek for 40 years and this image of an instant, taken not 40 feet from our house, is new to us. The figure provides a final opportunity to make visible the beauty that lies at our feet everywhere—beauty that for the most part we don't notice, or can't see because of its duration, or that is invisible to us because we don't understand the subtleties of the interaction of the parts. It's not the detritus that is beautiful, although the shapes of those old leaves catch the eye, the beauty lies in the invisible component that can be seen only by reflection.

It's our emotional brain that responds to shapes and colors, and they impact our state of mind. The angularity of repetitive patterns on the reflective surface creates a sense of motion, but the recognizing of that mechanism, separate from our quick response to it, is the purview of our rational brain. If we attend to this complex image to extract more of what is in it, we leave our aesthetic response and engage our rational parts. Those parts confront us with questions about the nature of water as well as the nature of our perception, and those carry us to the threshold of science. We really can't focus on both at the same time, in the same way that we can't focus on both the forest and the trees at the same time. Those two ways of seeing the world are inherent in the structure of our brains, but living in the world requires us to synthesize the two kinds

of input in order to make decisions. Those two ways are the basis of the arts and sciences, and we can access awe with either of them. Using both is more powerful still.

Failing to see the forest for the trees, is colloquial for failing to see the whole picture. If we hope to see them as a single entity—to see the whole community at its several levels—we must frequently shift our focus from the abstract working of the communities, to the individuals with whom we can identify, and back again. That explains the organization of this book, regularly and with purpose, shifting from one perspective to the other.

Emotional is a poor word to describe that combination of genetically imbued and learned responses; that word carries a lot of baggage, muddied by its more common use to mean: sentimental, sensitive, even hysterical. I have nothing better to suggest, but this might be a good place to remind the reader that it stands to represent feelings as opposed to rational responses sometimes identified as cold.

Our emotional response is nearly instantaneous. Inherent and learned responses guide the actions of the other animals that live in our slice of the Little Infinity. They lean more or less on inherent behaviors, depending on the complexity of their nervous systems. Our rational capacity rides atop our emotional system and the combination makes us something of a superpower in the ecological community. It is a newly acquired power—compared to the vastly older, polished, and well-worn paths of the trigger-and-response mechanism that we share with other animals—and we are still learning to use it. Poorly-developed and sluggish, the rational component of our arsenal of triggered responses, makes us literally of two minds. The rational parts—understanding the elements of energy flow, complex community interactions, and the like—are harder work and the most difficult to incorporate into our understanding of the world. Reason may be a superpower, but it is still in its infancy and it is slow; we have to mull things over.

Walking along a trail, we see things that feed our emotional needs, and the immediate experience is pleasurable, often delightful. Attending to those sensations is the first step toward understanding the overarching Rules that built them, and the intricacies of how they function, both individually and as part of an integrated community. I chose the image of flowing water with the hope that your response to it will con-

tribute to the distinction.

These words recap ideas put forward in the Preface, but they are worth repeating because we now have shared experiences, a common vocabulary, and access to some foundational ideas that are far-reaching. I can summarize the rational content, but not the emotional part—imagery can't be reduced to a summary without slipping into rational analysis. That is why there are so many photographs in this book; to provide a weak experience of the real world outside of this virtual one. We can recap then, only the rational constructions, but equipped with them, each of us can generate emotional responses and build connections independently.

The words Charles Darwin used in closing his best known work bear repeating: "There is grandeur in this view of life…whilst this planet has gone cycling on according to the fixed laws of gravity, from so simple a beginning, endless forms most beautiful and most wonderful have been, and are being, evolved." These words from a scientist, direct us toward seeing the wonders around us as part of our wealth, rather than as pawns to accumulate more.

Failing to engage both of our minds makes it less likely that we will be able to see our commonality with the rest of life, and less likely to experience the pleasures that come from belonging. That's the context of why we must continually remind ourselves to avoid becoming so focused on the trees that we miss the forest; and being of two minds makes it possible to do so, but it really needs to be intentional.

Here are the core elements of the forest, which can be summarized and condensed. However random and disorganized the world around us seems, it is faithful to the Rules of the Game and to all of the corollaries that stem from them; and they are legion. The pyramidal structure of communities is one consequence of The Rules. However abstract, it equips us with a simple but powerful image. It's only a visual mnemonic, of course, but it connects us to the related phenomena, among them, the routing of energy, the energy loss at each tier, and the required population structures that necessarily follow. The imperative to reproduce to excess is an outcome of the Rules and because of that, life is incredibly cheap. In our culture we treasure life, but then we are one of those peculiar social species. All of this leads inexorably to natural selection and a further proliferation of principles, axioms, and dogma: the competitive exclusion principle, niche theory, and ecolog-

ical succession, to name a few. The Rules make even the arcane impact of surface-to-volume ratios a matter of life and death rather than a mathematical curiosity.

This conglomeration of laws, theories, principles, and algorithms plays out at every organizational level, but because we are supremely invested in the level of the individual, rather than of populations, our innate drives and the cultures we build reflect that level almost to the exclusion of others, and that focuses us and our cultures on the assembly of energy/calories/dollars, and that keeps our collective feet on the accelerator. And it isn't just a human thing, though it is easier for us to see in our choices of cars, the sizes of our homes, and the clothes we wear. Acquiring wealth, however measured, addresses the prime directive of living things—to reproduce. That may lie in the control (ownership) of a quality section of cattails as it does in Red-winged Blackbirds, or in producing hyper-red flowers, or being able to afford a long and loud trill as the best toads do—all are demonstrations of wealth in the service of robust, even exceptional, reproductive success.

All of those things we have in common unites us, and drives all of us to pursue excellence in all of those ways and toward the same end. We are all in this together and yet all of us are inclined toward seeking advantage—a competitive edge—even though it is not quite polite to mention it.

One can easily see this book as a trove of informational bits—fodder for Trivial Pursuits. How much does a Chickadee weigh? How many articulations are there between the vertebrae of snakes? So what! That direct question lies in the back of every busy mind; mine too. It's a rephrasing of "Why should I care?" a derivative of "What's in it for me?" and a descendant of "Follow the money." It is an entirely legitimate question.

To respond to it, we need to make a couple of assumptions that seem self-evident, the most prominent of which is that we will choose to act in our own best interest. Given our collective actions over the centuries, this is not true, and it isn't true because we can't see the forest for the trees. Eloquently put forward in 1968 by Garret Hardin as the Tragedy of the Commons, it lays out clearly our penchant for accumulating personal wealth, even if our actions diminish our collective wealth. That brings us into contact with the elephant in the room that I've been trying to avoid. Actually, there are quite a lot of elephants crowded in our room, all with different names, and all connected trunk to tail as if in a circus parade. They are named for environmental changes that refer to losses: Climate, Biodiversity, and a set of triplets named for pollution—Ocean, Atmosphere, Soil. One of them is called Plastics.

I'll consider it a given that we want to live in a sustainable ecosystem with at least enough diversity to make it stable and productive, and preferably interesting and beautiful; few people would disagree. Further, I assume that we would like to live in a culture that meets our basic human needs as recognized by Maslow. That brings us to yet another pyramid that presents relationships as an icon.

Maslow's pyramid has five levels. I assume that we'd like to live in an environment that enables all of them, but we'll just aim for the three foundational needs that form the base of the pyramid. The first tier represents physiological needs: food, shelter, etc., needs that we share with Nuthatches and Toads. The second tier adds safety to our fundamental needs; our cocoons are built to address these two tiers. The third tier is belonging, a need presumably limited to social animals. These needs are based in the environment and can only be satisfied from outside of ourselves. The remaining two, self-esteem and self-actualization, are internal. Encouraging those would be wonderful, but I'll leave them for somebody else's book.

That brings us back to the environmental elephants that we have been ignoring. The environment operates strictly according to The Rules, and knowing even a little about them we don't need a Ouija Board to see the flashing red lights. The Rules give us mechanisms to control those signs of danger through our collective choices, but at the moment all nations have chosen to pursue unlimited growth on a planet with limits. This is forbidden by the Rules of the Game and any child can see it. Yet the people that we regularly choose to set policy, guide our decisions, and work toward our well-being just can't see it, or chose not to. E.O. Wilson presented a tidy summation of our situation: "We control god-like technology with medieval institutions, driven by Paleolithic emotions."

Our actions matter only because we have mastered the capture of energy. That's the origin of all of the named elephants in the room and all of them came out of Pandora's Box. Turning away from the mounting consequences doesn't make our situation any less immediate; each

of us can consume less, can do what is in our power to do as individuals, and can try to effect the election of political leaders that acknowledge the severity and the immediacy of the problem. Beyond that, we must tend to our mental health. One way to do that is to focus on the pleasures around us and delve into Circular Time—a major thrust of this book.

Here is some good advice given by Lao Tzu, from the 6th century B.C.E.: "If you are depressed, you are living in the past. If you are anxious, you are living in the future. If you are at peace, you are living in the present." Living in the present shifts our focus to Circular Time. More recently Georgia O'Keeffe advised us to take a flower, to really look at it, and to "make it your world for the moment." Still more recently, we advise friends to "Smell the roses." That sentiment has by now been reduced to a smiley face, but it is all the same advice. Consistent advice vetted for over eight centuries by countless cultures is worth our attention. We live in the Present at the intersection of Timeless rules, Linear, and Circular time. That is where we experience joy and awe, neither of which have much of a shelf life.

I've tried to show the value of an integrated, diverse ecosystem with an intact work force—a deep bench, to use the sports metaphor. In addition to the beauty, joy, and wonder available to us in such a place, that kind of ecosystem would also give us stability. It is hard to imagine how we can get there within the value system embraced by our society. In fact, we've pretty well established that we cannot. But some cultures have embraced these kinds of values and it should be no surprise that the best place to look for them is among tribal systems. Such groups were characteristic of humans for a long time before we began to live in enormous aggregations. Those cultures were sustainable, and they can model the values that would be desirable—if not essential—in order to reach a sustainable system.

Robin Wall Kimmerer provides such a view in Braiding Sweetgrass (2013). She is uniquely qualified to connect the dots for us and she does so eloquently and powerfully, speaking as one of the indigenous people of the northeastern United States who holds a Ph.D. in botany. Her culture of origin is Potawatomi, and her family was moved to Oklahoma where she grew up as an expatriate—living outside of the ecological community of her culture. Her culture was deeply embedded in that ecological community, so being an ecological ex-pat was more challenging for her than it would be for us where there is always a McDonalds or a drugstore/chemist to provide for our needs. The Potawatomi culture she describes, gives us a glimpse of what it looks like to live with respect for the non-human members of the whole community. The view she presents is tremendously appealing.

She describes going to a patch of wild Strawberries and "asking" for permission to take some. The question is, "May I have some of your berries?" and then she allows the Strawberries to tell her. Strawberries don't speak of course, except in their own language, in which they broadcast their readiness to be eaten, as is typical of the edible species in the Rose family. She is an experienced observer who asks non-verbal questions, and the berry patch answers her in what amounts to a conversation—an exchange of information by question and answer, where she asks the questions, and she translates the language of strawberries into her own. She begins the conversation by asking, "How are you feeling?" and she figuratively takes the "temperature" of the patch by assessing the status of the color and quantity of the foliage and looks for wilted leaves. She asks, "How are the kids?" and makes her evaluation. All of that information is displayed prominently by the Strawberries, even if you only speak their language haltingly. Some of it is directed at birds, but all of us can understand Strawberry language. It is just that we don't think of it as the Strawberry telling us whether it is ready to be eaten, or not. We think of it as deciding if collecting strawberries is worth our time.

Dr. Kimmerer makes her decision based on what the Strawberries tell her. If they say "yes", she proceeds to take some, but no more than half of the crop, respecting the needs of other life forms and nurturing the hope that other life forms will spread the seeds. By leaving half of what could be taken, a berry-picker can receive the gift of the strawberries and still permit the strawberries the natural vehicles of increase and dispersal that were in place long before humans. Box Turtles and Robins will do a much better job of that than we will. The difference between taking them all and leaving half is more than a few strawberries; it is the difference between recognizing them as a part of our community that shares its bounty for an attractive price (free), or, seeing them as a resource to be taken.

Gratitude is the recognition of a gift given. In our culture, we generally take, instead of accepting, gifts like these. It is hard to avoid the

conclusion that we are an ungrateful culture. The difference between taking a resource and accepting a gift is truly profound. In some indigenous cultures, gratitude is expressed regularly and formally as a community. They are grateful for the sun and for the water, and for the green things that give them oxygen and sustenance. There is a long list of the gifts of Mother Earth for which they actively and communally express gratitude. Our culture has nothing equivalent. The closest we come is to join together in singing the Star-Spangled Banner or reciting the Pledge of Allegiance.

Al Capp introduced the "Shmoo" to the country through the Li'l Abner comic strip in 1948. I was six years old at the time and the finer points went by me. Capp describes a surprising origin for this improbable creature, who was built like a bowling ball with chubby little legs and who wore only a smile. The vast majority of our population was born too late to experience the Shmoo phenomenon.

Driving out of New York and into the New England countryside, Capp was struck by "the good earth at its generous summertime best offering gifts to all." He writes, "Here we have this great and good and generous thing—the Earth. It's eager to give us everything we need. All we have to do is just let it alone, just be happy with it." I never attributed such thoughts to Al Capp (better known for his conservative political views) but he says, "The Shmoo didn't have any social significance; it is simply a juicy li'l critter that gives milk and lays eggs. …. When you look at one as though you'd like to eat it, it dies of sheer ecstasy. And if one really loves you, it'll lay you a cheesecake, although this is quite a strain on its li'l innards." Cartoonists think in pictures and when he reduced these thoughts to fit into a comic strip, "it came out a shmoo." Shmoos were the gifts of Mother Earth personified in a comic strip.

I'm a biologist but I grew up in the same culture as most of my readers, I expect. I think it is fair to say that collectively, we see ourselves as the life form for which everything was made, and so everything around us is there for our use. It's a reasonable conclusion to draw. The difference between the view laid out by Kimmerer and the cultural position that I live in, is profound, it is the difference between cooperation and confrontation. It is a consequential deviation from the world view that we held once, long ago, and then lost. It's our current world view that invited the elephants into the room.

In our slice of the Little Infinity here at Brawley Creek, living in the present means making connections with other living things, celebrating our kinship, and being part of—being a member of—such a successful enterprise. We take great pleasure in that relationship. We marvel at the colors and shapes that surround us as well as the elegance of the mechanisms that move them through their dance—our dance, really. The best place to do that is in Circular Time, in which our ancestors lived, and they found the world around them sacred. Living in Circular Time is our birthright.

The matter of belonging, the third of Maslow's basic needs, is in general agreement with the powerful significance of contact with "nature." Gregory Walton, a social psychologist, writes, "Belonging is primal, fundamental to our sense of happiness and well-being. Belonging is a psychological lever that has broad consequences. Our interests, motivation, health, and happiness are inextricably tied to the feeling that we belong to a greater community." Walton was talking about human communities, but I can see that it applies broadly and that has been our experience here at Brawley Creek.

That brings me to my experience of an epiphany. It was a long instant that took place during the early 1980s; it was powerful and it has been consequential. I was on a ladder building our house, still a work in progress to this day. I looked up to meet the eyes of a Red-tailed Hawk cruising slowly about 20 feet overhead. We were looking at each other. I was admiring his grace. I haven't an inkling of what he was thinking—probably, "not food", and maybe "low risk"—so I suspect he didn't get much out of our interaction. Time stretched out. I saw that both of us were busy with the mundane work of occupying our respective niches—both of us with the skills of predators, both of us transient in time and both of us dependent on a long chain of beings that provide for our needs and in due time will recycle us. I saw all of that laid out in a flash and I said out loud, "Hello Brother." Then as is the nature of epiphanies, he was gone, and my grasp of the real world shrank to ordinary. But I remember that intense feeling of membership and collegiality—of belonging. I treasure that moment that I can't explain, and still carry it with me. I wish such an experience for everyone, and I hope that the ideas and images in this book make it more likely.

We think of communities as functionally integrated groups of people. Ecologists could not have chosen a better term to describe a tightly-knit gathering of life forms tied together by the flow of energy.

Knowing the names of the most prominent members of the community is a good way to begin. It honors them by acknowledging their presence. Knowing about how they make their living builds connection and releases empathy. Ultimately, it provides us membership in those communities. All of us find pleasure in belonging and it is as deeply satisfying as a warm quilt. We experience that here on Brawley Creek where we serve as custodians. We feel our kinship with the other members of our community, drawing great pleasure from it and from them, as well as the regular experience of awe. For us this is a sacred place. This book is offered as a key to that kind of belonging and all of the other joys that follow, and it is offered in the hopes that we will see more clearly the gifts that surround us, and the beauty, the incredible abundance of beauty, for which to be grateful. It truly is a paradise. There is so much to see and enjoy around all of us. And it lies just outside of our cocoons where we can take the profound opportunity to get acquainted with the neighbors.

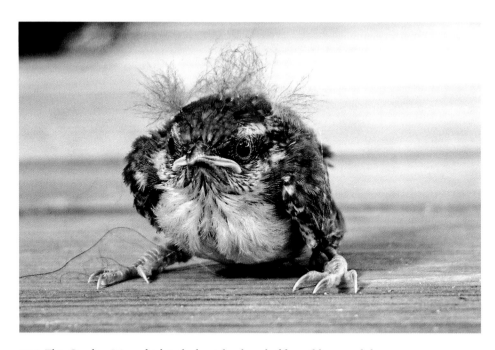

12.2 This Carolina Wren chick is the least developed of four siblings, and she is just out of her nest in a bucket on our back porch. She looks dazed and a bit wobbly, as if she doesn't quite have her land legs, and she looks stunned, seeing the big world around her with new eyes. She is challenged and intimidated, but ready to move out. A good closing metaphor.

Acknowledgements

Such a complicated book—some would say a book that runs off in all directions—has been in preparation for many years and has required a lot of support in many ways. My wife, Gina, has been through it all with me, a gentle person, a skilled observer with the eye of an artist, who has been here throughout, an extra pair of eyes and ears on the trail, she has provided an occasional photograph, and she has a wicked but priceless editing pen and a gift for words. She has been invaluable throughout the process, and the value of that gift can't be overstated.

My long-time, close friend Dick Kahoe has for many years been an enormous help in all things computer related, photographic, and conceptual, and he has a mastery of communicating skills that I envy. He was a marvelous sounding board for ideas, a few of which were good ones, so his contribution relates to the manner and level of presentation as well as all the rest. All of that was valuable in his work at the University of Central Missouri where he too is emeritus faculty.

I am incredibly fortunate to have family and friends with diverse areas of expertise, who are expert in their own fields and generous with their time. Among them, they cover a broad range of experience which they shared with me as beta-readers and more. Some are academics. Dale Hess (brother) would identify himself (probably) as a political psychologist and he was not only a source of information on the human mind, but something of an organizational genius in my eyes, and a source of encouragement that I needed during the long gestation period of this book. Kendy Hess (daughter) is a Professor of Social Philosophy and Ethics after working for a decade in environmental law. Her teaching skills are enviable, and her thorough editing and elegant phrasings brought clarity to the difficult ideas I was trying to express. Robert Bertin, a Distinguished Professor of Science, Emeritus, is an authority on the evolutionary biology of higher plants. His long experience in teaching biology and his familiarity with recent advances in ecological theory, has been invaluable in helping me keep the science in this work current.

It is true I think, that all of the academics recognized as emeritus achieved that rank since I began working on this project. I claim no responsibility for their decisions to retire.

Two of my beta readers are outside of academia and bring different skills that enlarge upon their essential skills in communication. Both are published authors and accomplished editors. Jeanne Kern writes and performs on stage in Nebraska and in films. Susan Croce Kelly, currently the Managing Editor of Ozarks Watch, has authored several books. Both apply skills of a different order to what I am trying to say, and I am grateful to them for the gift of their time, their expertise, and their kindness on this, only my second book—it appears that I'm a late bloomer. I'm also obliged to Rick Mitchell, a fellow photographer and long-

time friend. Rick has broad experiences and very wide interests. It was Rick who, while serving as Gallery Director at the Lawrence Arts Center in Kansas, brought to my attention the idea of Place as a wholistic concept.

In addition, I've imposed on the good will of others and taken advantage of their professional expertise. Jim Loch, a paleontologist at UCM, served as an always available authority for questions on geological history, local and global. He not only critiqued my writing in the relevant sections, but took the time to walk Brawley Creek with me, refine my identifications of the fossils we found there, and put them in context. Rich Monson is emeritus faculty also—an artist with an eye for "arrowheads," which I lack. He too spent some hours with me, walking the gravel bars in the creek bed, and he found the dart points that appear in the book. To me they were just artifacts, but I took them to Peter Yelton, an anthropologist at UCM specializing in Native American cultures, and he graciously provided context and estimates of their ages. Keshav Bhattarai, works extensively with geographic information system technology (GIS), also at UCM. He justified contemporary satellite photographs with the archival aerial photographs I was able to secure.

There is a camaraderie among biologists across the country that surprised me in my earlier work on the Galápagos book, and once again I went to that well and was not disappointed. I am indebted to Dr. Scott Shaw, an entomologist, at the University of Wyoming, who specializes in wasps of the Genus Meteorus. He enlightened me about parasitoids. Dr. Kristen A. Baum at Oklahoma State University has done extensive work with Monarch butterflies and verified my identification of caterpillars who live on milkweeds. Gary Emberger, of Messiah University, now emeritus, was another who generously provided identifications from the photographs of fungi I sent him. Photographs are often inadequate, but to a knowledgeable person, they sometimes permit a really good guess, which he kindly offered, always with the proper disclaimers on the hazards of identification from images alone. Daniel Janzen, at the University of Pennsylvania, has written widely about the relationships between over-sized fruits and the mammals—now extinct—for whom they were right-sized. He shared with me his thoughts on Hedge apples and their dispersal.

To all of these kind people I am grateful beyond words, every contribution helped to make this a better book with expertise as diverse as the subjects we've explored. Even so, the decisions on how to proceed and how to combine the disparate kinds of information so generously provided, are mine. Accordingly, any errors in this book are mine as well.

Sources

Bai, Yang, Maruskin, L. A., Chen, S., Gordon, A. M., Stellar, J. E., McNeil, G. D., Peng, K., & Keltner, D. (2017). Awe, the diminished self, and collective engagement: Universals and cultural variations in the small self. Journal of Personality and Social Psychology, 113(2), 185–209. https://doi.org/10.1037/pspa0000087.

Barlow, Connie. 2000. The Ghosts of Evolution: Nonsensical fruit, missing partners, and other ecological anachronisms. New York: Basic Books.

Daly, Herman. 1991. Steady State Economics (2nd ed.) Washington D.C.: Island Press.

Haidt, Jonathan. 2012. The Righteous Mind: Why good people are divided by politics and religion. New York: Random House.

Hardin, Garret 1968. The Tragedy of the Commons. Science 162:1243-1248.

Heinrich, Bernd. 2003. Winter World: The Ingenuity of Animal Survival. New York: Harper Collins.

Kahaneman, Daniel. 2011. Thinking Fast and Slow. New York: Farrar, Strauss and Giroux.

Kimmerer, Robin W. 2013. Braiding Sweetgrass: Indigenous wisdom, scientific knowledge, and the teachings of plants. Minneapolis: Milkweed Editions.

Kingsolver, Barbara. 2018. Unsheltered. New York, Harper Collins.

Lee, Wu-Jung, and Cynthia F. Moss. 2016. Can the elongated hindwing tails of fluttering moths serve as false sonar targets to divert bat attacks? The J. of Acoust. Soc. of Amer., 139, 2579. https://doi.org/10.1121/1.4947423.

Mann, Charles G. 2012. 1493:Uncovering the new world Columbus created. New York: Alfred A Knopf.

McKimLouder, Matthew. 2020. A conversation about Cowbird behavior (Personal communication), Texas A&M.

Schroder, Walter. 1982. Presettlement Prairie of Missouri (2nd ed.). Missouri Department of Conservation: Jefferson City.

Tyler, Windsor. M. 1964. "Brown Creeper." In: Life histories of North American nuthatches, wrens, thrashers, and their allies, A. C. Bent, editor. New York: Dover Publications.

van Grouw, Katrina. 2013. The Unfeathered Bird. Princeton: Princeton University Press.

Williams, Michael 1992. Americans and their Forests: A historical geography (studies in environment and history). Cambridge: Cambridge University Press.

Wilson, Edward O. 1984. Biophilia. Cambridge: Harvard University Press.

Wohlleben, Peter. 2015. "The Hidden Life of Trees: What they feel, how they communicate" Vancouver, B.C.: Greystone Books, Ltd.

Young, Jon. 2012. What the Robin Knows: how birds reveal the secrets of the natural world. New York. Houghton Mifflin Harcourt.

Topical Index

Species Index: common names

Species Index: scientific names

Actias luna, 16

Ageratina altissima, 211

Agrimonia parviflora, 217

Alligator mississippiensis, 661

Antheraea polyphemus, 7

Anaxyrus americanus, 143

Antaeotricha schlaegeri, 178

Aphis nerii, 173

Aquilegia canadensis, 137

Asclepias hirtella, 163

Asclepias sullivantii, 163

Asclepias syriaca, 163

Asclepias tuberosa, 163

Asclepias viridis, 163

Asimina triloba, 15, 135

Asarum canadense, 135

Betula nigra, 180

Bison antiquus, 62

Bison latifrons, 61

Bombus sp., 43

Calamites, 59

Caliroa quercuscoccinae, 179

Camelops, 62

Castoroides ohioensis, 62

Celastrus scandens, 222

Celtis occidentalis, 93

Cercis canadensis, 32

Choristoneura rosaceana, 99

Chrysocus auratus, 173

Cichorium intybus, 188

Cirsium altissimum, 194

Claytonia virginica, 44, 137

Colias sp., 215

Coluber constrictor, 167

Cornus drummondii, 222

Croesus latitarsus, 180

Cupido comyntas, 25

Cycnia inopinatus, 173

Cynanchum laeve, 170

Danaus plexippus, 172

Daucus carota, 160

Diospyros virginiana, 32

Equisetum hyemale, 59

Equus, 62

Erigeron sp., 186

Euchaetes egle, 173

Euonymus atropurpurea, 222

Gleditsia triacanthos, 42, 183

Glossotherium harlani, 62

Hemaris diffinis, 165

Hylurgopinus rufipes, 47

Hyphantria cunea, 201

Impatiens capensis, 218

Juglands nigra, 206

Leucanthemum vulgare, 188

Lithobates blairi, 145

Lobelia cardinalis, 192

Lobelia siphilitica, 158, 195

Maclura pomifera, 220

Magicicada sp., 103, 104

Mammut americanum, 62

Mammuthus columbi, 62

Manduca sexta, 46

Matteuccia struthiopteris, 60, 213

Mertensia virginica, 132

Meteorus sp., 202

Micrathena gracilis, 196

Mimulus ringens, 159

Misumenoides formosipes, 177

Monarda fistulosa, 194

Morus sp., 109

Nelumbo lutea, (ii)

Neotibicen, 103

Oncopeltus fasciatus, 173

Ophiostoma ulmi, 47

Pantherophis, obsoletus, 147

Papillica japonica, 96

Parasola plicatilis, 37

Parthenocissus quinquefolia, 223

Pecopteris, 60

Penstemon digitalis, 162

Phidippus audax, 98

Philaenus spumarius, 171

Phyllocnistis insignis, 180

Phytolacca americana, 187

Pinus strobus, 134

Plestiodon fasciatus, 13

Pleurotus ostreatus, 36

Pseudacris triseriata, 142

Ribes missouriense, 137

Rosa setigera, 43

Rudbeckia hirta, 155

Rudbeckia triloba, 186

Schizophyllum commune, 38

Schizura unicornis, 46

Scolytus multistriatus, 47

Smilax hispida, 42

Solidago altissima, 186

Speyeria cybele, 165

Sycios angulatus, 170

Symbos cavifrons, 62

Symphyotrichum pilosum, 210

Tapirus veroensis, 62

Taraxacum sp., 11

Tenodera sinensis, 176

Terrapene ornata, 168

Tetraopes tetrophthalmus, 173

Torilis arvensis, 155

Toxicodendron radicans, 209

Tradescantia ohioensis, 157

Tapir, 62

Trillium sessile, 135

Tubifera ferruginosa, 39

Typha latifolia, 212

Vernonia baldwinii, 186

Viola bicolor, 136

Vitis sp., 223